IN THE
SUNSHINE
OF
NEGLECT

**DEFINING PHOTOGRAPHS AND RADICAL EXPERIMENTS
IN INLAND SOUTHERN CALIFORNIA, 1950 TO THE PRESENT**

Published in conjunction with a joint exhibition held concurrently at
UCR ARTS: California Museum of Photography and Riverside Art Museum, January 19, 2019–April 28, 2019

Published by Inlandia Institute
4178 Chestnut Street
Riverside, CA 92501

ISBN: 978-1-7324032-2-2

Library of Congress Control Number: 2018965153

Front Cover:
Lewis deSoto
Tahualtapa, Hill of the Ravens, 1983–1988. Collection of UCR ARTS: California Museum of Photography, used by permission

In the Sunshine of Neglect

Defining Photographs and Radical Experiments in Inland Southern California, 1950 to the Present

Douglas McCulloh

UCR ARTS: California Museum of Photography
Riverside Art Museum

Essays by Douglas McCulloh, Thomas McGovern, Tyler Stallings, Susan Straight, Joanna Szupinska-Myers

Published by Inlandia Institute

My goal has been to assemble these photographs with a confident love and no special pleading. Like Inland Southern California itself, the artists' work is so rich and diverse as to resist summary description. Walk the galleries as you would a wonderfully varied neighborhood. Stay open to marvels. Bear in mind that the aim of a worthwhile project is to ask questions so ambitious that the photographs cannot answer them.

Draw your own conclusions. Make a photograph. Have an opinion.

—Douglas McCulloh

In the Sunshine of Neglect has a geographic filter: Inland Southern California. The heart of the place is agreed upon, well-defined. But, despite the demarcations of mountains, hills, and passes, discussions of the area's outer boundaries are surprisingly contentious. The center holds, the edges waver, the residents squabble.

Defining Inland Southern California is a sensitive operation. Consequently, the edges of our map are soft. Broadly speaking, the region stretches from Pomona/Kellogg Hill/Chino Hills in the west to the upper Coachella Valley in the east. It extends from Big Bear/Lake Arrowhead/Wrightwood in the north to Temecula in the south. Our definition acknowledges the two major portals into the desert—Cajon Pass and San Gorgonio Pass. The zone extends just a bit into the high desert at the north, incorporating Hesperia and reaching into Victorville. To the southeast, it encompasses the upper cities of the Coachella Valley, but ends short of the Salton Sea.

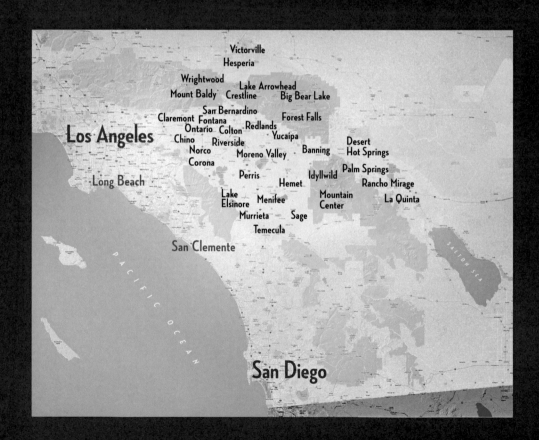

Photographs and Observations

Essays

In the Sunshine of Neglect: An Essay in Eight Parts Douglas McCulloh

◯1 PERIPHERIES AND WASTED SPACES

Inland Southern California occupies the margin between two mythical landscapes of the American West—the wide-open spaces of the Basin and Range and the strange dream of Los Angeles. It is set between L.A.'s distillation of golden structures on hardscrabble streets and 500,000 square miles of saltbush, sage, and aspiration. It contains a little of both, and a lot of nothing at all.

The inland region is Southern California's highest and lowest, hottest and coldest. It is sliced by the two most threatening branches of the San Andreas Fault. Faults cut through the Cajon Pass, push up the steep north face of Mount San Jacinto, and sink Lake Elsinore into its turbid trough. They splinter into innumerable traces, fingers, and offsets. Across this unstable terrain, fire and flood arrive with a frequency remarkable even in the vulnerable West. Long before it became the fashion, the Panorama Fire swept out of the foothills into the housing tracts of San Bernardino. In 1980, it was a startling event. Pushed by ninety-mile-an-hour winds, the fire burned its way through 310 suburban homes and killed four. This place is maximal Southern California, the region purified and heightened.

Despite this vivid geography, the region remains defined not by its attributes, but by its position. It is a periphery, a margin. It is in-between. It is viewed as a kind of placeless place, often secretly so even by those who live here. (As if any place can be placeless, a question to ask the Cahuilla, Luiseño, and Serrano who have long occupied these valleys, mountains, and desert fringes.)

Inland Southern California is an edge. It's where Los Angeles sends its ozone to simmer under the summer sun. Where commuters fill tract houses that overflow the valley floors and covet the custom homes that climb the hills into the fragrant, flammable chaparral. Where town after town have grown together, but not quite cohered.

A place of four-and-a-half-million people spread over 27,000 square miles of valleys and passes, mountains and desert edges.

Cahuilla artist Lewis deSoto, born in San Bernardino, characterizes the inland landscape as filled with opposites—"marvelous and abject." This characterization extends to the social landscape as well—one of the most ethnically, culturally, and economically diverse in the West. Robert Adams is a world-class artist who attended school here and returned over and over again to make photographs that helped deflect the course of photo history. Adams speaks of unexpected glories. "Over the cheap tracts and littered arroyos one sometimes sees a light as clean as that recorded by [1870s photographer Timothy] O'Sullivan. Since it owes nothing to our care, it is an assurance; beauty is final."[1]

In this sun-baked margin, suburbs finally taper to open desert. With every mile from the centers of influence in Los Angeles and Hollywood, attention likewise thins and attenuates. A periphery—especially one near the high-gravity communication marketplace of a megacity—becomes an overlooked region, a pass-through terrain, a zone of neglect—which makes it open ground for exploration and enquiry, for sifting and delving, for driving art in new directions.

At its core, *In the Sunshine of Neglect* is an exhibition about place and experiment. It is about artists using the rapidly developing spaces of Inland Southern California as a tabula rasa, a laboratory to dissect new subjects and deploy new approaches. In these interstitial spaces, this zone of neglect on the periphery of Los Angeles, artists have transformed extremity into new practice, banality into discovery. Some have been engaged here for long durations—even lifetimes, while others have cycled through like grad students visiting a research lab down the hall. But the entire current generation is influenced by the new avenues of photography established and

elaborated by this exhibition's artists—Robert Adams, Lewis Baltz, Joe Deal, Judy Fiskin, Anthony Hernandez, Sant Khalsa, Laurie Brown, and others—not long ago in the West, this part of the West.

In Inland Southern California, photographers criss-cross a landscape so stripped down, so newly manufactured that treasures can be found right at the surface, every surface. Most of this exhibition's artists do not define their task as delving into development, decay, or decline. For the most part, they seek to simply look at the wide range of what is, as if looking can ever be simple. But it's fruitful to undertake the task in a place especially exposed and revealing. A place founded on faith in constant expansion, regardless of cultural or ecological consequences. A place willing to consistently erase the present for a stake in an imagined future. In short, a place that nakedly stands in for the Western World.

Sight and thought in these images thus tends to be clear and unsentimental. The artists give us both beauty and warning. Some images lay bare the ceaseless workings of the economies of expansion and consumption. Others show us disasters and margins, places depleted and misspent. Some document the vast transformations of the landscape that serve our immoderate desires and habits. They capture the transfigurations that have changed Inland Southern California from open rancho to boundless sprawl in one swift century. But they do all this with a perceptible tenderness. Many are cautionary, but an equal number seem cautiously hopeful.

I have spent a lifetime traveling here, soaking up this landscape. I'm aware of the dangers. Extreme familiarity can have confounding effects. It can render a place opaque, indecipherable, can hide it in plain sight. This is partly why this exhibition casts such a wide net—fifty-four artists, one hundred ninety-four works. The artists in this exhibition present wide-ranging perceptions and

obsessions. They approach the region from acute or even opposite angles, and the interlocking fields of view produce a fiercely observant collective vision.

The artists in this exhibition are, of course, explorers. Better yet, we can view them as roaming experimentalists who pull new subject matter from these edges into the realm of art. Art readjusts, appropriates, takes in, recalibrates. Artists then seek the edge again, (sometimes without their contributions having been fully tallied in the first place). They begin foraging once more. The peripheries thus sustain and, in a sense create, the center. This dynamic also often highlights other margins—people and places marginalized by race or class or both.

Freedom is found at the raw edge, the neglected periphery. Few give a damn what you do here (or even give much of a damn about the place itself). The range is wide. Here, it's possible to move beyond rule and convention, even those so internalized as to be invisible. And this has happened to so many photographers here and with such consistency that it does not seem an accidental cluster of random actors. If you end up here, working, experimenting, do you leave the world behind, or does the world leave you? Either way this place extends unusual freedoms.

○2 PHOTOGRAPHY, PLACE, AND THE WEST

Photography rode along as a hired gun in the conquest of the West. The first photographers in the western territories arrived as members of government survey missions. Timothy O'Sullivan, William Henry Jackson, William H. Bell, and others were part of official expeditions dispatched to map the geography, appraise the land, assess the resources.

They produced photographs of extraordinary beauty and did so in full confidence of their role as part of a grand epic narrative. The federal government's four "great surveys" of 1867 to 1879 had explicit aims. They were discovery and destiny—the opening of the West for exploitation, expansion, and settlement.

Other key western photographers—from Eadweard Muybridge and Carleton Watkins to Edward Weston and Ansel Adams—also believed in a romantic narrative. Their version revolved around untrammeled nature, personal realization, the spiritual qualities of perception and form, and the wonder of artistic revelation. (Mix in an amalgam of the opportunities for commercial photograph sales in the instances of Muybridge and Watkins.)

In all cases, these photographers hunched, wizard-like, beneath black cloth in the solid belief that the ground-glass rectangle presented a virgin world available for exploration, capture, and conquest. This sentimental model of nature in the West is the nucleus around which photographers and the culture at large have constructed an image system of great density and durable popular appeal.

Eventually, as we know, exploitation in the West, by and large, triumphed over nature. Against this tide, photographers for a long time managed to avert their eyes while doubling down on nostalgia and nature. To this day, the overwhelming flow of popular landscape photography looks past human intrusion—or over, under, through, above, or whatever it takes—to emphasize remnants of an earlier world, to maintain the dream of a residual natural utopia.

The world as it is, of course, always punctures utopian reveries. The actual world of California and the West continues to diverge further and further from photography's persistent images of a pure untarnished world. To photograph Half Dome under summer light, Ansel found himself setting tripod legs into the hot asphalt of the 500-space Half Dome Village parking lot.

From there, it's just one small step to back up and show the packed parking lot, as Rondal Partridge did in 1960. (By 1965, Partridge had made a Yosemite documentary titled *Pave It and Paint It Green*.)

Under this pressure, photography was bound to change gaze, find new focus. "I was living in Monterey [in 1967]," said photographer Lewis Baltz, "a place where the classic photographers—the Westons, Wynn Bullock and Ansel Adams—came for a privileged view of nature. But my daily life very rarely took me to Point Lobos or Yosemite; it took me to shopping centers, and gas stations and all the other unhealthy growth that flourished beside the highway. It was a landscape that no one else had much interest in looking at. Other than me."[2]

Curator Ann M. Wolfe summarizes the change this way: "In an effort to depart from idealized notions of scenic beauty and the romantic sensibilities of modern nature photography, a small group of photographers working mostly in the American West, turned their cameras to everyday, mundane landscapes."[3]

This pivotal turn eventually came to be known as "New Topographics" after the influential 1975 George Eastman House exhibition of the same name. Aesthetic forays in the West—ever a site of pioneering photographic experimentation—shifted quickly and dramatically. The change began with tract houses, strip malls, concrete tilt-ups, and scarred land, but photographers in the West, and swiftly across the world, soon set off toward the far horizons of the new landscape. "The topic inevitably shifts to existential voids, environmental disasters, the hardships of the planet, the irresoluble dissent between natural and artificial, and the absence of humanity in all spaces, great and small, that make up the lost and lonely American continent," writes photographer Luigi Ghirri.[4]

If you seek a biting counterpoint to the thin grandeur of Yosemite Valley, viewed as an overwhelmed "nature reserve," Inland Southern California is a natural choice. An opposing narrative all but steps up and introduces itself. This is one reason why key *New Topographics* photographers Robert Adams, Lewis Baltz, and Joe Deal operated extensively in the inland region. And why other explorers fanned out into the new territory, including Judy Fiskin, Laurie Brown, Anthony Hernandez, Richard Misrach, Sant Khalsa, and Joel Sternfeld.

Various religions ban material representations of the natural and supernatural world, including as images. To do so is to usurp the power of God, the ultimate creator. "Thou shalt not make unto thee any graven image, or likeness of any thing that is in the earth beneath, or that is in the water under the earth," reads Exodus 20:4. Is every camera (and phone) an evil device and every photograph a sin? It seems possible. In Inland Southern California, the camera takes in a landscape almost wholly made by man, man as creator of the entire landscape. An instantly graven image—a double usurpation, a double sin.

Despite the dazzle of this new direction, replete with new subjects and new attitudes, *New Topographics*-inflected photography has roots in the photo traditions of the West. The photographs remain based in clear, precise representation and are focused on the sharply relevant current world. You can count on Lewis Baltz for a barbed summary: "If you read what, say, Weston was writing in the 1920s he talked about an industrial medium, reflective surfaces, contemporary subject matter—it's a straighter line to [Ed] Ruscha's *26 Gas Stations* than it would ever be to Ansel Adams' pictures of Yosemite and their kitschy calendar sensibility."[5]

Additionally, like earlier photographers of the West, current practitioners photograph things not just for what they appear to be, but for what else they are. The images can purport to flatly, unemotionally describe our etched, incised landscape, but they nonetheless carry a burden of metaphor. Earlier photographers saw nature as immense, endless, transcendent, even ecstatic. Current landscape photographs, including images in this exhibition, carry different messages: the planet is beset and fragile, overburdened and under-protected, out of joint and over-described, but also a place ripe for social and political inquiry.

03 NEW TOPOGRAPHICS AND POINTS DOWNSTREAM

The *New Topographics* exhibition was modest. The template was ten photographers, twenty prints each. Two artists showed fewer. Almost all prints were eight by ten inches. A handful were slightly larger. Only one artist showed color photographs. One was female. Press coverage was negligible. The story of the exhibition is instructive, laden with chance, and came to have important implications for photography in Inland Southern California.

The show began as a panic. William Jenkins, George Eastman House assistant curator for twentieth century photography, had been working on a major historical survey of worldwide architectural photography from the earliest days to the present. But in early 1975, a show fell through. An exhibition slot opened. Jenkins had just a handful of months fill it. So he shifted gears and in doing so shifted photo history. He took his cue from one small element of the architecture show he had been working on—new images of the built environment.

Jenkins had no time for systematic research, or much research at all, actually. He built a quick add-water-and-stir show from photographers whose work he had chanced upon in the previous few years. Some had passed through Eastman House to introduce themselves. One was in-house: Joe Deal, Eastman House's twenty-seven-year-old exhibitions manager. (Deal had started

at Eastman House in 1971, a Vietnam War conscientious objector doing alternative service as a museum guard.[6]) The curator had run across several other photographers while visiting former Eastman staff in New York and New Mexico. Jenkins did not tap a recognized movement, but scooped up artists catch-as-catch-can. *New Topographics* was not a cohesive group, but a chance operation. For years, Jenkins has been surprised and a little embarrassed at the show's impact.[7]

The full title of the sudden exhibition became *New Topographics: Photographs of a Man-altered Landscape*. There is a catalogue—more of a pamphlet actually. I hold one in my hands. There are forty-eight pages. Each artist gets three half-tone plates. The cover has no image, just title and names. There is a scant two-and-a-half page introduction. (In May 1975, Jenkins solicited participating photographers for a statement. Some responded. Four medium-length snippets form about half of the short introduction.) It includes the following statement by one of the photographers, Robert Adams, then age thirty-eight:

Pictures should look like they were easily taken. Otherwise beauty in the world is made to seem elusive and rare, which it is not.

I admire the work of many photographers, but none more than that of O'Sullivan and Lange.

By Interstate 70: a dog skeleton, a vacuum cleaner, TV dinners, a doll, a pie, rolls of carpet.... Later, next to the South Platte River: algae, broken concrete, jet contrails, the smell of crude oil.... What I hope to document, though not at the expense of surface detail, is the Form that underlies this apparent chaos.[8]

Adams' short poetic statement[9] summarizes the expanded field of photography set in motion by *New Topographics*. It emphasizes emotional distance and unadorned directness. No need to get fancy. "Pictures

should look like they were easily taken." Trust that photography will deliver. Beauty is everywhere in the world. (Alternately, be assured that the act of photographing will render anything beautiful.) And go ahead: pay attention to man's reshaping of the landscape. If you walk along Interstate 70—or anywhere at all—watch for photographable debris. An abandoned mattress is as much a part of the scene as peaks or pinecones. Chaos is form, form is chaos. Consider everything. Stay cool. Photograph it all. You get what you intend, or you get something else. And whichever is better, you print.

Curator William Jenkins describes the photographers' approach as "anthropological rather than critical, scientific rather than artistic."[10] Joe Deal has his own summary: "cool, distant, with a clear and hard view of the world—an unromantic and unfiltered way of looking through the lens."[11] Deal expands his description by citing novelist Donald Barthelme:

> Doing this work, you begin to be refreshed, to see how beautiful stuff is, regular stuff, the byproduct of our reputedly disgusting culture, the snail trace of the villain capital grinding up the natural world . . . Instead of looking for major natural beauty to jut up, instead of ignoring (or moaning about) the byproduct of 60 kinds of venal and reprobate corporate behavior (all of which you too abhor, more or less), you look around, you let yourself be touched.[12]

The ideas in *New Topographics* redirected photography with dizzying speed and reach. But how did such a modest exhibition have such an outsized effect? Photohistorian John Rohrbach:

> With great efficiency and clarity, the show visually summarized the beginning of America's shift from an urban-industrial culture to a service-oriented economy defined by suburban warehouses and standardized tract house

neighborhoods spreading out, especially across the West. This new America was marked by repetition and isolation, a place increasingly dominated by quickly constructed buildings and a culture defined more by corporate commerce than community, where people lived with a modicum of comfort but in an atmosphere of vacant alienation. The vision was so convincing that it instantly reshaped landscape photography.[13]

This deflection of photography proved durable, and nowhere more deeply and appropriately than in Inland Southern California. Suburban warehouses? A local specialty. Standardized tract house neighborhoods? That's where we live. Quickly constructed? Yes, it's all new and more is coming fast. Vacant alienation? We have our share.

New Topographics is a mental adventure of the most profound type and Inland Southern California was an immediate laboratory. When the exhibition opened in October 1975, two of the ten *New Topographics* photographers were already operating extensively in the inland region: Robert Adams and Lewis Baltz. A third had cycled through repeatedly and within a year would move in and stay for a while: Joe Deal. The new explorers, wrote Lewis Baltz, sought places where "the man-made, the cultural, and the natural are entropically merged."[14] Which pretty much exactly describes the wonderful ragbag potpourri of Inland Southern California. Adams, Baltz, and Deal roamed the inland landscape armed with cameras and new ideas. All three were active proselytizers for their revolutionary approach. And they found numerous converts and congregants, including many photographers in this exhibition.

Adams attended the University of Redlands as an undergraduate, graduating with a bachelor of arts in English in 1959, and went on to pursue a doctorate

in English at the University of Southern California.[15] After he turned to photography, he roamed the inland area with a camera. He returned repeatedly during the 1970s and early '80s. Baltz, born in Newport Beach, earned a master of fine arts in photography at Claremont Graduate School in 1971, photographing widely throughout the region. His first solo show was in 1970 at Pomona College.[16] Joe Deal passed through the region for years—photographing the landscape and often visiting Baltz—and finally accepted a job teaching photography at the University of California, Riverside (UCR) in 1976 (offered by Ed Beardsley, founder of the California Museum of Photography).[17]

A fourth photographer deserves discussion in this regard: Judy Fiskin. Seeking work for the *New Topographics* exhibition, curator Jenkins dispatched Baltz on his behalf to review the photographs Fiskin made in San Bernardino in 1974. (*In the Sunshine of Neglect* features a handsome selection.) It is clear that Fiskin pushed in a parallel direction and did so very early. "As for the work of the New Topographers," she said in a 1988 conversation with John Divola, "I had pretty much gotten to all the essential elements of what I was doing before I became aware of them. I was dismayed to find out that there was this other bunch of people who were doing such similar work."[18] Fiskin identifies elements that differentiate her work, and some have to do with a female point of view: "arbitrariness and depression and bleakness are not so present in the men who did New Topography. I wanted to inject certain kinds of emotional states into this neutral-looking work. That, I would say, is more female and less male." Among the emotional states she injects is one she shares with Ed Ruscha, another major Southern California *New Topographics* influence— wry humor. Fiskin was born on April Fool's Day and what at first looks to be spare work shines with droll commentary.[19] In the end, although Fiskin's pioneering work was considered for the *New Topographics* exhibition, she was not included in the show.

In the inland region, *New Topographics*-influenced photography takes on a distinctive political-social flavor. This is despite—or perhaps because of—the "factualness" advocated by Baltz and Deal in particular. Take the legacy of tack-sharp f.64 image-making and of '20s and '30s leftist Russian (and other) modernism, subtract the complex visual trappings of the avant-garde, and the result is a distinctly hardbitten, Chandleresque, hard-eyed West Coast viewpoint. Magic geographies result. Some artists present a crisply accurate topography, but metaphorically-speaking, omit compass directions. Others describe and catalogue, but through the prism of personal narratives and individual obsessions. Some are so deeply embedded in the place they claim their gaze can organize this world of velocity and fragmentation. Below it all we read a subtext of comment and critique.

It's hard to drive around the 27,000 square miles of Inland Southern California without arriving at a *New Topographics* viewpoint. Look as long as you like, you'll not find El Capitan or the picturesque wind-bent cypresses of Point Lobos. How about a warehouse, a littered lot, a housing tract? Certainly, how many would you like? We conquered the West, but what have we done with it? Critique is inherent. What has become of the land? How, camera in hand, can we face it? What better place to ask questions and seek answers than in the sunshine of the neglected outskirts, the periphery?

Thus, Judy Chicago sets about to "feminize" rugged San Antonio Canyon above Claremont with soft white enveloping smoke in her 1970 piece *Snow Atmosphere*. Corina Gamma presents us with deadpan views of a highly politicized and litigated landscape in her 2006 *California Elegance* photographs (which, if you didn't guess, take their name from a housing tract). Brett Van Ort and Mark Ruwedel give us militarized landscapes, but in the faux form of paintball battlefields. Kurt Miller haunts the demolition of the newsroom where he worked as a photographer for thirty-six years, six months, and

twenty-three days, a kind of politicized self-autopsy. Allan Sekula provides a 1993 diptych of the Kaiser Steel Mill being dismantled for shipment to China just thirty-six years after Will Connell photographs Kaiser's huge expansion.

The political turn is all the more effective for not being overt. In addition to rejecting the great-picture traditions of "photographing rocks and trees" in earlier West Coast photography, these photographers also eschew standard social documentary practice. The work does not mobilize opinion in a direct sense. They are not failed documentarians. They have different aims. In general, they approach their visual tasks with flat affect (Baltz) or with a residue of faith in beauty (Adams). The palms may be dead or dying, but the light is lovely nonetheless.

Over the years, photographs from Inland Southern California have been frequently conflated with Los Angeles. Distinctly inland images are labeled as L.A. Viewed from New York, Chicago, or even San Francisco, I gather it all looks the same. I understand. Ask me to differentiate between Brooklyn Heights and Williamsburg and I'll give you a blank look. But sometimes the conflation of Los Angeles and inland areas reaches strange levels. Here is an example. Photographer Robert Adams created a classic set of Southern California landscape images. He made them early and they've been shown often. The title is *Los Angeles Spring*. The photographs in *Los Angeles Spring* are beautiful and heartbreaking. From the title, one might guess that the photographs are from, say, Los Angeles. But take a look. You'll find photographs made in Riverside, San Bernardino, Ontario, Pomona, Fontana, Colton, Rialto, Upland, Rancho Cucamonga, Redlands, Loma Linda, East Highlands, Mentone, Reche Canyon, Grand Terrace. It's nearly a complete checklist of Inland Southern California. Of the fifty photographs in *Los Angeles Spring*, forty-seven were made in Inland Southern California.

Three are views of the city of Long Beach. There is not a single image of Los Angeles in *Los Angeles Spring*. I mean no disrespect to Adams; the photographs are as ethereal and incisive as ever. Nevertheless, why should the inland area stand in for L.A.? Perhaps Los Angeles was too busy making movies to play itself. Did a gallerist or publisher insist on a title that would sell? Or is the shadow of Los Angeles so enormous that the neglected periphery can't even stake a claim to its own name?

But here's the key point: Robert Adams' *Los Angeles Spring* photographs *could not have been made* in Los Angeles. (Except by time travel to the 1920s when L.A. itself was the open edge of development.) L.A. and Inland Southern California are different places. Robert Adams worked in the inland area for reasons that are written across the surface of every image—the glories of light in the last best spaces, the bare workings of development on the periphery, the poignant evidence of vanishing Edens.

The work of *In the Sunshine of Neglect* highlights another social strand of the practice—interconnection, influence, and succession. Embedded in the exhibition is the passing down of an art form from hand to hand, mind to mind, along with the constant nurturing of the growing tendrils of new directions.

When Laurie Brown decided to take a photography class at Orange Coast College in 1971, she knew it would be taught by an itinerant photographer, a "freeway flyer" stitching together a Franken-career teaching at any school available. The encounter changed her life. She walked through the classroom door to meet Lewis Baltz, still a grad student at Claremont. Brown's photographs in this exhibition are distinctly hers, but look closely and you'll see a panoramic ghost of Baltz.

Or you might look for a color piece with *New Topographics* overtones by Lewis deSoto. The title is *Riverside, Watkins Drive and Nisbet Way (former home of Joe Deal), January 2013*. It's an homage; deSoto

studied with Deal at UCR. Chelsea Mosher studied with Mark Ruwedel. Alia Malley, Ryan Perez, and Mark McKnight studied with John Divola. Sant Khalsa taught Sally Egan, Amy Bystedt, and Andrew K. Thompson. If you wonder about the depth of the connections, ask Tony Maher to pull up his trouser leg. On his left calf, Maher carries a tattoo of a twin lens Rolliflex wreathed in flowing script. Below is the name McGovern. Above you'll find Khalsa. This is interrelatedness beyond mere connection. This is community, possibly even cult.

04 TABULA RASA

Inland Southern California has no visual icons. There is no Hollywood sign. The swallows do not return to Mission San Juan Capistrano. No Ferris wheel glows and spins at the twilight end of the Santa Monica Pier.

Pick a defining symbol for the inland region. It's a tough task. Perhaps a standard stucco tract home? Ranch home layout but with the vaguely suggestive arches and red-tile roof of Spanish Colonial Revival? Try any one of a hundred thousand. They're largely interchangeable. (Though each carries a silent cargo of invisible life—see Tony Maher's *HiStory* series.) If the area has a Pantheon or an Eiffel Tower, it might be an early Del Taco. Try the one tucked back on a cramped corner lot at the out-of-the-way intersection of Brockton Avenue and 14th Street in Riverside. (See Lewis deSoto's *Del Taco, Riverside, California* made in 1978.) Taco Tuesdays are always good.

California manufactures imagery for export to the world. And icons, after all, are merely images that have assumed the uncommon power of symbols. Overtaken by their representations, Los Angeles and San Francisco take on the insubstantiality of pure idea. They are overwritten by emblems, abstractions. Silicon Valley and the Hollywood culture industry recognize this weightless power and use it to bundle heraldic tokens of California for market. Kids skateboard in Sri Lanka. Everyone knows where movies come from. Apple products worldwide eschew virtually all language. But every package carries one clean sans serif line: "Designed by Apple in California."

This magic extends to the landscape. Yosemite Valley alone spins off images like leaves falling from the dogwoods. The flow of photographs is deeper than the Merced River floods that sweep the valley floor in springtime. Representations are so thick that one can scarcely see the place. Half Dome floats in a cloud of clones. Visitors no longer arrive to make an image of Yosemite. They make a pilgrimage to reinforce one.

But here is the point: compared to the visual power centers of California, the inland area is blessedly free of obscuring iconography. This clears space for the operation of photographic artists. Photography, after all, deals in images that "represent," that are stenciled off the real, but which stand in for place, for idea, for identity, that carry metaphor. Ill-defined territories are ripe for exploration. The clearest modern lenses gravitate toward overlooked landscapes, unnoticed micro-histories, idiosyncratic ignored wrinkles of individual identity.

The inland landscape is scraped by time and thinly veneered with recent development. The place can feel rootless and provisional, even for people who grow up here. Locales with the deepest recent histories—downtown Claremont, Redlands, Riverside, the travel corridors that slash through Cajon and San Gorgonio passes—still seem improvised and temporary. Even the lakes are of recent manufacture, from Big Bear to Lake Perris, filled with Northern California water and pictured in ragged glory in Anthony Hernandez's *Public Fishing Areas #31* (1982).

There are notable exceptions to these themes of rootlessness. Artists are contrarians. They're ever willing to fight the tide, to rake leaves in the strongest wind. John S. Shelton's starkly beautiful aerial images pull far enough back to emphasize the durable bones of the land. By doing so, he reduces human additions to what they are: windswept, vulnerable, and temporary. Lewis deSoto, meanwhile, drills deep into history with his *Tahualtapa, Hill of the Ravens* (1983–1988) work, restoring the inland mountain of many names to its place in Cahuilla cosmology.

Despite these exceptions and others, when there is nothing solid to hang onto, there is little choice but to embrace the whole. That experience can become dreamlike, provided we bear in mind that nightmares are a precinct of the dreamscape.

This *tabula rasa* region is ill-defined, but richly varied. It is urban, desert, valley, and mountain. More significantly, on a social level Inland Southern California is like the rest of the country, but more so. The place has the revelatory purity of a roughed-out statue. There is no polish, no shine, no patina. The place is too new and raw for pretension. Affluence knocks off no edges.

Thus, while the region serves as an experimental field for photography, it also affords a look at California capitalism (free of the wistful iconography of Californios and rancho). After all, the area burst into prominence with World War II, orange groves and vineyards giving way to steel mills, open land being engulfed by a red-tiled tsunami of tract homes, braided flood plains becoming channels, dikes, and dams. In less than two generations, trails and tracks, barely paved in 1945, accelerated into freeways. The process underlying the region's swift creation as an urban/suburban center reveals just how much contemporary economic and political reality relies on growth. It is a merciless economic subjugation to expansion, transmuted by these artists into images.

The rawness of man's hand on the landscape imbues the region with the feel of a frontier. It seems like a front edge because it is. This is America amplified. We see America's divisions and conflicts, aspirations and dreams, but they're somehow closer to the surface, sharper, more acutely felt. The buffering effects of money, settledness, privilege, and proximity to power are absent. What remains is the confrontation with reality inherent in the unforgiving nature of a frontier, and a kind of honesty that carries with it some measure of redemption.

05 FIRES, FLOODS, AND FAULTLINES

During the drought-bleached dry season, Inland Southern California seems built of grit and shingle, dust and duff. Every footfall lifts a puff of powder and each twig snaps with a crack. The valleys swelter. The foothills feel like a fire ready to happen, anticipating each October's terrors. When the rains finally come—with luck—in the year's final month, the first fat drop smells acrid and dusty, like sweat hitting hot asphalt. Locals look at each other with a question: "Flash flood?"

Natural disaster is a fracture in a world we assume is stable. It's a rupture in the everyday, a tear in what we take for granted. The artists of this exhibition provide us a detailed accounting of disaster's commonplace consequences and after-effects.

Yes, the area presents a benign, palm-shaded impression. But make no mistake, Inland Southern California is a landscape of particular extremity. It's a place of fault lines, fire zones, and flood plains, of sun-baked valleys flanked by arid mountains. The place is an incubator for disaster. It's been unstable for millions of years. The land itself has been sculpted by faults and floods. Listen for the crackle of chaparral, the slide of talus.

Living here tends to be either an act of defiance or of submission. Build a house in a canyon, on a ridgeline, in the urban-wild interface, or along an Alquist-Priolo Earthquake Fault Zone, and your only firm feeling should be that it's temporary. Grab hold of a rock-solid sense of impermanence. The feeling of physical instability extends its reach to the social realm. Entire lives are lived out in Inland Southern California while vaguely making plans to move elsewhere.

Sant Khalsa has spent close to forty years documenting the Santa Ana River, her watershed. If you live here, she points out, your body consists in large measure of the Santa Ana River water you consume. It's your river, and the river is you. As with most rivers in the arid West, the Santa Ana perennially runs low or even underground. But, every so often, the river runs very very high indeed. Four of Khalsa's ten Santa Ana River photographs show flood events or their aftermath. Concrete bridges are collapsed, roads submerged, power poles uprooted. Behind these scenes is the black dog of the river. A flood aftermath is also the subject of Joel Sternfeld's *After a Flash Flood, Rancho Mirage, California* (1979). The normally non-existent Whitewater River has cut through the soft silts and sands of the Coachella Valley, slicing into a resort, swallowing trees, asphalt, vehicles.

Shortly after Joe Deal arrived to teach photography at UCR, he began to trace the region's fault zones: the Chino Fault, the San Andreas main line, the San Jacinto Branch of the San Andreas. This work was done in the immediate wake of the *New Topographics* exhibition. The results became known as *The Fault Zone Portfolio*. Four photographs from this body of work, begun in 1976, appear in the exhibition.

Deal's images are austere yet sumptuously composed. He brings the world into balance within the square confines of the viewfinder. And the photographs are made from the high angle he had come to favor. This was readily achievable; Deal had only to climb the hills and ridges thrown up by the faulting. As noted by photohistorian Colin Westerbeck, Deal's top-down view eliminates the horizon line that gave viewers their bearings in earlier work. The sweeping spaces of traditional western landscapes are thus rendered "alarmingly claustrophobic."[20] The western frontier, open for so long, is now definitively closed.

As abstract and distanced as they are, Deal's *Fault Zone* images are charged with tension. The unstable balance between human and nature is implicit in the photographs. The faults themselves go unseen in Deal's images, but below every surface they store their hidden energies. Who are the people who will occupy these houses being built right in the fault zone? Is the newly planted park placed along the hillside base because building was forbidden, because structures would be sheared? The mountainside palm grove at Soboba Hot Springs is undoubtedly fed by water being forced up along the San Jacinto fault, but what incinerated the palms? Note also this photograph's compound modes of disaster: a fire along a faultline perched above the flood-prone San Jacinto River. How do we live in a place predicated on ignoring such vivid dangers? How do we retain memory in a culture intent on forgetting?

Beyond the weight of the unstable relationship with nature lies a deeper tension—time. Deal's *Fault Zone* photographs carry at least three time scales, radically different and tugging against each other. Human scale—a lifetime living in the fault-adjacent house waiting for an earthquake that could happen any moment—is set against geologic time—millions of uncaring, inhuman years storing vast energy then, a few times a millennium, releasing it in violent jolts. These disparate time scales are juxtaposed against the nature of photographic capture, one one-hundred-and-twenty-fifth of a second.

Last in the arsenal of the region's top-three natural disasters is fire. Two photographers, Stuart Palley and Noah Berger, present us fire in pure form, still a natural phenomenon even if assisted by climate change and arsonists. Both are fire-obsessed, spending months on the firelines every fire season, which has recently expanded to cover all twelve months of the year. Palley and Berger's three fire photographs were made at night, a particularly elemental specter. Berger's *Embers From the Blue Cut Fire* (2016) shows little direct flame, focusing instead on a mountainside of glowing embers so boundless that apocalypse seems to encompass the visible world.

Andrew K. Thompson, meanwhile, shows smoke where there is fire. The four panels of *San Bernardino Smoke* (2014) are digital files heat transferred (yes, heat!) to canvas. Tangles of fiery yellow-red thread are stitched into magenta-tinged smoke issuing from somewhere near Cajon Pass. His composition underlines the sense of instability. Photography is literally about framing—what is in, what is out. Framing is also a kind of violence, an exclusion, a sundering. Thompson's four frames are unfixed. They drift up with the wind-driven plume of smoke, then tilt down to capture the threatened mountainside. Meanwhile, the entire foreground is eliminated, clipped out, even as an interfering power line is reinforced with black thread. What is in, what is out, and why? If the exclusions of framing are a form of minor violence, this photograph's framing of fire, in a sense, does violence to violence itself.

Richard Misrach's *Desert Fire #1 (Burning Palms)* (1983) captures a Coachella Valley palm grove in flame. He uses the term "flash fire." The image was made with an eight- by ten-inch view camera on color film. It's part of Misrach's enormous project titled *Desert Cantos* and is the cover of the book. Misrach's aim is large—to move past the descriptive into the metaphoric and political,

however complex. "In the past when I traveled," he writes, "I used to look for the light, the beautiful forms. Now I cannot escape the fact that every facet of the landscape is suffused with political implications."[21] He means to bear witness, to offer unsettling truths, to sound an alarm. Like Robert Adams, Misrach starts with the lure of beauty. "I've come to believe that beauty can be a very powerful conveyor of difficult ideas. It engages people when they might otherwise look away."[22]

Not all disasters are natural. Here is the darkest view. The region has been paved over in two or three generations. It has accumulated over four million people the way grit and leaves collect in a dead zone when the Santa Ana winds blow. There are no vistas of escape, no distant horizons. Just a crisscross overlay of rails and roads passing through on their way to somewhere else.

The photographs in this exhibition make clear that the impacts of human alterations of the landscape far outstrip those of natural disasters. A 7.2 temblor on the San Andreas Fault is nothing compared to seventy years of relentless development. But even so, it remains an unremarkable landscape, by now standard in much of the world, familiar, banal. So mundane and internalized that we do not move through this landscape, it passes through us.

While working on this exhibition, I drove three inland freeways during a rare deadfall rain—91, 60, 215. I am on a photo mission to a point near Temecula. I log the landscape through my windshield. I murmur notes into my iPhone. Ten wet freeway lanes shine anthracite black. Oncoming cars scarce and irregular. They appear out of the gloom and fade fast, trailing a spray of mist and an uncanny, disappearing luminescence. The bright flash of a Cheetos bag is an orange butterfly impaled on barbed wire. At road's edge, Q-tip palms scratch the flank of a two-tone concrete tilt-up. A copse of leafless trees is black-branched coral on a deep reef, the sky a weighty ocean.

I keep my speed up, hear the hiss of wet tires, absorb the smear of scenery close at hand, (everything beyond is effaced by curtains of rain): houses against the freeway edge—stucco, tacky colors muted by the downpour—houses which blur, merge, swim together, refocus, winking an occasional illuminated window through which one can glimpse, just beyond the shoulder's treasures (a sodden mattress, the tortoiseshell hump of a stray sandbag, shattered glass winking like a constellation, three oozing sofa cushions, assorted items suggestive of sudden trouble: tire blow-out scraps coiled like snakes, a car door shiny side down, an overturned baby carriage, the wind spinning its wire-spoked rim like a croupier at a roulette wheel) unknown people and their miscellaneous lives.

The storm stutters with every overpass. Staccato raindrop splatter stops. Just an instant—a rain shadow. Then restarts like a jump cut. Crackling spatter, back with a jolt. The failing light extinguishes in slow degrees wan remnants of color from the sodden vista. For a moment: CHP black-and-white, passenger door ajar, black-clad figure half-seen, hulking behind a gray stalled sedan. A mosaic of plastic bags against chainlink. The view slides away endlessly, yet somehow remains utterly the same. What lies beneath the skin of this inland world?

06 A COMMENT ON PHOTOGRAPHY AS ACTIVITY

"The operating principle that seems to work best," wrote Robert Adams, "is to go to the landscape that frightens you the most and take pictures until you're not scared anymore."[23]

At the very time Adams wrote this, we find him photographing on the outskirts of northeast Riverside. We look with him into morning light suffused with particulate scatter. Our eyes travel the quicksilver

traces of dirt roads across the swales and ravines of old orange grove land. (The exact spot—near what's known as Sugarloaf Mountain—has since been transformed into gleaming white-roofed rectangles of warehouses and concrete tilt-ups. But don't tell Adams. It'll just confirm what he already knows.)

We follow Adams' path across hillsides above Interstate 10 in east Redlands. From this vantage, surely he can see his alma mater, the University of Redlands. In the slow lane, a pickup tows a fifth-wheel RV up the hill toward Yucaipa, Beaumont, and points east. It seems an odd pleasure to follow the photographer at the discrete distance of 36 years. We watch him try to illuminate the mystery inherent in everyday scenes. The results are images that describe, but also dissect. Additionally, they're fiercely political. Ansel Adams pictured what should be saved. Robert Adams has a more direct approach; he shows us what we've wrecked.

We next locate the photographer amid the litter and debris of the Santa Ana River wash near Mentone. He approaches a rounded granitic boulder set into a field of dead Arundo cane fragments and delaminating plywood scrap. The rock looks like a giant egg. We can judge scale from empty cans and a bullet-riddled one-gallon gas container. The smooth white stone is perhaps three feet high. The boulder has been drizzled with so much paint that it looks like ribbons falling through a foggy sky. We watch as Adams aims his camera northeast toward the mountains. He places the boulder in the center foreground. His camera is askew, tilted west, the same direction the river flows. There's a deteriorating mattress in the distance. Over a scraped-up berm at the upper left, we catch a sliver glimpse of the Santa Ana gleaming, a scrap of beautiful redemption.

Is this the landscape that scared Adams the most? Did it compete with the tracts overrunning the Colorado front range where he came of age? We cannot say. But we do know where he went.

Photography is performative. Sometimes this is direct and visible, the center of the art. John Divola's *Dark Star* pieces are records of his presence in an abandoned house on Theodore Street close by the fault zone at the eastern edge of Moreno Valley. The black discs are freshly painted, simultaneously soaking up light and reflecting it.

Divola has a forty-year history of activating abandoned spaces by painting, modifying, and vandalizing, returning with photographs of the process and the effects. The *Dark Star* photographs feel like an ultimate statement of the practice. The black circles are as reductive as Malevich paintings. And the large-scale photographs are ferociously detailed—made using drum-scanned digital files from eight by ten film shot with a tripod-mounted view camera. The black circles gleam like the last light of day. They emit light and they kill it. You can smell the tang of the paint, feel the swing of the artist's arm, spray can in hand. The artist is present. And absent.

"I definitely see the work as existential," Divola said in 2012. "I've begun to see myself as an odd figure within my own practice. This is something that I have a very hard time talking about—this feeling that I'm kind of haunting my past, as I go back and work with ways of painting in spaces, something that I've done for a very long time."[24]

Judy Chicago offers a counterpoint performance. On February 22, 1970, scores of commercial grade, pure white, smoke-emitting flares hiss to life amid the shadowed stones and broken talus of upper San Antonio Canyon above Claremont. At a time when the Southern California art scene is dominated by men, Chicago's stated aim is to transform, to soften, and, by softening, for a short time to "feminize" an entire landscape.

The performance is called *Snow Atmosphere*. Chicago apprenticed with a pyrotechnics company so she could handle the flares herself. Carried on gentle updrafts, diffuse clouds of soft white vapor move slowly up the rugged canyon. Strands of smoke build and coalesce. The growing cloud envelopes trees and swirls around ridges. Photographs show diaphanous light filtering through smoke. The diffuse white mist lifts and it conceals. It curls into hollows and curves.

Chicago and other women had struggled within what she describes as "the macho art scene of southern California." Her peers were bulldozer-driving land artists such as Michael Heizer, James Turrell, and Robert Smithson. Chicago wanted to "soften that macho environment." The *Snow Atmosphere* piece was, of course, ephemeral, "while the guys were carving up the landscape, I was feminizing it, and softening it."[25] White mists and swirling smoke are non-destructive, they come and they go. But by the time the smoke eventually cleared on art in Southern California, Chicago and a multitude of other women had indeed feminized the landscape, permanently altering the art ecology of the region. Her photographs in this exhibition can be seen as a double commemoration—her 1970 performance in San Antonio Canyon, and women's ongoing transformation of the larger landscape of art.

For many of this exhibition's photographers, Adams, Divola, and Chicago included, a central characteristic of photography is to reach beyond description of space and object. It embraces human activity, including their own. We follow the photographer's path, we witness their activity, we acquiesce as they direct our eyes and mind. The activity of the artist dominates theme and content. We follow Adams across the region. We attend to his rethinkings and adjustments, to his patient labor of revisitation and reworking. Photographs are the residue of giving thought and action visual form.

07 SOCIAL LANDSCAPES AND THE IDENTITY OF INLAND SOUTHERN CALIFORNIA

The photographers in this exhibition have produced a social geography of Inland Southern California, but of a peculiar sort. They focus sharply on place, but are more than willing to mutate, transform, or distort. They explore the region's identity, but are not keen to pin it down.

Like the region itself, these artists find themselves betwixt and between. As a generalization, most have one foot in cool observation of things as they are and another in the slippery poetics of contemporary art. They occupy an intermediate zone, not quite one thing, not quite the other. In the end, most lean away from arm's length objectivity and toward subjective expression. But that, of course is the fulcrum of photography. Photographs are a balance, a shifting ratio—part report, part interpretation. Photographs are alloys within a cultural matrix—personal interpretation bonded to a base of factual representation.

Photography can take a quotidian landscape and lift it by mind, eye, and camera into poetry. A transmutation, a shift, a transformation of one thing into another. An act of creation, a sleight of hand, a shift of form. "An unnoticed corner of the world suddenly becomes noticed," writes Allan Ginsberg, "and when you notice something clearly and see it vividly, it becomes sacred."[26]

Italian photographer Luigi Ghirri, a specialist in neglected landscapes and overlooked fringes, points toward the treatment of a place like Inland Southern California, not as a stereotype, but an archetype:

Perhaps in the end the places, objects, things, or faces encountered are simply waiting for someone to look at them, to recognize them without contempt, without relegating them to the shelves of the endless supermarket of the outside world. Perhaps these places belong to our existence more than to modernity—and not only to the *deserts or desolate lands*. Perhaps they are awaiting a new vocabulary, new figures, because the ones we know are worn out, and because many of them have not constituted mere changes in the landscape as much as changes in life. [27]

Questions concerning the identity of Inland Southern California permeate this exhibition. In some cases, the identity of an individual artist feathers into the region. Or has the place seeped into them? In certain instances, it's hard to know where the artist leaves off and the place begins. Are artist and place congruent? Would a true socio-topographic map of this place settle perfectly over the artist's mind? Identical in form, coincident in spirit? Without the place, would the artist exist? If they die, does a portion of the region die with them? Jorge Luis Borges would absorb these photographs with his mind's eye and smile. A few artists deserve discussion in this regard.

Lewis deSoto is "of native blood, Cahuilla blood." He grew up in San Bernardino three blocks north of the Wigwam Motel's thirty-foot concrete teepees along Route 66. He studied with Steve Cahill and Joe Deal at UCR and left at thirty-one for photography professorships in Seattle, then San Francisco. But deSoto's soul and art continue to revolve around the place he calls the "Empire." ("Inland Empire" is an offhand vernacular tag for Inland Southern California.) In an important sense, he never left. Possibly more accurately, the place never left him. "Although I left the Empire three decades ago. . . I am fossilized, like the mollusks of ancient seabeds, in the landscape of my home territory. I inhabit its paradises and its hells. No place I have experienced offers the full range of elements that compel and inspire—the vast public works, the neighborhoods both grand and beat down, the air fragrant with citrus and acrid from smog and industry. Cool pine breezes waft off the snow and hot blasts of wind are scented with creosote. It is the Empire. It is everything."[28] The artist's identification with place is the heart of the work and he makes his photographs of *Empire* from deep knowledge and with remarkable scope. They manage to be compositionally rigorous but casual, intimate but immense, clinically distanced yet palpably personal.

"Ultimately I say I was raised by the streets," says photographer Aashanique Wilson. "I was raised by the [Riverside] Eastside, raised by downtown, raised by Rubidoux."[29] Wilson is forthright about what she calls her "rocky life." In compressed form, she was born in Riverside and raised in a changing string of settings by parents, grandparents, great-grandparents, godparents, friends of extended family. She spent years in the custody of Child Protective Services. She endured a parade of foster parents.

Wilson's four photographs in this exhibition—drawn from hundreds made over four years in black-and-white and color using both film and digital means—depict an oasis in the artist's otherwise tumultuous upbringing. Wilson's great-grandmother Juanita Powell lived for close to sixty years in the same house. It's in a traditionally black neighborhood in Rubidoux at the corner of Wallace and 36th Streets. Wilson lived with Powell, a legendary figure and not incidentally a civil rights pioneer in the region, for a handful of stable years. She took four buses per day to continue attending North High School on Riverside's Eastside. But in 2016 Powell, aged 101, died and the house was lost. Wilson's art is embedded in community, informed by its history, first-hand experiences, and lessons. We make sense of the world by seeing. Wilson gives us commonplace views: a street corner, a backyard of weeds overtaking an abandoned car. But in her life, in her personal cosmology, these are powerful places, and we sense that power. Wilson produces photographs, makes

videos, and records music under a host of names, most commonly Shrxxm. "When I walk down these streets, I get flashbacks. Memories come back at every corner."[30]

Amy Bystedt and Sally Egan are friends and rivals, artists and collaborators. They have also become, over the course of more than two decades, their own ceaseless subjects. Their work is embedded in the region, triply so: in current, past, and entirely fictional versions of the inland area. The relationship goes back twenty-two years. The pair met in high school—Alta Loma High School on Base Line Road in Rancho Cucamonga. While a student, Amy waitressed at a little breakfast and lunch place owned by Sally's parents, the Plaza Café in Ontario. Sally had taken some photography courses, so when Amy decided to attend Chaffey College, the pair agreed to sign up for a photo class together. "We were friends, of course," recalls Amy, "but in class we were also competitors, rivals."[31] Nonetheless, the two became mutual sounding boards, bouncing ideas around. Then, lacking ready models for assignments, they turned to each other. Stepping in front of the camera started as a convenience, but it eventually commandeered their practice.

This exhibition shows work from their *Fotomat* series, completed in 2015, but in spirit translocated from the weirdly utopian heart of the 1970s. In it, as in all their collaborative work, they are the photographers, casting agents, location scouts, prop managers, set designers, costumers, stylists, models, and post-production crew. Every person in every photo—including every disembodied arm or truncated leg—is Bystedt or Egan. If a child appears, it's theirs. Beyond that, the place is theirs as well. The locales are scattered across the inland region, centered in Ontario, Pomona, and vicinity. The work manages various neat tricks. It is entirely contemporary but casts its modern gaze to a disappeared world. The settings, clothing, and style are 1970s, all fabricated to be photographed. They even round up

El Caminos, Oldsmobiles, and other semi-absurdist iconography for backgrounds. The images evoke film and Fotomat processing, but they are produced via high-resolution digital files and Photoshop. Through these means, Bystedt & Egan reconstruct a convincing 1970s psychogeography. They extend place and identity across time. They embrace the contingent, the banal, the ordinary, the tossed-off, even if they have to spend days to achieve it. Blessedly, they restore, if only for short moments, a mostly forgotten capacity for amazement and epiphany.

From a start in San Diego, Fotomat Corporation dotted parking lots with gold-roofed kiosks that provided fast photo processing of dubious quality. At its height in the late 1970s, more than 4,000 flanked shopping centers across the country. Bystedt & Egan's *Fotomat* series reanimates that time, imbued now with the distant warmth of a more stable, more honest period. The past is a foreign country. Bystedt & Egan not only visit that country, but bring us back photographs. The results feel utopian, with a touch of wistful elegy. They may prompt viewers to look into their own past for useful ideas and images. Every generation mines the past for what it needs.

"We love old shoeboxes of funky images," says Bystedt. "Snapshots, cropped weird, shadows everywhere, around the back of the house. They're not the current manicured presentation. They had soul, maybe even reality. Now we all have the ability to edit instantly. So you miss all the mistakes; we erase all the cool stuff. The best things don't make it in the frame, don't make it onto the wall. Now they don't even make it into the shoe box."[32]

Bystedt & Egan employ a canny tactic. They draw on the mythological power of the snapshot. They sense our trust in presumptively unmediated tossed-off images to reliably offer small revelations and glimpses of truth. So they carefully manufacture scaled-up snapshots that

offer our beliefs a firm handshake. And they're so funny and appealing and oddly profound that we buy the ruse, even though we're fully aware that these forty-year-old snapshots are freshly minted. And so they transport us a second time, out of the '70s and back to the present moment where artists do this sort of contemporary work. We find ourselves in both worlds at once.

A related point is worth making. The duo essentially "perform" technical incompetence. Theirs is a calibrated strategy of deskilling and destabilization. They restore the casual. Bystedt & Egan do not aspire to the status of the inept amateur, but they adopt that guise and borrow its visual vocabulary to reintroduce the "cool stuff" they feel photography has lost. This at a moment when photographs are the neck-deep debris of the era. The ceaseless outpourings of Instagram have many uses. But the primary mode is this: tokens of self-esteem, crafted braggadocio, enviable arrivals, statements of strut, all curated to project a manicured image. Despite the volume of images, Bystedt & Egan imply, social media has actually unfriended consequential photography. The artists' implication is clear—do not mistake flow for significance, velocity for heft. It's no accident that the Instagram masses are called followers. Interchangeable images are so thickly layered over reality that they form a second world, an opaque image map increasingly leached of significance and meaning. But snapshots resist. They remain linked to life histories. Or such is the power we accord them. With their everyday grammar and diaristic focus, snapshots obdurately epitomize biography, autobiography, life.

Regional identity is a funny business. We live in a superstore of modernity, a sprawling emporium of stores and vehicles, houses and malls, signs and wonders, graveyards and garbage dumps. Nearly identical elements repeat endlessly as if the earth has been struck repeatedly by the same huge rubber development stamp. Is that *your* Bed Bath & Beyond, or the Bed Bath &

Beyond beyond? The only problems occur if there's a shortage of parking, or if overly lengthy drive-thru lines threaten a ready supply of Double-Doubles Animal Style.

By now, across the valleys and basins of Inland Southern California, each city blends into the next with no sense of boundary and only imperceptible shifts in aura. Is that north Redlands or the edge of Highland? Why is none of Lake Perris in Perris? Does the wind really blow in Cabazon because Palm Springs sucks? Where does Upland give way to the upper fringes of Claremont, let alone Montclair? Where does Eastvale yield to east Norco? What constitutes the corona of Corona? Who but a real estate developer with the head of a city planner can parse such mysteries?*

Remarkably, however, local residents attribute the place they live with distinctive characteristics. They're insistent about differences (just like everyone else). And of course, they are right. But teasing out elusive divergences requires great subtlety and attention. It's like trying to sense mute, nearly imperceptible forces. Like driving at night tuning in an exceedingly distant radio station. Like using the complexities of feng shui to analyze invisible architectures. Or parsing the subtleties of palmistry to tease out identity and fate. Pay careful attention indeed. I think this wrinkle in my palm signals strong idealism and imagination. But wait. Look closer. What is that indistinct subset of branching creases? What if this is not imagination, but the sentiment line?

As a consequence, it's possible some highly attentive viewers of this exhibition will be surprised, possibly less than fully pleased, at a shortage of pretty pictures highlighting Chamber of Commerce attributes in the region. But artists are not in the promotion business. Art is bound to cause offense. It's virtually a point of pride. Not to worry, since the first photographers arrived in California, a vast industry

has churned out promotional images. They're readily available. The Victorian graces of Redlands, the leafy streets of Claremont, the tiled domes of the Mission Inn, the dangling oranges against a backdrop of snowy mountains. They've been overgrazed by photography, bitten down to the roots.

In general, the photographers in this exhibition combine a hard eye with tenderness and wonder. Sometimes a simple direct image is the best way to show without telling. It surely goes without saying, but this exhibition focuses on photography used as a vehicle for sight, for description, not promotion, evasion, or sugarcoating. We applaud the words of critic John Berger: "A radical system has to be constructed around the photograph so that it may be seen in terms which are simultaneously personal, political, economic, dramatic, everyday and historic."[33] We define overlooked parts of the landscape as especially eligible for recognition. Photographers should never sell out their photography. Someone might be tempted to buy.

08 PREDICTIONS

"Photographs open doors into the past, but they also allow a look into the future," writes photographer Sally Mann.[34]

Photography's central theme is time. Not form, light, or representation, but time. It's a commonplace assumption that this relationship is unidirectional, that photographs are in league with the past. Photography "impales the dazzling moment," states Henri Cartier-Bresson, a momentary specialist. "Grabbing snatching blink and you be gone," summarizes photographer Carrie Mae Weems in her more modern cadence.[35] Images snatch a moment from eternity.

But what if some photographs, taken in some places, spin the clock hands? What if they look to the

future? What if they offer glimpses of things to come? What if, in grabbing moments of the past, they offer predictions about the future? As the White Queen told Alice, "It's a poor sort of memory that only works backwards."

California has long been viewed as a predictor of the future. California is where the future can be divined, possibly where it's minted. Theater director Peter Sellars reminds us: "It's the newest edge of America, whatever that's going to be. New York and Chicago remind you of what America was. In California, the question is, what will America be?"[36]

So we find ourselves in a strange place. Much of Inland Southern California seems a familiar landscape, prosaic and common. But in the lenses of these artists, a dimension of strangeness invades. Robbert Flick fractures willow trees rooted in fifteen million-year-old Puddingstone conglomerate above Pomona. Naida Osline floats a hallucinogenic Datura plant into the luminescent night sky over Riverside. John Divola paints gleaming black discs—absorbent and reflective—on the walls of an abandoned house in Moreno Valley. For all their inscrutable impact, the photos are shaped, shaded, nuanced, in a word, intelligent. They emanate idea. All the work is personal, and in some cases an emergency.

The built landscape of Inland Southern California has been created—is being created—with breathtaking speed. Virtually every year for sixty years, inland cities have been on the list of fastest growing places in the country. Between 1950 and 2000 the population grew an average of fifty-eight-and-a-half percent *every decade*. Now, more than 100,000 new people arrive every year. This seems fantastic, a break with the real. The only remarkable thing is that there's nothing remarkable about it. Nonetheless, it has the air of a fable. A place that exists in parallel with the real world without

altering its coherence. A magnifying mirror. Our place is speedily created, a raw place, a place we look at and that looks back, a place we have shaped and that shapes us. A place where the future leaks into the present.

Philip K. Dick is a quintessential Southern California writer who directed dark eyes toward the future. "I have never had too high a regard for what is generally called 'reality'. Reality, to me, is not so much something that you perceive, but something you make. You create it more rapidly than it creates you." [37]

Is this the laboratory of our future? Wander the margins of the margin. Colton, Moreno Valley, Mentone, Rubidoux, Beaumont, Chino, San Jacinto, Murrieta, Snow Creek, Muscoy, Mead Valley. Pay attention. Is that an air of restlessness? A sense of disquietude? Do we note the future of California? Of the country? Was Jean-Luc Godard correct when he commented that in the fast-moving edges of our moment "the future is more present than the present"?[38] Are this exhibition's photographs a base camp from which we can catch a small glimpse of times to come? *Talis sum qualis eram*; I am what you will be.

There are no definitive answers when it comes to the future, but the *New Topographics* photographers have some thoughts. "When a photographer chooses a subject," writes Frank Gohlke, "he or she is making a claim on the interest and attention of future viewers, a prediction about what will be thought to have been important."[39]

"What a landscape photographer traditionally tries to do," explains Robert Adams, "is show what is past, present, and future at once. You want ghosts and the daily news and prophecy. . . .It's presumptuous and ridiculous. You fail all the time."[40]

NOTES:

1. "Robert Adams," *photoquotations* (website), accessed September 27, 2018, http://www.photoquotations.com/a/7/Robert+Adams. The website photoquotations.com is curated by Douglas McCulloh.

2. "Lewis Baltz," *photoquotations* (website), accessed September 27, 2018, http://photoquotations.com/a/51/Lewis+Baltz.

3. Ann M. Wolfe, ed., *The Altered Landscape: Photographs of a Changing Environment* (New York: Skira Rizzoli, 2012. Published in conjunction with an exhibition of the same title organized by and presented by Nevada Museum of Art, September 24, 2011–January 8, 2012), 134.

4. Ghirri, Luigi, *The Complete Essays 1973–1991* (London: MACK, 2016), 135.

5. "Last Interview with Lewis Baltz with Jeff Ryan," *The Eye of Photography* (website), accessed September 27, 2018, http://www.loeildelaphotographie.com/2014/11/25/in-memoriam/26709/last-interview-of-lewis-baltz-with-jeff-rian.

6. Westerbeck, Colin, *Seismic Shift: Lewis Baltz, Joe Deal and California Landscape Photography, 1944–1984* (Riverside, CA: The Regents of the University of California, the University of California (UCR), and UCR/California Museum of Photography. Published in conjunction with an exhibition of the same title organized by and presented by UCR/California Museum of Photography with the assistance of the Getty Foundation as a part of Pacific Standard Time, October 1–December 31, 2011), 41.

7. Foster-Rice, Greg, and John Rohrbach, eds., *Reframing the New Topographics* (Chicago: The Center for American Places at Columbia Chicago, 2013) XIII.

8. Jenkins, William, *New Topographics: Photographs of a Man-altered Landscape* (Rochester, NY: International Museum of Photography at George Eastman House, 1975. Published in conjunction with an exhibition of the same title organized by and presented by the International Museum of Photography at George Eastman House, 1975), 7.

9. Adams was a professor of English before turning to photography, Westerbeck, 42.

10. Jenkins, 7.

11. Westerbeck, 41.

12. Rice, Mark, *Through the Lens of the City: NEA Photography Surveys of the 1970s* (Jackson: University Press of Mississippi, 2005), 178.

13. Foster-Rice, Greg, and John Rohrbach, eds., XIV.

14. Sobieszek, Robert A., *The New American Pastoral: Landscape Photography in the Age of Questioning* (New York: Whitney Museum of Art, 1990. Published in conjunction with an exhibition of the same title organized by and presented by the International Museum of Photography at George Eastman House, 1990), 3.

15. Jenkins, 8.

16. Baltz, Lewis, *Maryland* (Washington, DC: Corcoran Gallery of Art, 1976), 26.

17. Westerbeck, 42.

18. Fiskin, Judy and Virginia Heckert, ed., *Some Aesthetic Decisions: The Photographs of Judy Fiskin* (Los Angeles: J. Paul Getty Museum. Published in conjunction the exhibition *In Focus: Los Angeles 1945–1980* organized by and presented by the J. Paul Getty Museum, December 20, 2011–May 6, 2012), 20.

19. Fiskin, 2.

20. Westerbeck, 41.

21. "In Photographica Deserta—The Desert Cantos of Richard Misrach," *Gerry Badger* (website), accessed September 27, 2018, http://www.gerrybadger.com/in-photographica-deserta-the-desert-cantos-of-richard-misrach/.

22. Misrach, Richard, *Violent Legacies: Three Cantos* (New York: Aperture, 1992), 90.

23. "Lewis Baltz," see note 2 above.

24. Divola, John, *John Divola As Far as I Could Get* (Santa Barbara, CA: Santa Barbara Museum of Art; Munich, London, New York: Del Monico Books • Prestel, 2013. Published in conjunction the exhibition of the same name organized by and presented by the Santa Barbara Museum of Art, Los Angeles County Museum of Art, and Pomona College Museum of Art, 2013), 179.

25. "When Judy Chicago Rejected a Male-Centric Art World with a Puff of Smoke" by Alexxa Gotthardt, July 26, 2017, *artsy* (website), accessed September 27, 2018, https://www.artsy.net/article/artsy-editorial-judy-chicago-rejected-male-centric-art-puff-smoke.

26. "Allen Ginsburg," *photoquotations* (website), accessed September 27, 2018, http://www.photoquotations.com/a/272/Allen+Ginsberg.

27. Ghirri, 124.

28. deSoto, Lewis, *EMPIRE: Photographs and Essays by Lewis deSoto* (Berkeley, CA: Heyday, 2016. Published in conjunction with an exhibition of the same title organized by and presented by the Robert and Frances Fullerton Museum of Art, 2016), XV.

29. Aashanique Wilson in conversation with the author, July 2018.

30. Aashanique Wilson in conversation with the author, July 2018.

31. Amy Bystedt in conversation with the author, 2017.

32. Amy Bystedt in conversation with the author, 2017.

33. "John Berger," *photoquotations* (website), accessed September 27, 2018, http://www.photoquotations.com/a/77/John+Berger.

34. "Sally Mann," *photoquotations* (website), accessed September 27, 2018, http://www.photoquotations.com/a/439/Sally+Mann.

35. "Carrie Mae Weems," *photoquotations* (website), accessed September 27, 2018, http://www.photoquotations.com/a/716/Carrie+Mae+Weems.

36. Isenberg, Barbara, *State of the Arts: California Artists Talk About Their Work* (New York: William Morrow, 2000), 151.

37. Gillespie, Bruce, ed., *Philip K. Dick: Electric Shepherd* (Melbourne: Nostrilia Press, 1975), 65.

38. Adams, Robert, *Why People Photograph* (New York: Aperture, 1994), 9.

39. "Frank Gohlke," *photoquotations* (website), accessed September 27, 2018, http://www.photoquotations.com/a/277/Frank+Gohlke.

40. "Robert Adams," *photoquotations* (website), accessed September 27, 2018, www.photoquotations.com/a/7/Robert+Adams.

Transect 01: *New Topographics* and Downstream Explorations

OBSERVATIONS

At its core, *In the Sunshine of Neglect* is an exhibition about place and experiment. It is about artists using the rapidly developing *tabula rasa* spaces of Inland Southern California to dissect new subjects and deploy new approaches. In particular, three photographers—Robert Adams, Lewis Baltz, and Joe Deal—operated extensively in the region at the precise moment the concerns of photography took a sharp, permanent turn. Adams, Baltz, and Deal are three of the ten photographers in the hugely influential 1975 exhibition: *New Topographics: Photographs of a Man-altered Landscape*. (A fourth area photographer, Judy Fiskin, was on the show shortlist. The curator dispatched Baltz to review her pioneering work, including her 1974 San Bernardino photographs. *In the Sunshine of Neglect* features a handsome selection.)

New Topographics swiftly reshaped landscape photography in the region, the West, the country, and the world. The deflection of photography proved durable, and Inland Southern California became an immediate and continuing laboratory for experiment. Photography pivoted away from scenic natural grandeur and toward the built environment. Instead of Yosemite or Point Lobos, cameras pivoted toward subdivisions and industrial buildings, strip malls and offices, the new western landscape of commerce and alienation.

New Topographics emphasizes emotional distance and unadorned directness. No need to get fancy. Pictures should look like they were easily taken. Trust that photography will deliver. Beauty is everywhere. Go ahead: pay attention to man's reshaping of the landscape. A bulldozer track, a discarded sofa, or a subdivision is as much part of the landscape as peaks or pinecones. Chaos is form, form is chaos. Consider everything. Stay cool. Photograph it all. *New Topographics* is a mental adventure of the most profound kind. It marks a paradigm shift that helps reintegrate photography with the larger arenas of contemporary art. It is safe to say that all current photographers in this exhibition operate in its wake. Some follow the flow, others swim against it, but all feel the ripples.

ARTISTS/WORK

Robert Adams [pages 019–022]

"The operating principle that seems to work best," states Robert Adams, "is to go to the landscape that frightens you the most and take pictures until you're not scared anymore."

In the year he wrote this, we find him photographing on the outskirts of northeast Riverside. (*Looking Past Citrus Groves into the San Bernardino Valley; Northeast of Riverside, California.*) We look with him into morning light suffused with particulate scatter. This spot—near what's known as Sugarloaf Mountain—has since been transformed into gleaming white-roofed rectangles of warehouses and concrete tilt-ups.

Robert Adams attended University of Redlands, graduating with a bachelor of arts in English in 1959, and earned a doctorate in English at the University of Southern California. After he turned to photography, he roamed the inland area with a camera. He returned repeatedly during the 1970s and early '80s. Adams leapt to prominence in the mid-1970s through the book *The New West* and the landmark exhibition *New Topographics: Photographs of a Man-altered Landscape*.

Robert Adams photographed the inland area for reasons that are written across the surface of every image—the glories of light in the last best spaces, the bare workings of development on the periphery, the poignant evidence of vanishing Edens. Through it all, he retains faith in the persistence of beauty and of nature.

Lewis Baltz [page 023]

This is an important photograph. A dark window framed by stucco. Reflections of a somber sky, inky palm top, and, dimly, a foreshortened glimpse of what might be a Renaissance portrait. But you can see all this yourself.

Lewis Baltz was a central figure among the *New Topographics* photographers—named after the hugely influential exhibition that catalyzed a radical countermovement to previous romantic representations of the American landscape.

The photograph is from a very early set he titled *Prototypes*. A prototype is "the first of its kind." That is not an exaggeration. The image precedes the *New Topographics* exhibition by two years but is utterly characteristic. Note the flatness, blank refusal of narrative, tautness of construction. The subject is mundane and the view direct. The image yields appearance but resists knowledge.

Baltz is deeply connected to Inland Southern California. He was born in Newport Beach in 1945. He attended Claremont Graduate School from 1969 to 1971 and taught at Pomona College. His first solo exhibition was at Pomona College in 1970.

Judy Fiskin [pages 024–037]

"When I first started I was really interested in atmosphere—a sort of Raymond Chandler atmosphere—too much sunlight, making you squint, everything really menacing. That's how I picked San Bernardino. I grew up in Southern California, and on my childhood map, after San Bernardino there was a big void that you would fall into if you went any farther. And then one day I was driving through there, and the smog was so thick it was palpable. It made the place look filthy and disgusting, and that was very appealing to me. In my mind, it was a very creepy place. That's why I wanted to photograph there."

Judy Fiskin's San Bernardino photographs are among her earliest. They formed her first solo exhibition in 1975 at California State University, San Bernardino. Even then, they signaled the distinctive approach that characterizes her work—serial operation, everyday subjects, high contrast "bleached-looking" prints, and, of course, diminutive size. It was variably titled *31* or *35 Views of San Bernardino*. Following her reductive sensibility, Fiskin now shows a set of fourteen.

Some have viewed her work as aligned with the *New Topographics* photographers. But Fiskin rejects their neutral stance and flat affect, "arbitrariness and depression and bleakness are not so present in the men who did New Topography. I wanted to inject certain kinds of emotional states into this neutral-looking work. That, I would say, is more female and less male."

Anthony Hernandez [page 039]

"Being aware is more important than the evidence of the awareness on a piece of paper. Being sensitive to what passes in front of you is more important than what passes into the camera." For photographer Anthony Hernandez, experience is paramount, photographs secondary. Attention comes first. Images are a bonus.

Hernandez works in series. Between 1978 and 1982, Hernandez made four influential, interconnected bodies of work—*Automotive Landscapes*, *Public Transit Areas*, *Public Use Areas*, and *Public Fishing Areas*. The images have some visual affinity with fast, 35mm camera street photography, but Hernandez used a five by seven Deardorff camera mounted on a tripod. He slowed the process, concentrated his attention, and captured the scene in fierce detail.

Of the four series, *Public Fishing Areas* arguably travels the farthest, both in its geographic reach and its exploration of the social sphere. Hernandez was born in East Los Angeles. He has spent a lifetime making visible disregarded spaces and overlooked people. The fishing area photographs are not overtly political, but nonetheless incisively dissect the social stratification of Southern California. They portray the "very humble recreations" of working-class Southern Californians, commented Lewis Baltz. Photographer Robert Adams describes them as showing "a fishing place where one might not want to eat the catch." The photograph in this exhibition is from a number made on the north shore of Lake Perris.

Lewis deSoto [pages 040–051]

Artist Lewis deSoto has undertaken two *Empire* projects. Both are ambitious, wide-ranging photographic portraits of Inland Southern California. Remarkably, they are also a bracket around time. Separated by over thirty years, the projects are named *Empire 1979* and *Empire*. They are a circling back, a revisitation, a return, a haunting.

Empire 1979 signals its year of production; *Empire* was made between 2012–2015. Unavoidably, these twin projects focus on meaning and memory in an environment of extreme change. The artist has used cameras and time to construct, to commemorate, to inhabit, his own city of memory.

For *Empire 1979*, deSoto modeled his thinking on color photography pioneers such as William Eggleston. He eschewed a tripod, employed an embracing 28mm wide-angle lens, and consciously choose grainy, consumer-grade Kodak Gold color film. He describes *Empire 1979* as "an experiment in being led by photography" first, and secondarily about place. The later *Empire* series, he says, reverses the equation: place first, photographic concerns second.

What did deSoto find? The artist's report: change is everywhere, erasure is the norm. Time touches everything. Vast portions of the former landscape have been effaced, overwritten. In the end, deSoto visits his own history (and ours) the way one visits a foreign country. He carries two passports—photographs and memory. Listen closely. Beneath deSoto's new *Empire* work we can hear the whispers and tiny cries of the vanished world of the past.

Laurie Brown [pages 053–056]

Laurie Brown makes photographs at the frontier. She seeks the collision point between nature and culture, the impact zone between natural and human-made. Her title signals her preoccupation: *Recent Terrains*. The West subdued, parceled out, reshaped. Machines consume the hills and leave behind a vast scene of terraformed building pads.

There is critique inherent in the photographs. We conquered the West, but what exactly have we done to it? Is it sustainable? Is there an alternative? But there is this fact: the artist herself lives in a newly constructed Newport Hills neighborhood. It is a landscape she roamed with camera in hand as Caterpillar 630-series scrapers tore into hillsides. She says this calmly as she looks out her living room window at rank after rank of townhomes and red-tiled rooftops.

The artist made these photographs in south Temecula. In these massively reshaped places, Brown's cool eye and wide views produce disturbingly serene stillness, regimented beauty. Brown gives us structured landscapes, balanced and alluring. But they exist outside nature. And they're utterly unpopulated. They feel inhuman, unearthly. Likewise, they seem to exist outside of time. They are certainly not past, nor present. They represent ceaseless growth at the margins, constant expansion. But no growth can be endless. Is it possible that this artist looks through her viewfinder into the future, our future?

Herb Quick [pages 057–060]

Herb Quick "lived a life wasted in photography," in his own sardonic description. For nearly sixty years, he was omnipresent in the regional photographic community. Over that time, we witness Quick's technically

immaculate work respond to the shifting arc of photography.

Quick began as a practitioner in the mainstream of West Coast photography traditions. He started as a formalist, a technical master, a modernist with precisionist overtones. His resume carries an impressively familiar set of touchstones. He had early training from the Art Center School in Los Angeles. He studied and worked, in one form or another, with a string of California photography luminaries: Ansel Adams, Fred Archer, and Edward Weston. He embraced the rigors of Ansel Adams' 'zone system' for black-and-white tone control. The stories in circulation take on the flavor of the apocryphal. He worked for a time as Dorothea Lange's printer. He developed his photographic style under the guidance of lifelong friend Max Yavno.

Quick's origins as a formal modernist show in his 1969 photograph made in San Bernardino—raking light, taut composition, calibrated balance, and next to no social content. His other landscape images in the exhibition, however, show a radical deviation in subject matter, a late response to the seismic shift set in motion by the *New Topographics* photographers. In them we find unadorned directness, hard-eyed reserve, and a critical focus on man's reshaping of the landscape.

Chelsea Mosher [pages 061–064]

Chelsea Mosher's photographs were made on "a magical ranch in a canyon in Riverside." The organic family farm, she says, has "every imaginable strain of citrus in wild clusters, peppered with avocado trees across the land." The photographer returned again and again, brushed by the arms of reaching branches and breathing the intoxicating aroma of orange blossoms.

The farm Mosher photographed is a remnant. It's a residue in a region once centered on the navel orange. Our "forest primeval" writer Susan Straight calls the vanishing orange groves. From the 1880s forward, entire inland area towns were laid out within spreading estates of Washington navel oranges. Grapefruits, lemons, oranges became a culture, a bounty, a regional identity. "In spring," writes Straight, "white blossoms like millions of stars fall in perfumed drifts. In summer, we dangled our feet in the canals where water grass waved at the bottom of the silent currents. Water cascaded from the cement irrigation pumps into the furrows between trees, like silver ribbons in the heat."

Mosher's photographs in this exhibition focus on citrus as subject, but are largely shaped by photographic concerns. She approaches the places she works as an outdoor studio. "I am driven by the possibilities that occur when physical space is translated into photographic space. Most of my images are made observationally while thinking deeply about the constructed image."

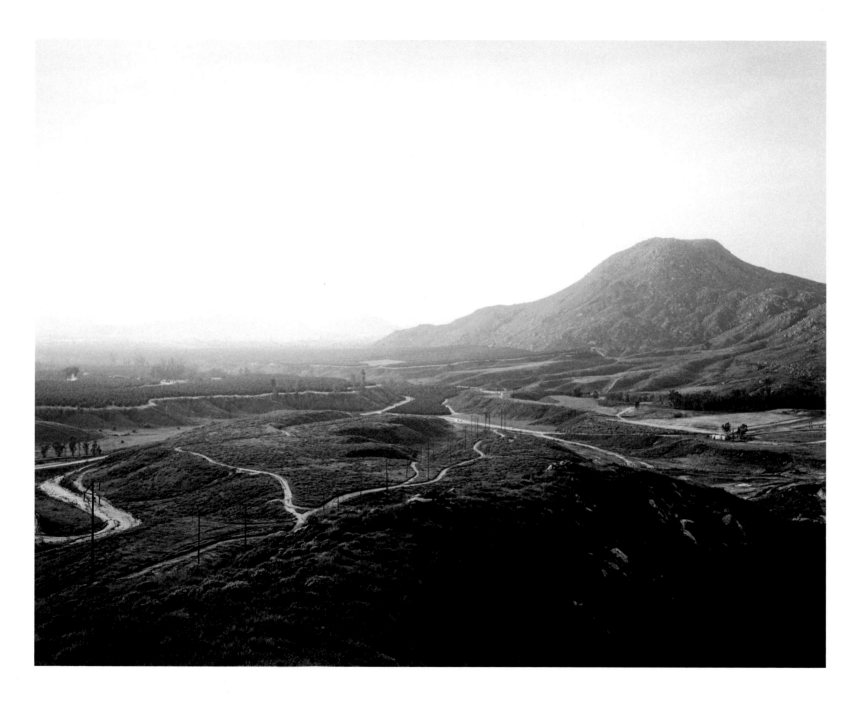

Robert Adams, *Looking Past Citrus Groves into the San Bernardino Valley; Northeast of Riverside, California*, 1983, © Robert Adams, Courtesy Fraenkel Gallery, San Francisco

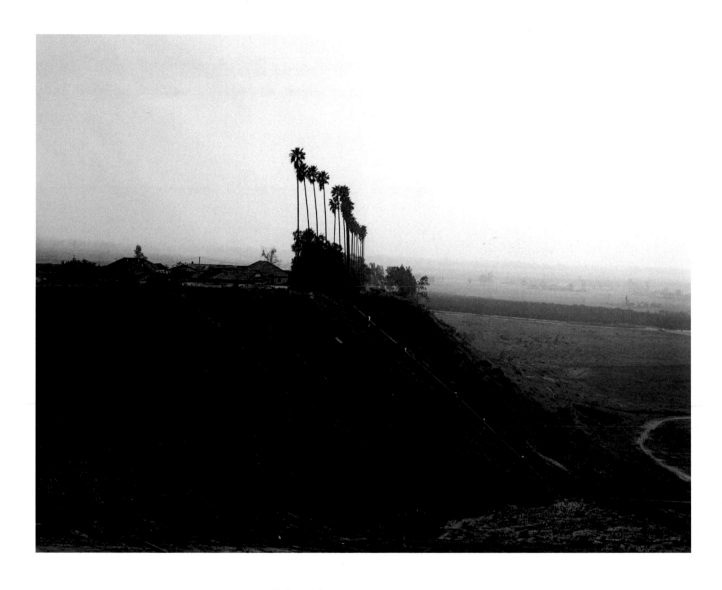

Robert Adams, *New development on former citrus-growing estate, Highland, California,* 1983,
© Robert Adams, Courtesy Fraenkel Gallery, San Francisco

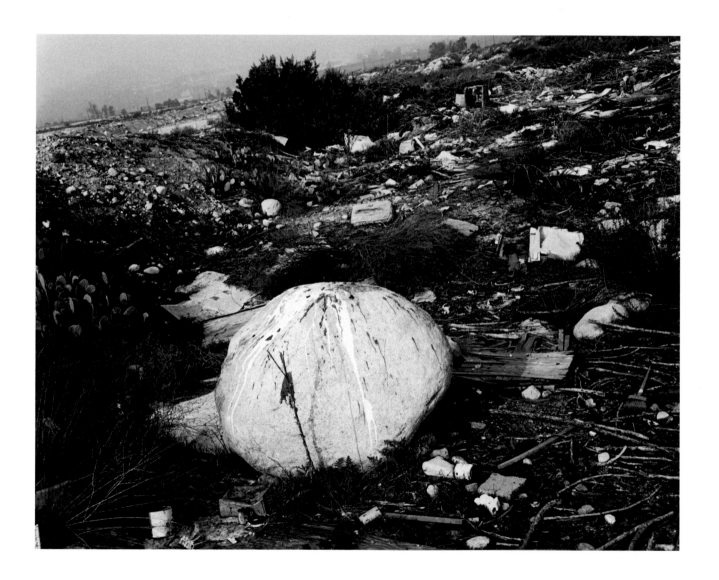

Robert Adams, *Santa Ana Wash, San Bernardino County, California,* 1983, © Robert Adams, Courtesy Fraenkel Gallery, San Francisco

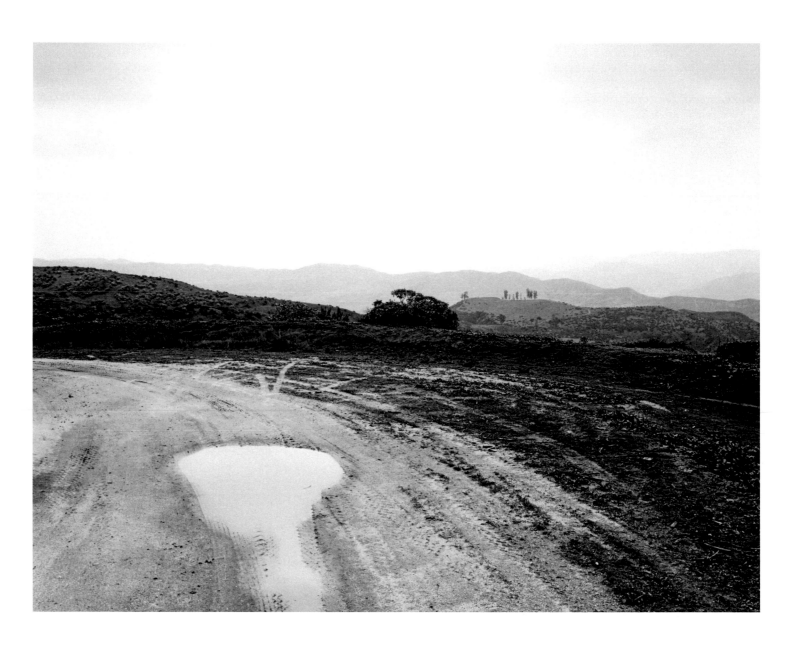

Robert Adams, *Development Road, San Timoteo Canyon, Redlands, California,* 1978,
© Robert Adams, Courtesy Fraenkel Gallery, San Francisco

Lewis Baltz, *Claremont*, 1973, © J. Paul Getty Trust. Getty Research Institute, Los Angeles

Judy Fiskin, *Untitled,* from the series *35 Views of San Bernardino,* 1974

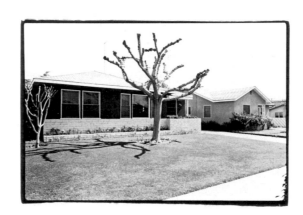

Judy Fiskin, *Untitled*, from the series *35 Views of San Bernardino*, 1974

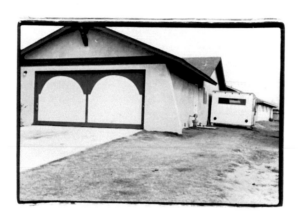

Judy Fiskin, *Untitled*, from the series *35 Views of San Bernardino*, 1974

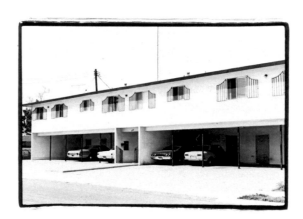

Judy Fiskin, *Untitled*, from the series *35 Views of San Bernardino*, 1974

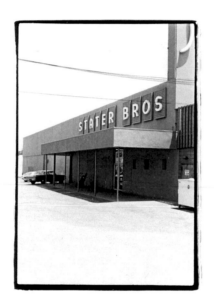

Judy Fiskin, *Untitled,* from the series *35 Views of San Bernardino*, 1974

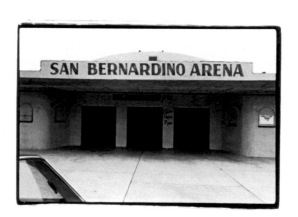

Judy Fiskin, *Untitled,* from the series *35 Views of San Bernardino,* 1974

Judy Fiskin, *Untitled*, from the series *35 Views of San Bernardino*, 1974

Judy Fiskin, *Untitled*, from the series *35 Views of San Bernardino*, 1974

Judy Fiskin, *Untitled*, from the series *35 Views of San Bernardino*, 1974

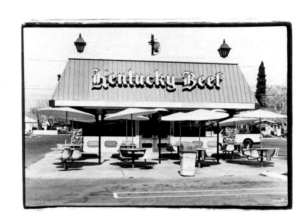

Judy Fiskin, *Untitled,* from the series *35 Views of San Bernardino,* 1974

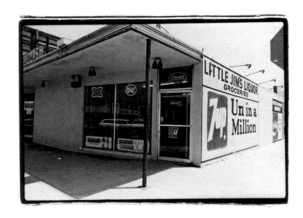

Judy Fiskin, *Untitled*, from the series *35 Views of San Bernardino*, 1974

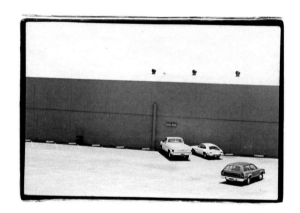

Judy Fiskin, *Untitled,* from the series *35 Views of San Bernardino,* 1974

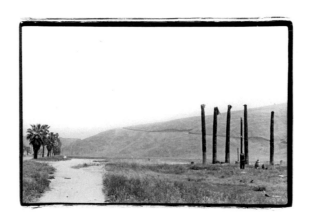

Judy Fiskin, *Untitled*, from the series *35 Views of San Bernardino*, 1974

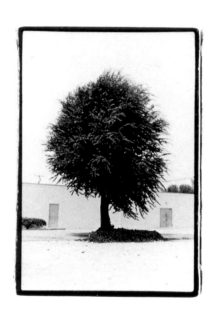

Judy Fiskin, *Untitled,* from the series *35 Views of San Bernardino,* 1974

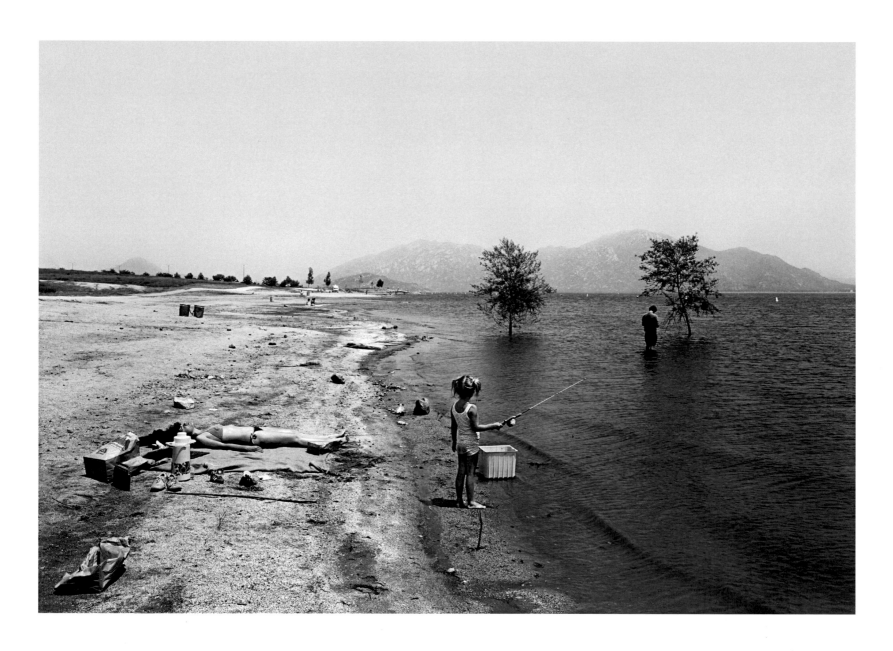

Anthony Hernandez, *Public Fishing Areas #31*, 1982

Lewis deSoto, *Del Taco, Riverside, California,* 1978

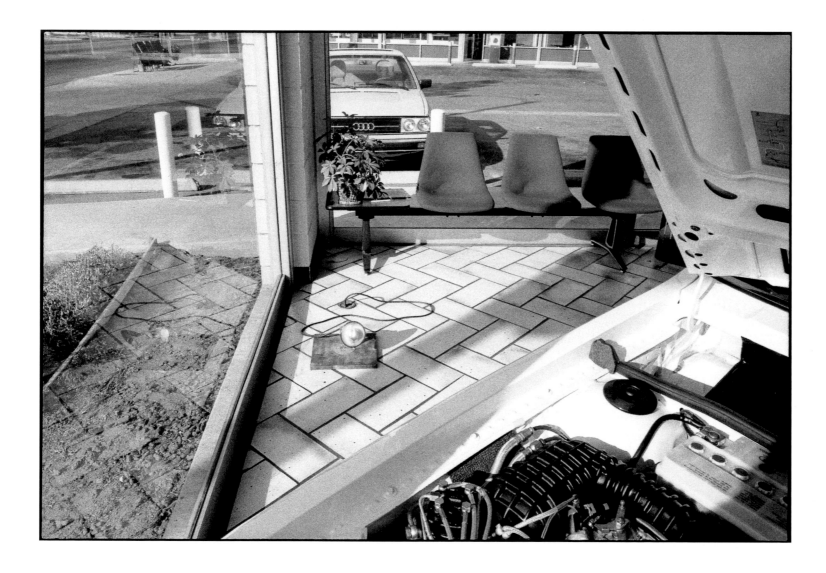

Lewis deSoto, *Audi dealership, Riverside, California*, 1979

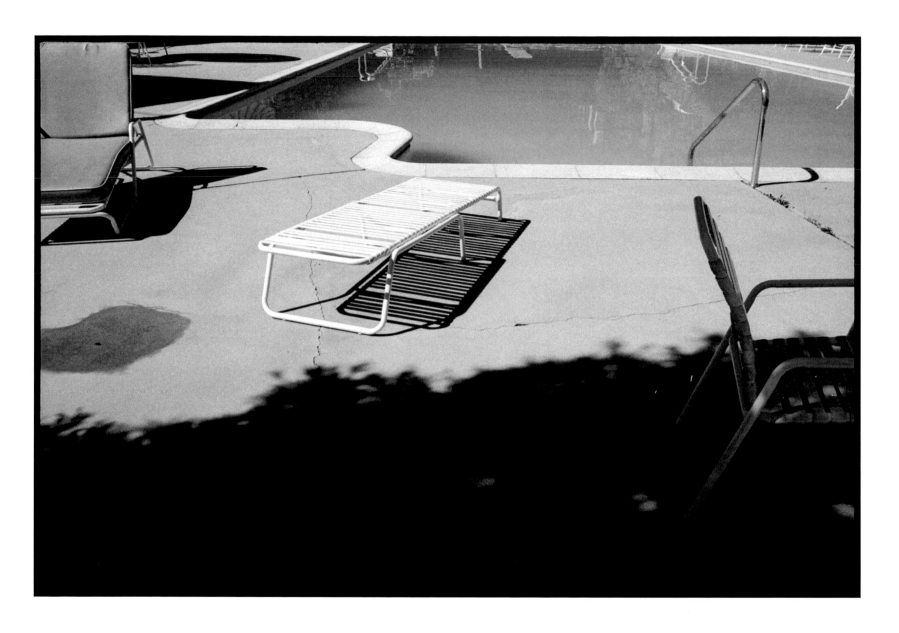

Lewis deSoto, *Green pool, San Bernardino, California*, 1979

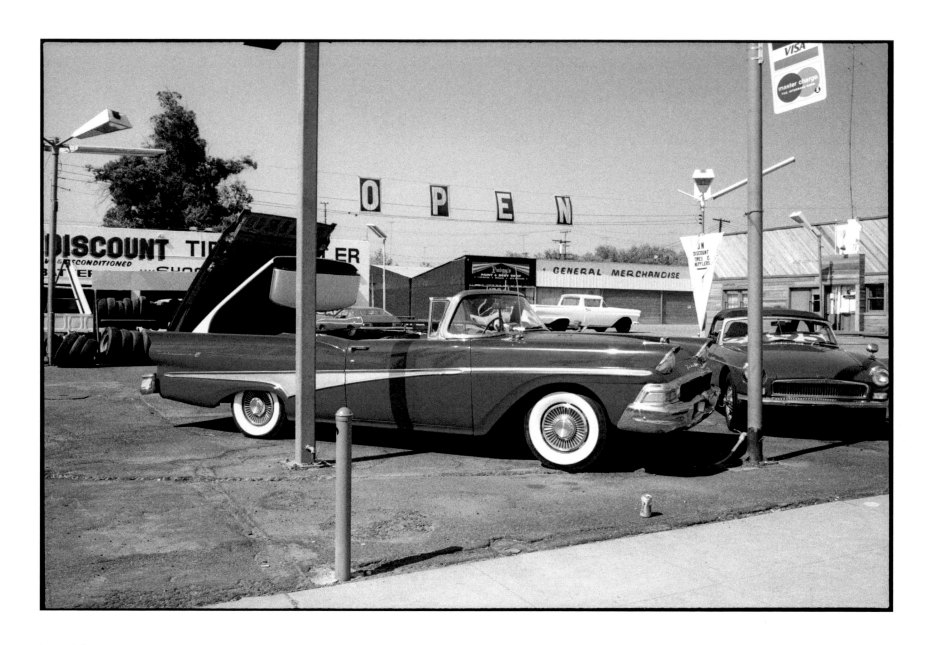

Lewis deSoto, *E Street car lot, San Bernardino, California,* 1979

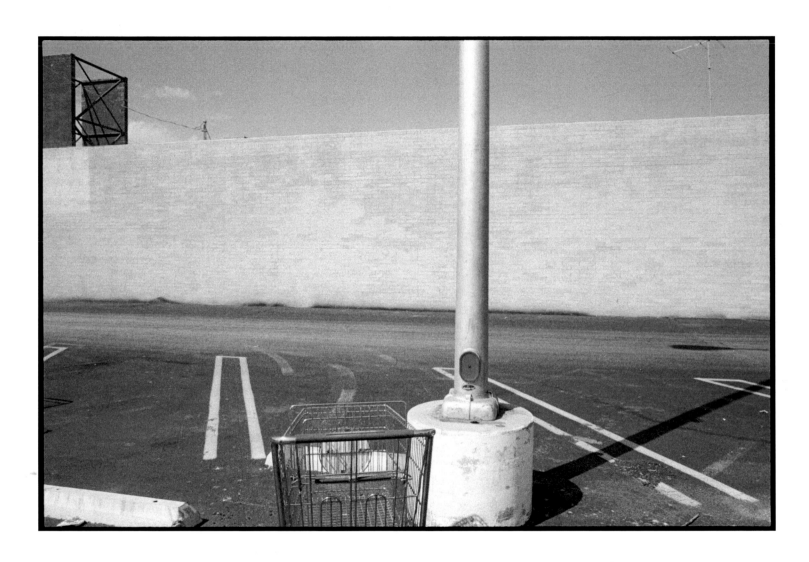

Lewis deSoto, *Car lot, Banning, California*, 1979

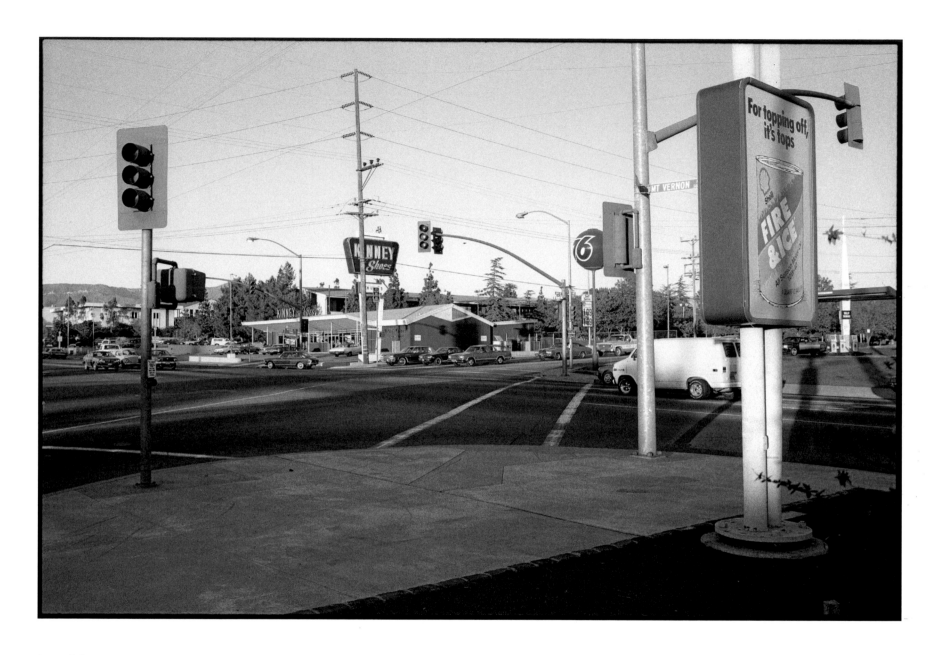

Lewis deSoto, *Mount Vernon, Colton, California*, 1979

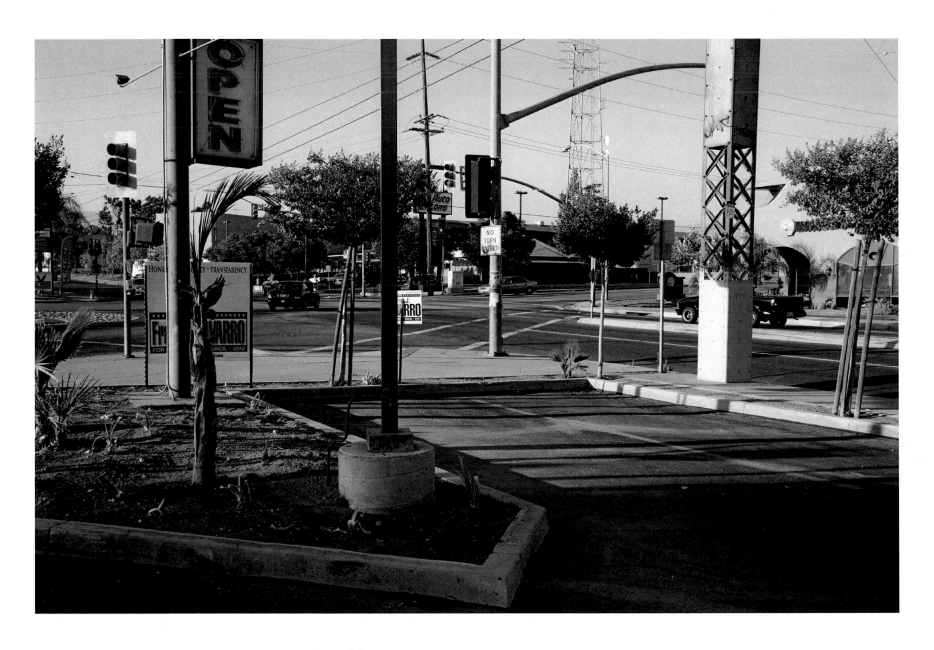

Lewis deSoto, *Colton, intersection of North Mount Vernon Avenue, North La Cadena Drive, and East Grant Avenue, July 2012, 2012*

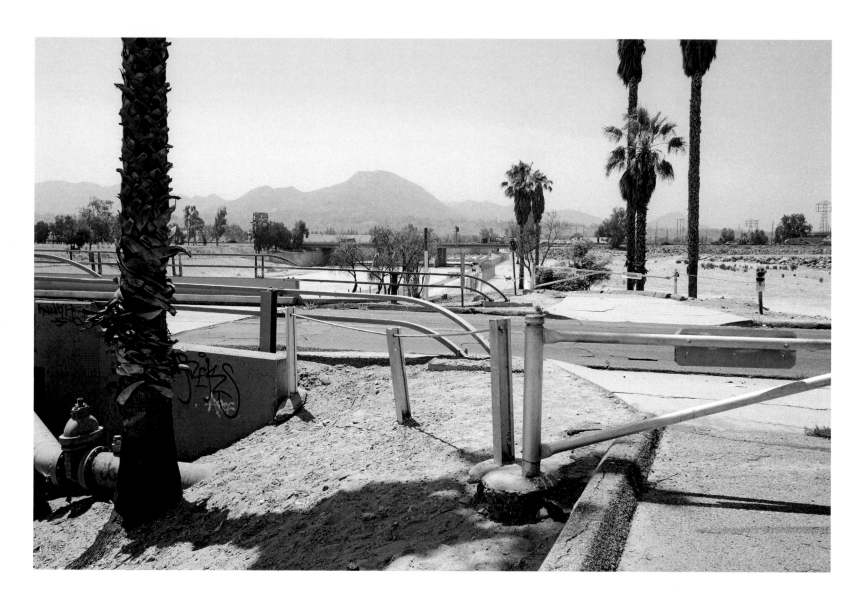

Lewis deSoto, *Colton, Fairway Drive at the intersection of the Lytle Creek Wash flood canal, August 2012, 2012*

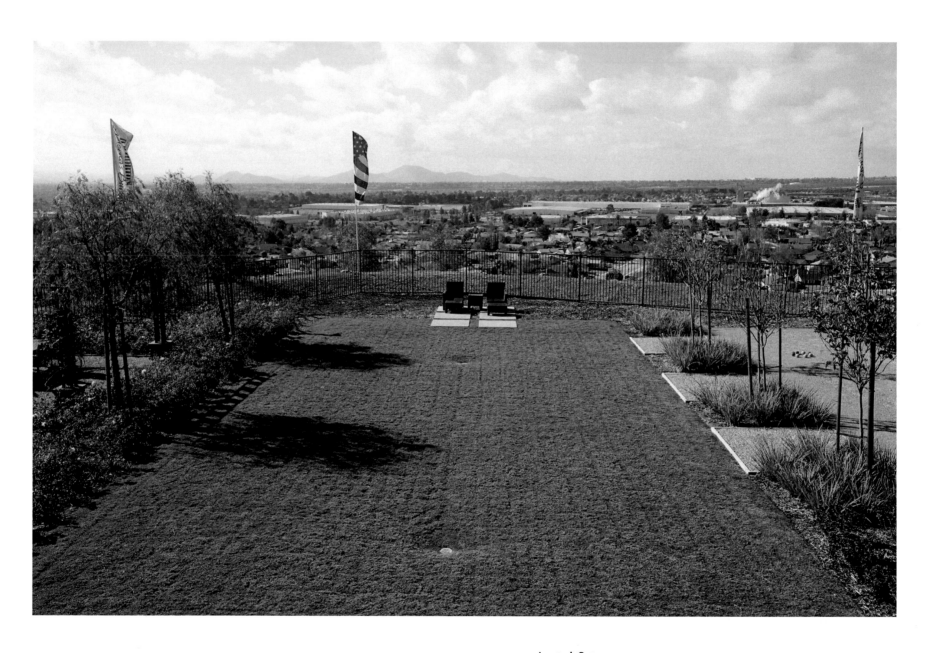

Lewis deSoto, *San Bernardino, model home, Pinnacle Lane, February 2013*, 2013

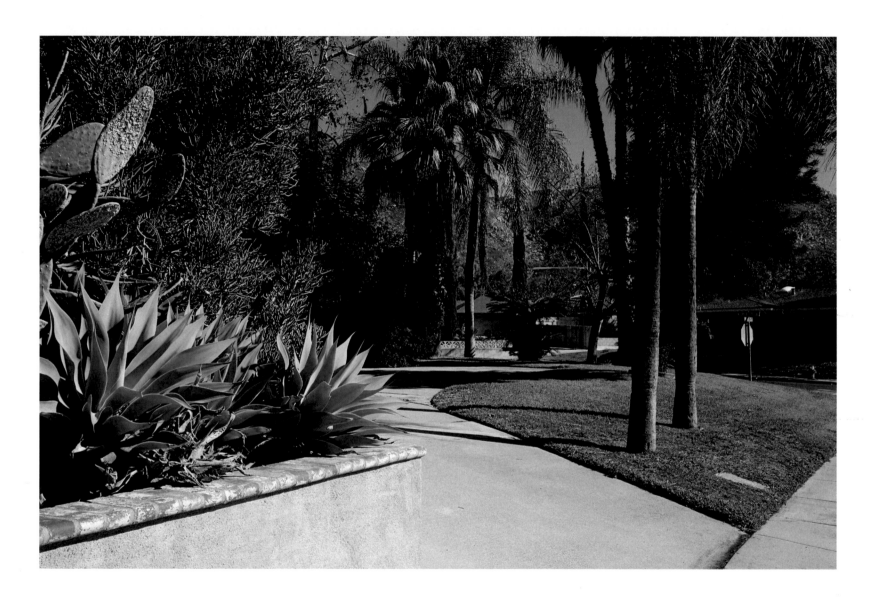

Lewis deSoto, *Riverside, Watkins Drive and Nisbet Way (former home of Joe Deal), January 2013*, 2013

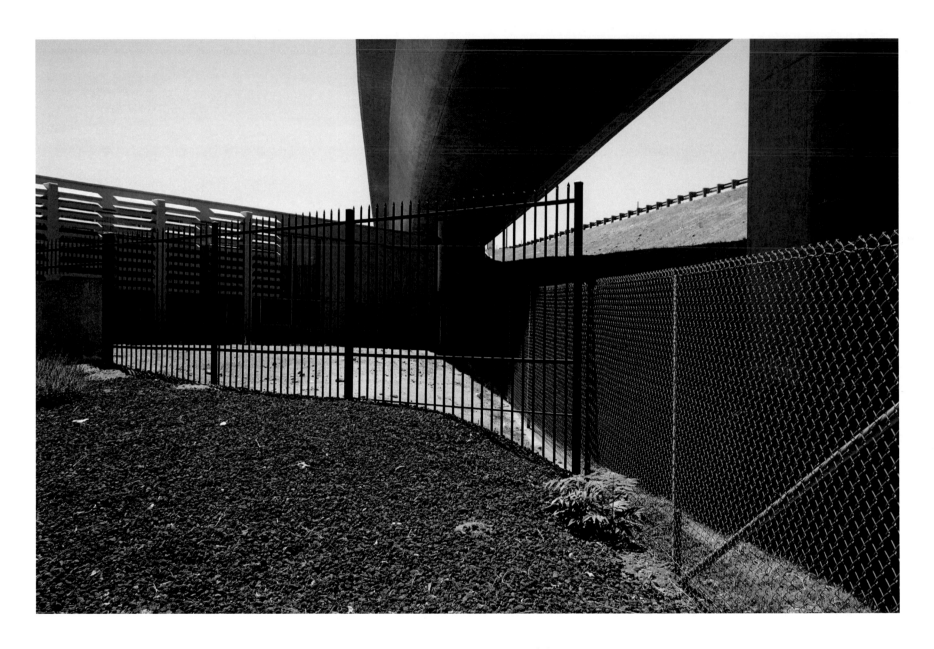

Lewis deSoto, *Riverside, I-215 and Caltrans building, Spruce Street, February 2013*, 2013

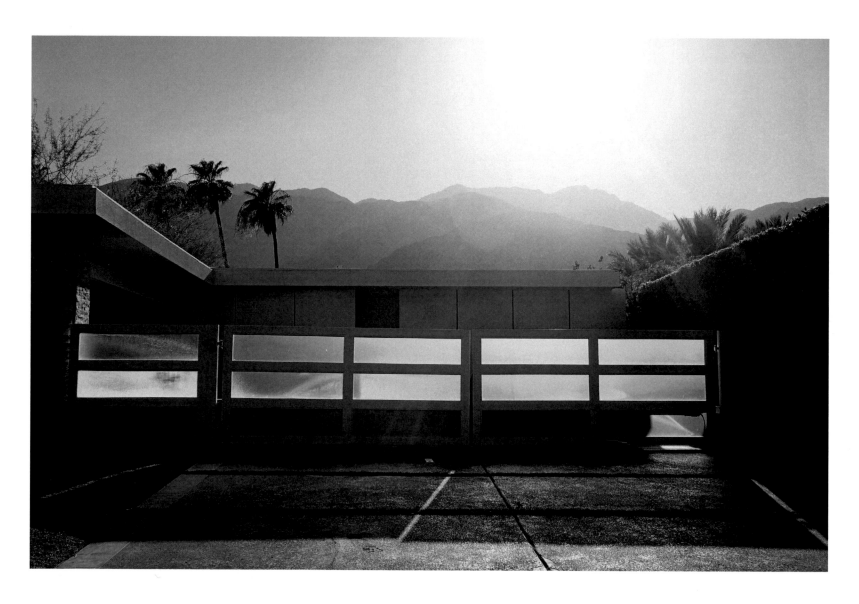

Lewis deSoto, *Palm Springs, glass gate, S. Caliente Drive, June 2013*, 2013

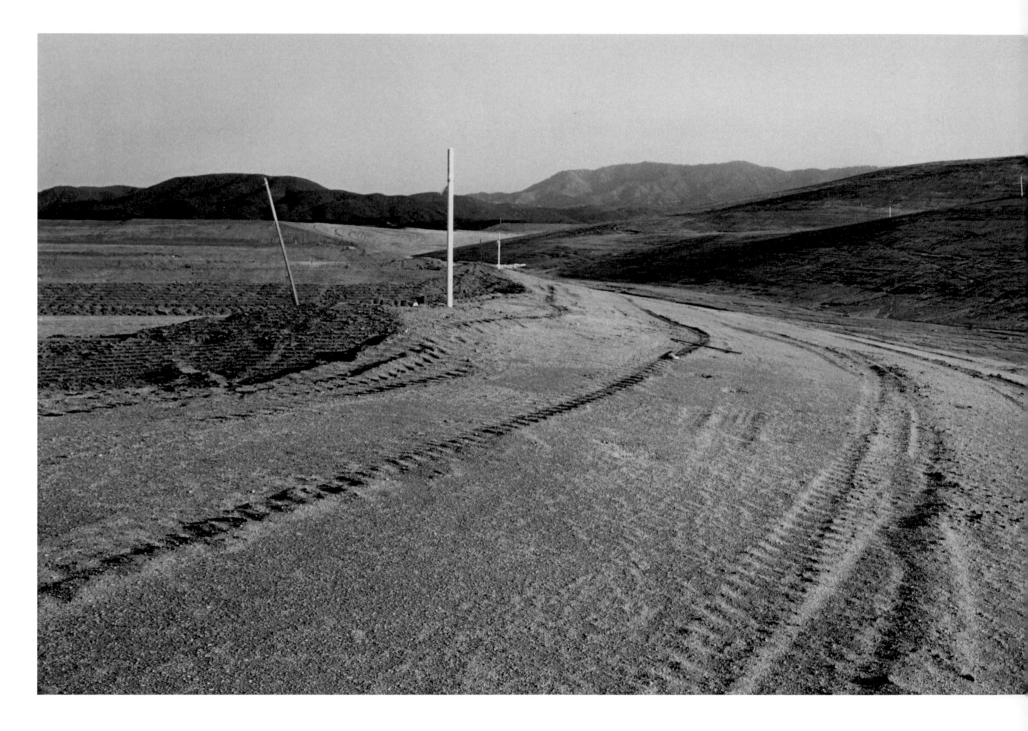

Laurie Brown, *Recent Terrains #8*, 1991

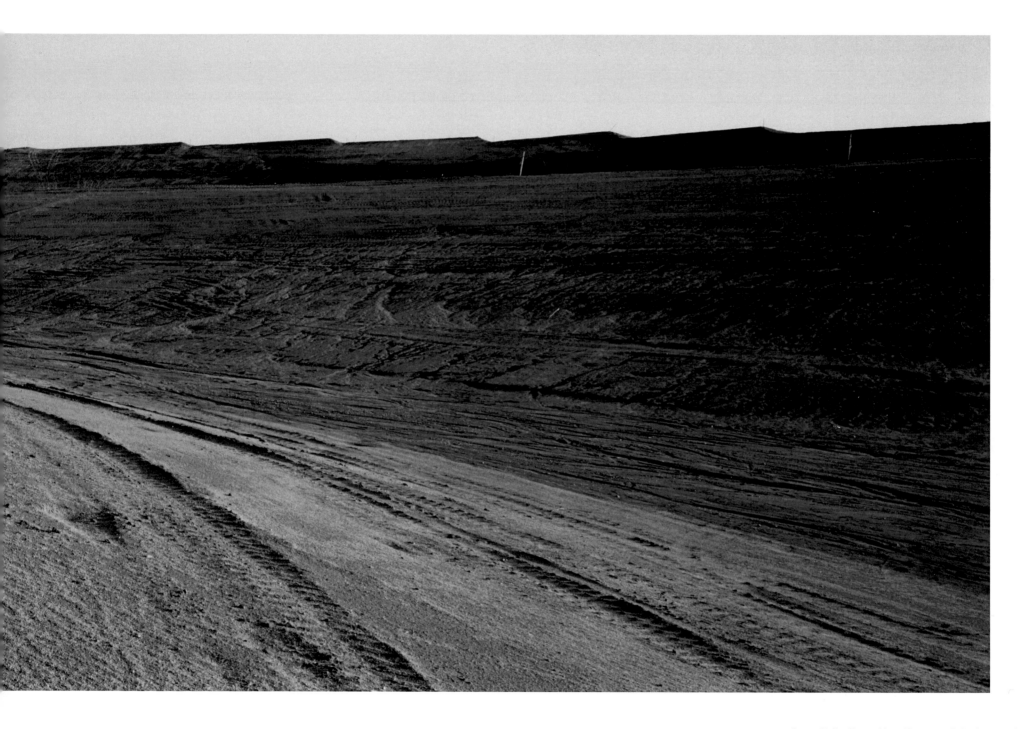

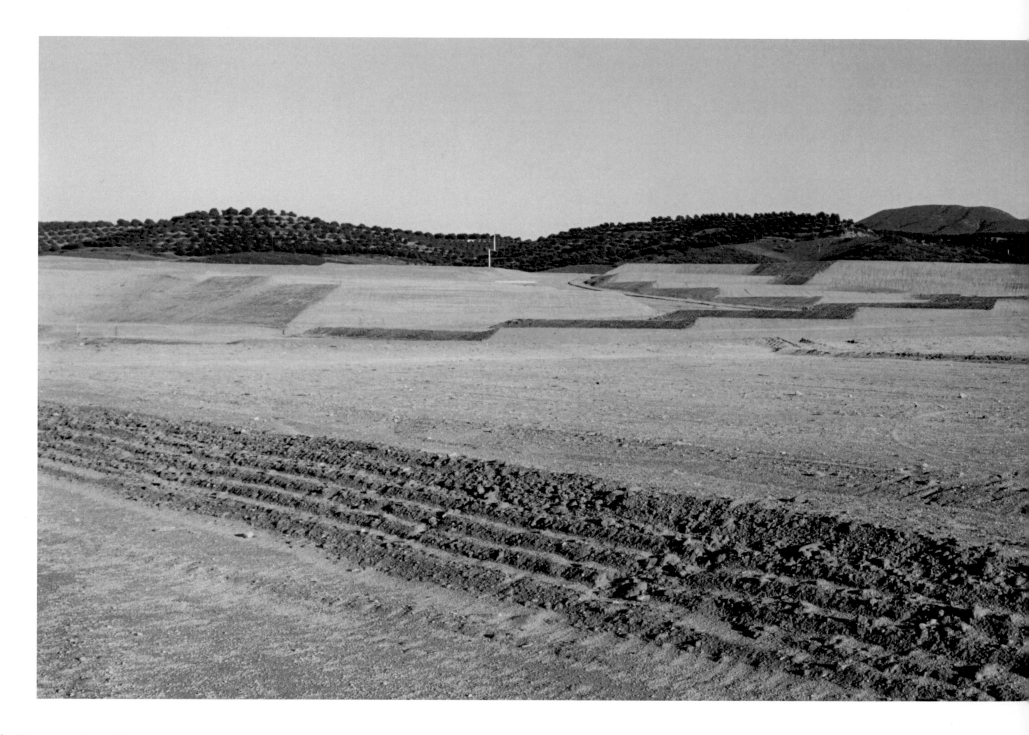

Laurie Brown, *Recent Terrains #7*, 1991

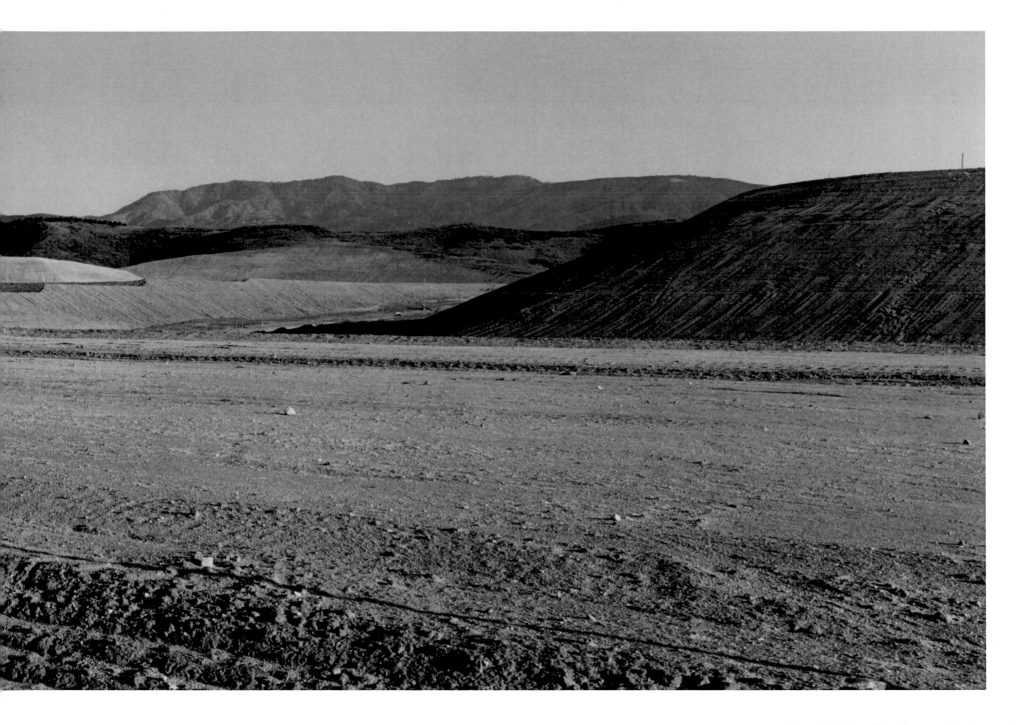

Herb Quick, *San Bernardino, CA*, 1969,
© Regents of the University of California

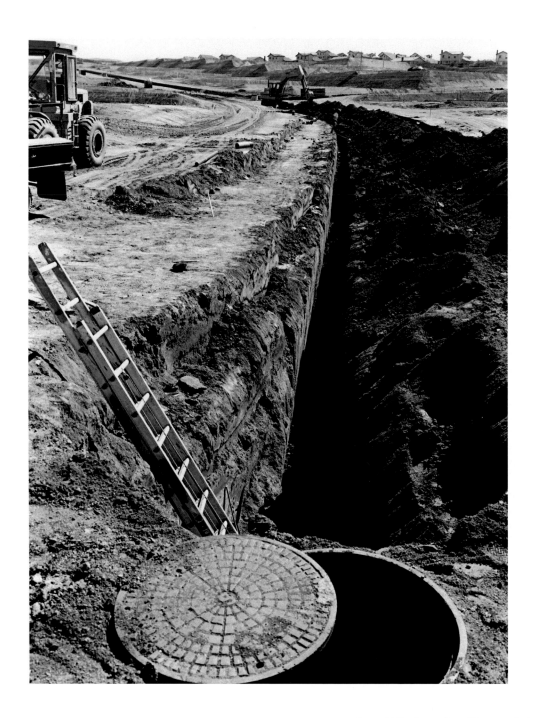

Herb Quick, *New Sewer, Riverside, CA*, 1987
© Regents of the University of California

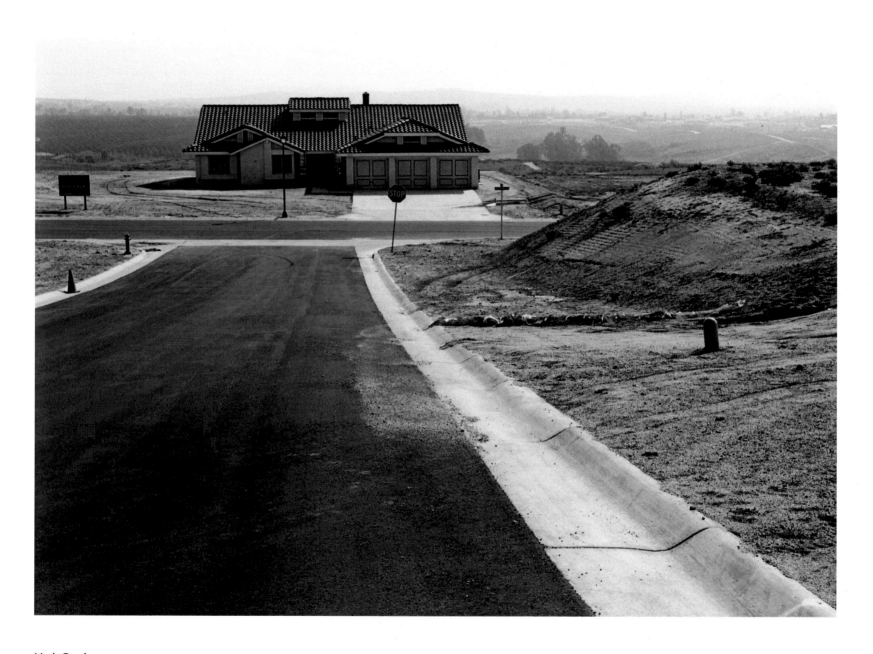

Herb Quick, *Trafalgar and Alessandro, Riverside, CA*, 1987, © Regents of the University of California

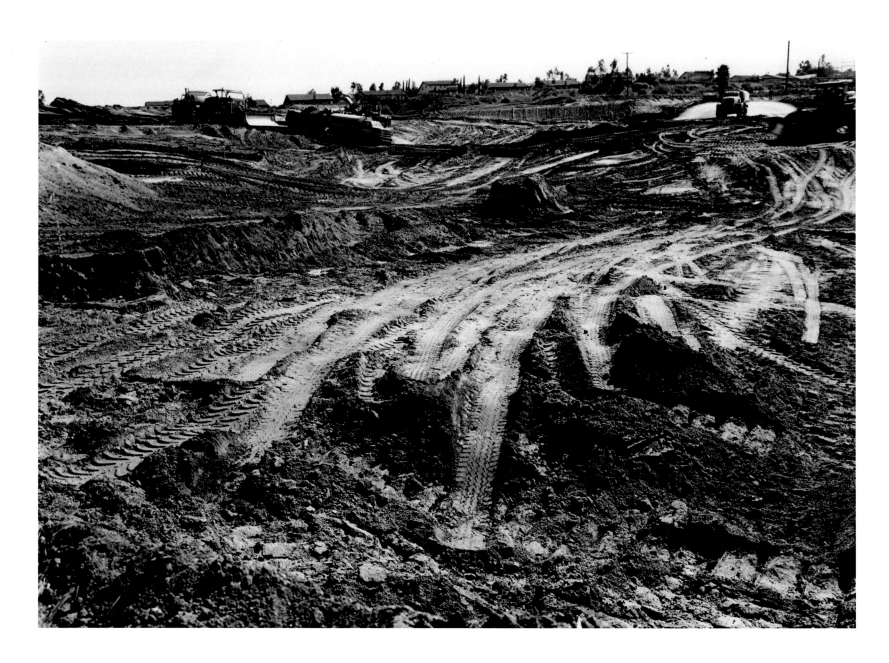

Herb Quick, *Riverside (Grading)*, 1987, © Regents of the University of California

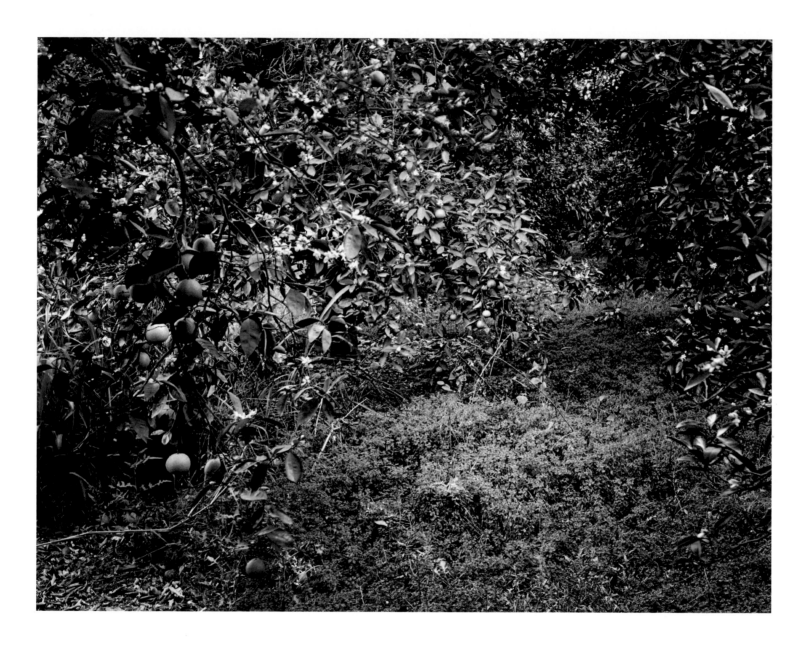

Chelsea Mosher, *The Orange Blossom*, 2015

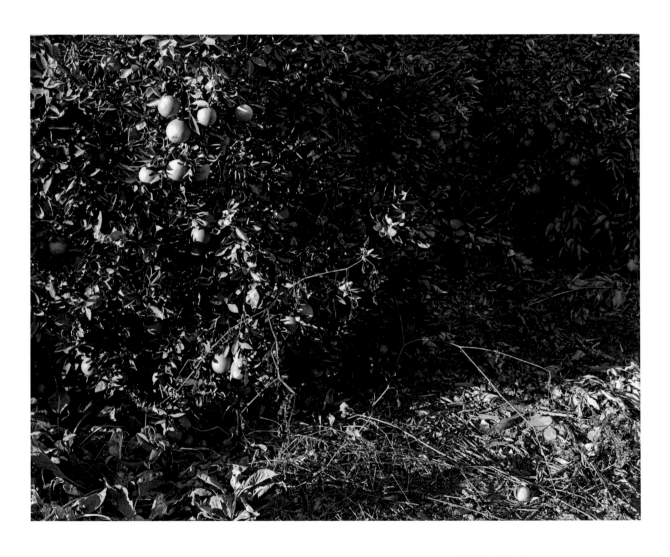

Chelsea Mosher, *Evening (Ranch)*, 2017

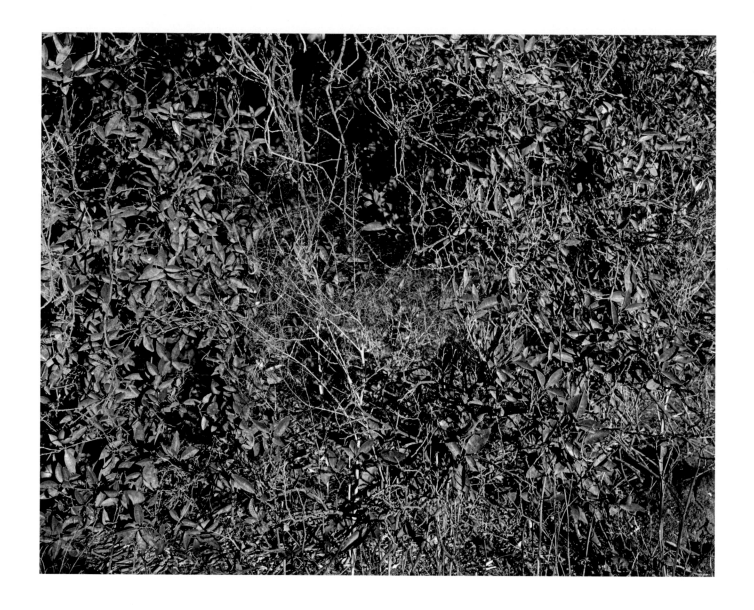

Chelsea Mosher, *Untitled (Roadside)*, 2017

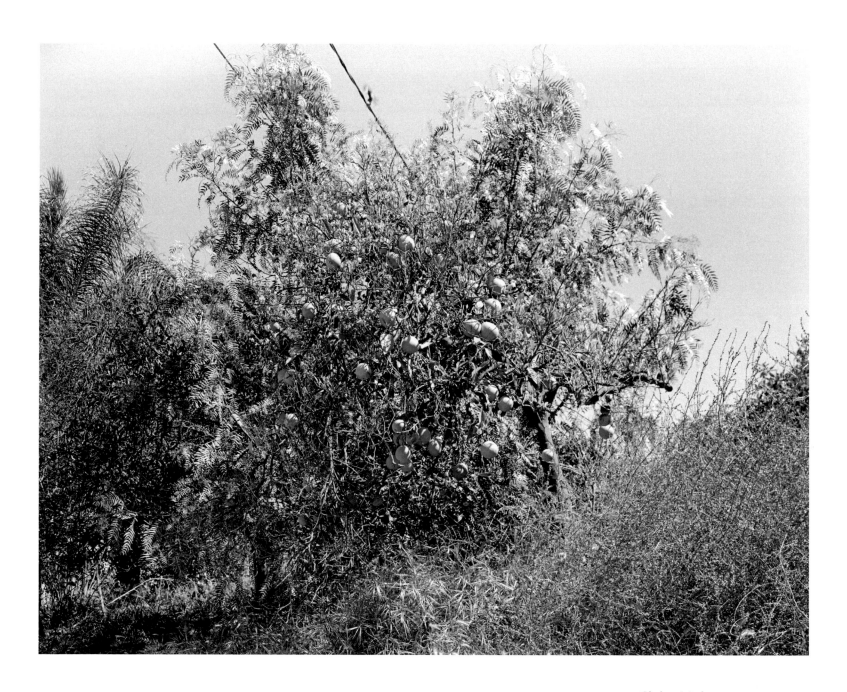

Chelsea Mosher, *Winter's Lane,* 2015

Illumination in Our Geography of Home: *In the Sunshine of Neglect* Susan Straight

The first time I saw the images in *In the Sunshine of Neglect*, a survey by Douglas McCulloh of the vast territory of landscapes in my beloved native country, a beautiful confluence of memory, history, image, and dreams came pooling into the space. I knew almost every location in these photographs. I knew the Pomona garages of Tony Maher, the Ontario living room of Amy Bystedt and Sally Egan, the Colton hills of Lewis deSoto, the arroyos and river washes of Robert Adams and Sant Khalsa, the Route 66 of Thomas McGovern, but also two Rubidoux places—the iconic drive-in shot by Julius Shulman and the intimate backyard by Aashanique Wilson.

This is because of the geography of love, family, and desire. These photographers captured a landscape first imprinted with the planet's own ripples and shrugs, then overlaid with layers of our human wants and needs, even in the geology and watershed, and the way people tried to alter the earth even as families fell apart. Of course, there are cars—cars that left garages where young boys waited for fathers to return, cars that cruise proudly down the avenue of the past and present, cars that wait marooned in grass for someone to remember, cars from whose window a lit cigarette sparked a conflagration, cars that will pull into an asphalt lot to see huge flickering scenes that drivers passing on the nearby freeway may even glimpse for a fractured moment in time.

But if we begin with home, I have to begin with driving, even though that seems a cliché. When writers and artists speak of their singular obsessions with their cities—the arrondissments of Paris, the districts of London and the boroughs of New York beloved by poets, the Chicago wards and Miami neighborhoods—they are recording the sights as *flâneur* and *flâneuse*—walking every step of the places they love, observing every detail. When Americans speak of American panoramas, of Appalachians and Rockies, of Mississippi and Hudson

Rivers, of fields of wheat and herds of bison, I feel the omission of my home geography. I want to say we have the San Jacinto Mountains where the god Tahquitz rules, the Santa Rosa Range where bighorn sheep and rattlesnakes move along the stony trails, the Cajon Pass through the San Bernardino Range where countless wagon-borne pioneers from the 1800s and countless tractor-trailers from last week entered California.

Of course, others always chide Californians for believing that to drive is to also see, and love, a place in great detail. We know what we're doing. We drive a lot. We get out and stand in a place. We might stand for hours, watching a hawk, seeing a fire, watching people move through the fields picking strawberries or watermelons, watching a trailer explode. We might look only at the boulders collected in a flood. We might laugh, and fight with someone there, on the side of a remote road in the foothills. We might cry.

My dear friend Mike Davis, the iconic writer of our American home, was born in Fontana, and I was born in Riverside. During our years of intense conversation about our region, we talk about how he learned the landscapes of California as a truck driver, and how my father taught me to drive in the abandoned vineyards of Cucamonga. We talk about the historic pinpoint location we love—where Baseline and Meridian meet near the Lytle Creek Wash—the place where Colonel Henry Washington laid out the foundation for the grid of roads that cast nets over all of Southern California, from San Bernardino all the way to Santa Monica.

Together, Riverside and San Bernardino Counties encompass more than 27,000 square miles. To grow up in a place that large, bigger than ten states, is to have vistas and panoramas other Americans might not have seen, mountains and rivers and fires and floods and faults perhaps unknown to other humans.

There could be no better photographer and artist than Douglas McCulloh to put together this immense and

yet intimate tour of our home. He's spent decades taking his own photographs throughout these counties, all over this empire of sunshine that has often been neglected as an American geography as vivid and singular as any other. I know this because for the last ten years, Douglas and I drove everywhere, hearing stories and gathering images, sometimes laughing at a stranger's tale and sometimes waiting until we got back into my car to sit shaken and silent at someone's heartache.

If we begin with a home that knew no cars, Lewis deSoto's images are the perfect start. His work *Tahualtapa, Hill of the Ravens* (1983–1988) showing the Colton railyards and Slover Mountain takes the viewer through the entire history of a place that seems to belong to commerce, when really, it is sacred. This was the Hill of Ravens to the Cahuilla peoples here long before anyone else. Then the Californio settlers gave it the name *Cerro Solo*. After that, Isaac Slover, a Kentuckian, killed a bear there, and his name was given to a mountain initially injured by marble quarrying for headstones to commemorate the dead and virtually destroyed by mining limestone for concrete. But in his work, deSoto restores the mountain to life.

Robert Adams photographed the edges and boundaries of places not far from the Hill of Ravens, in his beautiful series from 1978–1982: *Development Road, San Timoteo Canyon, Redlands, California* (1978); *New development on former citrus-growing estate, Highland, California* (1983); and *Santa Ana Wash, San Bernardino County, California* (1983). I recognize the Santa Ana wash image from having stopped there accidentally one afternoon with my dog, a place I always consider representative of the way our river and flood and geologic movement differ from what other Americans might think of as watershed: we have massive drifts of river rock and boulder, white and gray as if to remind us always of the power of winter storm. Sant Khalsa's evocations of the

river also reflect deep knowledge of this place—her work shows the power of winter storms, the architecture of stone we walk over to get to our creeks. Khalsa has looked at the land along and near the river for decades. Her work leads the viewer to consider how our California is formed and refined by fault, flood, fire.

Joe Deal's fault zones are embedded in the landscape at a powerful remove, formal and forbidding. Then Noah Berger takes us into the otherworldly lunar landscape we all know as the scorched earth after fire—his Blue Cut Fire photograph is so redolent of ash and char and the violence and speed of flame that maybe someone not from here might understand our kind of conflagration.

The human taming of the natural world in a small place is captured in Robbert Flick's willows at Puddingstone reservoir—the man-made lake where my father took me fishing during my childhood—a place where men from every part of America stood lost in reverie in a California where they had arrived from elsewhere.

Kaiser Steel brought thousands of men and women to Fontana to work, and Will Connell's series of photographs from the foundries during the 1950s are both astonishing and so personal, astonishing in the immense scale of furnace superstructure and personal in their terrifying light—molten steel being poured into forms to make slab steel to be rolled and sold all over the world—the men watching, working, so close to that light. During these years, my grandmother, an immigrant from Switzerland, was "nurse-in-charge" for Kaiser Steel, the woman to whom injured were brought, located in a small wooden building far from sight of this massive enterprise. Kaiser Steel, Goodyear, Alcan, Toro, Boeing, Rohr—all these plants shaped the area, bringing thousands of families here. Allan Sekula's diptych of the dismantling of Kaiser, *Kaiser steel mill being dismantled*

after sale to Shougang Steel, People's Republic of China. Fontana, California. May and December 1993, which everyone in my family and neighborhood remembers with melancholy bitterness, as I grew up with countless people who worked there, reflects the solemn dignity of industrial demise.

Kurt Miller's exploration of the loss of daily story in a community like ours, with the Riverside *Press Enterprise* newspaper building's transformation from nerve center of information to a ghostly remembrance of narrative, reflects that solemnity as well.

Work, land, and home—humans came to this part of California for hard work, for relatively affordable land when compared to other places, for the sunshine and snow-capped San Bernardino and San Jacinto Ranges as backdrop to lush citrus on green trees just past Route 66. They built the structures of home they thought would last forever—in the new paradise—which was not Los Angeles or San Francisco, which was this home.

I fell in both love and hurt with the work of these chroniclers of the place I love so much, and my memories of how our families fall apart, or hold together, and what we drove past while we heard our people laughing or crying or considering what to eat. Tony Maher's images of the model homes of his childhood—his history as recreated with tender care—take me back to my own street: the garage of every tract home I saw from my own bedroom window. It nearly made me cry to learn that he upgraded the color of his father's car to red, the vehicle that drove away in *The Day Dad Moved Out, 1986* (2010)—as did the Mustang of my own father. Maher's work leaned perfectly into the stunning photographs of Amy Bystedt and Sally Egan, who met at Chaffey College, whose series *Fotomat* (2015) takes many of us directly back to our youth and the little castles where our lives were handed back to us in envelopes as slides, which my stepdad would

show us on the wall—click rasp click rasp click—or as square photos we tucked into weirdly-elaborate paper corners on the pages of albums. The two women shoot each other and their children, replicating the 1970s with a precision remarkable for its detail. These were our true lives, in those decades of Pomona and Ontario subdivisions, California sharp-edged light and orange and green and geometry of mantel and driveway.

Judy Fiskin's *35 Views of San Bernardino* (1974) shows a fine miniaturist in a big landscape—the amputated limbs of the fruitless mulberry trees ubiquitous here, the arches on the garages, the apartments and carports like corrals for humans and their vehicles, and the welcome sight for all the hungry of the A-frame of Der Weinerschnitzel, words that never made any sense to me, whose grandmother spoke German. We did not buy breaded veal at the amazing cottage of the hot dogs. We loved the roof.

I loved Yolanda Andrade's personal landscapes of home in Riverside, the Casa Blanca places I recognized immediately from my youth, the porches and gardens like shrines, testament to family and fidelity. I loved Thomas McGovern's *People in Cars* (2008–2012), taken at the Route 66 Rendezvous—the parade of classic cars restored and worshipped by so many of my friends, the way we know a 1964 Impala cherried out, the way that historic street still belongs to us, who live in this Inland Empire, driving slow and raising a chin to acknowledge the things we do that the rest of America may never understand. We polish the hood and chrome the engine. We play Art Laboe on the speakers, the hooting of *Nite Owl,* and we cruise.

The photographs in this show of Rubidoux are a perfect evocation of time and place and earth and human desire—spanning the centuries. Rubidoux, alongside the west bank of the Santa Ana River, first a settlement of Cahuilla peoples who built brush shelters

on the slopes of the foothills above the water, where the riparian landscape was the perfect home filled with game, fish, wild tobacco trees, painkilling bark from native willows, and fall acorns. Rubidoux, "acquired" by the Spanish as a land grant held by the Bandinis, then purchased by Louis Robidoux, a fur trapper born in Missouri who came west, then the home of Mercedes Alvarado, a Californio woman who married Cornelius Jensen, a Swedish ship captain, and by 1960, when I was born not far from their adobe home, an "unincorporated area" that remains deeply home to me, and often invisible to the millions of people who drive through the small city on the freeway, on their way to Los Angeles to Palm Springs to Arizona to the rest of the nation.

But if you are stuck in slow traffic as you drive through at night, you can see part of a movie at the Rubidoux Drive-In, shown in Julius Shulman's *Rubidoux Drive-In* (1951) just as I remember it, a precisely-landscaped dream of Saturday night, where the cars all faced the screen like dutiful ships docked at each speaker. I was the oldest of five, and we were free on the playground, free to wander the aisles between the chrome-bumpered cars, and since I was the one looking for story, searching for narrative, I saw it in the faces of people turned toward their windshields or each other, or the faces of kids sitting in lawn chairs in truckbeds, their parents' vehicles facing the wrong way, or rather, the right way. Because that's how my husband and I parked our truck when our daughters and nieces and nephews and their friends came to the Rubidoux Drive-In with us on the weekend—and how he still parks when he brings our adult daughters during their visits to Riverside. The drive-in is ours, is California, is Rubidoux. We are the people who not only see movies there, we go to the Sunday swap meet for the essentials in life, sold in the big parking lot, laid out on tables and truckbeds and under tents, clothes and tacos and pots and pans, and car parts and tools for our vehicles.

The final images for this essay were also taken in Rubidoux by Aashanique Wilson, a young woman who calls me her aunt. I know the backyard with the resting car, off Wallace Avenue, and I know the mailbox of Wilson's great-grandmother, Juanita Powell, a heroic and generous woman who remains legend where we live. Mrs. Powell was born in Tennessee, and her mother died shortly afterward; she was raised by her grandparents, who had been enslaved, on a farm with no running water or electricity. She was a true intellectual who graduated from high school, went to Cleveland and met her husband, began to fight for civil rights in the 1930s, and upon arrival in Rubidoux, sent her daughter Marcille to be the first African-American child to attend West Riverside Elementary in 1936. Juanita Powell built her stucco bungalow next to Cleo Warhop, and these two pieces of land, shown with tenderness in the images of Aashanique Wilson, are the earth she calls home. Six generations of Californians have lived there. I was born less than a mile away and when I drive on those roads, I feel in my blood the sunshine, the wild oats and foxtails, the tobacco trees and chainlink fences.

When Douglas McCulloh and I met, after his show *Dream Street* (2009), I asked him to photograph some of the places I loved most along the Santa Ana River and we began working together. Over nearly ten years, we've produced nearly a hundred stories for KCET, for newspapers and magazines, writing about and photographing people and places throughout Riverside and San Bernardino Counties.

McCulloh and I are lucky enough to be true *flâneur* and *flâneuse*, even if we are in a vehicle. I drove. He looked. I took him to the historic cemetery in Agua Mansa, to the community of Belltown in Rubidoux, to the sheepherders of Nuevo and San Jacinto, to the mobile home communities of Hemet, to the rock houses

of Redlands. We went to date gardens and watermelon fields in the Coachella Valley, to the Indio Date Festival, and upscale tents of Coachella Music Festival.

We stop and talk to people, we pull over for every geometric beauty of beet field but we also talk to the people in the field. Driving with McCulloh is better than walking the streets of Paris—because he is the son of a geologist, and tells me all about the fault lines and gradations of particulate in a hillside—and I am the daughter of one father who stocked cigarette machines and liquor stores telling me about every small casino, café, and hotel lobby throughout this landscape, about winter sandstorms and summer mirages on the road—and one father who took us camping, where we saw scorpion and wild verbena, roadrunner and date palm, every beauty in both counties. For the last ten years, McCulloh and I have documented Riverside's Eastside for an exhibition called *More Dreamers of the Golden Dream*, and another, *Wild Blue Yonder*, that tackles the history of the military in San Bernardino and Riverside Counties.

Where do we come from, the people whose geography this is? Some of us were born here—some of us came here during the Civil War, during the Depression and Dust Bowl, some came for defense work during World War II, some came after being stationed at one of the many military bases here, and some came following the citrus harvest, or the call of steel, or the glow of sunshine swallowed to heal the lungs and heart.

People ask us: the residents of this vast territory of landscape that we call home and that no one quite knows what to call—the Inland Empire? Inland Southern California? People say: what's even out there, where you live?

Everything in the world.

Transect 02: Social Landscapes

OBSERVATIONS

Humans are scarce in the photographs of *In the Sunshine of Neglect*, but their marks are everywhere. This exhibition emphasizes place, not portraits. The social landscape is the main focus for the artists of this exhibition—the constructed world, the political and economic, the everyday, the visionary, the personal. The photographers explore this terrain with a hard eye, but with a sense of tenderness and wonder. Their images are clear and unsentimental. They have depth and bite.

Inland Southern California occupies the margin between the two mythical and most powerful landscapes of the American West, the wide-open spaces of the Basin and Range and the strange dream of Los Angeles. Inland Southern California is an edge. It's where Los Angeles sends its ozone to simmer under the summer sun. Where commuters fill tract houses that fill the valley floors. And where they come to covet custom homes that climb the hillsides into the chaparral. Where town after town have grown together, merged at the edges, but never quite cohered. A place of four-and-a-half million richly diverse people spread over 27,000 square miles of valleys and passes, mountains and desert edges.

Inland Southern California is so stripped down, so freshly manufactured that photographic treasures can be found right at the surface, every surface. The place is founded on a faith in constant expansion, regardless of cultural or ecological consequences. A place willing to constantly erase the present for a stake in an imagined future.

Cahuilla artist Lewis deSoto, born in San Bernardino, characterizes the inland landscape as filled with opposites "marvelous and abject." Robert Adams attended school at the University of Redlands and returned over and over again to make photographs that helped bend the course of photo history. Adams speaks of unexpected glories. "Over the cheap tracts and littered arroyos one sometimes sees a light as clean as that recorded by [1870s photographer Timothy] O'Sullivan. Since it owes nothing to our care, it is an assurance; beauty is final."

ARTISTS/WORK

Lewis deSoto [page 076]

Lewis deSoto regards *Tahualtapa* as the epicenter of his photographic journey. The artist is "of native blood, Cahuilla blood." The photograph is history made visible. It encapsulates culture and power, destruction and reclaiming. In *Tahualtapa, Hill of the Ravens*, deSoto makes a savaged mountain whole, overlaying his photograph with silver enamel that restores the peak's original profile.

Tahualtapa is from deSoto's extensive project centered on a dramatically solitary peak that rose on the north bank of the Santa Ana River in what is now West Colton. The 1,184-foot mountain was once the tallest in the San Bernardino Valley. Four successive names signal its fate. *Tahualtapa* means "Hill of the Ravens" and references the mountain's significance to the Cahuilla people of the region. The missionary Spanish renamed it *El Cerrito Solo* (The Little Hill That Stands Alone). Anglo-American arrivals in the early days of California statehood began quarrying it for building stone, dubbing it *Marble Mountain*. And finally it became *Mount Slover*—named after Isaac Slover who lived nearby until he was killed by a bear in Cajon Pass in 1854. In this last incarnation, mining operations blasted the mountain to a low, terraced stub. An estimated hundred million tons of Mount Slover limestone has been hauled away and turned into the cement that built Southern California.

By every name, the mountain reveals time in its weightiest form—change, erosion, degradation, conquest. Consequently, deSoto's luminescent restoration feels like a sacred act.

Julius Shulman [pages 077, 099-100]

Julius Shulman was one of the most influential architectural photographers in history. His iconic, powerfully seductive images have become virtually synonymous with California mid-century modern architecture. They carried the golden dream around the globe in dramatic black-and-white. Visualize the utopian hopes and ambitions of mid-century California, and Shulman's images come to mind. They're a portable architectural dreamscape. "His work will survive me," summarized architect Richard Neutra. "Film is stronger and good glossy prints are easier to ship than brute concrete, stainless steel, or even ideas."

Inland area architect Hermann Ruhnau repeatedly employed Shulman to photograph his mid-century modern structures. Ruhnau was one of the area's top architects of the time. He graduated from Riverside Poly High School in 1928 and founded the still extant architectural firm known today as Ruhnau Clarke Architects.

Shulman's best-known photographs depict case study houses cantilevered over nighttime Los Angeles, or glass-walled structures built among Palm Springs boulders. (In 1953, we find him photographing Ruhnau's own newly built low-slung mid-century modern house in Riverside.) For Ruhnau, Shulman mainly photographed less exalted subjects—theaters, schools, commercial buildings. Nonetheless, the images are classic Shulman. They're perceptive interpretations of structure expressed as precise composition. They are studies of rhythm and shape, light and shadow. And they project a picture of idyllic California living—fine new schools and visionary buildings, and Saturday night at the drive-in, a romantic centerpiece of post-war California car culture.

Hiroshi Sugimoto [page 078]

When the movie starts, Hiroshi Sugimoto opens his camera shutter, when the credits roll, he closes it. The luminescent white screen is a summary of the entire film, every frame, a gateway to time. Time is what Sugimoto pursues, and each image pours us full. His photographs of drive-in theaters are the ultimate film still.

The work is conceptual. "If I already have a vision, my work is almost done. The rest is a technical problem." In a third person statement he wrote: "Anything can be said about Sugimoto's work, and nothing is wrong."

The photograph shows other artifacts of time: the twitchy blur of palm tree tops, the tracks of an airplane. The luminosity of the screens varies by movie. "Different movies give different brightnesses. If it's an optimistic story, I usually end up with a bright screen; if it's a sad story, it's a dark screen. Occult movie? Very dark."

Sugimoto was born in Tokyo and received a bachelor of fine arts at Art Center College of Design in Pasadena. The exhibition includes two other photographs of the Rubidoux Drive-In. Compare and contrast Sugimoto's approach to the image made by architectural photographer Julius Shulman and to that by Lewis deSoto, who studied with *New Topographics* photographer Joe Deal.

Will Connell [pages 081–082]

It was the largest industrial expansion in the western United States. Kaiser Steel's Fontana facility added three new oxygen furnaces, a blast furnace, a slabbing mill, a strip mill, and ninety coke ovens. In one stroke, the Fontana plant nearly doubled its capacity,ß becoming "the largest of its kind in the world."

"Last year," stated the all-color Kaiser Steel Annual Report, "as each of the new units in the expansion were placed in operation, noted California photographer Will Connell was commissioned to capture the scope and color of the nation's most modern steelmaking facilities." For decades, Connell, now an unfairly faded figure, was arguably the region's most prominent industrial-commercial photographer. He wrote a monthly column for *U.S. Camera* magazine and founded the Photography Department at the Art Center School in Los Angeles (among his students: Horace Bristol, Wynn Bullock, and Todd Walker).

On February 1, 1959, with the new medium of television beaming a signal to western homes, Henry J. Kaiser and California Governor Edmond G. "Pat" Brown threw the lever that poured the first oxygen steel. But the world changes fast. Just thirty-six years after Connell photographed Kaiser's huge expansion, Allan Sekula photographed it being dismantled for shipment to China.

Allan Sekula [page 083]

Allan Sekula identifies his central subject as "the imaginary and material geographies of the advanced capitalist world." The artist uses camera and intellect to dissect the workings of global economic systems.

The fate of the Kaiser Steel Mill appears in Chapter 7—Dictatorship of the Seven Seas— of Sekula's sprawling masterwork, *Fish Story*. The project vividly depicts the world industrial economy as a vast integrated global space of ships, containerized cargo, ports and workers. Sekula traveled the world's oceans on the project between 1989 and 1995. *Fish Story* is a highly evolved articulation of what Sekula calls "critical realism." His tools are photographic series and extensive text.

Sekula's narrative explores the symbiotic relationship between steel mills and ships. Behind every ship is the steel mill that produced it. But ships also feed the mills and transport their product to the world market. And in Fontana, of course, Sekula's photographs depict a sort of cannibalism. The ships devour their birthplace. Sekula shows us the disassembly of the Kaiser Mill, the loading of its cauldrons aboard the bulk cargo ship *Atlantic Queen* for transport to Shougang Steel in China. The project stands at the intersection of documentary photography, conceptual art, and socio-political analysis. It also marks Sekula's call for the renewal of realist social engagement in art.

Herb Quick [page 084]

The social landscape of the inland region is subject to the societal forces that act on thenation as a whole. During the holiday season of 1948, a very youthful Herb Quick captured this civil rights protest in downtown Riverside in front of the Kress building, now home to UCR ARTS: California Museum of Photography.

Aashanique Wilson [pages 085–088]

"Ultimately I say I was raised by the streets," says photographer Aashanique Wilson. "I was raised by the [Riverside] Eastside, raised by downtown, raised by Rubidoux." Wilson is forthright about what she calls her "rocky life." In compressed form, she was born in Riverside and raised in a changing string of settings by parents, grandparents, great-grandparents, godparents, friends of extended family. She spent years in the custody of Child Protective Services. She endured a parade of foster parents.

Wilson's four photographs in this exhibition—drawn from hundreds made over four years in black-and-white and color using film and digital means—depict an oasis in the artist's otherwise tumultuous upbringing. Wilson's great-grandmother Juanita Powell lived for close to 60 years in the same house (with fallen mailbox). It's in a traditionally black neighborhood in Rubidoux at the corner of Wallace and 36th streets, shown in the image with the stop sign. Wilson lived with Powell, a legendary figure and not incidentally a civil rights pioneer in the region, for a handful of stable years. She took four buses per day to continue attending North High School on Riverside's Eastside. But in 2016 Powell died (at 101!) and the house was lost. Wilson's art is embedded

in community, informed by its history, first-hand experiences, and lessons.

Yolanda Andrade [pages 089–090]

In 1991, the California Museum of Photography hosted an arts residency for photographer Yolanda Andrade. The results appeared in an exhibition titled *Between Worlds*. The Mexico City artist gravitated to Riverside's traditionally Latinx neighborhood of Casa Blanca. She captured daily life—a handshake at the senior center, a boy checking out a book at the library, boxing instruction at the Casa Blanca Gym.

But suddenly, a different set of photographs materialized. They are poetic, affecting, and intensely personal. They pair emotional reports with images of Casa Blanca. These photographs emerged from what Andrade called, looking back recently, a time of personal distress. They forthrightly express uncertainty, doubt, loneliness, and they are honest. To view them is like reading a diary. And their extreme particularity blossoms into something universal.

In 1992, Andrade wrote this about these images: "A photograph is always a document and meaning always changes from the moment I took it, to the moment I print it, to the moment I see it among other images. Sometimes a photograph transcends the document." Photographs shift and alter. So does the photographer. "Now that I see these photographs again," Andrade said in 2018, "I think I would photograph the same place from another perspective."

Kurt Miller [pages 091–098]

Kurt Miller's photographs are the postmortem of a profession, a 7,651-image autopsy of his own life. For thirty-six years, six months, and twenty-three days, Miller was a staff photographer at *The Press-Enterprise* in Riverside. His last day was Thanksgiving 2016.

The photographs depict the demolition of the mothballed Press-Enterprise building in downtown Riverside. "It looks like a crime scene," says Miller, "and I definitely see it that way." The images bring to mind John Divola's *Vandalism* series, but in this case the vandalism has been inflicted on local journalism by technological change and buccaneer capitalism.

The eight photographs in this exhibition focus primarily on the destruction of the one-time editorial floor. Understandably, Miller haunts the photo department, darkroom, photo equipment lockers. But the building is not the only thing that's been destroyed. At one time, *The Press-Enterprise* was a Pulitzer Prize winner. It won US Supreme Court cases establishing press coverage freedoms. But in 1998, after 120 years of local ownership, the paper was sold to a corporation based in Dallas. By 2007, the paper moved out of its building, leaving it empty, mothballed, frozen in time. The pressure of the internet built. Another sale, a bankruptcy, a third sale at auction.

The photo staff, once eighteen strong, is now down to three. At loose ends, between occasional freelance gigs, Kurt Miller spent the spring of 2018 documenting the destruction of the old building. Day after day, he walked the dusty darkness and was swept by emotion.

Douglas McCulloh [pages 101–105]

Douglas McCulloh is best-known for system-driven projects that combine chance operations with high-volume photography. The results often include layered information: photographs, text, maps, sound, or other data. Two projects are represented in this exhibition.

Dream Street began when the artist won the right to name a street. This chance win at a charity event launched McCulloh into an obsessive relationship with a 134-home subdivision commencing in Bloomington, just east of Ontario Airport. He spent several years chronicling the lives of builders, workers, and prospective homebuyers. By a quirk of timing, the artist's presence at *Dream Street* sliced through the heart of the American housing boom and bust. Short narratives accompany the photographs.

Google Image Search pieces are produced by the chance returns of an internet image search. The title is the blueprint that makes the art: *Google Image Search: "Inland Empire"—Any Size, No Filter*. It is cameraless photography, a meta photography that takes everything in the world as a potential subject. The search transforms the phrase "Inland Empire" into a collection of images—a meta-image comprised of 1,670,000 units. One level deeper, a search for "Search" itself generates an image consisting of 1.7 billion parts. Cameras seem optional. "The idea is a machine that makes the art," said artist Sol LeWitt. The Google image world provides deeply layered, remarkably resonant views of every subject imaginable—every place, every culture, every object, every idea.

Larry Sultan [pages 107–108]

The photographs show Larry Sultan's parents, newly moved to the Coachella Valley. The completed pool appears as a pale blue wedge beyond the struggle with the vacuum cleaner.

Sultan writes: "The house is quiet. They have gone to bed, leaving me alone, and the electric timer has just switched off the living-room lights. It feels like the house has finally turned on its side to fall asleep. Years ago I would have gone through my mother's purse for one of her cigarettes and smoked in the dark. It was a magical time that the house was mine.

"Tonight, however, I am restless. I sit at the dining-room table; rummage through the refrigerator. What am I looking for?

"All day long I've been scavenging, poking around in rooms and closets, peering at their things, studying them. I arrange my rolls of exposed film into long rows and count and recount them as if they were lost. There are twenty-eight.

"What drives me to continue this work is difficult to name. . . . I wake up in the middle of the night, stunned and anguished. These are my parents. From that simple fact, everything follows. I realize that beyond the rolls of film and the few good pictures, the demands of my project and my confusion about its meaning, is the wish to take photography literally. To stop time. I want my parents to live forever."

Mark McKnight [pages 109–112]

Mark McKnight produces what might be termed urban abstractions. "Window works" is his description for one set. These photographs are artifacts of a search for hidden windows, and McKnight's search for the search. Workers primitively sawcut the scarred stucco of old buildings in an attempt to locate bricked-in original windows. McKnight says the "latent" windows represent "truth, transparency, a desire to see beyond the skin of things, an attempt to apprehend meaning." The window, of course, is a key metaphor for observation, self-expression, the photographic frame. "The notion that one would bury a window is, of course, distressing to a photographer—I've committed my life to seeing through them."

A second body of work is based on the proposition that insignificant things are meaningful parts of a richer, larger, picture. A dilute pool of spilled paint transforms a gouged, cigarette butt-strewn gutter into a turquoise window opening on an infinite sky. Leaning palm trunks hazy with overspray extend the brown earth skyward past a masked window. McKnight "pictures the accumulating scars of an aging American urbanism, in which contemporary economic austerity has resulted in a surreal piling-up of provisional fixes and removals," summarize intertwined writers Julian Myers-Szupinska and Joanna Szupinska-Myers.

Thomas McGovern

Swap Meet: This is San Bernardino [pages 113–114]

Like the car show, the swap meet is just down the street from McGovern's house. He has lived and taught photography in San Bernardino for eighteen years. He loves the place, the people, every hardscrabble edge. For perhaps a hundred Sundays, McGovern has hung out at the swap meet held on the grounds of the National Orange Show. He has photographed vendors and visitors, the goods, the goings-on, and even the ground. He gives away photographs and collects friends. His photographs of temporary tarps are found paintings, raked with light, edged by glimpses of the market tableau.

People in Cars [page 115]

Classic car shows present automobiles as aesthetic objects. But everyone knows the truth. For the owners, show cars are not mainly about the cars. They're personal identity in the form of sheet metal, horsepower, and paint. Hot rods, muscle cars, and custom rides are expressions of self. Thomas McGovern's *People in Cars* twists this logic. He flips normal car show photography on its head. He focuses on people first, cars second.

McGovern moves fast and shoots reflexively. The photographs are from five years shooting at the largest of Southern California car shows: San Bernardino's Route 66 Rendezvous. (It drew nearly a half million people, and possibly as many cameras, until in 2012 it was doomed by the City of San Bernardino's bankruptcy.) The artist employs medium format camera to capture detail. His on-camera strobe punches hard light into corners and car interiors. The cars are containers, edges, frames for the people. Yet, against the odds, the photographs don't feel invasive. Despite his paparazzi tactics, McGovern's camera is embracing and the images celebratory, even reverent.

Ryan Perez [pages 116–118]

On his eighteenth birthday, Ryan Perez acquired a dream in physical form—a used 1996 Acura Integra GSR, pearl finish Matador Red with a 210-horsepower Type R engine. Over time he tricked it out with eighteen-inch white rims, a full body kit, racing cams, racing header, racing exhaust, black-tinted windows, and a giant rear wing spoiler. "I was pulled over every week driving that car."

The artist's *I.E. Barbarians* photographs arise from this personal history. "Cars are a way to create an identity, to express your subconscious," Perez says. "When I was eighteen, I was trying to find out who I was. I was part of the street racing scene in the Ontario warehouse district. Transgressive, feeling good, going fast. But also claiming territory, establishing myself, making the statement: 'I'm present. I'm here'."

The dead ends pictured in *I.E. Barbarians* are in Fontana, Perez's home town. They are relatively recent landscape features, created in 2003 when the new I-210 freeway sliced from Glendora to Fontana through twenty miles of north-south streets. The high-angle view is hard-won. The artist shot from atop the biggest box truck he could rent. He wanted to juxtapose the freeway's straight-line slash with gloriously expressive burnt-rubber scribbles inscribed by drivers at play on the edge where velocity meets freedom. "These cul-de-sacs," writes Perez, "point toward a landscape that I can identify with even at an older age—a desirable landscape wide open to rebellion, frustration, catharsis, and what feels like fleeting freedom."

Julie Shafer [pages 119–123]

Julie Shafer's photographs were made in Cajon Pass. They were taken where the Mojave Trail, the Mormon Trail, and the Spanish Trail converge. It is a transitional landscape, a focus point, a portal between the desert West and the inland valley and coastal basin. It is the

path traveled by Native Americans, trappers, explorers, and scouts on their way to what would become the San Bernardino Valley.

The photographs are from Shafer's sweeping project, *The Parting of the Ways*. The project "centers around the American landscape and how our desire to conquer new territory and accumulate resources has scarred those spaces," she writes. Shafer has been working along the old trails of the West, following ghosts and wagon ruts etched into the earth. From Wyoming west, she's been tracing the paths where the migration route splinters into the California, Mormon, and Oregon trails.

The photographs focus on vestiges, histories, marks on the earth. They feel soaked in time. In Cajon Pass, evidence of passage is everywhere. Shafer shoots high-grain black-and-white film, then makes brutally detailed digital drum scans. The results are gritty, stark, and blasted, not unlike the landscape. They exhibit a contemporary sensibility, but contain knowing nods toward more romantic landscape traditions. In some photographs, we catch glimpses of modern trails necessarily following the same desert pass carved by the San Andreas Fault—rail lines and freeways.

Mark Ruwedel [page 125]

Mark Ruwedel loves remote places, primarily deserts. Abandoned railways and ancient footpaths above ice-age lakebeds. Uninhabited houses surrendering to the desert and atomic bomb test craters filling slowly with blow sand. "I have come to think of the land as being an enormous historical archive," he comments.

Ruwedel's approach combines the grid presentation of topologies with the clinical stance of *New Topographics*. But the artist offers an additional distinct (and consistent) point of view. Ruwedel's photographs suggest the world will move on.

Mankind may wound, but the planet will heal. Ruwedel's six images in this exhibition carry this theme directly on the surface. The photographs were made over six years at paintball battlefield sites along the alluvial outwash plains of the Little San Bernardino Mountains. They are in the scruffy open spaces below Palm Springs, but not as far as Indio. All are improvised. They are already being reclaimed by heat and sand, mesquite and tamarisk. We throw an ephemeral shadow on the abiding earth.

We scrabble on the planet's surface, but nature will prevail. Ruwedel's camera bears witness not to ruin, but to recovery. The artist presents us disparate scales—human trifles vs. geologic eons. Some photographs are a glimpse into the abyss of time. Our hubristic monuments and gestures may seem encompassing in the moment, but they are swiftly dissolved by the full flow of time. This is a reassurance.

Brett Van Ort [pages 126–128]

Downed helicopters and sandbagged bunkers. Charred tanks, bomb craters, and plywood palaces. Brett Van Ort's battlefield photographs present us with low-rent versions of war zones: Baghdad, Bosnia, Beiruit.

The images depict literal "theaters of war"—paintball battlefields. These three are among fourteen faux war zones at SC Village, a sprawling 100-acre paintball site in the Santa Ana River floodplain on the outskirts of Corona. Each references a specific war.

The artist's project explores the complex—and he thinks dangerous—entanglements between war and American life. From a photographic point of view, it also points up a baleful cross-pollination: photographs of actual wars guide the layout and look of the faux battlefields. The paintball theaters are, in some fashion, like photographs. They are stenciled from the real (and from photographs

of the real!). They create a parallel universe. But the violence they enable is neutered. It produces splatters of paint in place of blood. The artist, however, still sees the activity as troubling. "The end result of this masquerade produces a trivialization of warfare," writes Van Ort, "and disconnects the general public even further from the wars our volunteer armies face."

Van Ort has photographed imaginary battlefields in Europe, California, and Texas. This concentration is informed by his immediately prior project: photographing desolate, eerily beautiful minefield landscapes produced by the Bosnian war.

Rachel Bujalski [pages 129–130]

John Hockaday has lived for years in the oldest house in Cajon Pass. If you made that statement, however, he'd immediately correct you. He lives in a *side canyon* in Cajon Pass. It's variously known as Coyote Canyon, East Cajon Canyon, or Crowder Canyon. And Hockaday knows. Over the course of decades, the former construction worker has become an avid and obsessive researcher of Cajon Pass history. He's written two books on the subject, *Trails and Tales of the Cajon Pass: The Man Who Built Camp Cajon* and *From Indian Footpath to Modern Highway*.

Rachel Bujalski's photographs of Hockaday and his property arose from her long-term project photographing Californians who live off the grid. Until the 2016 Blue Cut Fire nearly took his house, Hockaday spent several years living off the grid. He saved his home using a garden hose. Even with the chaparral cleared by fire, the house is hard to spot—it's tucked far back southeast of the truck scales on Interstate 15. Bujalski summarizes: "At 86, he still lives in his house, content to be in a place he has studied and written two history books about."

Naida Osline [page 131]

Sacred Datura induces visions, sometimes vibrant and soothing, sometimes so powerful as to produce madness or even death. Naida Osline's portrait of the local area plant is one such hallucinatory vision.

It's an early image from a large series in which the artist pays homage to important psychoactive plants that have long, complex, and intimate relationships with humans. "We have become high, addicted, awestruck, apathetic, focused, scared, sexy, stupid, enlightened, and dead through our relationship with these plants," she writes.

The piece depicts *Datura innoxia*, native to the region, southwestern United States, Mexico, and Central America. *Datura's* psychoactive properties gave it a significant role in local area native culture. "For the Cahuilla Puul (shaman)," writes Cahuilla tribal leader and scholar Katherine Silva Saubel, "*Datura* offered not only a means to transcend reality and come into contact with specific guardian spirits (nukatem), but it also enabled him to go on magical flights to other worlds or transform himself into other life forms."

Osline's artistic practice involves growing or locating the plants, photographing them at various stages, and finally recombining the images into fantastical compositions that suggest their psychoactive nature. The composite image of *Datura*, took over a year to grow, photograph, and digitally assemble. It floats in the night sky over Riverside.

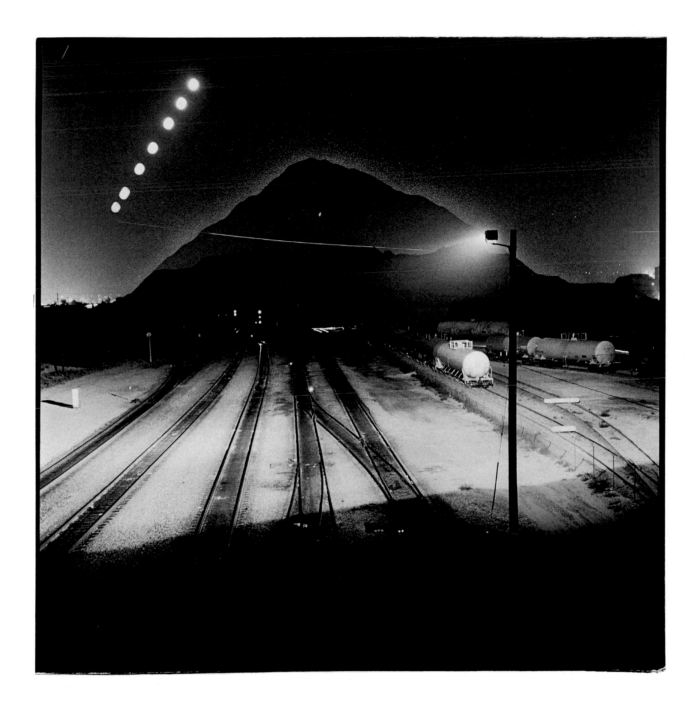

Lewis deSoto
Tahualtapa, Hill of the Ravens, 1983–1988

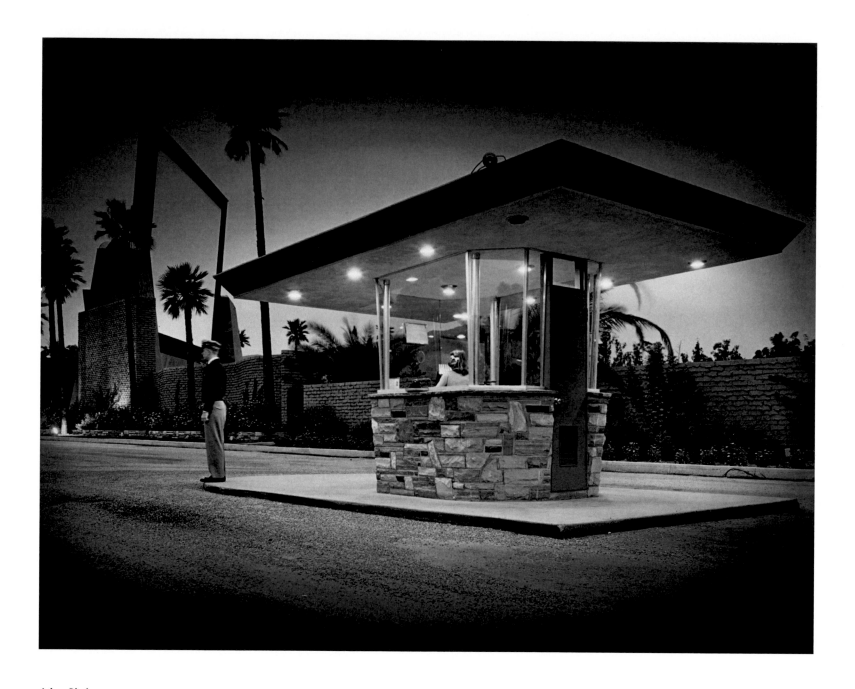

Julius Shulman, *Rubidoux Drive-In*, 1951, © J. Paul Getty Trust. Getty Research Institute, Los Angeles

Hiroshi Sugimoto, *Rubidoux Drive-In, Rubidoux*, 1993, © Hiroshi Sugimoto, Courtesy Fraenkel Gallery, San Francisco

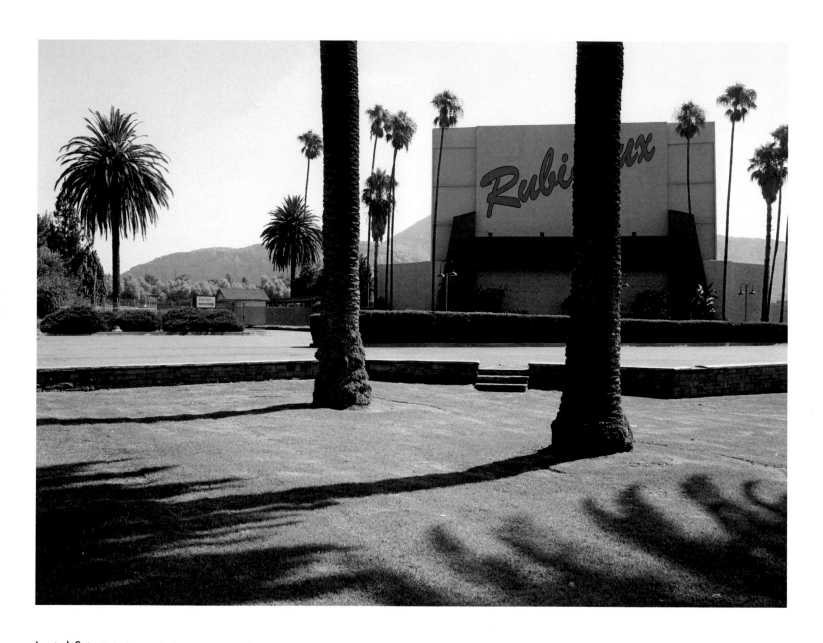

Lewis deSoto, *Rubidoux, Rubidoux Drive-In, July 2012*, 2012

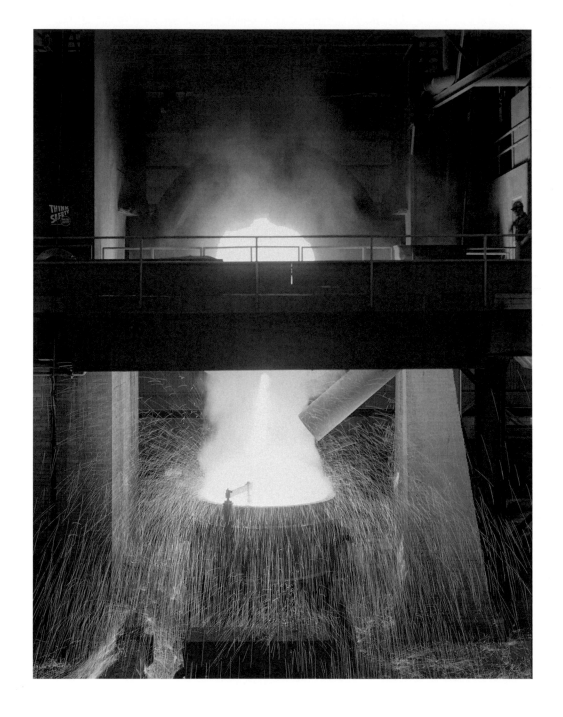

Will Connell, *Kaiser Steel Furnace*, 1958,
© Estate of Will Connell

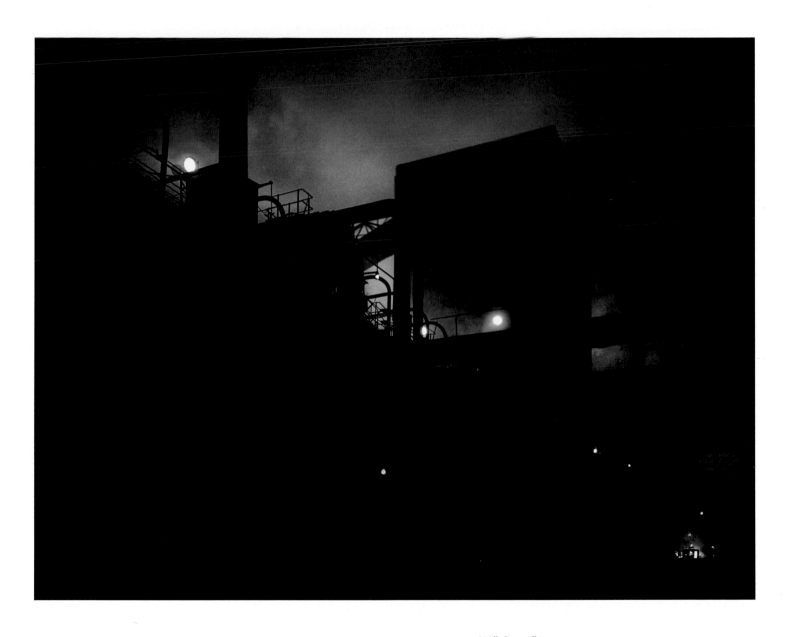

Will Connell, *Kaiser Steel Mill*, 1958, © Estate of Will Connell

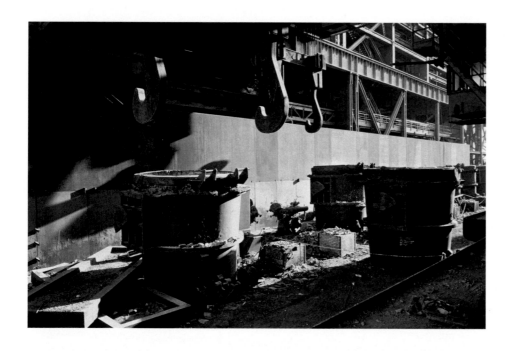

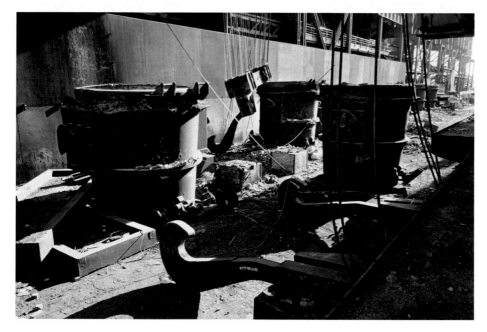

Allan Sekula, *Kaiser steel mill being dismantled after sale to Shougang Steel, People's Republic of China. Fontana, California. May and December 1993*, from the series *Fish Story, 1989–1995*, 1993, © Allan Sekula Studio

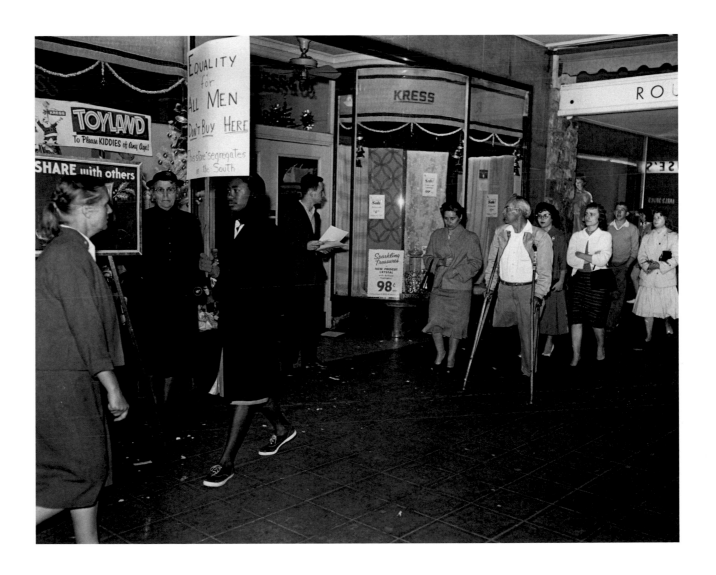

Herb Quick, *Protest in front of Kress*, 1948, © Regents of the University of California

Aashanique Wilson, *Untitled*, 2018

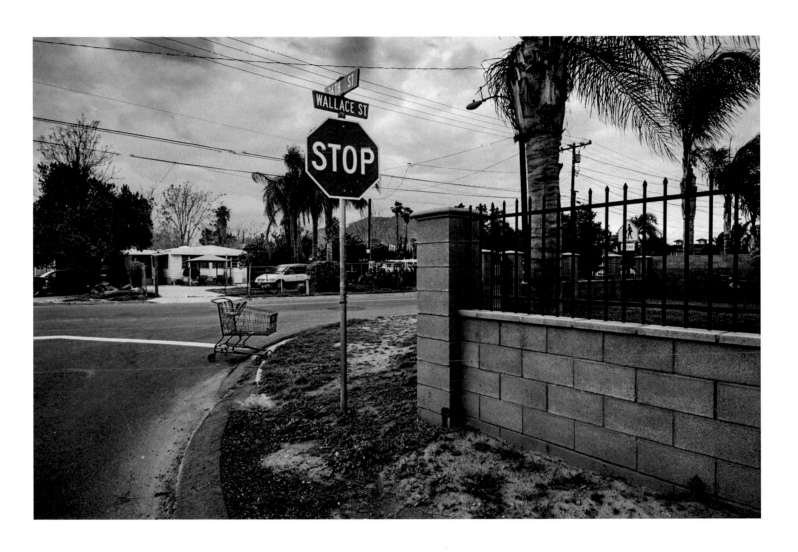

Aashanique Wilson, *Untitled*, 2018

Aashanique Wilson, *Untitled*, 2018

Aashanique Wilson, *Untitled*, 2018

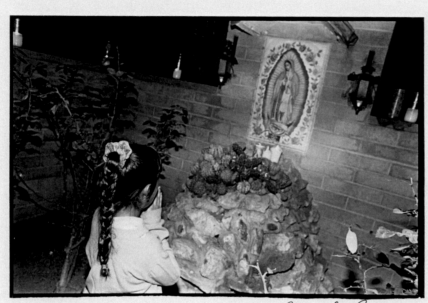

Riverside, Ca. 1991

I feel lonely here, but I have to overcome
this, as a real pro? Do pros feel
lonesome, anguished? Do they always
get piles of successful and wonderful
pictures? I think of those tough guys
on the front line of battle, determined,
willful, almost suicidal. I like it
my way. And I feed myself with
some books: Agee/Evan, Wright Morris.
John Berger...

Yolanda Andrade, *I Feel Lonely Here*, 1991

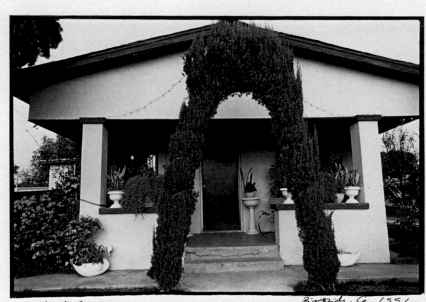

Mexico, D.F. 1992 Riverside, Ca. 1991

This is a time of changes, of intense work, of illnesses,
of emotional definitions. While I am printing these
photos, my mind is in a state of turmoil: why
didn't I go deeper into this particular shooting?
We talk the same language, but do we? Our
way of looking at life is different. Still their
roots are in mexico, and they do not belong
completely to their adopted country. Most
of the people I talked to are third generation
mexican – Americans. Should I show these
photographs together with the others in the
"Between Worlds" exhibition in Riverside?
I tried to do my best, but it was a very short
time.

Yolanda Andrade, *Casablanca*, 1991

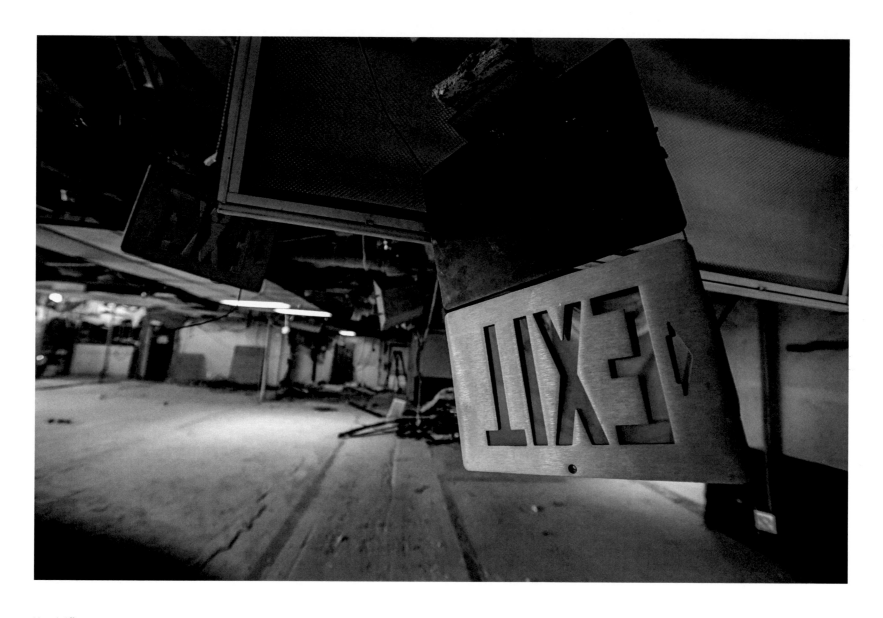

Kurt Miller, *Untitled,* 2018

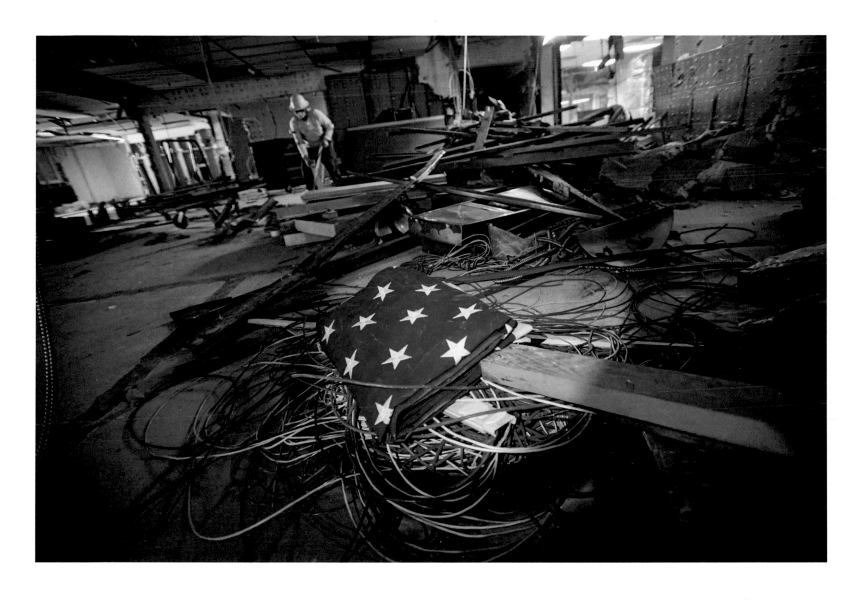

Kurt Miller, *Untitled*, 2018

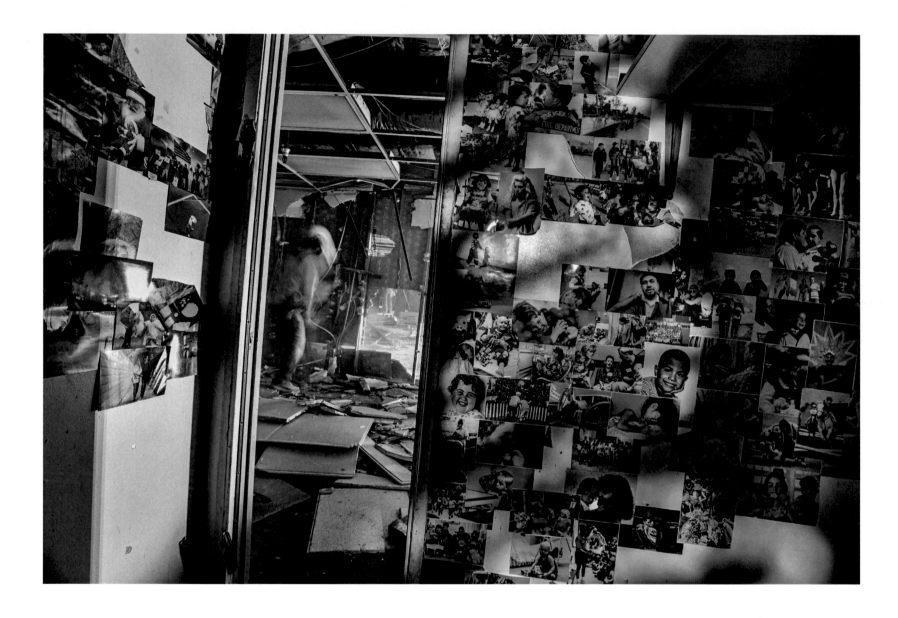

Kurt Miller, *Untitled,* 2018

Kurt Miller, *Untitled*, 2018

Kurt Miller, *Untitled*, 2018

Kurt Miller, *Untitled*, 2018

Kurt Miller, *Untitled*, 2018

Kurt Miller, *Untitled*, 2018

Julius Shulman, *Riverside Press-Enterprise*, 1956,
© J. Paul Getty Trust. Getty Research Institute, Los Angeles

Julius Shulman, *Sierra Junior High School, Riverside,* 1956, © J. Paul Getty Trust. Getty Research Institute, Los Angeles

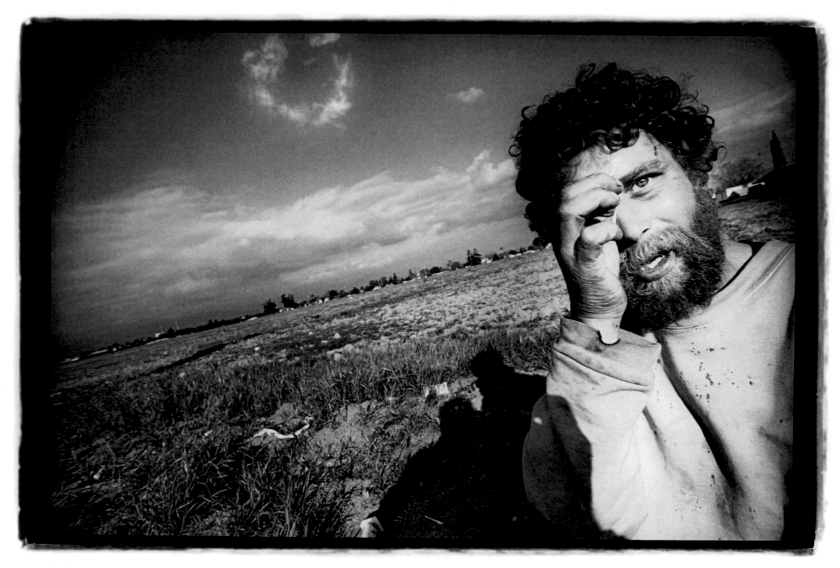

On my first day at Dream Street, I peered at my faxed tract map and walked the stubble-covered field where the street would be. A man in a blood-splattered sweatshirt approached me. Two assailants had beaten Eric to the pavement in a dispute over a bucket of street-sales flowers. When he was down, Eric said, they had taken a sharp stick and deliberately put out his right eye. The attack had occurred six days ago and Eric said he was self-medicating with Vicodin and vodka. He lurched and sat down amid the straggling weeds. He lifted the bandage to show me how the doctors had sewed his eye shut forever. The stitches looked like black spider legs.

I told Eric that the forty-acre strawberry field was soon to be transformed into 134 houses, that there would be a street directly where we were sitting, and that I had named it Dream Street. A cloud shaped like an eye floated in the eastern sky. I told Eric this was my first visit to the site.

Eric looked out across the forty empty acres with his single eye: "This will look good, look nice, when they . . . I can see it. I can visualize it."

Douglas McCulloh, *Untitled,* from the series *Dream Street,* 2005

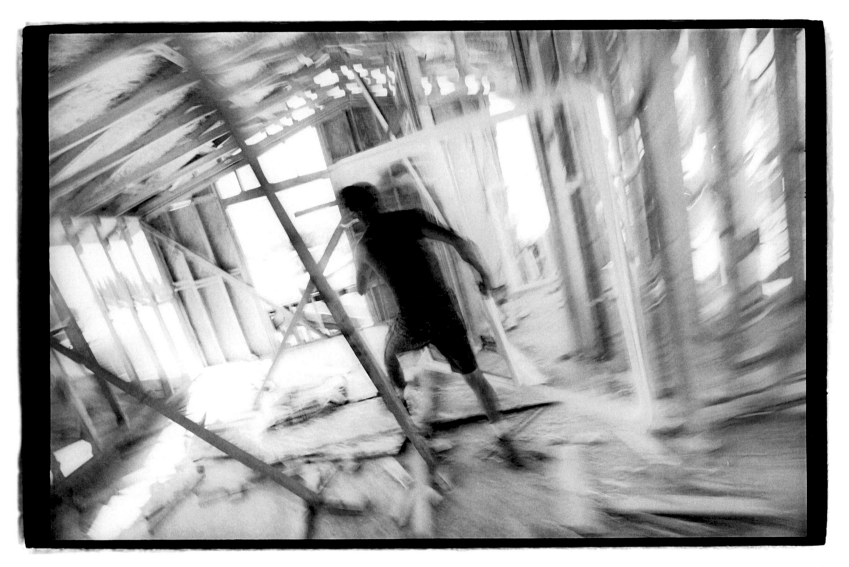

Justin called it "slamming windows." The process moves quickly—wedge the pre-made aluminum window in the framed opening, shove a four-foot level on top, pry and bash with a short crowbar until the bubbles on the level line up, pop the window in place with a nail gun, then move on to the next window. At times, Justin was literally running through the framed houses. He hinted that he got a buck a window. He thought the company owner got five dollars for every window he installed. "I'm kind of senior man on the crew, so I'm hoping to get a little piece of the action. Talk to the owner, maybe fifty cents or a dollar more per window."

Dave, owner of the Dream Street painting subcontractor, summarizes: "A lot of guys piecework their stuff anymore, so they don't have to pay all those benefits and stuff. That's why they can save a few bucks. But you don't usually get as good a job from your pieceworker. Because they don't care. Because the more they can get done, the more they get paid, basically. So, there's a strong incentive just to whack through everything."

Douglas McCulloh, *Untitled,* from the series *Dream Street,* 2007

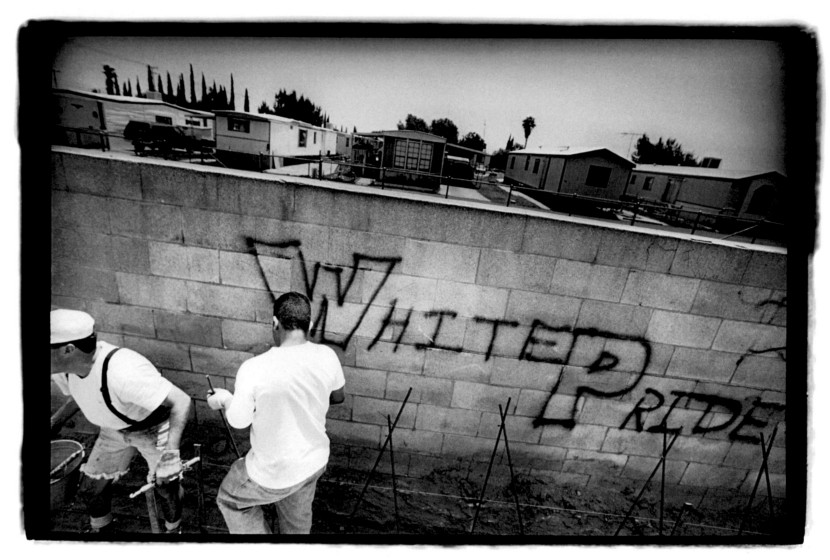

Jesús and Jesús walled out Dream Street's neighbors. The 219-space Cedar Village Mobile Home Park shoves a quarter-mile of double-wides against the tract. Young Homes thought the visible underbelly would scare off home buyers. So they hired Jesús and Jesús to build a concrete-block wall along the boundary. Then they topped the wall with a six-foot wood fence.

Race is everywhere at Dream Street. Its expression ranges from brutal to benign, but race is never absent. One Jesús (with the white cap) speaks only Spanish. He goes by the name Chuy, diminutive for Jesús. The other Jesús goes by the Americanized name Jesse. Spanish-speaking Latinos mock those who cannot speak Spanish. "Jesse's a gringo; doesn't even know any Spanish." English-only speakers like Jesse are said to have been "whitewashed." They are called "coconuts"—brown on the outside and white on the inside.

"I don't begrudge any of them for coming up here and wanting to go to work," one white worker told me. "If I could make better money south of the border, I'd be down there in a heartbeat, you know. But the guys I think ought to be—I think they should give criminal penalties to employers that make a habit of hiring illegals, actually give them jail time . . . I don't mean to sound pissed at the illegal aliens. Most all of them that I've met on job sites are decent people. The economics of this have gotten global. In other words, it used to be you could have regional economies, but now it's all one big system."

Douglas McCulloh, *Untitled,* from the series *Dream Street,* 2006

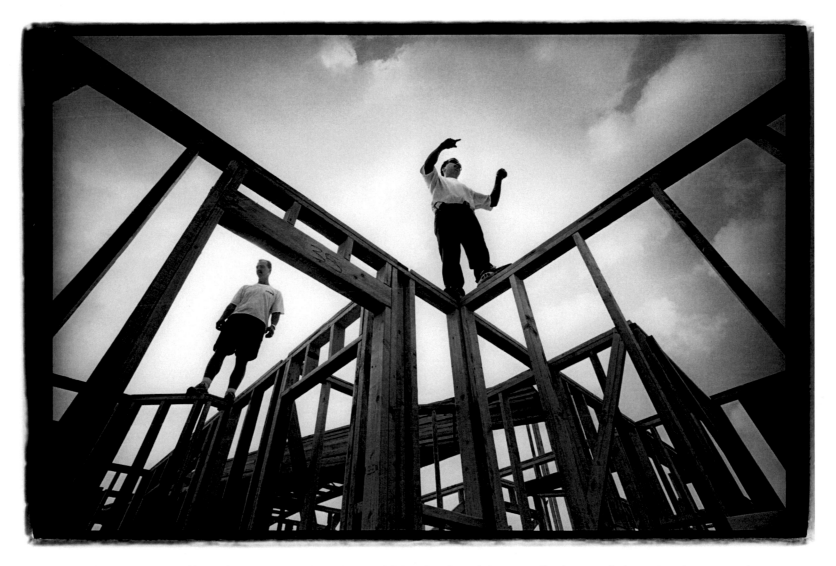

David and Brent discover a major problem with the 492 model. The roof trusses fall three feet short of a bearing wall in the master bedroom. Framing crew members try to take home a hundred bucks each, daily. They have to blast through two or three houses a day to do so. The nail guns rattle like a hellish hailstorm.

"These guys right here, they're pieceworkers, they're piecers," David explained. "They'll come in today and they'll do how many houses they can. They might be down on another job by tomorrow. I may see these guys two or three months later, you know. So these guys come in and their whole objective is to get that house done and get their money. The faster they get that house done, the faster they've made their money. And that's just it. So why is he going to get down off that roof and go look for a two-by-eight? He sees a two-by-six there and jumps up there, and he's nailing that thing on.

Douglas McCulloh, *Untitled,* from the series *Dream Street,* 2005

Douglas McCulloh, *Google Image Search: "Inland Empire"—Any Size, No Filter*, 2013

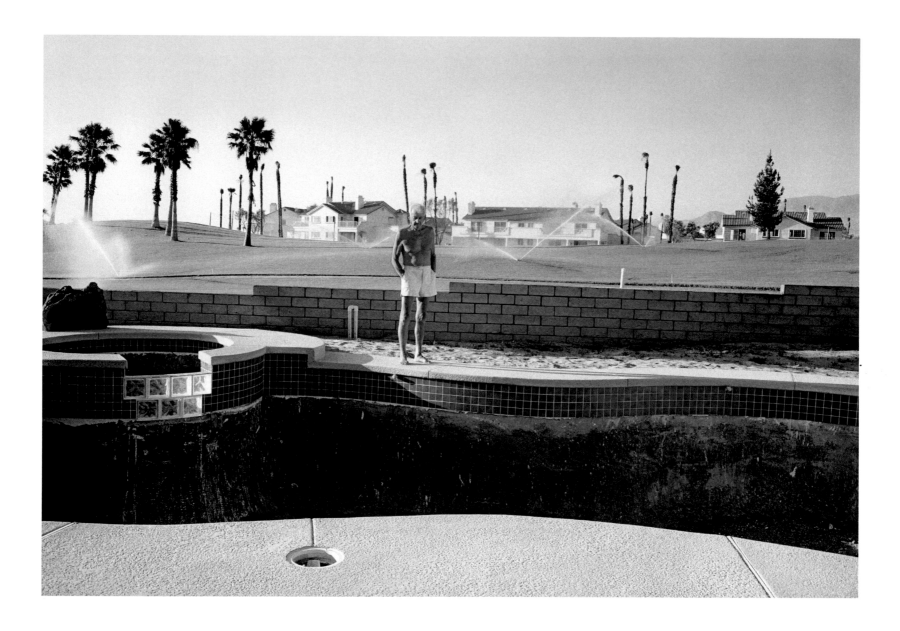

Larry Sultan, *Empty Pool*, 1991

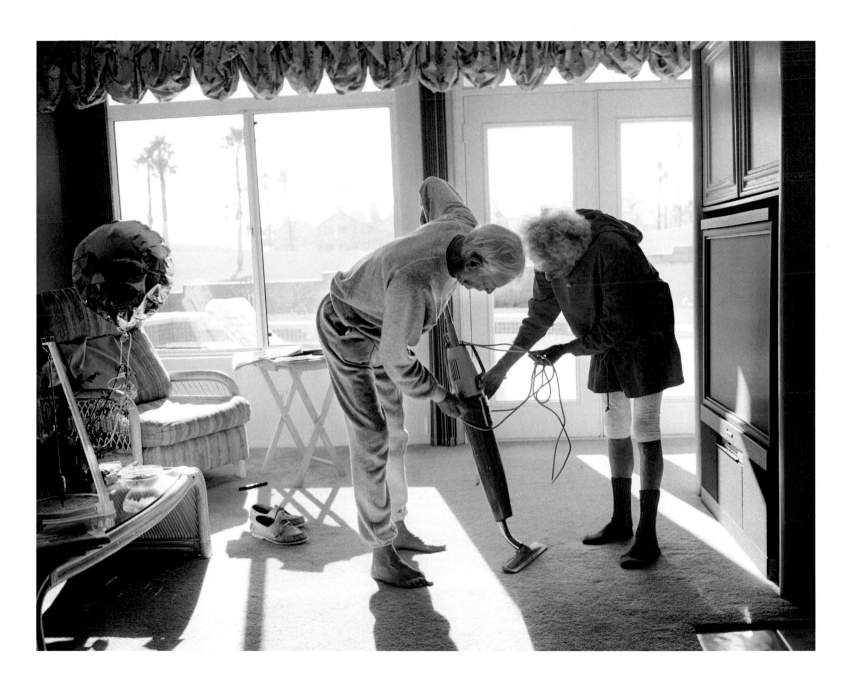

Larry Sultan, *Fixing the Vacuum*, 1991

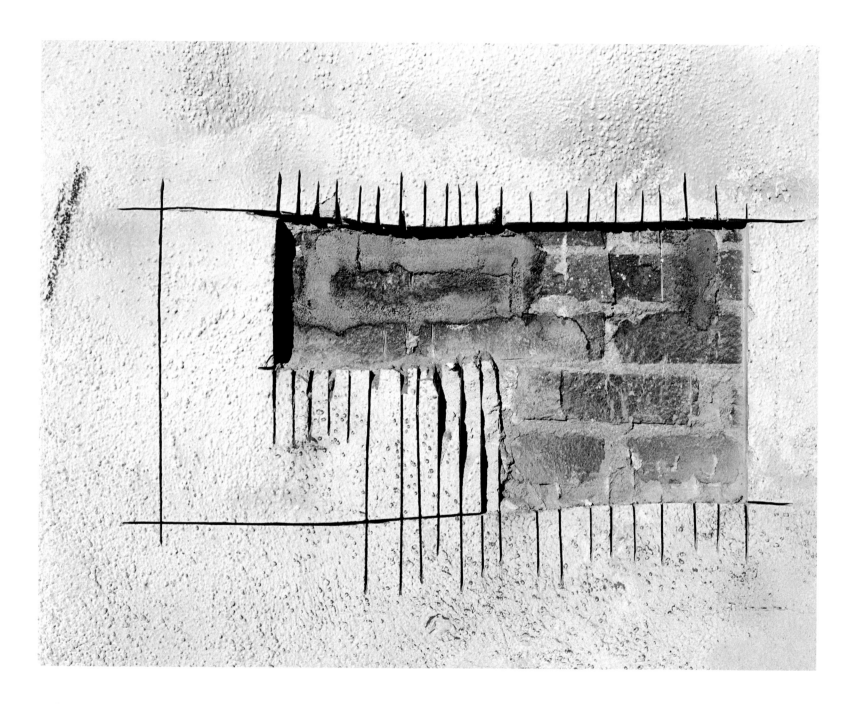

Mark McKnight, *Window 4*, 2016

Mark McKnight, *Window 3*, 2016

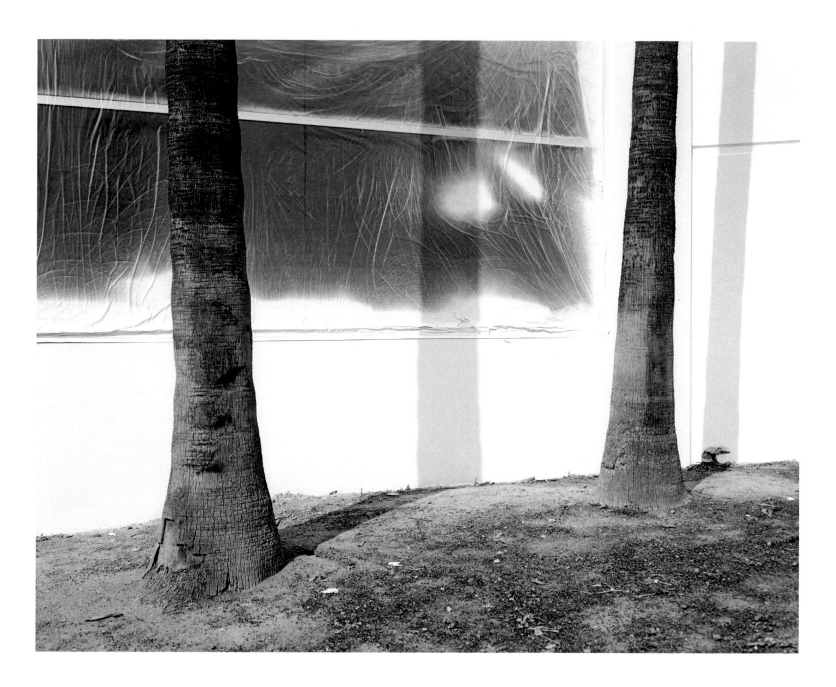

Mark McKnight, *Untitled (Palms & Paint)*, 2014

Mark McKnight, *Cloudy*, 2018

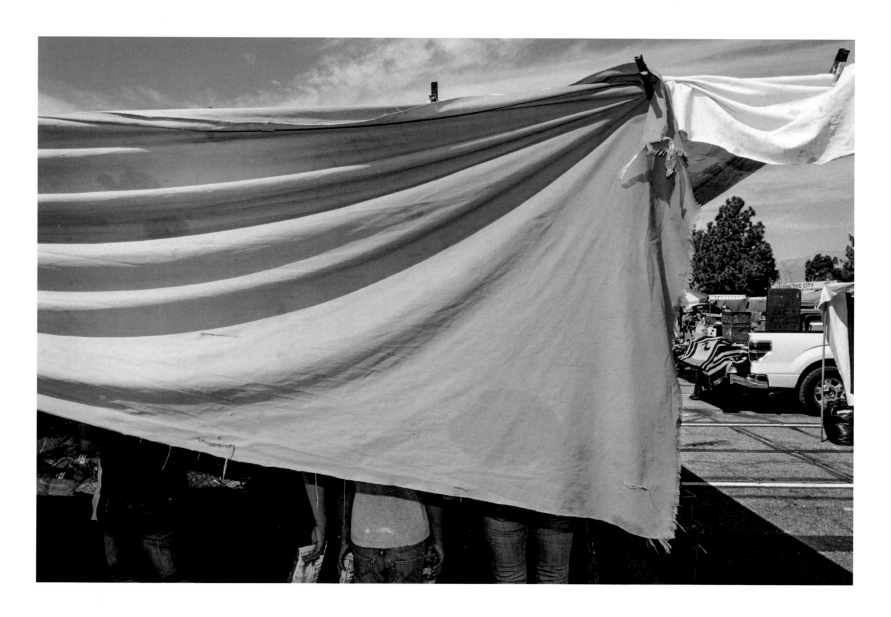

Thomas McGovern, *Untitled,* from the series *Swap Meet: This is San Bernardino,* 2015

Thomas McGovern, *Untitled,* from the series *Swap Meet: This is San Bernardino,* 2015

Thomas McGovern,
Untitled, from the series
People in Cars, 2008–2012

Ryan Perez, *I.E. Barbarians (Catawba Ave.)*, 2015

Ryan Perez, *I.E. Barbarians (Lytle Creek Rd.)*, 2015

Ryan Perez, *I.E. Barbarians (Maloof Ave.)*, 2015

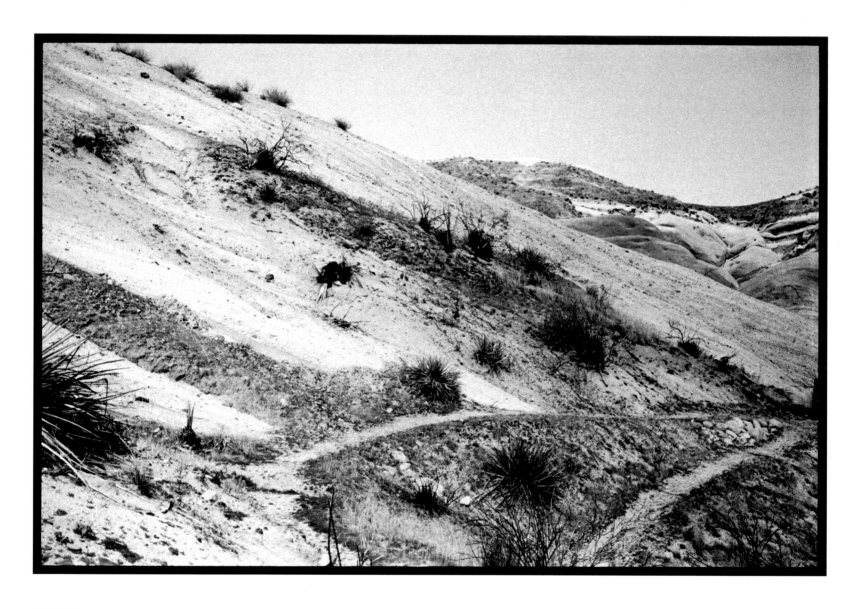

Julie Shafer, *Cajon Pass n.3*, from the series *The Parting of the Ways*, 2018

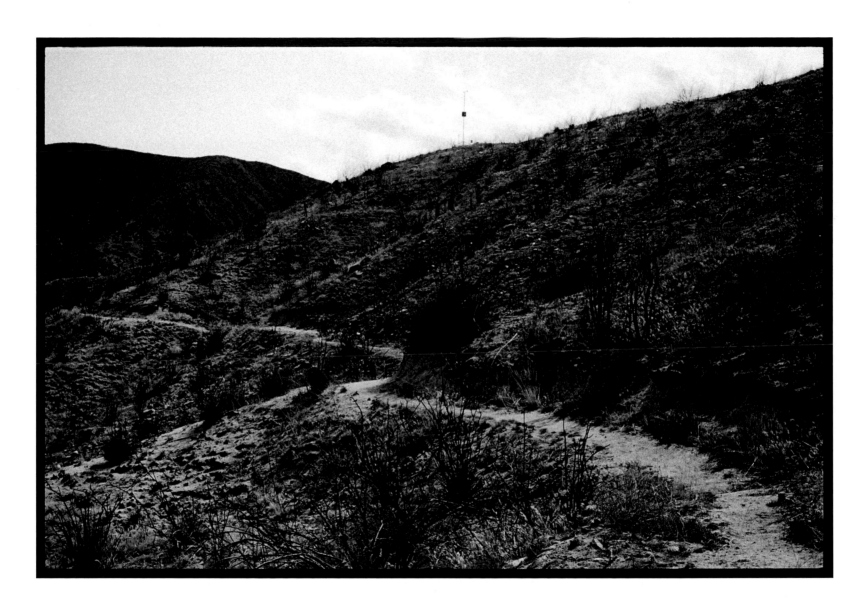

Julie Shafer, *Cajon Pass n.2,* from the series *The Parting of the Ways,* 2018

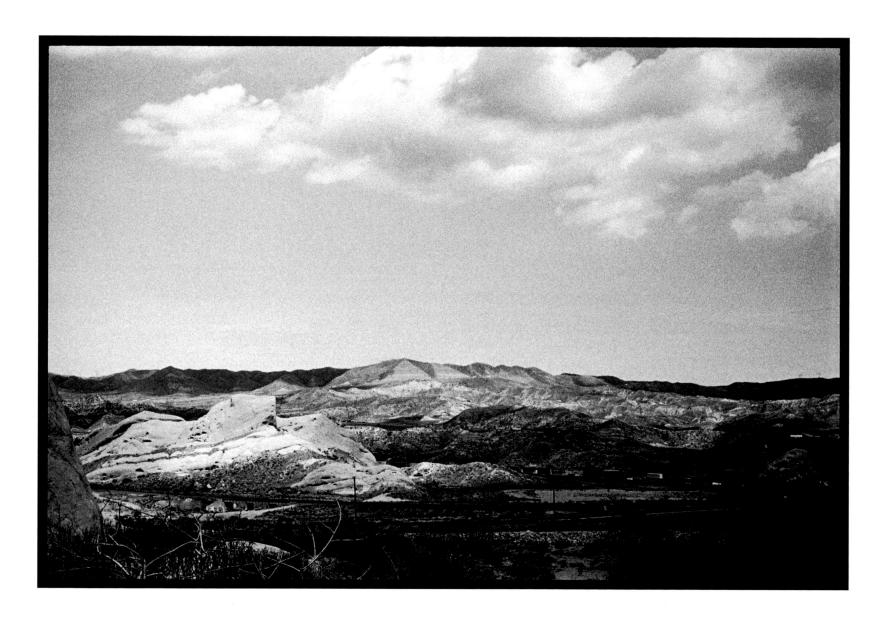

Julie Shafer, *Cajon Pass n.1*, from the series *The Parting of the Ways*, 2018

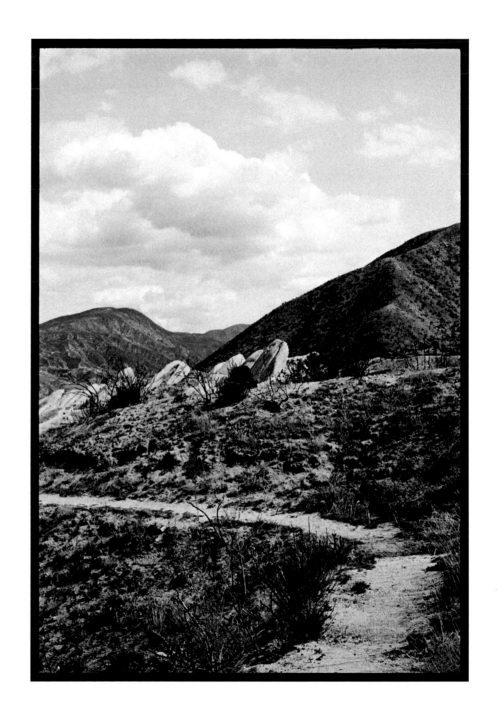

Julie Shafer, *Cajon Pass n.5*, from the series *The Parting of the Ways*, 2018

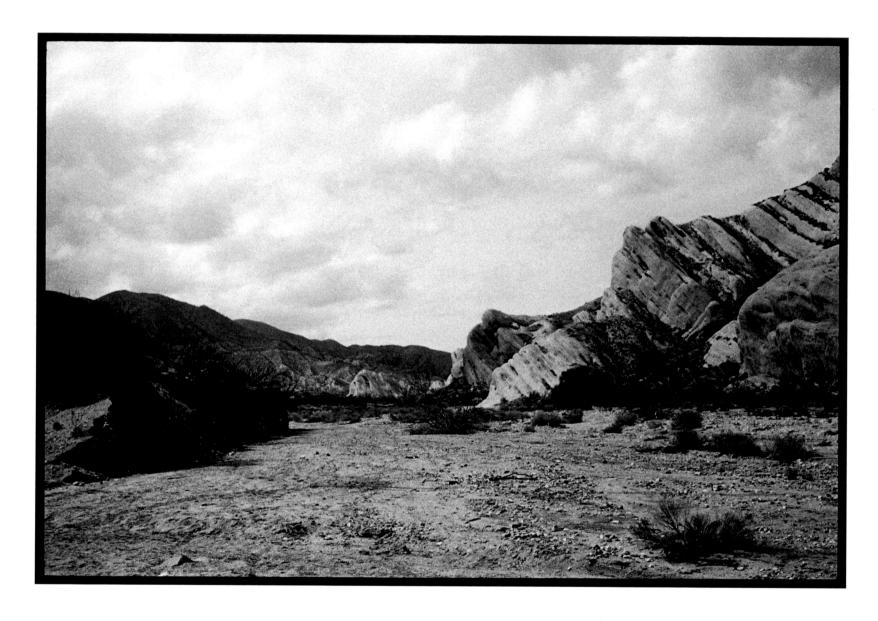

Julie Shafer, *Cajon Pass n.4*, from the series *The Parting of the Ways*, 2018

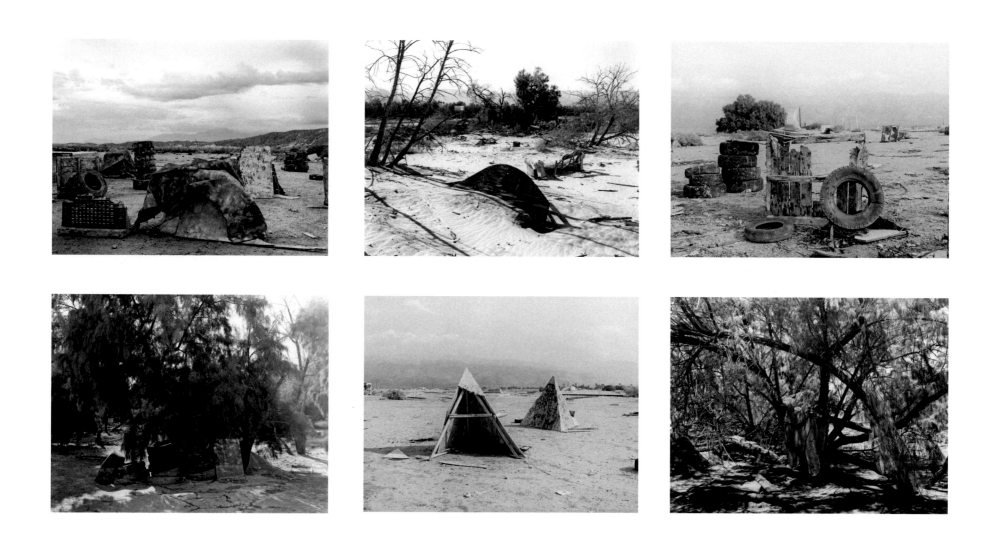

Mark Ruwedel, left to right upper row: *Dillon Road Orchard #13*, 2012; *Myoma #2*, 2015; *Dillon Road Orchard #18*, 2017; left to right lower row: *Off Dillon Road #11*, 2012; *Dillon Road Orchard #24*, 2017; *Off Dillon Road #13*, 2013; from the series *Paintball Sites*

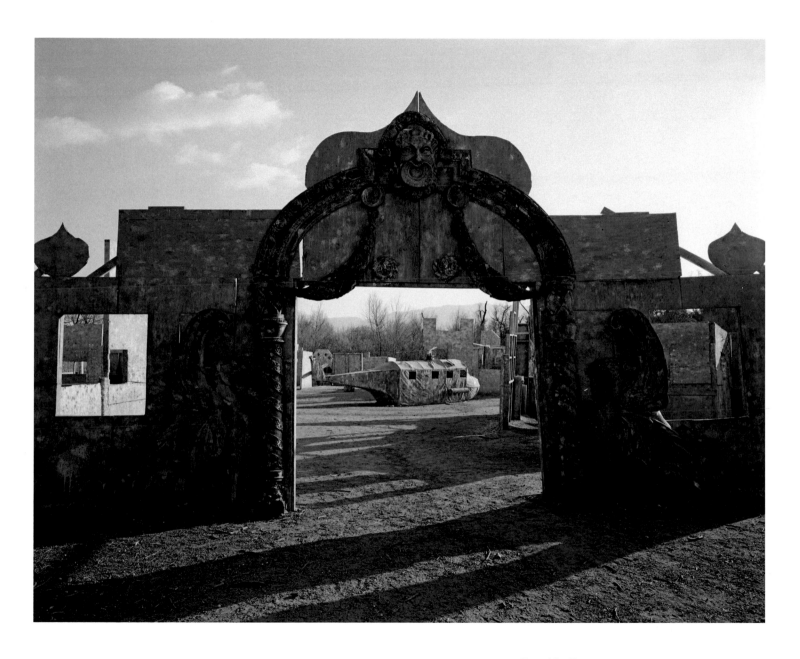

Brett Van Ort, *"Beirut," Corona, California, USA*, 2013

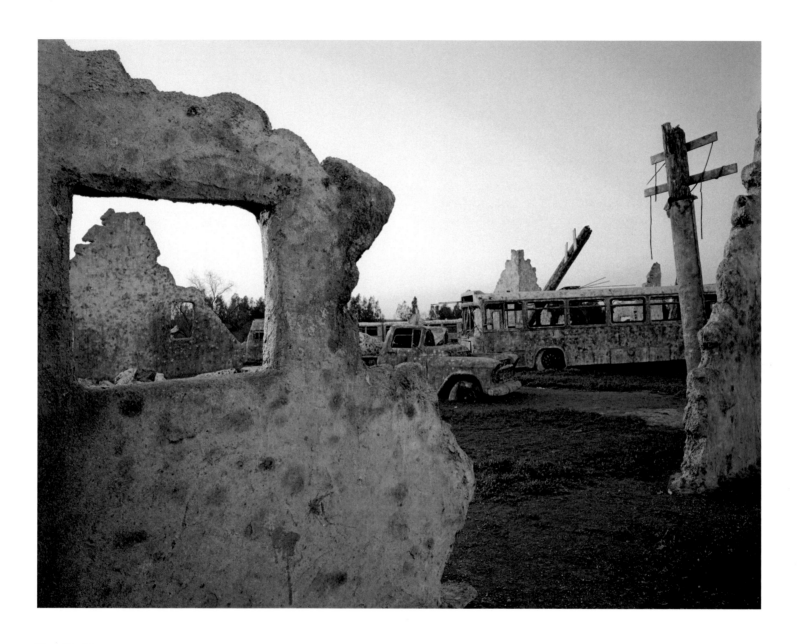

Brett Van Ort, *"Baghdad," Corona, California, USA,* 2013

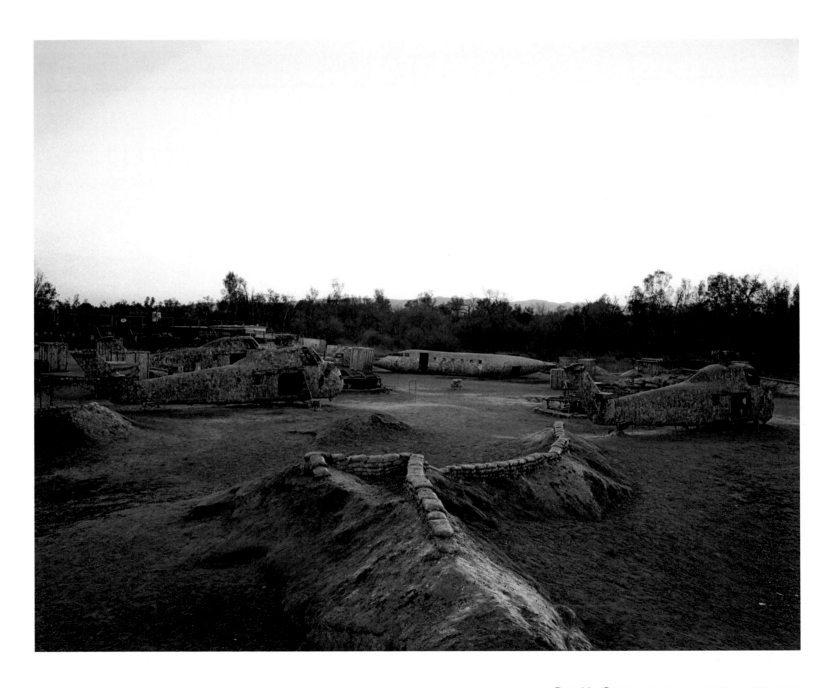

Brett Van Ort, *"Bosnia," Corona, California, USA*, 2013

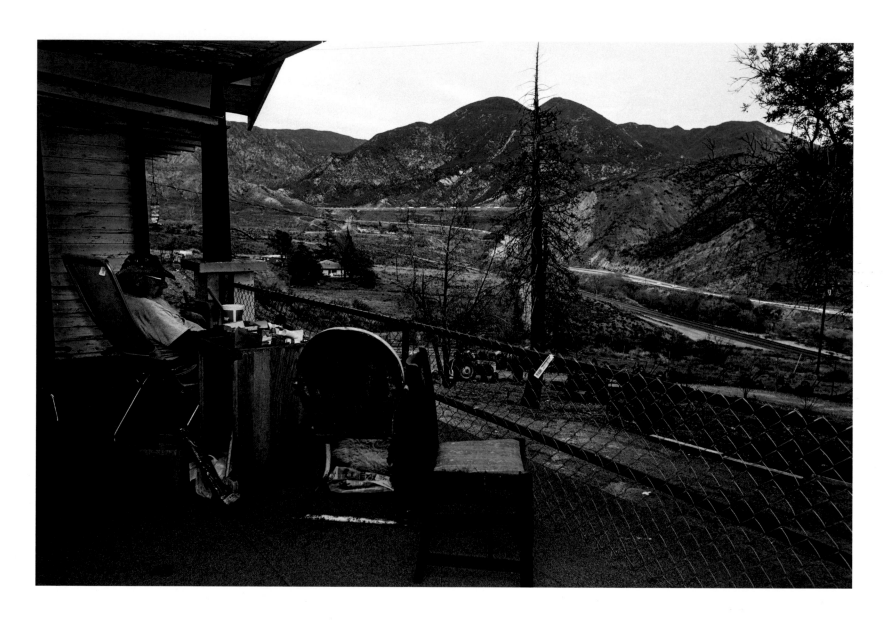

Rachel Bujalski, *John Hockaday on his Porch, Cajon Pass, CA*, 2018

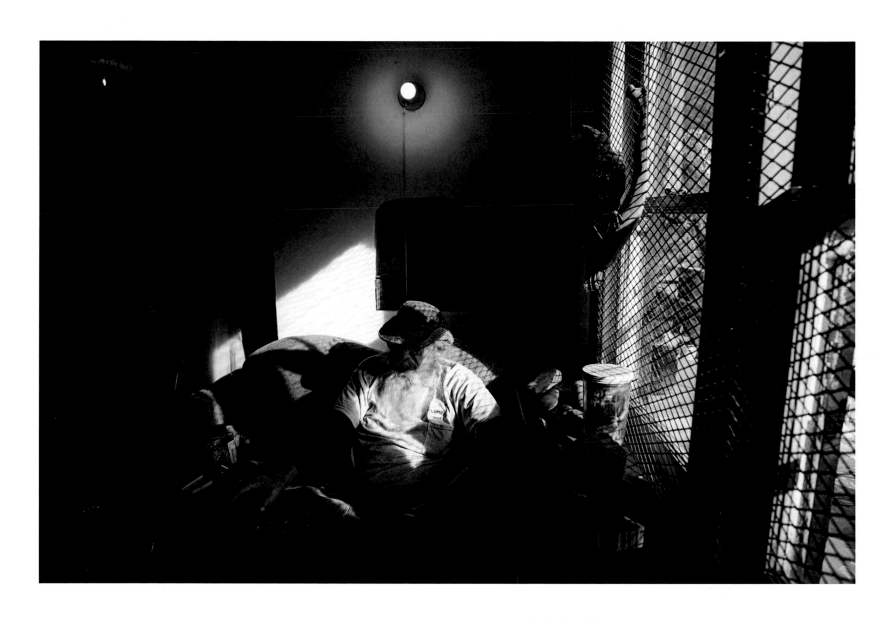

Rachel Bujalski, *John Hockaday in his Living Room, Cajon Pass, CA*, 2018

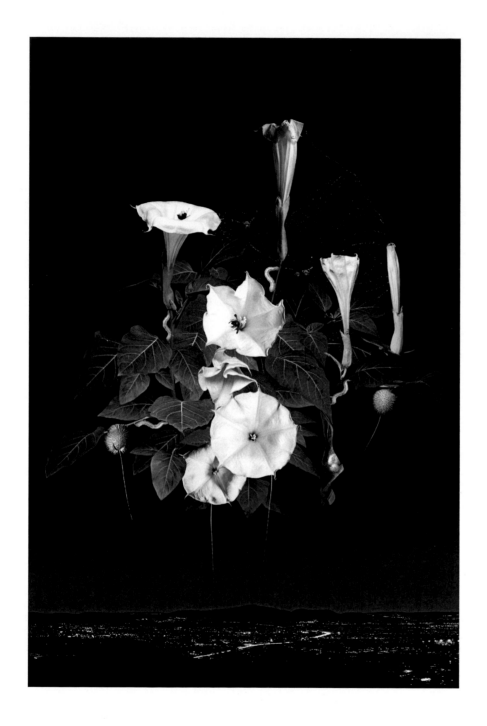

Naida Osline, *Sacred Datura*, 2010

Transect 03: Interventions: Photography is Performative

OBSERVATIONS

Every photograph is the residue of a performance. We know this. A photographer lies behind every image (and lies incessantly). A photographer directs our eyes. She points camera, scanner, phone, or computer and tells us to pay attention to this. But sometimes photography's performative aspect is direct and visible, the heart of the art. *In the Sunshine of Neglect* offers clear examples: Kim Abeles, Bystedt & Egan, Judy Chicago, John Divola, Tony Maher, and Kenda North. Among other things, their photographs record actions taken, performances recorded, pieces gathered and shaped, scenes fabricated to photograph.

ARTISTS/WORK

Judy Chicago [pages 137–138]

On February 22, 1970, scores of commercial grade, pure white, smoke-emitting flares hiss to life amid the shaded stones and broken talus of upper San Antonio Canyon above Claremont. At a time when the Southern California art scene is dominated by men, artist Judy Chicago's stated aim is to transform, to soften, and, for a short time, to "feminize" an entire landscape.

The work is called *Snow Atmosphere*. She apprenticed with a pyrotechnics company so she could handle the flares herself. Carried on soft winds, diffuse clouds of soft white vapor move slowly up the rugged canyon. Strands of smoke build and coalesce. The growing cloud envelopes trees and swirls around ridges. The photographs show diaphanous light filtering through the smoke. The diffuse white mist lifts, and it conceals. It curls into hollows and curves.

Chicago (and other women) had struggled within what she describes as "the macho art scene of southern California." Her peers were bulldozer-driving land artists such as Michael Heizer, James Turrell, and Robert Smithson. Chicago wanted to "soften that macho environment." The *Snow Atmosphere* pieces were, of course, ephemeral. "While the guys were carving up the landscape, I was feminizing it, and softening it." White mists and swirling smoke are non-destructive, they come and they go. But when the smoke eventually cleared on art in Southern California, Chicago and many others had indeed feminized the landscape.

John Divola [pages 139–140]

John Divola's *Dark Star* pieces in this exhibition are records of his presence and actions in an abandoned house on Theodore Street, close by the fault zone at the eastern edge of Moreno Valley. The black discs are freshly painted. Gleaming surfaces simultaneously devour light and reflect it.

Divola has a forty-year history of activating abandoned spaces by painting, modifying, and vandalizing, returning with photographs of the process and the effects. The *Dark Star* photographs feel like an ultimate statement of the practice. The black circles are as reductive as Malevich paintings. And the large-scale photographs are ferociously detailed—made using drum-scanned files from eight by ten film in a tripod-mounted view camera. The black circles gleam like the last light of day. They kill light and they bounce it back. You can smell the tang of the paint, feel the swing of the artist's arm, spray can in hand. The artist is present. And absent.

"I definitely see the work as existential," Divola said in 2012. "I've begun to see myself as an odd figure within my own practice. This is something that I have a very hard time talking about—this feeling that I'm kind of haunting my past, as I go back and work with ways of painting in spaces, something that I've done for a very long time."

Christina Fernandez [page 141]

Christina Fernandez's *American Trailer* is a symbolic object. It gives way from intact dream at the far left to burned-out shell at the right. It is transitional. It crosses time and bridges meaning.

For Fernandez, travel trailers are deeply symbolic. "I know this sounds corny, but I first looked at the trailer as a symbol of sorts for the American Dream. Trailers mean freedom and adventure. They symbolize hitting the road. They stand for home, but a mobile sort of home." Over the extended course of making her photograph, however, the symbolism took a darker turn.

The project began with an accidental discovery. Christina Fernandez found a trailer boneyard when she took her son to the Milestone MX motocross park in Agua Mansa. She repeatedly photographed the 1950s "canned ham-style" trailer closest to the road as her son returned to ride his dirtbike. Then, six months into the project, the trailer burned. "I was so disappointed when I first saw it. But I started thinking. Was that really such a problem? What was I trying to say?"

The meaning of such a trailer, she says, has flipped, has inversed. The 1950s meaning was freedom, release, the open road. The symbolic meaning now, she says, is "not to get away, but to survive. People make these trailers home. It's not about vacationing, but a place to live. The meaning is no longer adventure, but surviving, just barely staying out of homelessness."

Bystedt & Egan [pages 143–148]

Bystedt & Egan have been friends, rivals, and collaborators for more than twenty years. The duo is Amy Bystedt and Sally Egan. Every person in every photo—including every disembodied arm or truncated leg—is Bystedt or Egan. If a child appears, it's theirs. Beyond that, the place is theirs as well. The locales are scattered across the inland region, centered in Ontario, Pomona, and vicinity.

This series is called *Fotomat*. It is entirely contemporary but casts its modern gaze toward a disappeared world.

The clothing, props, cars, settings, and style are 1970s, all fabricated to be photographed. The past is a foreign country. Bystedt & Egan not only visit that country, but bring us back photographs. The results feel utopian, with a touch of wistful elegy. The images evoke film and Fotomat processing, but are produced via high-resolution digital files and Photoshop.

Bystedt & Egan draw on the mythological power of the snapshot. They sense our trust in presumptively tossed-off images to reliably offer small revelations and glimpses of truth. We link snapshots to personal histories. With their everyday grammar and diaristic focus, snapshots epitomize biography, autobiography, life.

Tony Maher [pages 149–152]

Memory and photographs intertwine, or so we believe, but the relationship is complex and its resolution unclear. To recollect is to call up an image, or is it the image that triggers a recollection? Does a photograph encapsulate a story, or overwrite it? Is a photograph a "hard copy memory" as photographer Jim Goldberg suggests? Or is it, according to theoretician Roland Barthes, "never, in essence a memory . . . but it actually blocks memory, quickly becomes a counter-memory?"

Clearly, images complicate memory's task, and this field of complications is the haunted playground for Tony Maher's *HiStory,* an extremely personal project.

HiStory was set in motion by an overflowing dumpster near the photo department at Chaffey College where Maher worked. In a discarded heap of age-old student models, Maher found a tract home uncannily similar to the 1950s single-story tract home of his childhood. This triggering event started him recollecting, constructing, photographing. "The object, the place, and the photograph work in unison to create the memory," he says. In each title, he gives us a poignant clue. Houses, cars, parents, pools, youthful skinnydippers in a distant

dusk. Maher's models are traces of his life. Photographs of the models, then, are traces of traces. Image and biography blend.

In these photographs, we see the artist recollecting, revisiting, deciphering, attempting to return home. Eventually, we conclude, he does make his way home, but home turns out to be in photography.

Kenda North [pages 153–155]

Kenda North's *Kress Building* photographs were created at the site of the California Museum of Photography. In 1987, the building was the empty shell of a five-and-dime department store. As plans were being drawn to transform the commercial space into a museum, North repeatedly returned with students from the dance department at the University of California, Riverside. (This was at the invitation of museum director Charles Desmarais.)

The photographer and her impromptu dance troupe worked upstairs. There was little electricity and little fresh air. But the open spaces of the upper floors proved to be an unconstrained refuge filled with light and possibility. A central influence, says North, was Gaston Bachelard's *The Poetics of Space*. The French theorist emphasizes the primacy of architecture as lived experience, the personal and emotional response to buildings. "Bachelard talks about how the architecture of a space can provide a creative refuge," says North.

The photographer and the dancers together conjure up elegantly hued compositions that respond to a now disappeared architecture, a vanished place, a ghost in the shell. The figures are both sculptural objects and vessels for emotion. The world of North's photography, wrote poet Dinah Berland, is "a realm in which the body speaks a language of its own—a language of light, color, gesture, texture and sensation."

Kim Abeles [page 156]

Kim Abeles laughs a lot, but takes art seriously. Her projects emerge from a blend of amused curiosity and serious social engagement. They operate at the intersection of exploration, activism, and art. And they involve community. She constructs work from crowd-sourced elements, historical tidbits, personal responses, found objects. They're assemblage with ideas woven throughout. *The Map Is the Legend (Equidistant Inland Empire)* is a perfect example.

To begin, Abeles asked Inland Southern California scholars, writers, and artists about "the center of the Inland Empire." She made a discovery—this place is decentered. The centerpoints identified are literally all over the map. They vary by as much as 30 miles— Mystic Lake, the Andreas Fault, UC Riverside, the Riverside Public Library, the San Bernardino Mountains "Arrowhead," Poetry Night at Back to the Grind in Riverside. Finally, she contributed her own personal centerpoint—the San Andreas fault north of Beaumont.

Abeles then used social media to solicit photographs of inland area sites of importance, "places that resonate." Using her centerpoint as the pivot, she generated a "twin, a sister site" for each contributed photograph. Each twin is exactly opposite and equidistant of the original. Abeles bought a new pair of hiking boots and filled her car with gas. With camera and notebook in hand, she chased the centerpoints, located the paired sites.

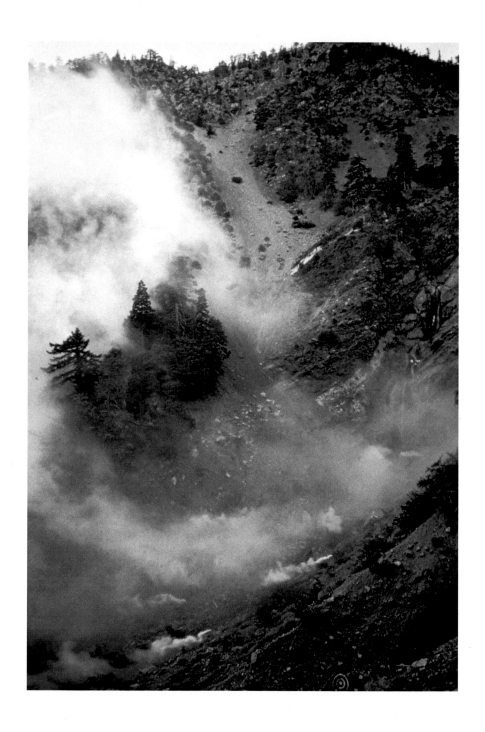

Judy Chicago, *Snow Atmosphere*, 1970,
© Judy Chicago / Artists Rights Society (ARS), New York

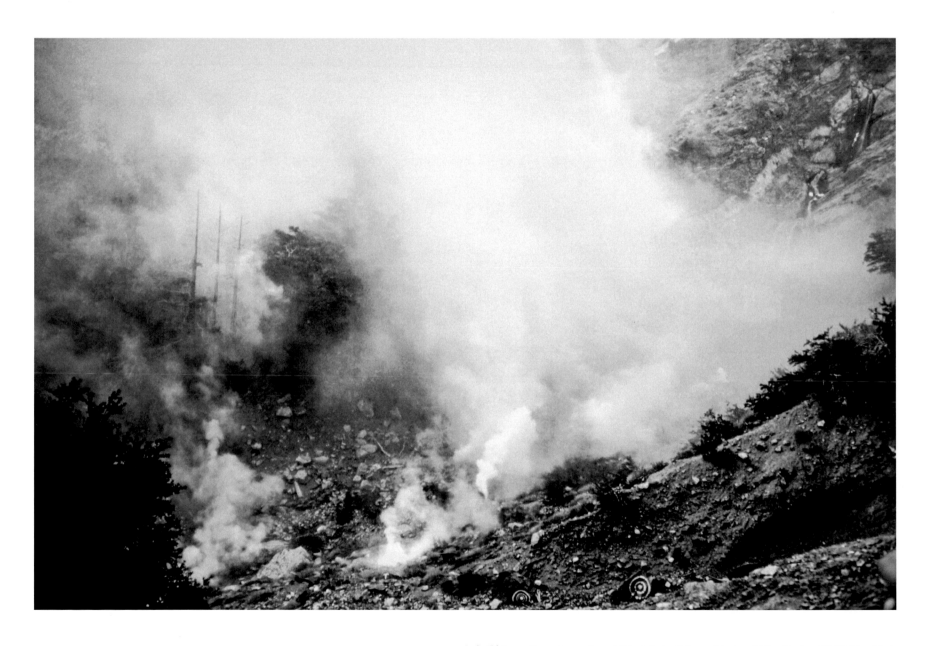

Judy Chicago, *Snow Atmosphere,* 1970, © Judy Chicago / Artists Rights Society (ARS), New York

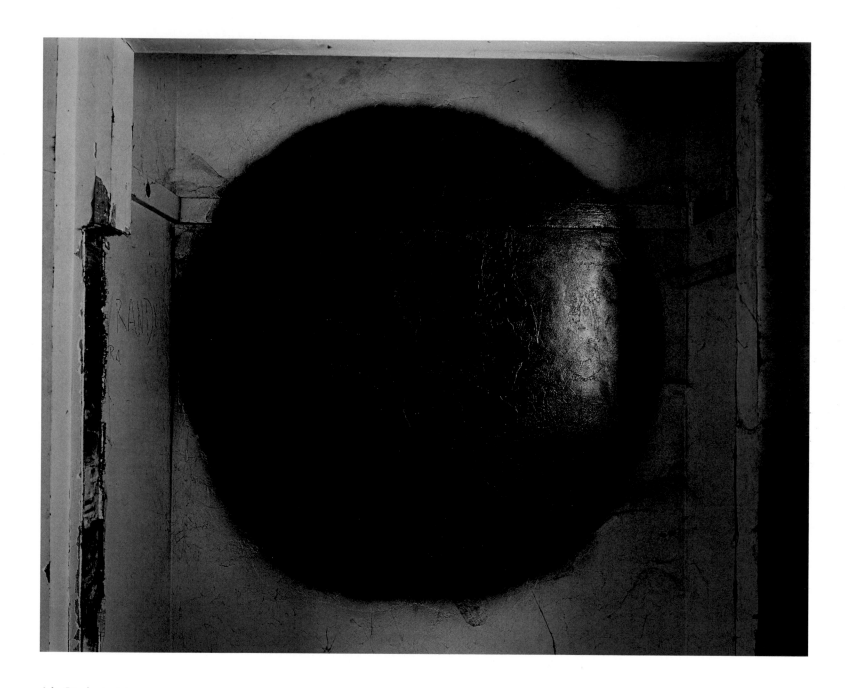

John Divola, *Dark Star B*, 2007

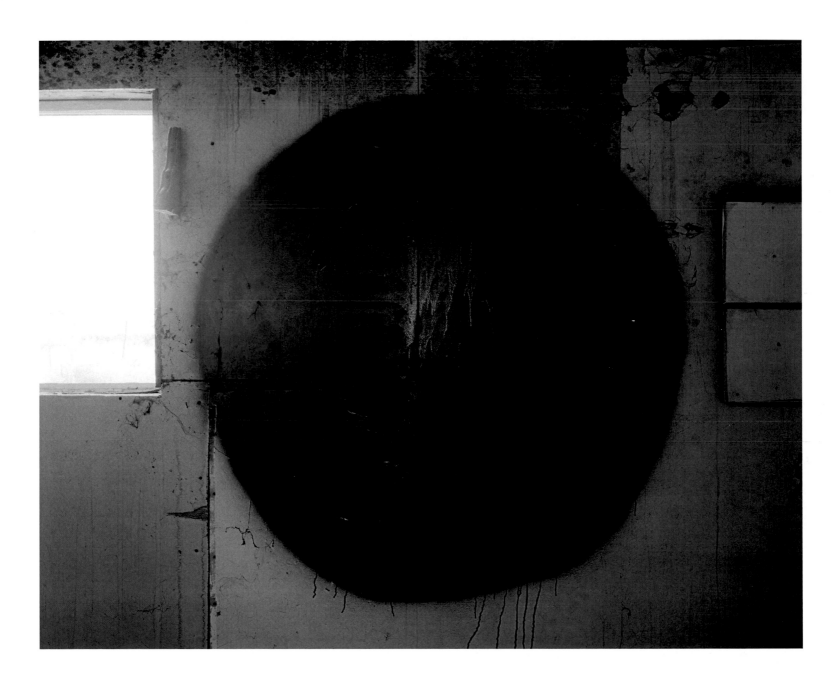

John Divola, *Dark Star D*, 2007

Christina Fernandez, *American Trailer*, 2018

Bystedt & Egan, *Fotomat 01,* 2015

Bystedt & Egan, *Fotomat 03*, 2015

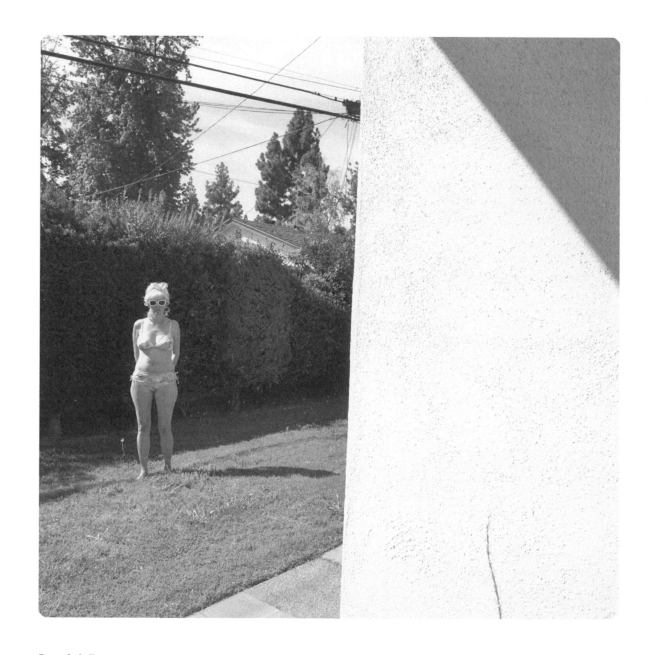

Bystedt & Egan, *Fotomat 07*, 2015

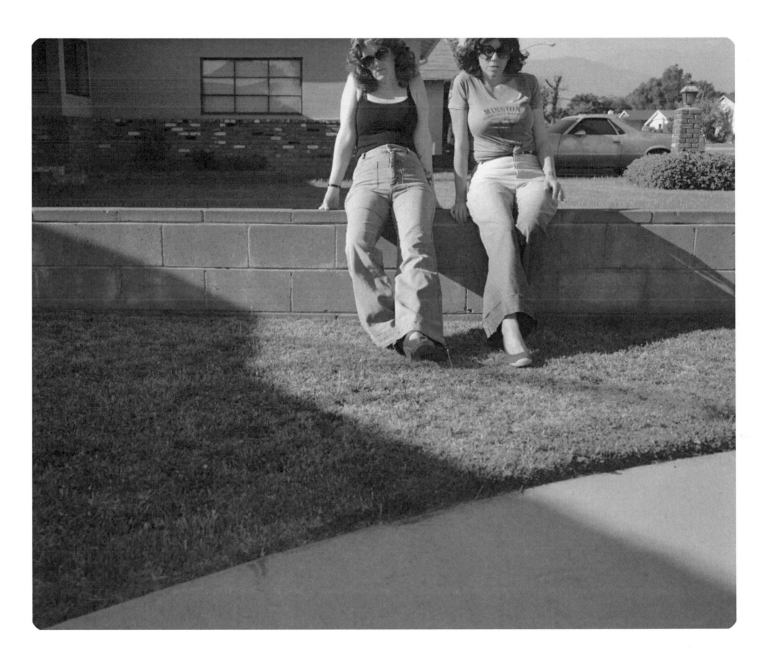

Bystedt & Egan, *Fotomat 12*, 2015

Bystedt & Egan, *Fotomat 02*, 2015

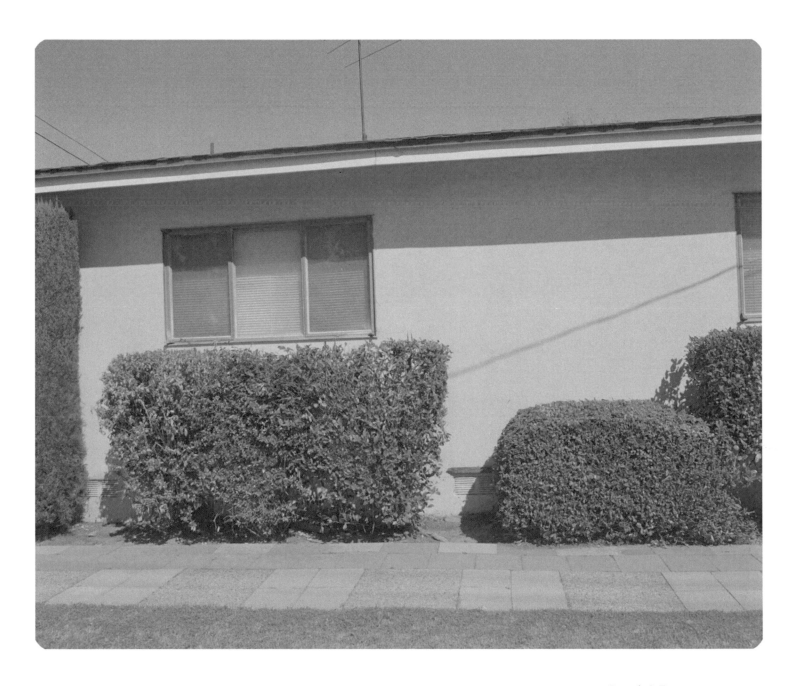

Bystedt & Egan, *Fotomat 09*, 2015

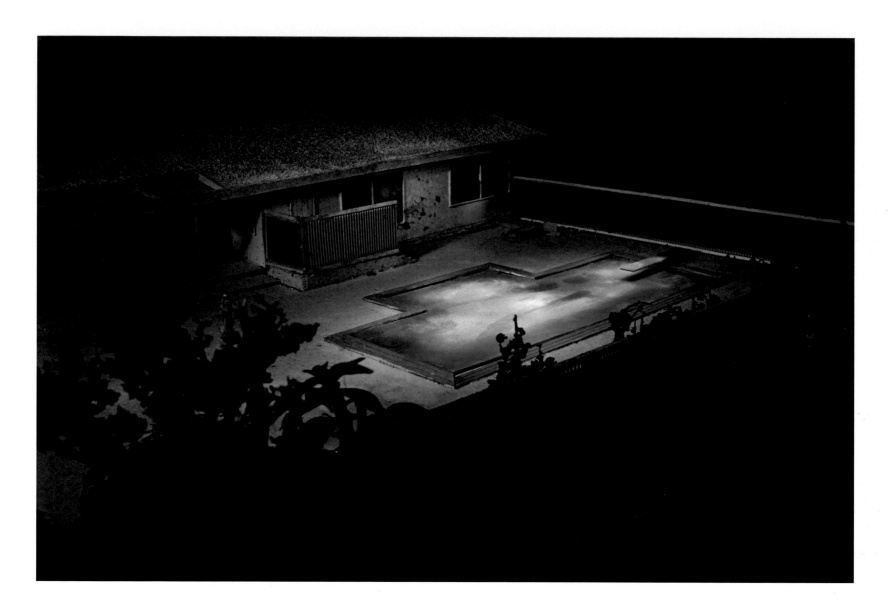

Tony Maher, *Skinny Dipping with Christie at the Stafford's Pool, 1996,* from the series *HiStory,* 2008

Tony Maher, *The Day Dad Moved Out, 1986*, from the series *HiStory*, 2010

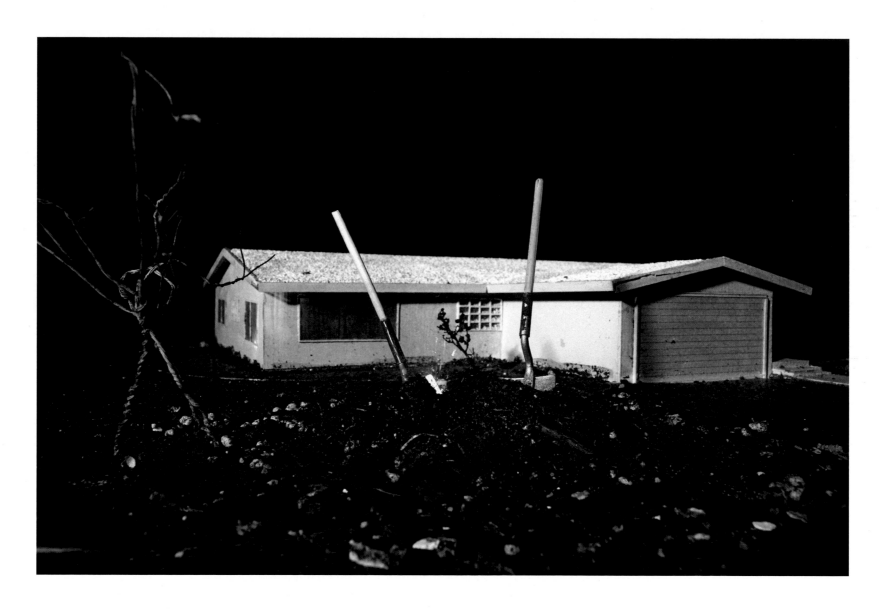

Tony Maher, *Fixing the Sprinkler with Gramps, 1994,* from the series *HiStory,* 2008

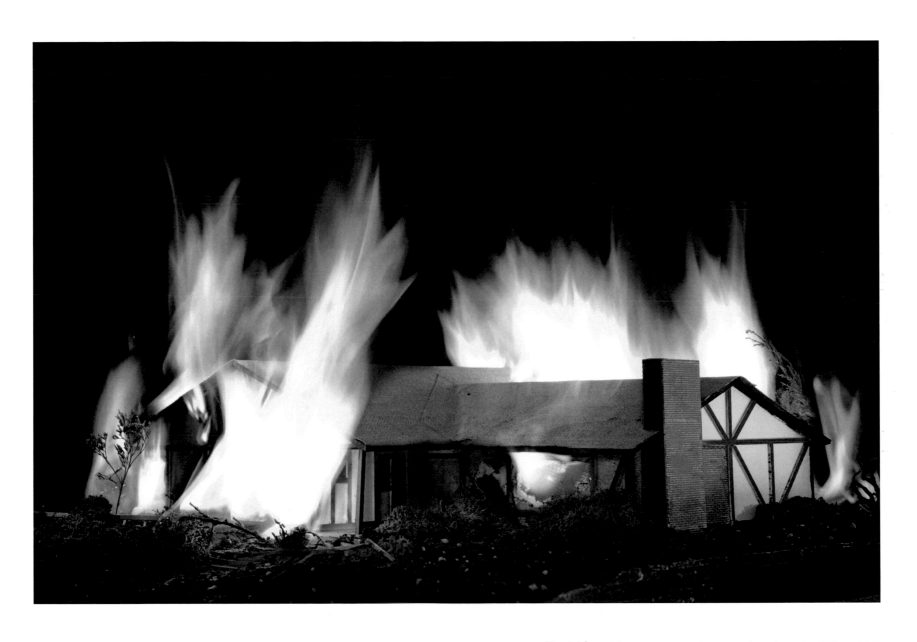

Tony Maher, *Old Fire, San Bernardino, 2003*, from the series *HiStory*, 2013

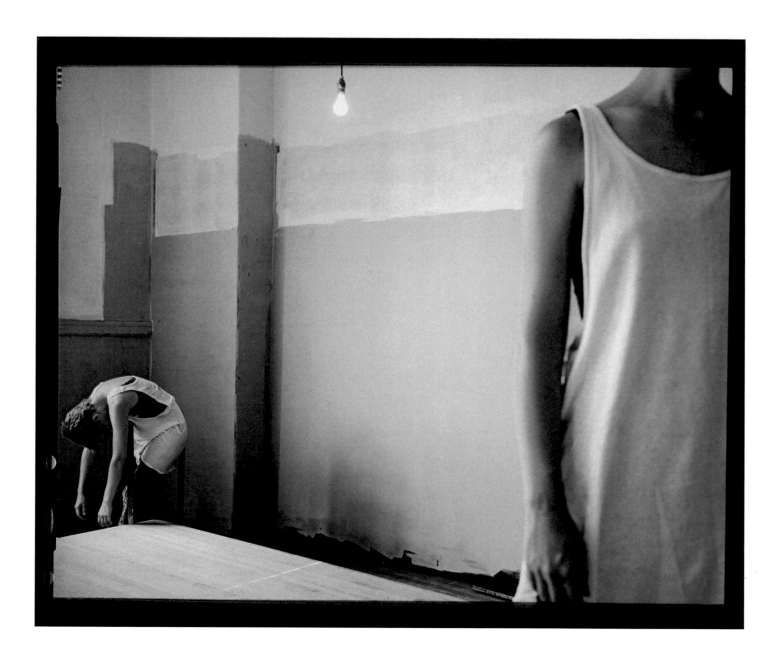

Kenda North, *Untitled*, from the series *Kress Building*, 1987

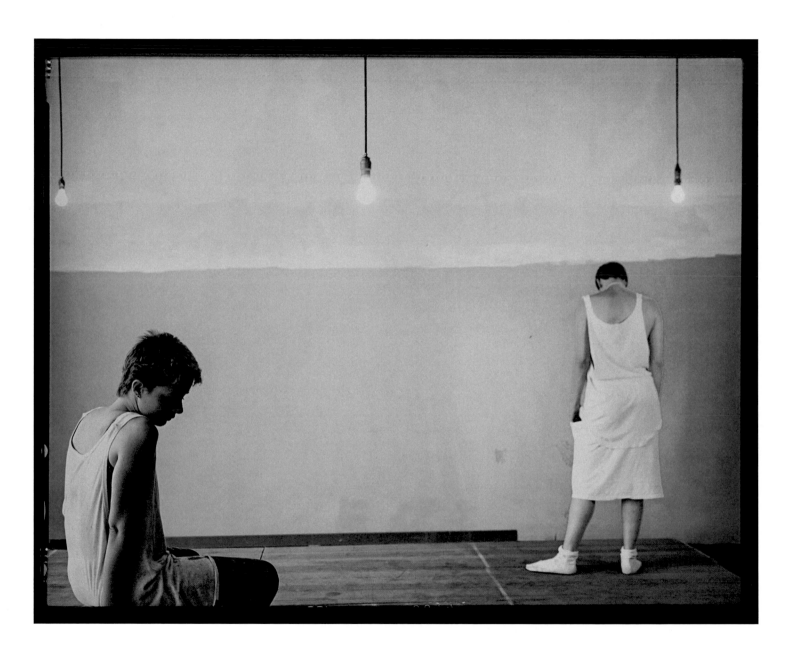

Kenda North, *Untitled*, from the series *Kress Building*, 1987

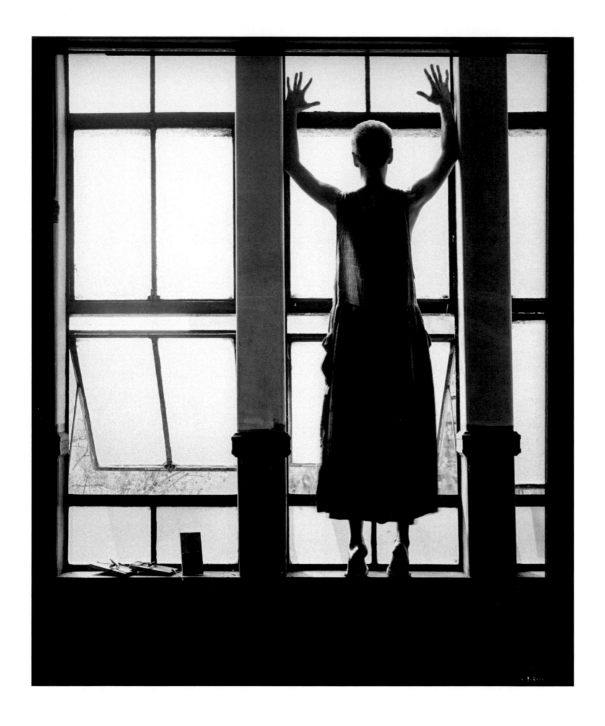

Kenda North, *Untitled*, from the series
Kress Building, 1987

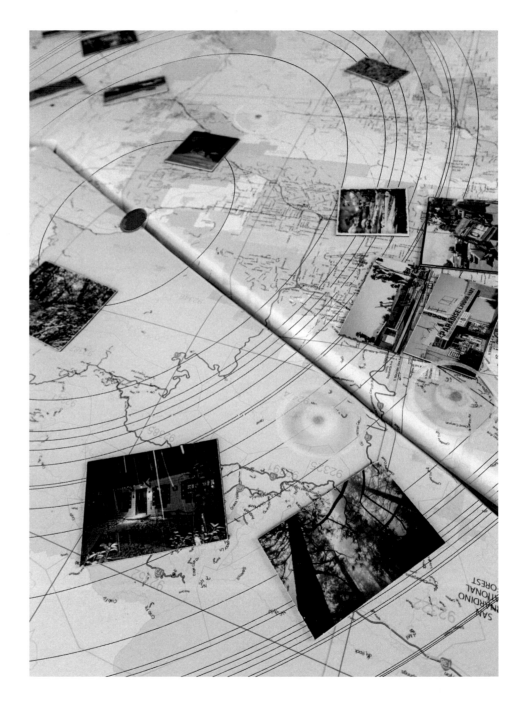

Kim Abeles, *The Map Is the Legend (Equidistant Inland Empire)*, 2018

Collaborators providing original photographs, family photos, and video for the project: Cindy Bendat, Brooke Bender, Fred Beshid, Carolyn Campbell, Diane Cockerill, Martin Cox, Jill D'Agnenica, Cheryl Dullabaun, Anita Getzler, liz gonzález, Suzanne Hackett-Morgan, Sant Khalsa. Lewis Koch, Stephanie MacConaghy, Mary Manusos and Mel Durand, Ken Marchionno, Thomas McGovern, Bob Orso, Alfred "Freezy" Rice, Karen Feuer-Schwager, Stella Stauffer, Meriel Stern, Amy Zapata, and Jody Zellen.

Thank you to scholars, writers, and artists who suggested centerpoints for the Inland Empire. Like the place itself, a passionate variety prevailed. Judith Auth, previous director of Riverside Public Library system; Patrick Brien, executive director, Riverside Arts Council; Larry Burns, teacher and poet; Douglas McCulloh, photographer and senior curator, California Museum of Photography; Vince Moses, architectural historian, previous director of Riverside Metropolitan Museum; Ruth Nolan, professor of English, College of the Desert; Drew Oberjuerge, executive director, Riverside Art Museum; Naida Osline, artist; Elio Palacios, filmmaker; Cati Porter, poet and executive director, Inlandia Institute; Connie Ransom, artist and former gallerist; Diana Ruiz, public affairs manager, Riverside Corona Resource Conservation District; Susan Straight, writer and Distinguished Professor of Creative Writing, UC Riverside; Frances Vasquez, previous director of Riverside County Mexican American Historical Society, and board member, Inlandia Institute.

Transect 04: Fires, Floods, and Faultlines

OBSERVATIONS

The inland region is Southern California's highest and lowest, hottest and coldest. It is sliced by the two most threatening branches of the San Andreas Fault. It is beset by fire or flood with a frequency remarkable even for the vulnerable West. It is maximal Southern California, the region purified and heightened.

Naturally, photographers respond to this geography. Shortly after he arrived to teach at UCR in 1976, Joe Deal began following the area's fault traces. The results became known as the *Fault Zone Portfolio*. They're a perfect example of *New Topographics* photography. Cool, austere, distanced, a clinical look at human impact. But the images are charged with tension—the unstable balance between man and nature is implicit. And below the surface, invisible faults store their hidden energies.

Fire is the subject of works by four photographers: Noah Berger, Richard Misrach, Stuart Palley, and Andrew K. Thompson. Four photographs by Sant Khlasa focus on flood events made over forty years of photographing the Santa Ana River.

But not all disasters are natural. From the photographs of this exhibition it is easy to see that the impacts of human alterations to the landscape far outstrip those of natural disasters. A 7.2 temblor on the San Andreas Fault is nothing compared to the ramifications of a century of relentless development. The region has been paved over in a few generations. It has accumulated over four million people the way grit and leaves collect in a dead zone when the Santa Ana winds blow. For all that, it remains an unremarkable landscape, by now standard in much of the world. In fact, it's so familiar, mundane, and internalized that we do not move through this landscape, it passes through us.

ARTISTS/WORK

Joe Deal [pages 161–164]

Joe Deal made the *Fault Zone Portfolio* using a straightforward system. He took a medium format camera and followed the region's faults. He made images along the Chino Fault, the San Andreas main line, and the San Jacinto Branch of the San Andreas.

Deal's *Fault Zone Portfolio* project began in 1976, in the immediate wake of *New Topographics*, the hugely influential 1975 exhibition that came to signify a new mode of landscape photography. That exhibition included eighteen of Deal's photographs. Deal summarizes the approach: "cool, distant, with a clear and hard view of the world—an unromantic and unfiltered way of looking through the lens."

Beneath austere surfaces, Deal constructs calibrated compositions. The latent power of the faults remain subsurface, hidden, concealed, while Deal fills his frames with the helter-skelter evidence of humankind's haphazard development. He offers expansive vistas, but photographs from a high angle that removes the visual anchor of a horizon line. He sets human time scales against the deep time of geology, and captures both in photography's one-hundred-and-twenty-fifth of a second.

Richard Misrach [page 165]

"In the past when I traveled," writes Richard Misrach, "I used to look for the light, the beautiful forms. Now I cannot escape the fact that every facet of the landscape is suffused with political implications." With his interlocking projects in the American desert, Misrach sets an ambitious goal—to move past the descriptive into the metaphoric and political, however complex. He means to bear witness, to offer unsettling truths, to sound an alarm. He means to merge reportage with poetry and politics.

Misrach used an eight by ten inch view camera to make his photograph of a Coachella Valley palm grove in flame. The photographic apparatus is as slow as the fire is fast. The artist terms it a "flash fire." Palm thatch burns with explosive speed and heat. The image is part of Misrach's enormous project titled *Desert Cantos* and serves as the cover of his book.

Like photographer Robert Adams, Misrach starts with the lure of beauty. "I've come to believe that beauty can be a very powerful conveyor of difficult ideas. It engages people when they might otherwise look away." But his messages are alarming and potent. Beneath the seductive beauty of the images, *Desert Cantos* finally focuses on the defilement of the West and the calculated destructiveness of its inhabitants.

Noah Berger [page 166]

Noah Berger is fire-obsessed. The San Francisco-based freelance photographer shoots editorial assignments for Associated Press, *The New York Times*, *San Francisco Chronicle*, *Bloomberg News*, and others. But he has a standing agreement with his clients. When major wildfires break out—and lately that's been delightfully often—he'll disappear for weeks at a time, breathing the smoke, living on the firelines.

The Blue Cut Fire was first reported August 16, 2016, at 10:46 a.m. The fire began, cause unknown, along the Blue Cut hiking trail in the Cajon Pass. A high fire danger warning was in effect. Temperatures hovered near one hundred. Erratic winds gusted to thirty miles per hour. Fire danger was rated extreme. Burning through parched chaparral, the fire exploded to 5,500 acres in less than six hours. The California Highway Patrol closed Interstate 15 in both directions. Cal Fire ordered evacuations for West Cajon Valley, Lytle Creek, and Lone Pine Canyon. Then Oak Hills, Phelan, and Summit Valley. In the end, the fire destroyed 105 residences and 213 other structures.

Berger's *Embers from the Blue Cut Fire* (2016) focuses on a mountainside of glowing embers so boundless that the apocalypse seems to encompass the visible world.

Stuart Palley [pages 167–168]

Stuart Palley's first fire wasn't much. On August 1, 2012, he photographed the Volcano Fire in the affluent La Cresta neighborhood east of Murrieta. It generated the standard trailing cloud of news helicopters and local anchors as it burned through 355 acres of bone-dry chaparral. The fire torched only a single hilltop mansion—a meager toll by current California conflagration standards. Even so it ignited an obsession in Palley.

Since then, Palley has worked on a project called *Terra Flamma*—the new fire ecology of California. To date, he has photographed close to one hundred fires, embedded with frontline firefighters for weeks at a time. He's completed the Firefighter II training through the National Interagency Fire Center. He's driven twenty thousand miles, made fifty thousand photographs, and rung up a five-thousand dollar camera repair bill. He's added specialized gear to his brace of Nikon digital SLRs—thermal goggles, Bendix King fire radios, and, in case of the very worst, a new generation Nomex emergency fire shelter.

Palley has a photojournalism degree from the Missouri School of Journalism, and his work is centered in the documentary tradition. He's conversant with issues of climate change and human intrusion into the wildland urban interface. But from the start he has aimed his cameras at something more ethereal and unpredictable—the effects produced by long exposures at night. He opens his shutter for a second to four minutes or more. He bathes the sensors in the unique radiant light of fire and moon, smoke, and stars.

Andrew K. Thompson [pages 169–172]

Andrew K. Thompson is an imperfectionist. He cuts and punctures, stitches and experiments, and calls the results photographic. "I not only think perfection is impossible, but also sterile, elitist, and hierarchical. Also, as in nature, imperfect things lead to evolution."

Thompson's core attitude is promiscuous possibility. The playground is large. Anything is possible, so let's get to it. The full range of the medium is available, so let's use it. "I play a game of 'what if,' 'wouldn't it be cool if . . .' I do something just to see what happens. Then I respond to what the work tells me. I feel like tearing photography apart to put it back together, but I do it out of a genuine love of photography." Thompson gleefully rejects photographic purity and dogma. He seeks a rupture with photographic traditions, but one that's articulate and anchored in knowledge. (His proficiency is deep: he worked commercially on both coasts and now teaches photography and photo history.)

Thompson's practice has a punk edge. Destruction as creation. Even so, he retains metaphoric aims. His markers of scruffy Inland Southern California—palm trees, power lines—are intentionally generic: a place, not this exact place. And his work contains a streak of environmental activism. "It's no longer authentic to create pristine images of grand landscapes. That's obvious. The actual landscapes are falling apart in front of us. On the other hand, if we're already on the road to ruining everything, there's an intense freedom in that."

Joel Sternfeld [page 173]

From the time it showed at The Museum of Modern Art in 1984 and was gathered into a book in 1987, Joel Sternfeld's *American Prospects* has taken on the aura of a classic. The aftermath of a flash flood in the Coachella Valley is one the project images that imprint indelibly on the mind. The photograph typifies Sternfeld: sociological

comment, indulgent distance, a strand of ironic humor. A prospect, of course, is a view of a landscape. But it carries another meaning: a predictor of future events.

Sternfeld was granted a successive pair of Guggenheim Fellowships in 1978 and 1982. He bought an eight by ten view camera (for which he could scarcely afford to buy expensive sheets of color film). Then he roamed the country for nearly a decade in a Volkswagen camper van, his trips varying from a week to a year at a stretch.

On one level, *American Prospects* represents that great American pilgrimage—hitting the road. "But I reckon I got to light out for the territory ahead of the rest," concludes Huck Finn in Twain's classic, "because aunt Sally says she's going to adopt me and sivilize me, and I can't stand it. I been there before." But Sternfeld's project is also grounded in a second seminal American journey—the photographic survey. Sternfeld employs the cumbersome traditional view camera, and his magisterial overviews bring to mind the early photographers of the American West, Timothy O'Sullivan, Carleton Watkins. But Sternfeld's wry perspective renders the lush color subversive and transforms the echo of manifest destiny into a sardonic joke.

Sant Khalsa [pages 174–183]

Sant Khlasa has spent close to forty years documenting her watershed, the Santa Ana River. If you live here, Sant Khalsa points out, "your body consists in large measure of the Santa Ana River water you consume. It's your river, and the river is you." She often refers to the Santa Ana River as "my river." As she says, "never intending 'my' to allude to ownership or control but rather an intimate relationship one develops over time with a lover or a dear old friend."

But Khalsa's friend can be temperamental. As with most rivers in the arid West, the Santa Ana perennially runs

low or even underground. But, every so often, the river runs very high indeed. Four of Khalsa's ten Santa Ana River photographs in this exhibition show flood events or their aftermath. Concrete bridges are collapsed, roads submerged, power poles uprooted. Behind it all is the black dog of the river. Her work reveals the power of the river in full flood. Over millions of years this force has filled the downstream basins with sand and silts and boulders to depths exceeding twenty-thousand feet. Thus, Khalsa's photographs cover everything from the millennia that dismantles mountains to this morning's drink of water.

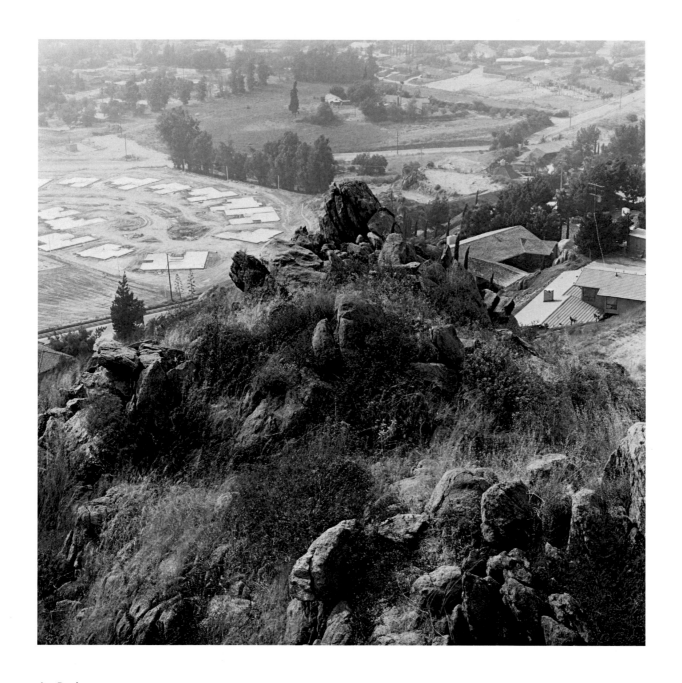

Joe Deal, *Colton, California*, from the *Fault Zone Portfolio*, 1978, © The Estate of Joe Deal, Courtesy Robert Mann Gallery, New York

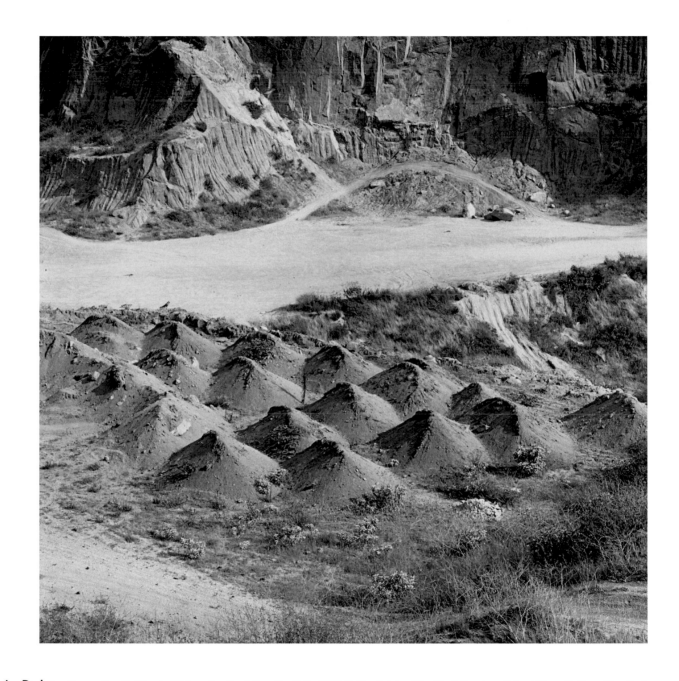

Joe Deal, *San Bernardino, California (I)*, from the *Fault Zone Portfolio*, 1978, © The Estate of Joe Deal, Courtesy Robert Mann Gallery, New York

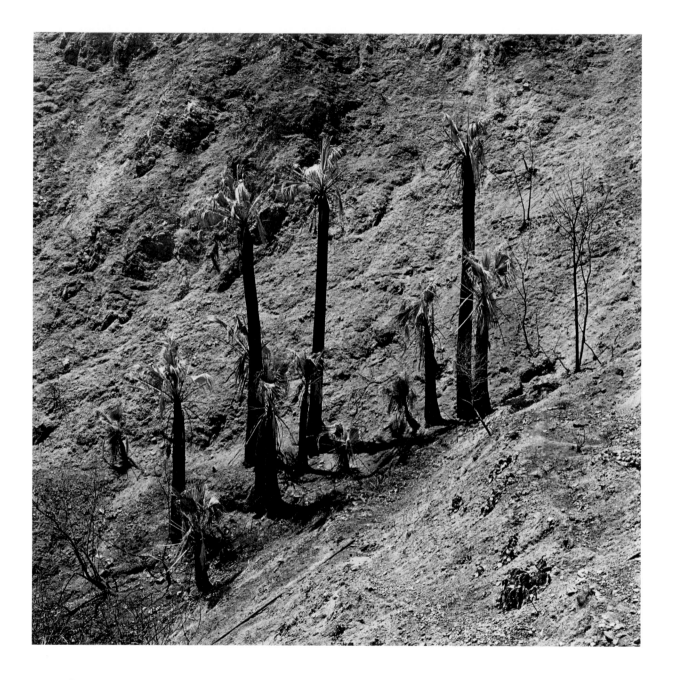

Joe Deal, *Soboba Hot Springs, California (II)*, from the *Fault Zone Portfolio*, 1979, © The Estate of Joe Deal, Courtesy Robert Mann Gallery, New York

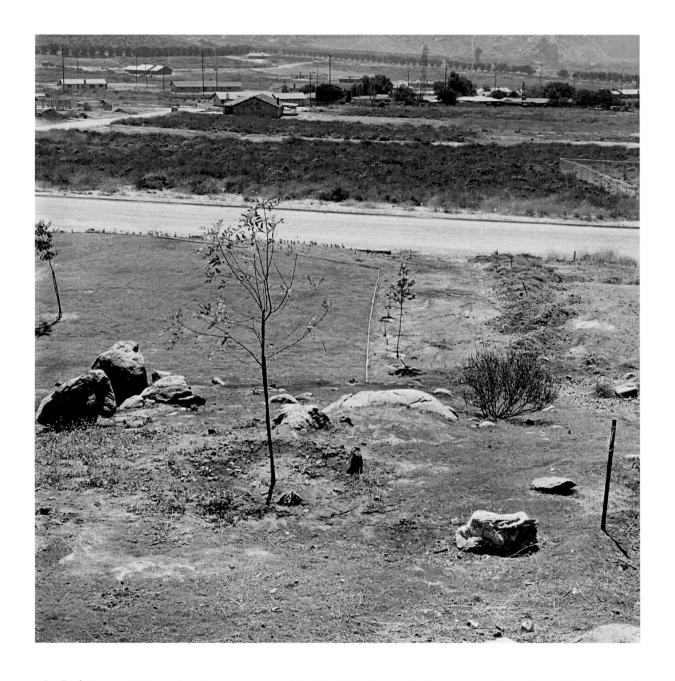

Joe Deal, *Fontana, California*, from the *Fault Zone Portfolio*, 1978, © The Estate of Joe Deal, Courtesy Robert Mann Gallery, New York

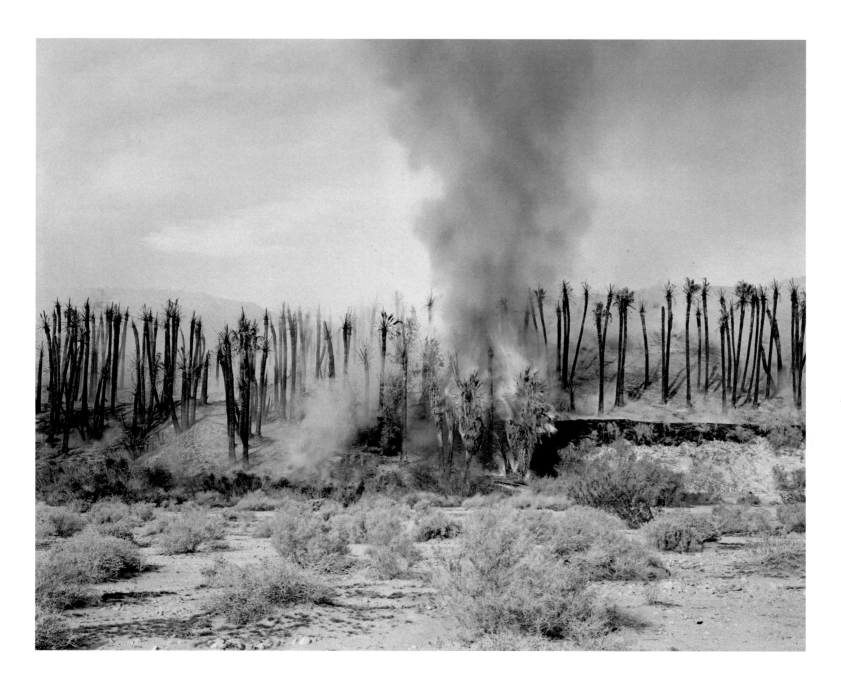

Richard Misrach, *Desert Fire #1 (Burning Palms)*, 1983, © Richard Misrach, Courtesy Fraenkel Gallery, San Francisco

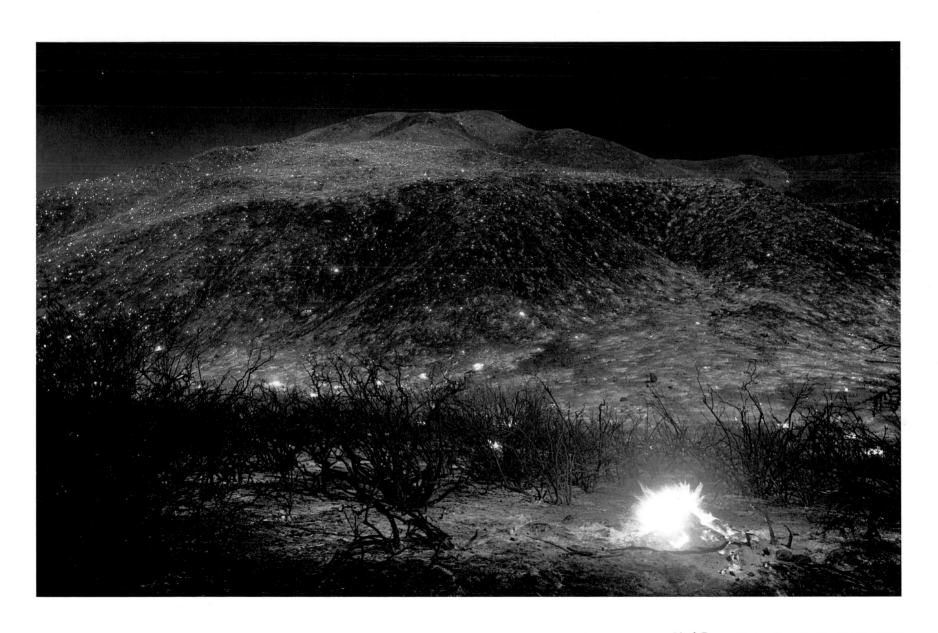

Noah Berger, *Embers From the Blue Cut Fire*, 2016

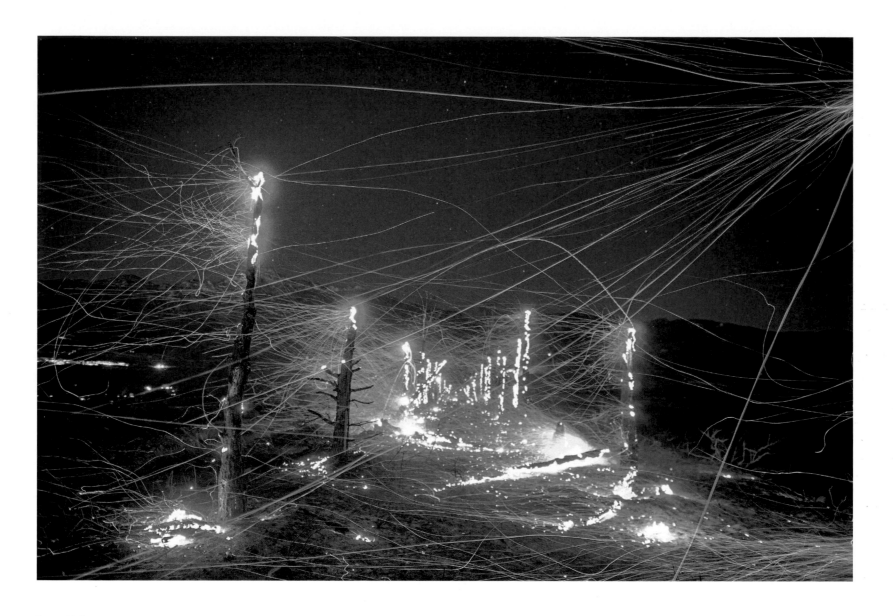

Stuart Palley, *The Etiwanda Fire*, 2014

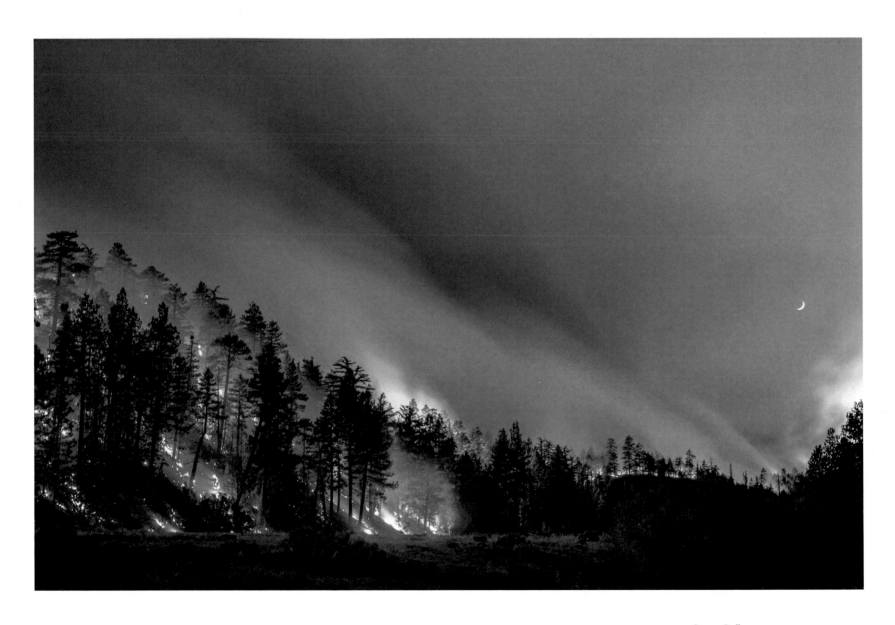

Stuart Palley, *Lake Fire Meadow*, 2015

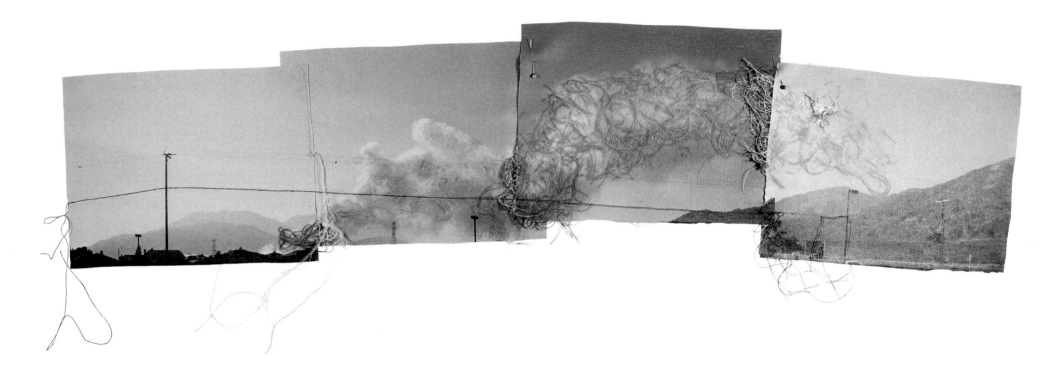

Andrew K. Thompson, *San Bernardino Smoke*, 2014

Andrew K. Thompson, *San Bernardino Weed*, 2015

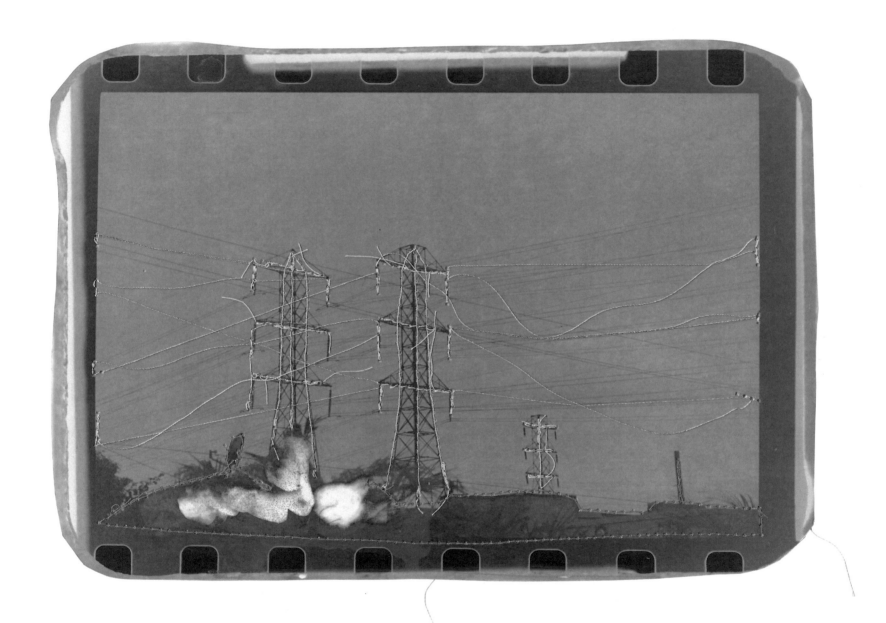

Andrew K. Thompson, *Untitled (Orange landscape with blue powerlines)*, 2016

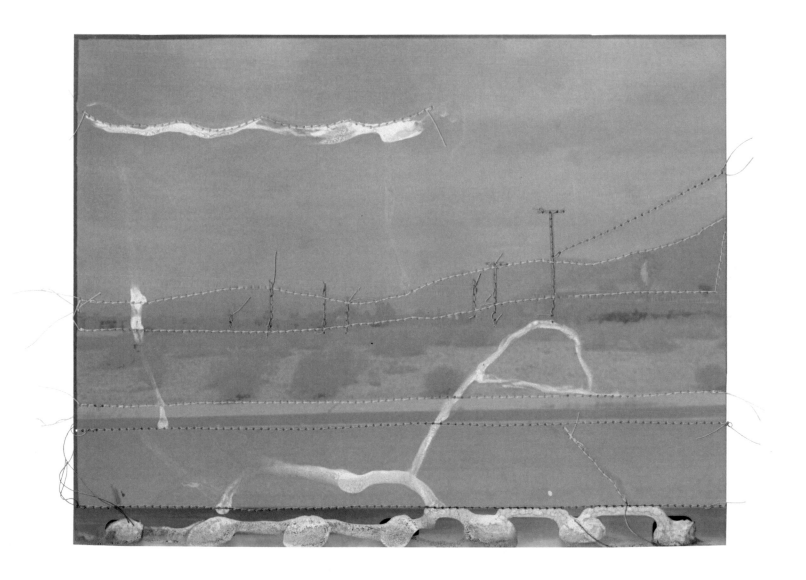

Andrew K. Thompson, *Untitled (Yellow and green landscape)*, 2016

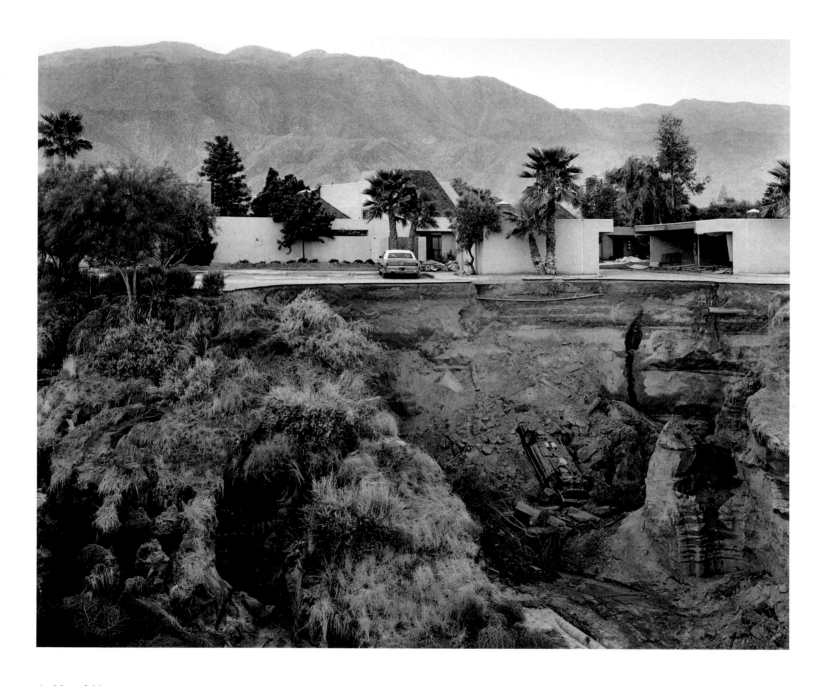

Joel Sternfeld, *After a Flash Flood, Rancho Mirage, California*, 1979

Sant Khalsa, *Santa Ana River, Riverside, 1993*, from *Paving Paradise*, 1993

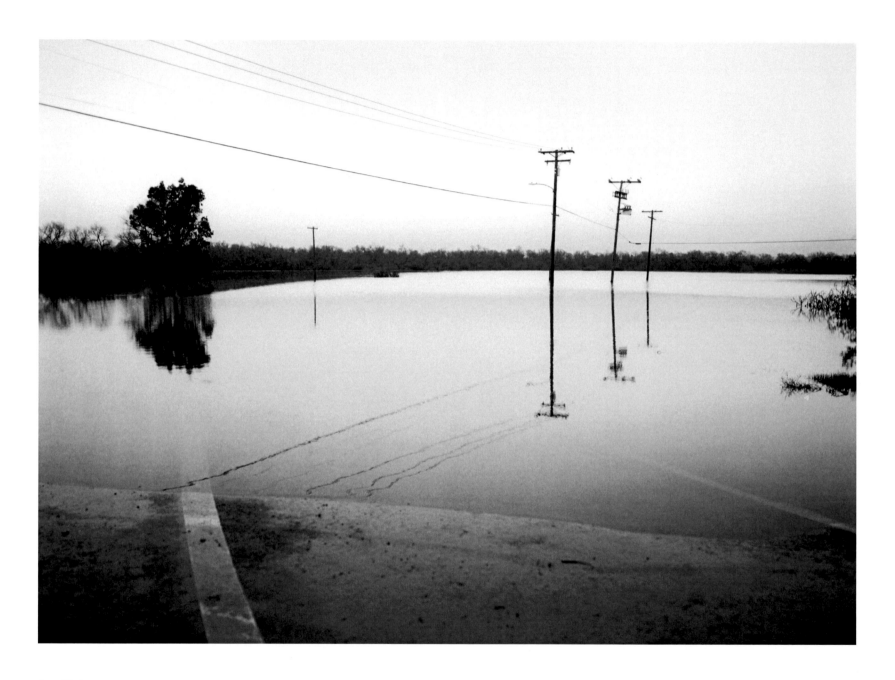

Sant Khalsa, *Flooding Behind Prado Dam, 2005*, from *Paving Paradise*, 2005

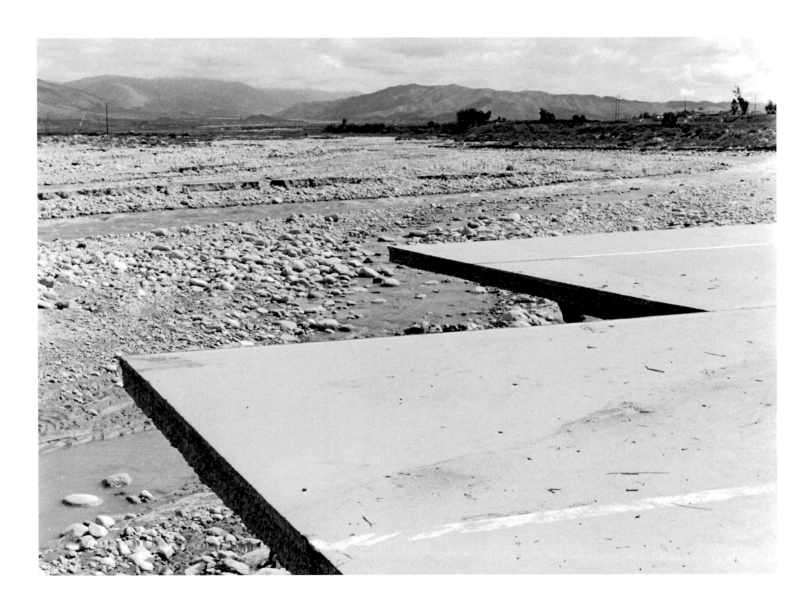

Sant Khalsa, *After the Flood, Santa Ana River, Redlands, 1995*, from *Paving Paradise*, 1995

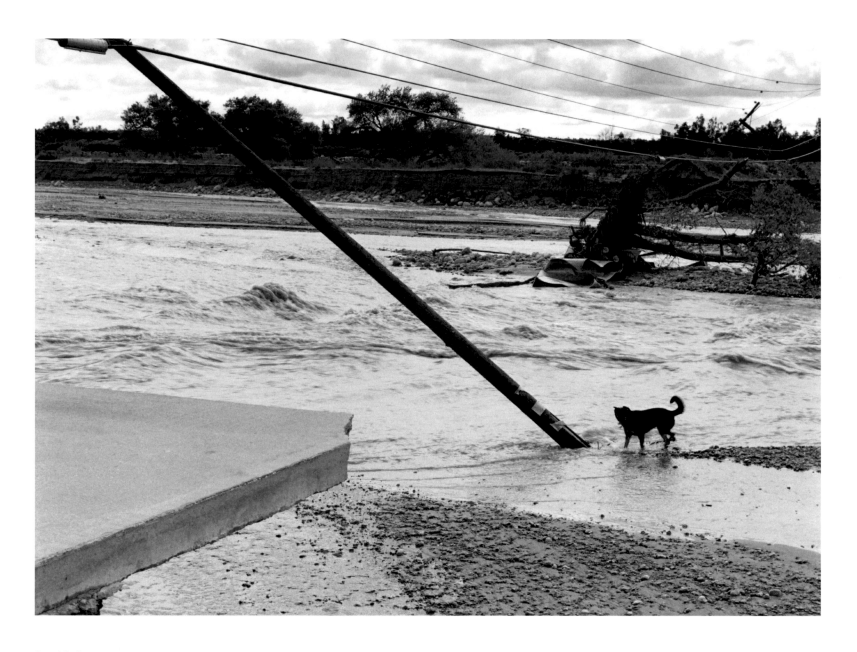

Sant Khalsa, *After the Flood, Santa Ana River, Redlands, 1995*, from *Paving Paradise*, 1995

Sant Khalsa, *Prado Wetlands, 2002,* from *Paving Paradise,* 2002

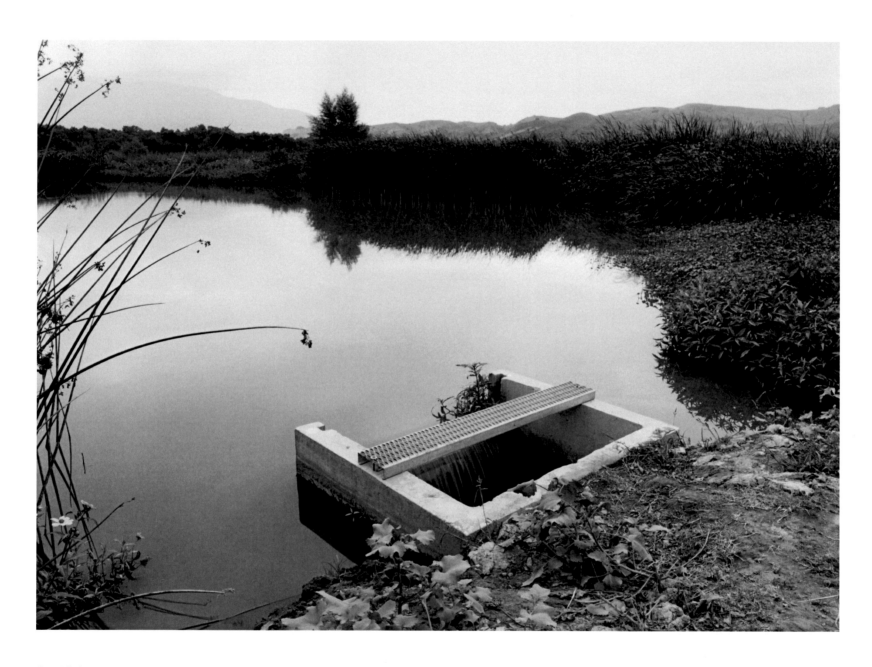

Sant Khalsa, *Prado Wetlands, 2002*, from *Paving Paradise*, 2002

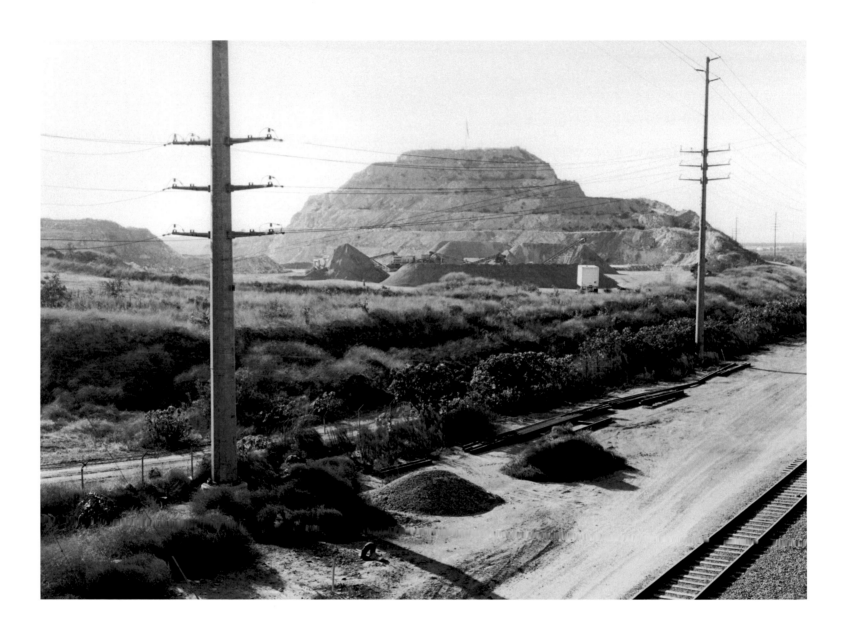

Sant Khalsa, *CalPortland Cement Plant, Remains of Slover Mountain, formerly known as Catalmacay and Cerrito Solo (Lone Hill), Colton, 2005*, from *Paving Paradise, 2005*

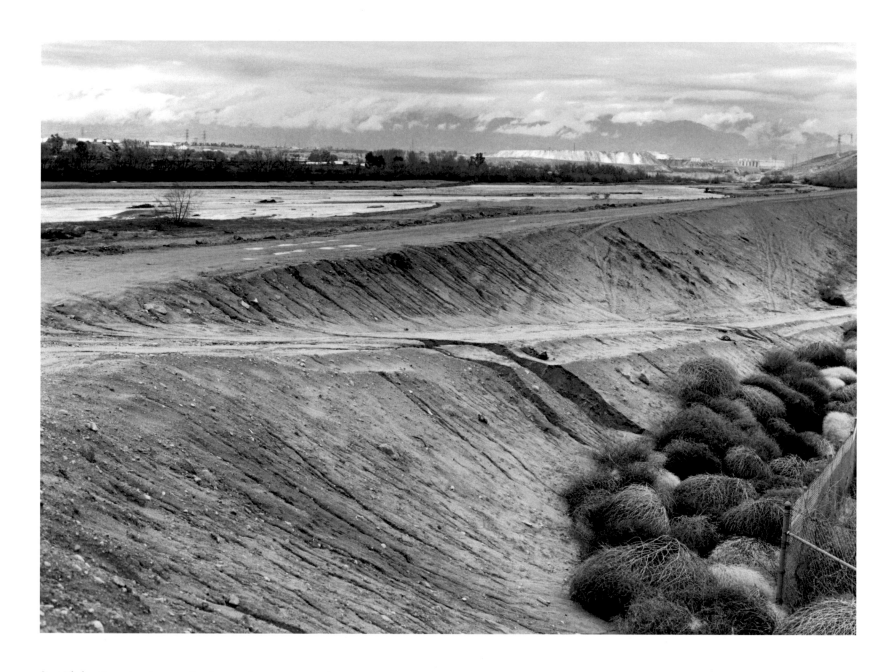

Sant Khalsa, *Santa Ana River, Redlands, 1993*, from *Paving Paradise*, 1993

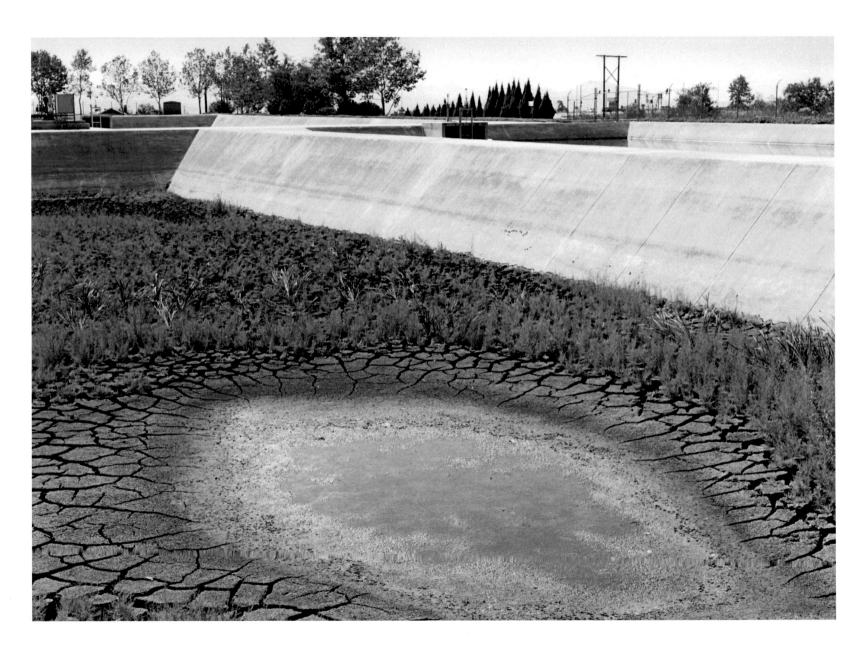

Sant Khalsa, *Water Treatment Plant, East Valley Water District, Highland, 2005*, from *Paving Paradise*, 2005

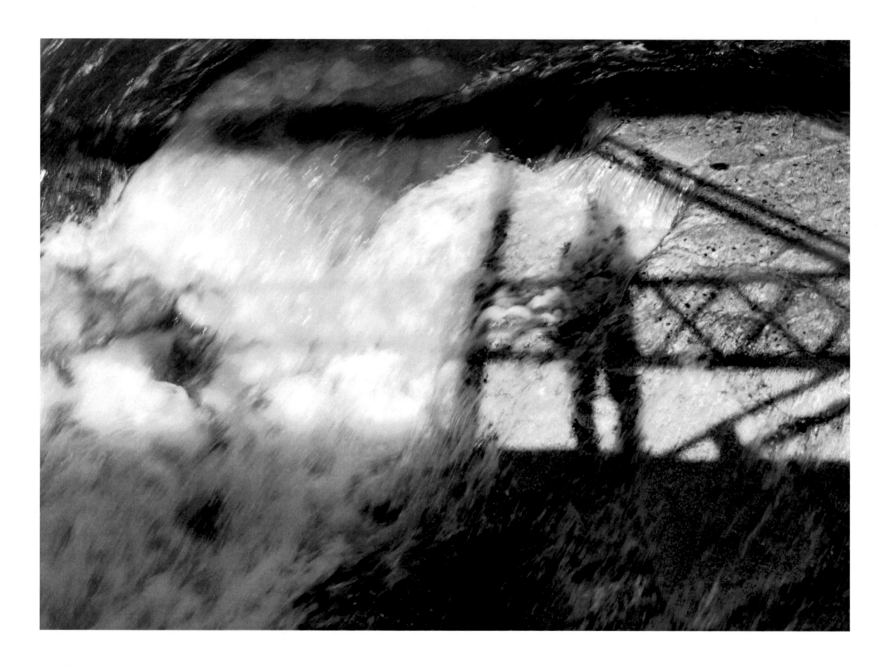

Sant Khalsa, *Self Portrait with the Santa Ana River, 1996*, from *Paving Paradise*, 1996

Sunshine and Neglect Thomas McGovern

Inland Empire is a name that evokes the aspirations of those who have developed and exploited this region for more than 150 years. Some of it was settled by Mormon pioneers on ancient Native Peoples' lands or gentlemen farmers looking to escape harsh eastern winters. The region called to those who wanted more space or had less money, to those who needed a new start or had something to hide. This is truly the land of opportunity and opportunists, bookended by Los Angeles and Palm Springs and more than just a stopover on the I-10 if you're out of gas, or need a Big Gulp.

There are a lot of advantages to photographing in a region that is underappreciated and even disdained—there's not a lot of competition for subject matter, and what you decide to photograph isn't well known. It has been said that a good picture is determined by where you stand, and when you're standing in the Inland Empire, you have a good chance of finding something interesting to photograph. The people, landscape, and events in the IE appeal to a critical eye, one that sees past the glitz of cheap mall jewelry, tricked-out Hondas, and monotonous stucco housing developments. The famous inland smog creates spectacular sunrises and sunsets, and the hazy mid-day light veils the landscape in a dusty mist. When the wind blows, it does so with a vengeance, bending palm trees and overturning eighteen-wheelers on the freeways.

Flying into Ontario Airport gives a viewer the perspective the planners had in mind. The neat geometry of warehouses and housing developments, the staccato-lit roads and bright blocks of parking lots are serene and prosperous. The region was constructed along a grid emanating from Baseline Road, a surveyor's straight line from Highland to Azusa. Large squares and rectangles appear so neat from above, but at street level where we photographers travel, the chaos of humanity reigns, and the contrasts between old and new create a rich experience that defies easy categorization.

The fifty-four photographers in *In the Sunshine of Neglect* have mined this deep vein and come up with scenes both familiar and strange, befitting our maligned region and people sometimes derisively referred to as "909ers." They approach their subjects with the eye of an investigator and the mind of a psychologist. They see evidence of humanity in the spectacular and the mundane, and place their subjects in historic, contemporary, and personal contexts, producing a nuanced experience and view that is fresh yet familiar. This is a place of competing scenarios: commercial, retail, and industrial within the natural beauty of the desert and mountains; of aspiring families in upscale housing developments and amid pervasive poverty in trailer parks and homelessness on the streets; of sleek industrial parks and dilapidated strip malls. All are part of the ebb and flow of the boom and bust cycle of our history.

LANDSCAPE

An ongoing concern for many photographers in the exhibition is the definition and exploration of place through landscape. This quest goes beyond the encyclopedic visualization of things in the physical environment to one that suggests a psychological dimension that gives it character.

Kim Abeles merges the subjective and objective in a quasi-collaborative project that asks others to choose a point of interest. She then pairs crowd-sourced images equidistant from that point of interest, producing a chance-based exploration that relies on its systematic logic to create an authentic, objective document. Variations of this exploration of the land and its shapes and natural habitat are seen in images by Laurie Brown, whose panoramas aptly depict the region's expansive space.

The merging of the subjective and objective may be best exemplified by Robert Adams whose photographs so well describe that which many would ignore. Adams was a participant in the seminal 1975 *New Topographics* exhibition, and his influence is evident in most of the landscape images in *In the Sunshine of Neglect*. His style is characterized by attention to mundane details along with insightful juxtapositions, producing timeless documents that suggest profound importance.

This theme continues in the works of Chelsea Mosher, who photographed what she calls "a magical ranch in a canyon in Riverside." Sant Khalsa has been photographing the land from the personal perspective of an environmentalist and concerned photographer for over thirty years. Her work is well-researched and characterized by its meticulous framing and truly democratic compositions that masterfully disperse the pictorial elements across the picture plane. The land as metaphor for humanity is central to the *Parting of the Ways* (2018) series by Julie Shafer, who photographed along routes traveled by early European pioneers. One can imagine the awe and hardships they encountered, but also note the impacts of exploitation and excavation which left a silent, scarred land in their wake. That seemingly detached stance and lingering loneliness is also evident in the *No Lifeguard on Duty* (2005) images of abandoned pools by J. Bennett Fitts.

DISASTER

A sense of impending trouble if not outright disaster is a subtext in many photographs of the IE. There is something about the ennui of suburban sprawl and hazy smog, as well as the ever-present but subconscious knowledge that the earth could shake violently at any moment, that invites fantasies of destruction. Joe Deal's *Fault Zone Portfolio* (1978–1980) gelatin silver prints follow the veins of the San Andreas fault, a defining if

only occasionally felt presence. Noah Berger's *Embers From the Blue Cut Fire* (2016) near Lytle Creek radiates heat and light, as does *Desert Fire #1* (1983) by Richard Misrach. Fire is an ever-present reality when living in a drought-prone region, and while others fled the destruction, Stuart Palley rushed in to make pictures. His *Etiwanda Fire* (2014) and *Lake Fire Meadow* (2015) create a dilemma for the viewer: to revel in their beauty or be repelled by the death and destruction left in the wake of what they picture.

A nice contrast to the fire images with their heat, smoke, light, and testosterone, are Judy Chicago's *Snow Atmosphere* (1970) photographs documenting a performance that softens the mountains by bathing them in a billowy white, non-threatening smoke from harmless flares.

The suggestion of destruction past or future is seen in Corina Gamma's insightful images of *California Elegance (houses)* (2006) in Upland, California, where all appears calm. Sandbags by a barrier belie their elegant formality, implying the all-too-real devastation of flash flooding, while the serenity of *After a Flash Flood, Rancho Mirage, California* (1979) by Joel Sternfeld is a counterpoint to the terror of a flood-ravaged cliff that has plunged a car into a newly-made ravine on a residential street.

A subtle uneasiness emanates from Anthony Hernandez's 1979 gelatin silver print of *Public Fishing Areas #31* (1979). The mountains are veiled in smog in this stark landscape where a sunbather and her daughter relax in the foreground with a man wading to his thighs next to two trees inexplicably out in the water. They serve as the image's punctum, drawing our attention to their incongruous placement and destabilizing an otherwise banal scene.

MAN-MADE LANDSCAPE

Some changes happen slowly, and Judy Fiskin's images of humble homes and vernacular architecture in *35 Views of San Bernardino* (1974) could have been made yesterday but in fact are over forty years old. Mount Slover is an ever-present icon of the region whose limestone was a key ingredient in the concrete of the I-10 freeway and just about every other major regional concrete structure over the past 100 years. Lewis deSoto re-imagines the mountain, restoring it to its pre-concrete days as a ghostly presence, *Tahualtapa, Hill of the Ravens* (1983–1988) showing its 1,184-foot height prior to many decades of mining. That so much mineral has been removed but so much still remains is an apt metaphor for a region exploited for its resources, land, and people.

Mark Ruwedel's *Paintball Sites* (2012–2017) series fits into his interest in places and things that appear abandoned. Approached formally with meticulous compositions, they exude a sadness of place. The monochrome and softly lit landscapes are devoid of spectacular scenery, and there is a sense of tragedy to his work, as if these places were, or could have been, wonderful. This, of course, is the ruse of photography, Ruwedel's intention overwhelms any facts of the place, particularly those that might challenge the mood he creates. Gone are any splashes of bright color that might imply traces of visitors laughing and having fun. Conversely, Brett Van Ort also photographs a Corona paintball park with sites modeled after real battlefields for weekend warriors at play. Van Ort's color photographs are more Disneyland than Beirut, revealing the obviously staged artifice.

The peripatetic Douglas McCulloh often works within systems he creates for his photography. In *Dream Street* (2009), he won the opportunity to name a street in a new housing development and spent several years photographing the rise and fall of the homes through the housing bubble and bust. The resulting book is a tale of the underpaid piece workers and child laborers who have displaced union carpenters and sheet rock hangers, and the aspirations, both realized and lost, of the homeowners whose dreams were to have a place called home. Within similar suburban developments you can almost hear the screeching tires and smell the burning rubber in Ryan Perez's *I.E. Barbarians* (2015) series of skidmark donuts on cul-de-sacs. Aligning the horizon and using a consistent point of view, he creates formal images with inscrutable scribbles, reminiscent of Cy Twombly.

MEMORY

Photography and memory seem symbiotic but actually have an uneasy alliance. They can reinforce one another, but photographs can corrupt, allowing the repeated viewing of an image to displace or create memories, both real and imagined, of their own. Photographers prowl sites and respond to seemingly arbitrary objects and scenes to mine their own history, as Ron Jude does in his series *Lago*, exploring the desert of his childhood. Of course, similar images could have been made anywhere but what Jude does is remind us of the powerful intersection of vision, emotion, and memory. Where Jude wandered his childhood desert for memorable images, Tony Maher fabricated models of events in his life, both happy and sad. Knowing the pain such a memory stores, one can only flinch at *The Day Dad Moved Out, 1986* (2010), in which the shiny red Chevy sits in the driveway, ready to go. Dad is nowhere to be seen, but his presence is sharply felt and implied by the spotlight on the open car door and packed suitcase sitting nearby.

Personal documentary has been consistent throughout Christina Fernandez's career, where

she investigates the intersection of public places and personal identity. *American Trailer* (2018) is a commentary on the human condition and the deterioration of community, an idea continued in Larry Sultan's *Pictures From Home* (1991), a series about his aging parents, infused with the sadness of times past, and emanating a child-like desire to make things stay the same.

CONCEPTUAL

Photography as a conceptual documentation of performance is used by John Divola in the *Dark Star* (2007) series to record his mysterious, quasi-sinister orbs in abandoned buildings. Like a graffiti writer tagging at night, Divola's clandestine markings claim the space and project himself into it, acting as artifacts of performance and intervention.

Willow trees are familiar throughout Victorian cemeteries, inspired by Greek mythology and the belief that the fast growing trees symbolized rejuvenation and even resurrection. Robbert Flick is no classicist indulging such romantic notions. His *Willow130202a* (2016) and *Willow131217a* (2016) vibrate with life and light in composite images where a lone tree takes on the presence of a forest. Ellen Jantzen also uses digital technology, re-imaging the landscape and imbuing it with personal histories of time and place in her *Call the Wind* (2016) series, taking us on a journey similar to the traditional photography road trip.

Photographers have been compared, often unfavorably, to hunters with the obvious term shoot used for both guns and cameras. While we reject the violent and lethal aspects of the comparison, the notion of hunting for a subject that resonates is apt. Photographers may wander the space seeking that which, to paraphrase Lisette Model, hit them in the pit of their stomachs, signaling the moment to make an exposure. Hannah

Karsen's clear images of cryptic markings and juxtapositions of light and shape suggest the most personal of visions and transcend both time and place, leaving the viewer with an ethereal experience more than physical substance.

Experience is at the heart of the images suggesting altered states of mind in Naida Osline's series using psychopharmaceutical plants. Through careful and complex construction, her *Sacred Datura* (2010) floats above Riverside and signals its use by Native American shamans to transcend the physical world and achieve magical flights. Less psychoactive but nonetheless mind-altering are Andrew K. Thompson's unique objects. He cuts, sews, and otherwise reconstructs his landscape photographs into a commentary on the creative process and the places he photographs, particularly the neglected and scarred city of San Bernardino.

Aerial photography creates an abstraction of our familiar world and gives us the perspective of just how awesome the earth is, overlooking the dirty details of walking on the planet with its litter and debris. John Shelton is a geologist, pilot, photographer, and author of *Geology Illustrated*, considered one of the most influential geology books of the last century. A similarly detached approach is used by documentarian and Marxist Allen Sekula, whose work examines the structure of capitalism through a critical realism of images and words. In this case, the dismantling of the Kaiser Steel Mill. When read together, the two images in the diptych *Kaiser steel mill being dismantled after sale to Shougang Steel, People's Republic of China. Fontana, California. May and December 1993* shows the disappearance of equipment and the ensuing economic impact of globalization on our region and its once vibrant manufacturing base.

To quote Lewis deSoto, the IE is the land where "anything is possible but rarely occurs."[1] This is the place

of the abandoned Kaiser Steel Mill and its lost jobs, as well as those of the Santa Fe railroad. Does anyone remember the World War II prisoner of war camp in Pomona or Southern California's oldest Jewish cemetery in San Bernardino, or the Mormon settlers, or the Native American tribes who have lived here for centuries? Here in the IE we have the acrid smell of tires, oil, and smog mixed with the perfume of citrus blossoms, eucalyptus trees, and sage. The ever-present threat from the San Andreas Fault is just beneath the surface of every town along the freeways, and everyone's homes have cracked walls from the last rumble. Those glorious snowcapped mountains in winter become invisible smudges in summer. How many palm trees can you count and how much stucco have you seen beneath terra cotta roofs and manicured lawns in monotonous developments new and not so new?

The photographers gathered here ask such questions and see, hear, and smell these things and know them well. They seek clues that provide evidence of the unseen-but-experienced, such as the quality of light and air, the feel of the terrain, the movement and juxtaposition of the landscape, architecture, and people. Sounds, smells, signage, and roadways provide palpable, defining markers. Their photography tells stories, both personal and public, and they find the visual devices to do so in pursuit of their investigations.

NOTES:

1. "1. deSoto, Lewis, "Inland Empire," *Boom California*,
July 31, 2015 (website), accessed September 27, 2018,
https://boomcalifornia.com/2015/07/31/inland-empire/.

A Burnt Orange Sky: Photography in the Anthropocene Tyler Stallings

In the mid- to late-twentieth century, landscape photography was characterized by two trajectories. The first, which developed in the first part of the century, depicts nature as primeval, where humans are unseen for the most part, whether seascapes or desert locales. This view was often in service to environmental preservation efforts, epitomized by photographers such as Ansel Adams and Edward Weston. Then, in 1975, a landmark exhibition, *New Topographics: Photographs of a Man-altered Landscape,* dealt with what had been absent in images, hovering just outside the frame—human intervention in the landscape. Instead of transcendental scenery, industrial parks, factories, and urban sprawl came to the foreground. Three of the ten photographers included in *New Topographics*—Robert Adams, Lewis Baltz, and Joe Deal—are also represented *In the Sunshine of Neglect.*

This essay, *A Burnt Orange Sky: Photography in the Anthropocene,* extends these competing approaches from late-twentieth century photography into the twenty-first century by discussing the photography included *In the Sunshine of Neglect* within the context of the Anthropocene.

This is a new term that the field of geology has been considering for nearly twenty years. Presently, we are still in the Holocene epoch, which started 11,700 years ago as the glaciers of the last ice age receded enabling complex human civilization. However, some geologists have argued that humans now affect the earth more than natural forces. In order to argue for a new epoch, geologists require an environmental golden spike, as they call it, a marker of change the evidence of which can be found around the globe. In light of their new definition, they focus on the first detonation of a nuclear weapon conducted by the United States Army at 5:29 a.m. on July 16, 1945, as part of the Manhattan Project, also known as Trinity. The blast, along with subsequent ones, spread distinctive radiation around the globe, a clear mark of mankind upon the earth, detectible millennia from now when future archaeologists dig through sediments yet to be.

The majority of the *In the Sunshine of Neglect* artists were born in the Anthropocene, that is, after 1945, the year for the Anthropocene's designated golden spike marker. In addition, the preponderance of images from these artists selected by curator Douglas McCulloh present terraforming of the earth on such a scale that the effects of humans will survive through many eras. In this light, both the artists and their work can be recast as examples of "Anthropocene photography," a retroactive label based on this newly-defined era.

What led up to the atomic bomb, the Anthropocene's golden spike? It was the human discovery of not only how to tend a chance-ignited fire, but also how to create fire itself.

The discovery of fire by humans has led to technical marvels from rudimentary metal tools to satellites. It has allowed us to break down the hard fibers of plants and animal meat which improved nourishment to our bodies exponentially. While it increased our warrior strength with better weapons, it also increased our effect upon the earth. We have spread to every land mass, bringing wheels, sundials, gunpowder, trains, automobiles, nuclear weapons, and the internet. It has also brought us closer to cleansing the earth of humans ourselves through the same fire. Human ignition of fire has led to an overriding human imprint on earth, hence, the Anthropocene, and, hence, part of this essay's title, *A Burnt Orange Sky.*

In the Sunshine of Neglect includes several artists who have captured images of fire that embody both the ingenuous human pursuit of it that led to civilization as we still know it, and also images of fire out of control, as a result of our advancement. In effect, the presence of humans also means the presence of fire.

Will Connell's *Kaiser Steel Mill* and *Kaiser Steel Furnace* (1958) are images that take us back 6,000 years, when humans discovered the necessary temperature for extracting metal from its ore, including silver, iron, and copper. A knowledge of smelting led to hard implements in the Bronze Age when copper and tin were combined—coin currency and armaments—the ingredients of human progress.

Connell's factory settings also harken back to the beginnings of the Industrial Revolution in the eighteenth and nineteenth centuries. It was a time when a real sense of human mastery of the world gained steam literally, with the invention of the steam engine. It was a time when there was both an increase in the production of material products, which improved the lives of many people, and also technological changes that required more of earth's resources. This process has continued until the present, buttressed with escalating privatization of land and unaccountable corporations and nations.

Twelve years later, in 1970, Judy Chicago created some of her first *Snow Atmosphere* prints. These photographs document her site-specific pyrotechnic performance pieces. The works in *In the Sunshine of Neglect* document a performance in the San Antonio Canyon above Claremont where she used smoke-emitting flares to temper the dry, sharp edges of the landscape. For Chicago, her intention was to "feminize" the landscape through her action; made during a time when men occupied most of the positions of power in both the general culture and in the art world too. But, it was also an action that was emblematic of the rising voice of feminists and women in the art world then, often through performance, working outside the patriarchal structures of galleries and museums. The bottom line is that Chicago highlighted creation and beauty with *Snow Atmosphere,* rather than destruction and utility.

The settings that Connell and Chicago depict are dichotomous, the former destructive and the latter creative. However, the images in and of themselves are beautiful in their emphasis on primordial fire and effervescent smoke. In a sense they have taken Ansel Adams' (whose work is also in the exhibition) emphasis on an Eden-like quality of nature absent of human presence, and found beauty in human-generated fires.

Perhaps Richard Misrach's *Desert Fire #1* (1983) best embodies this notion. It is from a portfolio he calls the *Desert Cantos*, in which he has captured the adverse effects that *Homo sapiens* has had on the deserts of the US, ranging from environmental degradation to nuclear test sites. The choice of "cantos" is his way of evoking not only the idea of chapter breaks, but also a poetic, literary tradition. In this work, the beauty of an uninhabited desert is presented, underscored by the immersive experience of the large-scale photo, yet there is a fire. Its isolation within the landscape suggests that it could either be controlled burning by humans or a large-scale accident. In spite of the mystery of its source, the work evokes an ominous atmosphere in which humans have abused the western landscape—the region of the country often torn between conservation and extraction of resources as a result of its vastness and much of it being under federal jurisdiction.

Ansel Adams was only fooling himself and us with images that evoked a timeless, virgin wilderness, absent of sightseers. For a very long time, the wilderness has been both used and managed by humans. Today, even where there are few roads, there is management: wildlife is kept to certain population levels, fires are suppressed, non-native species of flora and fauna are removed. Wilderness management exemplifies extraordinary human influence on the landscape.

Yet, in California, despite this management, fires have increased and become more intense and while a few occur naturally, most are started by humans, either by mistake or intentionally. They are intensely hot as a result of a build-up of fuel from both management practices and drought, enhanced by the climate change brought on by humans. Some of the intense destruction and increased cost is due to the urban sprawl of more humans expanding cities and building homes closer to the fuel.

In the Sunshine of Neglect features several photographers who are also photojournalists documenting the fire seasons from Northern and Southern California.

Stuart Palley photographed two fires in the San Bernardino National Forest. *The Etiwanda Fire* (2014) was caused by an escaped illegal campfire, and *Lake Fire Meadow* (2015) is also believed to have been human-caused. They are part of his large-scale collection of California wildfires, *Terra Flamma: Wildfires at Night*. His nighttime work uses long exposures to capture flaming illumination, as if he were tracing the trajectory of stars that have fallen to the ground, as well as the destructive impact on the landscape.

Noah Berger's *Embers From the Blue Cut Fire* (2016) also documents the beauty and tragedy of peripatetic wildfires in the Cajon Pass, San Gabriel Mountains, and Mojave Desert in San Bernardino County. Palley's and Berger's images, when considered collectively, are post-apocalyptic in their increasing familiarity. Such scorched-earth scenes are now becoming part of our visual vocabulary, at least in the West, reinforcing a sense of the Anthropocene being visited upon us, with all its ash-laden forests and fire clouds in the distance.

But humans are not necessarily going to be erased from the landscape. There will just be fewer of them in these areas if the fires continue. Rachel Bujalski's photographs featured in *In the Sunshine of Neglect* focus on John Hockaday, who has lived off the grid in the Cajon Pass for many years and has written books that explore the region's history. He had a very close call with the 2016 Blue Cut Fire, the same one documented by Noah Berger. He saved his home by drenching it with water from a garden hose.

Continuing to weave this fiery narrative of a nascent Anthropocene photographic tradition, the survival of Hockaday presents us with an end to a classic narrative found in ancient mythologies and religious tales, often still recounted as if true: fire not only destroys but also purifies. It is a story of renewal, rather than an ending. It brings about change, which will be led by the human survivors (who are, of course, the ones telling these stories of destruction and renewal for their own benefit and hope). Hockaday is a version of the Old Testament Noah, but instead of surviving a cleansing flood, he endured fire.

Perhaps this tale of renewal is best told through the photographic medium. A photograph keeps in the present what was once in the past, both a time and a place. It is this indexical quality that can aid memory and help reinforce and shape our identity.

In this sense, Christina Fernandez goes beyond the indexical by overtly collapsing various time periods into a single photographic image that evokes both the landscape and the history that unfolds on it. In Agua Mansa she found a small, abandoned house trailer and documented it over time. Six months into her project, it burned. She composited the different time periods into one photographic image, *American Trailer* (2018). There is a singular trailer that is intact, once used, now cast-off, viewed at the left, but by the time your eyes have reached the right of the photograph, the trailer is blackened from the soot of the fire that consumed it. She uses the verisimilitude of photography to confound our

sense of what is real and not. It is a remembered place rather than a real place.

Constructing photographs in this manner may become the standard as the Anthropocene advances: stitching together fragments left over from fires that cleanse the earth of some of us and show us how our evolution has gone too far.

In the Sunshine of Neglect reinforces what the *New Topographics* artists emphasized, and intuited as more honest, which is the inseparability of humans and nature. We are part of and affect nature simultaneously. The built and managed landscape is nature in the Anthropocene. Instead of images of sublime landscapes that aim to transcend time and place, the human interaction with the landscape takes its place in the foreground. Instead of lava emerging from the core of the earth, spreading over the planet, as it did millions of years ago, we have Kaiser Steel spilling its blazing, metal contents, and we have wildfire. Beauty and harmony can be found still, but there is more for photographers to consider since the Anthropocene's demarcation in 1945 by a radiated mushroom cloud.

Boom and Bust at the Margins Joanna Szupinska-Myers

Driving west toward the Pacific, I pass a dozen or so independent cities and urban communities that mark my route. Departing from the California Museum of Photography in Riverside, I traverse Ontario, Pomona, Diamond Bar, Hacienda Heights, and Montebello along the 60 freeway, connecting to the 10 in downtown Los Angeles toward Culver City and Santa Monica. There exists no distinguishable line between Los Angeles County and the so-called Inland Empire; it is simply one vast expanse of development. Signs for gas stations, fast food restaurants, and big box stores dot the skyline as the landscape becomes ever greener along the route from east to west. Whether moving swiftly or over the course of hours in dense traffic, the freeway signs mark the progress of my journey and call up disparate memories from the better part of a lifetime as an Angeleno, every other exit conjuring not a generic idea of suburban sprawl but favorite restaurants, artist studios, and friends' homes (and, more accurately, their backyards) to which those exits lead. Having lived in Riverside for four years and worked here for six, it is a trek I have made on countless occasions. Despite any particular memories of stops along the way, at times I still get the sense—an experiential sensation more than a mental impression—that the whole earth rolls out before my wheels, endless in its urban and suburban development, and that we will all just continue driving forever.

Traveling east is another story. Continuing along the 60 through Riverside, I head past Box Springs Mountain Reserve and drive through ever more desolate terrain. The previous, seemingly inevitable, dense cityscapes drop away past the 76 gas station near my onetime apartment—nestled in a cluster of beige buildings where rabbit, hawk, owl, and coyote sightings were not infrequent—and give way to unmarked warehouses and eventually the rolling hills that rise up around my vehicle on drives to Palm Springs. Driving east calls up different memories: not of deadlines and social obligations but road trips, adventures, beginnings rather than endings.

Here the endlessness seems one of vast nature rather than urban sprawl. It is here, at the edge of that long stretch from the coast to the far end of Riverside, here straddling built and wild environments, that I begin to understand the word "margin." But this margin works in two directions: it is both the end of the sprawl, and also the end of the untouched earth. For the lizard and the snake it is the culmination of the wilderness, while for the artist the lack of expectations attached to the margin affords freedom and possibilities for experimentation. Such thinking, at least, seems to have guided the curator's organization of this exhibition. But is this inland region really as wild and free as such a visual contrast suggests?

Like my own apartment complex, many of the residential buildings in Riverside and San Bernardino Counties were built recently. Beginning in the 1950s, a succession of housing booms developed what had been small towns, founded in the previous century, surrounded by agricultural land. Laurie Brown's photographs take us to the moment of the earth's transformation from wild or agricultural to suburban during the most recent explosion of growth in the 1980s and '90s. In *Recent Terrains #7* (1991), tracks made by heavy machinery scrape into the earth of the picture's foreground, creating a dynamic, violent diagonal that comes toward the viewer as idyllic rolling hills adorn the horizon beneath a clear sky above neat ranchlands in the distance. Made in the early moments of Temecula's housing boom following the city's incorporation in late 1989, Brown's series documents bulldozer tracks and other evidence of the earth's transformation. Barren, unpopulated, her compositions recall the otherworldly planets of space photography. How is it that her camera has come to document progress from this very place, clearly neither a pedestrian-friendly nor particularly attractive hiking destination for even an able hiker? It is difficult to locate the body of the photographer behind the lens, as if it were a machine that landed

here to record the work underway, not a person. The unlikeliness of the views, paired with the absence of any people, echoes satellite imagery of Mars. In this way the photographs underscore the strangeness of our actions to and on the surface of our own planet.

Long devoted to documenting the changing landscapes of Southern California, for over four decades Brown has photographed areas of undeveloped land as they were being transformed into suburban spaces. Working in a style related to the *New Topographics* movement—which she first discovered in 1971–72 while studying with the influential photographer Lewis Baltz—Brown produces photographs in series, and composes reductive, straight-ahead shots that some have called "objective." Here, however, her panoramic framing and from-the-ground vantage point create a foreboding view rather than a clinically objective one. This uncanniness is heightened by the passage of time, as we now associate her so-recently desolate landscapes of Temecula with built environments that already house over 100,000 people.

We experience a similar effect through the photographs of Herb Quick. In *Riverside (Grading)* (1987), fresh black asphalt slopes down to a large single-family home with three-car garage. To the right, beyond the nearly pristine concrete drainage gutter lays an untended mound of dirt and rock topped with desert shrubs, earth waiting to be leveled. Marking the otherwise wild landscape, the first roads, street signs, and house reveal the grid that will define a neighborhood, and the artificial Cartesian logic that will shape the real lives of those who must inhabit it. The house is built in the cookie-cutter style of housing tracts, but stands alone in the frame, surrounded only by empty lots. After all, someone had to be the first. Surrounded by wilderness atop a cliff, we become aware of the home's likely distance from grocery store, hospital, any of the services that might help resolve an urgent need, to say

nothing of cultural institutions like libraries, museums, or concert halls. Situated at the crossroads of a three-way intersection, the photographer's view heightens the home's sense of precariousness as it faces the perils of both wild and urban landscapes. Centered at the bottom of the road, wilderness still at its doorstep, it is also at risk of civilization itself, located in the perfect spot for a driver speeding past the stop sign to smash through the front door.

The American Dream found the expansive and available terrain in Inland Southern California just as many in the urban middle class sought to get away from the density, high crime rates, and troubled public schools of Los Angeles during the last quarter century. Moving east became a promising solution. In Corina Gamma's *California Elegance (houses)* (2006), stately two-story homes look out over a lake that is part of a flood control project in Upland. It is an idyllic picture of the affluent lifestyle, comfort, cleanliness, and safety that the growing population sought. But the days of manicured lawns and air-conditioned living rooms were numbered. Foreshadowing the financial crash of 2008, a hazy grey sky looms large above the strip of earth below. Indeed, when the recession hit, it hit the Inland Empire hard. Many subdivisions of homes such as these were built and sold simultaneously, underwritten by unsound mortgage agreements that led to nearly simultaneous bank foreclosures. Whole communities were deserted and soon fell into disrepair.

Scarcely a decade out of the housing crash, the disenchantment with the Empire's version of the American Dream lingers, but industry and social life go on. Thomas McGovern frequents the National Orange Show swap meet in San Bernardino, and in 2014 began photographing sellers, their booths, and their goods for sale in the series *Swap Meet: This is San Bernardino* (2015). His pictures allow us to attend to the cracked parking lot asphalt, punishing sun and deep shadows, and arrangements of objects displayed on

temporary stands, haphazard counters, and sheets laid directly on the pavement. Bright citrus is sold directly from the back of a pickup truck, shampoos and other hair products weigh down a folding table, and ladies' undergarments are hung on plastic hangers from the aluminum frame of a booth. Whole families of vendors and customers pose smiling for McGovern's camera, and he rewards their generosity with prints on subsequent visits. But no one is immediately recognizable under the blue tarp in *Untitled* (2015). Beneath the tarp, we glimpse only four people, turned away from the camera toward a counter crowded with pastries. The frayed sheet casts the dark line of a shadow on their bodies, shading the booth as well as protecting the identities of the customers. The composition, with this delicate temporary construction nearly filling the frame, speaks to an imperfect, hand-made modernism that stands in contrast to Gamma's landscape of pristinely fabricated, just-built homes.

Decay over time is a theme that appears throughout this exhibition, following an arc that begins with mid-century optimism and ends in a less than optimal present. Christina Fernandez's *American Trailer* (2018) is a composite image of a travel trailer sitting in a wrecking lot in Agua Mansa. Evoking getaway weekends and the enjoyment of contemporary comforts while exploring the great outdoors, the travel trailer is the ultimate symbol of American leisure culture and middle-class aspiration. Over the months that Fernandez photographed the vehicle, it caught fire. She shows us the stages of its demise from left to right, from a slightly worn, rusty exterior, to charred and crumbling metal. But green grass, full trees, and bright sky remain all around, perhaps a hopeful setting for possible rejuvenation—if not for the trailer, then for our aspirations.

In the second half of the twentieth century when Herb Quick and Laurie Brown were working, the American suburb was still the primary destination

for an image of a prosperous form of life. Visible in their photographs are stretches of Inland Southern California in human-imposed transition from semi-arid landscapes of sand, earth, and sky as they were being sculpted into rolling hills that are now dotted with houses, trees, and lawns. Such housing is only possible with massive infrastructure projects that allow for the constant movement of people, electricity, and water. We see in those earlier photographs not only documents of fateful and fleeting moments—the first phases of transition between natural and built environments—but prescient warnings of our current reality.

The theme of artificiality continues through the mid-aughts in the work of photographers such as Corina Gamma, who shows us horizons dotted with identical doll-like houses. These represent the tastes of a new generation of elegant suburbanites who took on unprecedented amounts of debt in its pursuit of college education and homeownership. Since the Great Recession, our understanding of the American suburb has shifted in terms of both our environment and our economy. Christina Fernandez's burned out trailer stands as a symbol of loss and disappointment. But if some of these pictures seem critical, it is not for a lack of love or commitment to the place. Thomas McGovern's photographs of the swap meet pay homage to a new optimism—not one of cookie-cutter houses and giant swimming pools, but the humanity behind any major endeavor. Lest my narration of the Inland Empire's mid-century development of the suburbs, turn-of-the-century mortgage boom, and subsequent housing crash strike a negative chord, let us consider all those who have remained here, building full lives and communities. Here at the edge of the urban sprawl, between city and nature, is a margin of promise and possibility, if sometimes disillusionment.

Transect 05: **Speculative Terrain**

OBSERVATIONS

We can only photograph the present, but photographers look to the future. "When a photographer chooses a subject," writes *New Topographics* photographer Frank Gohlke, "he or she is making a claim on the interest and attention of future viewers, a prediction about what will be thought to have been important." Photography is a speculative undertaking, and each photographer speculates in her own way.

Philip K. Dick is a quintessential Southern California writer who directed dark eyes toward the future. "I have never had too high a regard for what is generally called 'reality'. Reality, to me, is not so much something that you perceive, but something you make. You create it more rapidly than it creates you."

ARTISTS/WORK

Ellen Jantzen [pages 199–200]

Ellen Jantzen's photographic constructions are hybrids—a real place combined with a purely mental space. Her start point in this case is a photograph of an immense field of Vestas wind turbines in the San Gorgonio Pass. One might assume this is a sufficiently surreal place in its own right. It's a vivid, memorable landscape, essentially industrial in nature—4,000 turbines in a stark desert setting. In season, cars with out-of-state plates clog the shoulder of Interstate 10 as cell phone cameras send dispatches to the world.

Behind the turbines, in Jantzen's image, rises the steep face of the San Jacinto massif. It seems familiar. Where is Chino Canyon and the thin line of the Palm Springs Tram? Take another look. What are those mountains? And in what circumstance does the sky invade the land? Jantzen thinks the landscape of the American West is fraught with cliché, so she injects her own point of view. The work is both window and mirror—an observed

state combined with the artist's inner state. "I merge the observed environment with my internal intuition."

Ansel Adams [pages 201–202]

Fiat Lux is the largest photo project photographer Ansel Adams ever tackled, (his lifelong Yosemite obsession aside). It is not too much to say that *Fiat Lux*, from which these two photographs are drawn, pushed the iconic landscape photographer off-center.

Previously, Adams had concentrated on photographing epic remnants of nature in California and the West. With *Fiat Lux*, a multi-year commission from the University of California, he found himself in his sixties, clambering across building rooftops and agricultural preserves. Instead of Half Dome he focused on craggy professors.

In addition to this radical shift in subject matter, his project sliced through the tumultuous 1960s. While Adams worked, society—and photography—changed beneath him. The *Fiat Lux* project began in 1963. Clark Kerr, visionary UC president, commissioned Adams and writer Nancy Newhall to produce a portrait of the sprawling nine-campus empire. By 1964, students with bullhorns were atop police cars at UC Berkeley. Then came Vietnam War protests, civil rights marches, and tumult. The 1960s also pushed photography toward new obsessions: alienation, critique, sexuality, obscenity, and violence.

By the time *Fiat Lux* circulated as a book commemorating the UC's 100th anniversary in 1968, Bobby Kennedy and Martin Luther King were dead. UC campuses were overrun with student activists and the scent of tear gas. New California Governor Ronald Reagan had fired Clark Kerr. *Fiat Lux* reveals Adams' fight to master new subject matter and struggle with changes in photography. The overall archive reveals a refreshing off-balance rawness absent in his romantic depictions of pristine landscapes.

Lewis deSoto [pages 203–206]

Lewis deSoto's *Empire* panoramas are crafted constructions, but the artist hides his hand. They begin as up to two hundred photographs made with a handheld digital camera. He does not use automated image stitching software but instead painstakingly assembles and adjusts, warps and smooths in Adobe Photoshop. The photographs appear to represent a single instant, but the artist has abandoned the decisive moment for prolonged, compound time. Artist Sant Khalsa comments, "deSoto's practice fuses reality, time, and meaning. We are sited with deSoto in the landscape, bearing witness, standing still, in an extended moment."

Lewis deSoto is Cahuilla. Both panoramas were made near the area landmark known to the Cahuilla as *Tahualtapa*, the Hill of the Ravens. In *Grand Terrace, July 2012*, the blasted off remnant of what became known as Mount Slover is visible toward the left side of the image beneath the high voltage transmission lines in the middle distance.

The artist's deep identification with place is the heart of the work. He grew up in San Bernardino along Route 66, three blocks north of the Wigwam Motel's thirty-foot concrete tepees. He studied with Joe Deal at University of California, Riverside, and left at thirty-one for photography professorships in Seattle then San Francisco. But deSoto's soul and his art continue to revolve around the place he calls the Empire. In an important sense, he never left. More accurately, the place never left him.

Leopoldo Peña [pages 207–210]

"I'm attracted to contradictions in the landscape," says photographer Leopoldo Peña. "That's what I find myself wanting to photograph." Peña pursues photographs that pose questions about belief and ideology. What is the end point of a culture of extreme production and extravagant waste? What happens if society's

paramount value is the development of desire without limit? He asks: "How have people become convinced that because the land is open, it has no value? That they can just dump something and escape?"

It's no accident that Peña's elegantly critical landscapes have an intellectual underpinning. He's been a graduate student at the University of California, Irvine, for six years. His PhD thesis focuses in part on a tight circle of artists and photographers who orbited through Mexico in the 1920s and '30s—Edward Weston, Tina Modotti, Paul Strand, Anita Brenner.

Peña's extended engagement in the inland area began with visits to his brother and family. They live at the east end of Moreno Valley where the housing tracts give way to rocky outcrops (in Spanish: peña). From that base camp, Peña has wandered ever wider, looking at the land, its uses and abuses, from a critical position, exploring our culture of consumption. He does not hesitate to interrogate himself. "The idea of consuming and discarding applies to photography as well. Our age is marked by the overproduction of images. And they come to mean less and less. So I always question: Why am I taking this photograph?"

Ellen Jantzen, *Call the Wind One*, 2016

Ellen Jantzen, *Call the Wind Two*, 2016

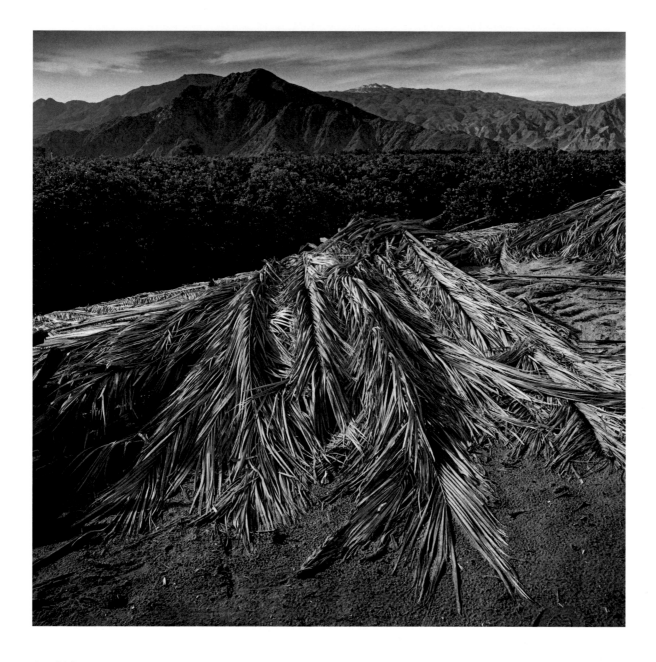

Ansel Adams, *Palm Leaves Near Palm Desert*, 1966, © Regents of the University of California

Ansel Adams, *Campus Scenes, UCR*, 1966, © Regents of the University of California

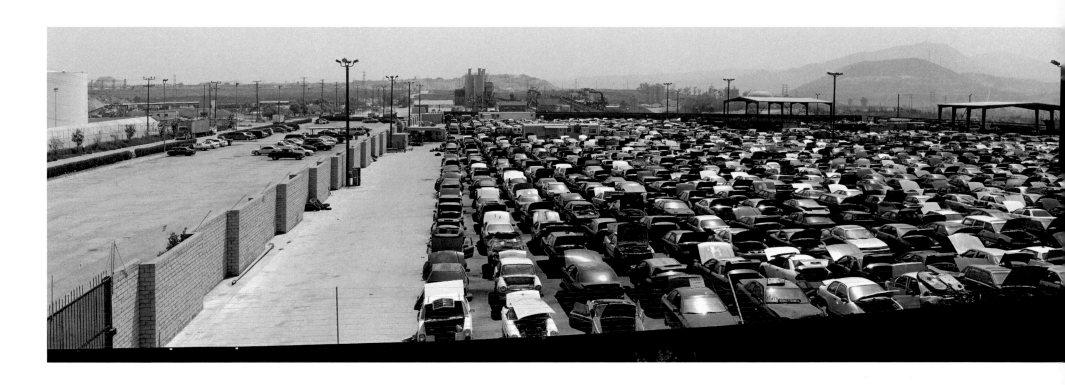

Lewis deSoto, *Agua Mansa, July 2012*, 2012

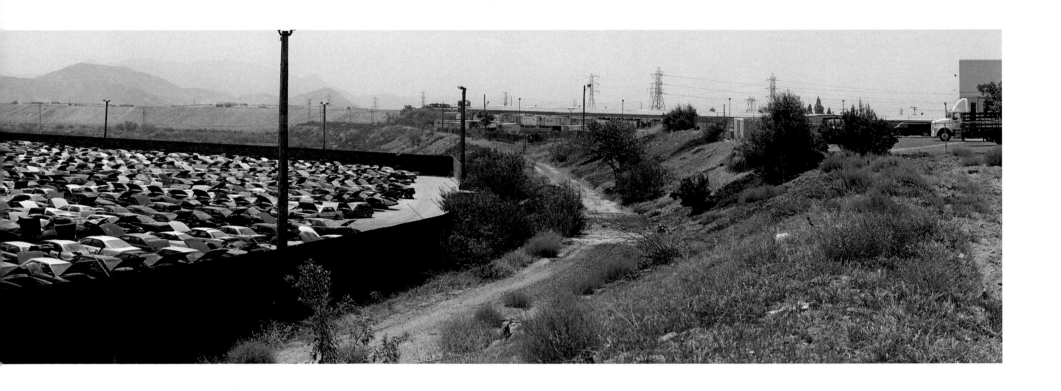

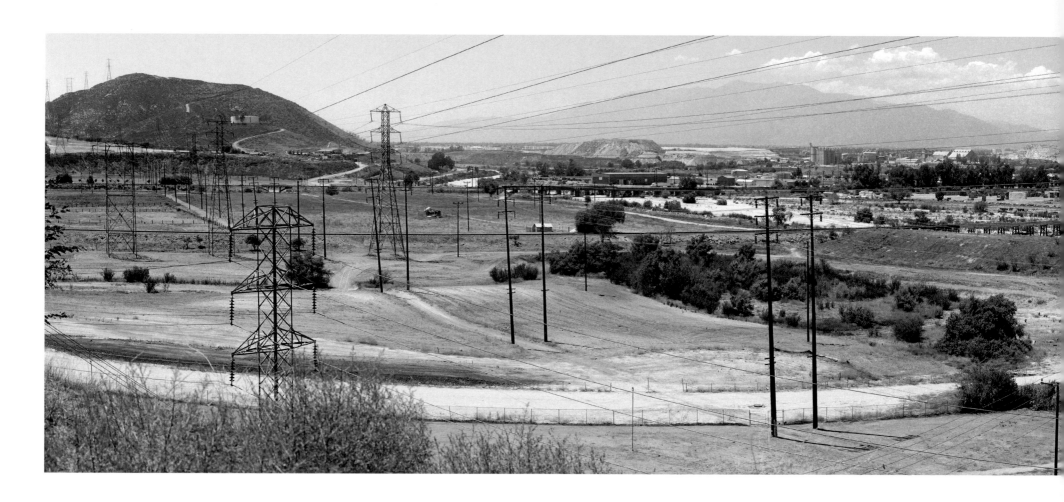

Lewis deSoto, *Grand Terrace, July 2012*, 2012

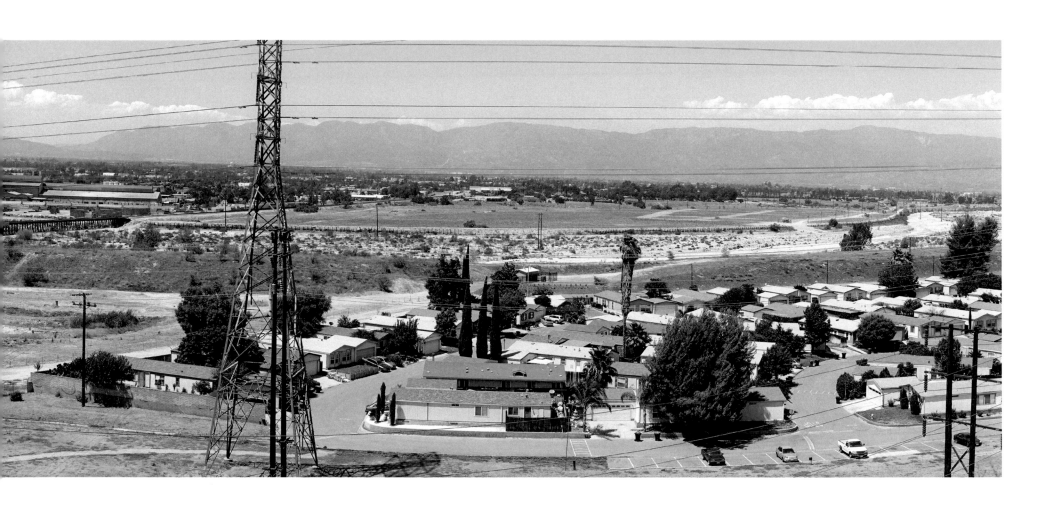

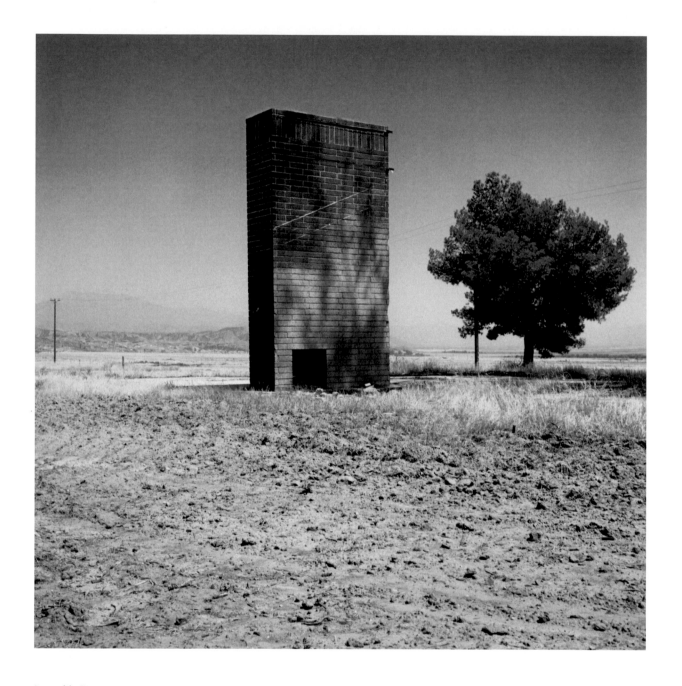

Leopoldo Peña, *Chimney, Moreno Valley*, from the series *Desert Errant*, 2015

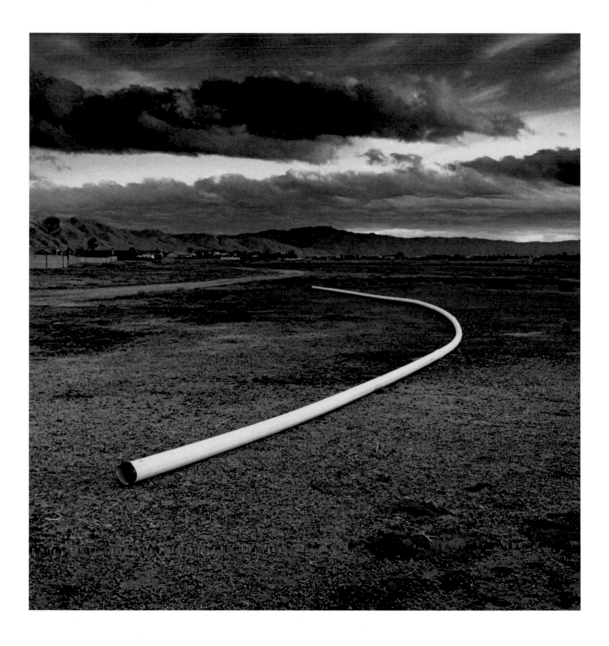

Leopoldo Peña, *Pipe, near Victorville*, from the series *Desert Errant*, 2013

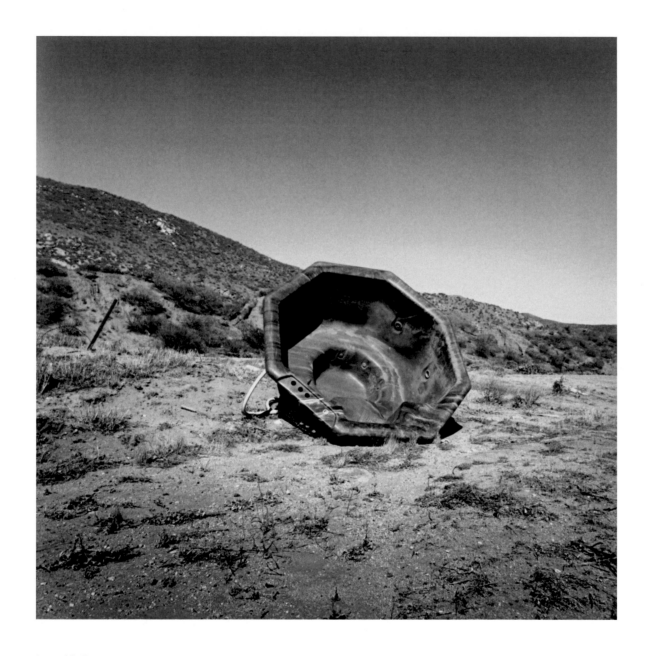

Leopoldo Peña, *Jacuzzi, Jurupa Valley*, from the series *Desert Errant*, 2014

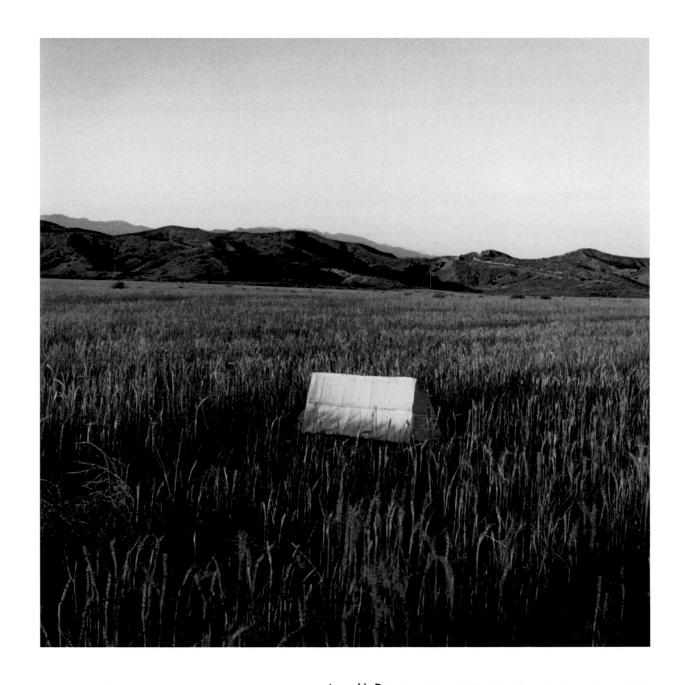

Leopoldo Peña, *Box, Moreno Valley*, from the series *Desert Errant*, 2014

Transect 06: Peripheral Visions

OBSERVATIONS

Inland Southern California is a periphery, a margin between Los Angeles and the desert. But even edges have edges. Some photographers of *In the Sunshine of Neglect* have decided to operate at the periphery of the periphery. They have produced distinctively linked work.

The inland region is defined by topography. Hills, ridges, and the area's highest mountains define the perimeter. Fault-formed gaps puncture passes into the rim of the great western deserts. This container of geographic constraint is inhospitable to wholesale development. Some mountains are too rugged to scrape or terraform, hills too unstable to subdue and subdivide. Consequently, nature maintains a toehold of a sort on the edges.

Robbert Flick, Sant Khalsa, Meg Madison, and Ken Marchionno have all undertaken projects on these peripheries, and all use the language of photography as a means to interact with the natural world. Almost inevitably, these artists have also aligned their practice with the patterns, the rhythms , even the time scales of nature. Flick has returned again and again over eight years to the hills above Pomona. Marchionno practices a photographic meditation , walking over and over into the space outside his home/studio in Crestline and deeply engaging with a small slice of forest. Khalsa's *Growing Air* project reaches back to 1992 and will continue far beyond her lifetime. Images cannot mimic the sublime, but they offer hints of the ineffable. Khalsa has manufactured a forest as a gesture of restoration and an artistic act.

"Working in the inexhaustible natural pageant before me," wrote photographer Sally Mann, "I came to wonder if the artist who commands the landscape might in fact hold the keys to the secrets of the human heart: place, personal history, and metaphor." In the end, these artists do not hold themselves separate from the living world they photograph. They are embedded, joined. Ultimately perhaps, it is through their eyes that the natural world perceives itself.

ARTISTS/WORK

Robbert Flick [pages 215–216]

Robbert Flick refers to his willow photographs as "extended views" —an ongoing documentation of a selected site over time. "The 'extended view' allows for the tracing of shifts in appearance and representation of the same subject matter while questioning media related phenomena." The photographs were made at Frank Bonelli Regional Park in the hills north of Pomona. Flick has been a habitual park visitor for the past eight years. (Bonelli is a ten-minute drive from his house in Claremont.)

For many decades, Flick has taken orthodox landscape photography—engagement with a place, landscape as description—and radically expanded it. His work is built from continuing personal interaction and extended engagement. His extensive use of expansive grids connects him with broader fields of art. The results are sumptuous patterns of image and meaning that convey idea, emotion, and beauty. The traditional shutter click of the single image opens one window on a landscape. Flick runs pell-mell around the whole house of photography, throws open every shutter, takes in every view.

The willow photographs also become a dance with serendipity, as he says, "inadvertently, contextual processes such as the tending of place, shifting climate conditions and cultural changes become visible."

Sant Khalsa [pages 217–219]

Sant Khalsa has a decades-long artistic engagement with the forests and ecology of the San Bernardino Mountains. Her projects in the exhibition share a focus on the cyclical nature of life, destruction, and creation.

Trees and Seedlings lean against the wall like planks. The reference to a lumberyard display is intentional. Each poplar slab displays a high contrast gelatin silver transparency of burned trees in the San Bernardino Mountains. For Khalsa, they represent the cycle of life and the "memory of the forest."

Capsules was done in collaboration with artist Charles Morehead. Small wood specimen cases display photographs made in the 1980s and early '90s. "The sites have drastically changed since I made these images," writes Khalsa. "The photographs serve as evidence (or a specimen) of that moment and place. The work also is a response to how landscape photographs are often treated as more valuable and precious than the place they represent. They ask us to question how an image encased in a capsule can possibly replace the real—nature or any experience."

Growing Air focuses on what Khalsa calls "my forest." In spring, 1992, the artist planted more than a thousand ponderosa pine trees in Holcomb Valley near Big Bear. It was part of an effort to restore clear cuts that date to Southern California's 1860s gold rush. Khalsa's trees, now 30 to 40 feet in height, are generating their own seedlings. This is self-perpetuating art, art that generates new art.

Meg Madison [page 220]

Meg Madison's six-part cyanotype is a life-size photogram made in Holcomb Valley just north of Big Bear. The artist hand coats watercolor paper with potassium ferricyanide and ferric ammonium citrate. The resulting iron-based emulsion is mildly sensitive to any ultraviolet light source, such as sunlight. The formula has long been used for blueprints.

And who is the figure? Who did Madison persuade to lie in a forest glade stock-still for a seven-minute exposure under the summer sun? Sant Khalsa, the creator of that very forest. In 1992, Khalsa planted more than a thousand ponderosa pine trees in a Holcomb Valley restoration project. A photograph of Khalsa's forest is included in this exhibition. (In a photographic side-note, British botanist Anna Atkins used this exact process in 1842 to produce contact cyanotypes of seaweed and algae. By doing so, Atkins became one of the earliest female photographers and the first maker of a photographically-illustrated book.)

For Madison, the piece is as much a performance as a photograph. Madison regards her subjects as "co-performers" making a record of a "body-land connection." The ingredients are paper, iron salts, fallen branches, wind, air, sun, and one human. In a final connection to basic elements, the development of a cyanotype is effortless. Simply rinse in water. This photogram was developed in lake water on the north shore of Big Bear Lake.

Ken Marchionno [pages 221–224]

Ken Marchionno's panoramic views are sight distilled. Each photograph captures a 360-degree sweep. They're assembled out of sixty to one hundred high resolution photographs. This is concentrated observation, the reduction of time and presence into image.

Marchionno leaves his house/studio. (It's perched on the steep north-facing slope near Lake Gregory in Crestline.) He walks. He finds a spot in the woods, or perhaps near the lake. He sits. Sometimes he lies down. He absorbs the scene. It's a meditative process. He says he doesn't seek the extraordinary, but the everyday, the mundane.

The artist is already close to nature, embedded actually. Then he uses a lens that pulls subjects even closer— a telephoto lens, a Nikon 180mm. In one further step he sets the focus at the closest possible distance—exactly five feet. And sets the depth of field at the minimum — f/2.8.

It's a Zen practice. Direct presence, bare awareness. Respectful attention, possible illumination. Over five or ten minutes, Marchionno shoots an overlapping sweep of images. The assembled images are drenched in time. They feel less like a photograph and more like a memory.

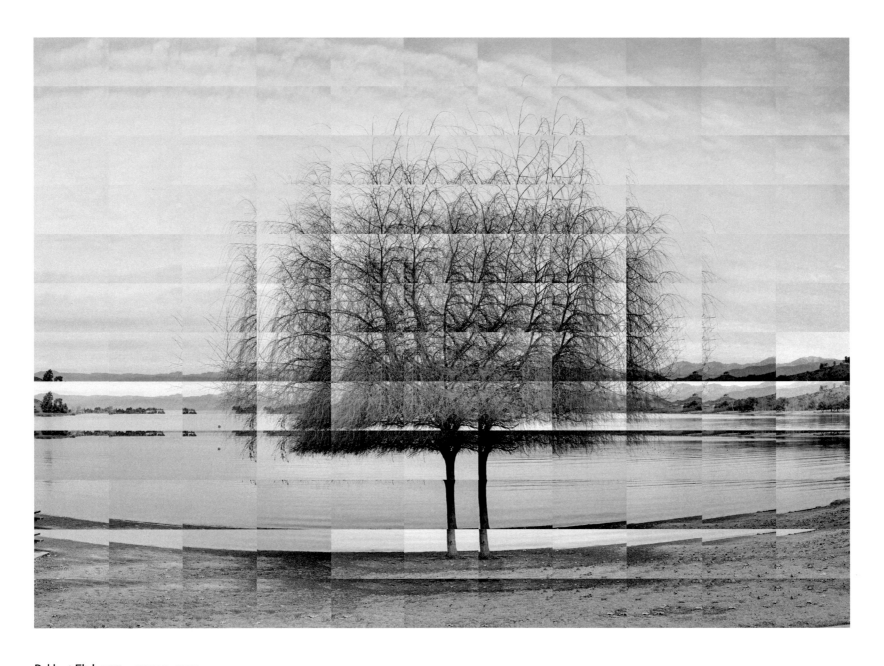

Robbert Flick, *Willow130202a,* 2016

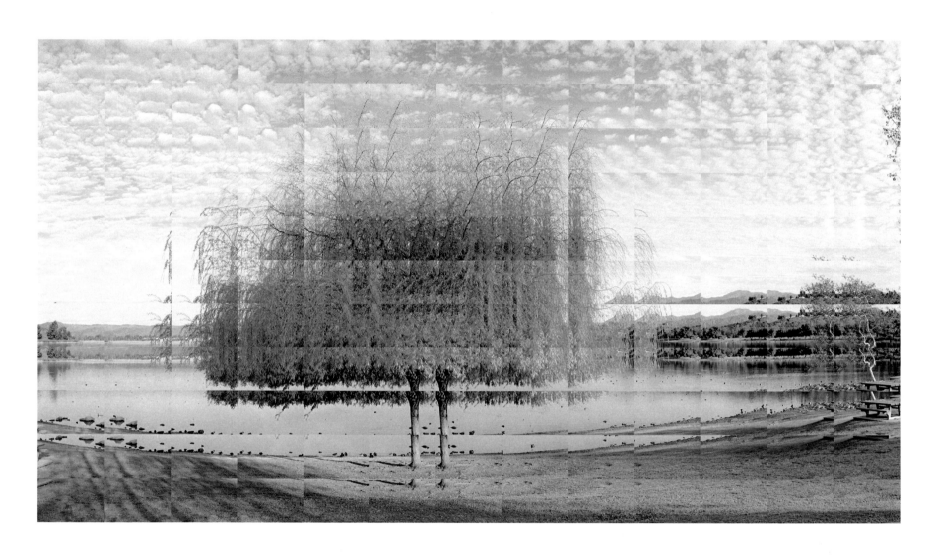

Robbert Flick, *Willow131217a*, 2016

Sant Khalsa, *Holcomb Valley (Ponderosa pines planted in 1992,* from *Growing Air)*, 2017

Sant Khalsa, *Trees and Seedlings*, 2000–2009

Sant Khalsa and Charles Morehead, *Capsules,* 1993

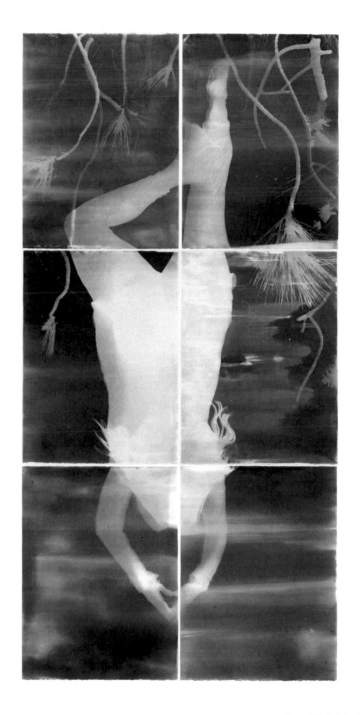

Meg Madison, *Planted, Big Bear Lake, A performance in the forest with Sant Khalsa*, 2018

Ken Marchionno, *Crestline Panorama 05 (Home)*, 2016

Ken Marchionno, *Crestline Panorama 11 (Lake Gregory)*, 2016

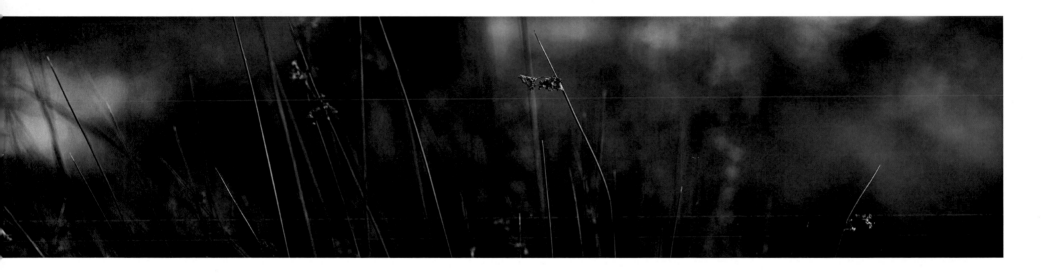

Transect 07: **Contested Landscapes**

OBSERVATIONS

Photography is social and political. Images pose questions, make claims. Photographs of Inland Southern California reveal a contested landscape.

The West has long played a major role in US photography. Early photographers concentrated on the romantic, even mystical qualities of sublime natural landscapes. Ansel Adams, Edward Weston, and many others produced accomplished images of powerfully wild places untainted by human encroachment. But photography bent another direction in the 1960s and '70s. The sharpest turn was signaled by the hugely influential 1975 exhibition: *New Topographics: Photographs of a Man-altered Landscape*. Photography pivoted from natural grandeur to the built environment. *New Topographics* photographers came to regard epic photographs of natural remnants as feebly decorative at best, sentimental and evasive at worst.

It's hard to drive around the 27,000 square miles of Inland Southern California without arriving at a *New Topographics* viewpoint. Look as long as you like. You'll not find El Capitan or the picturesque wind-bent cypresses of Point Lobos. How about a warehouse, a littered lot, a housing tract? Certainly, how many would you like? We conquered the West, but what have we done with it? Critique is inherent. What has become of the land? How, camera in hand, can we face it? What better place to ask questions and seek answers than in the sunshine of the neglected outskirts, the periphery?

What do we find? Ron Jude gives a bullet-riddled *Horno de Microondas* box. J. Bennett Fitts, an empty motel swimming pool on the desert's edge. Kim Stringfellow, a detailed overview of streets, rail lines, and industrial plants. Tony Maher, arbitrary landscapes centered on discarded furniture. Hannah Karsen, a mousy brown granite outcrop painted, repainted, and overpainted again. So what are our answers? The evidence is partial, the testimony cryptic. But the aim of a worthwhile project is to ask questions so ambitious that photographs cannot fully answer them.

ARTISTS/WORK

John S. Shelton [pages 229–232]

John S. Shelton was a pilot, pioneer of aerial photography, and professor of geology at Pomona College (possessor of a PhD from Yale). Shelton began flying and making photographs in the 1940s. He used a military aerial reconnaissance camera that produced large negatives and tremendous detail. He logged almost 6,000 hours of flight time, primarily across the American West.

Shelton's initial purpose in making aerial photographs was to illustrate dynamic geological processes: uplift and erosion, faulting and deformation. But aerial photography became a passion, an obsession, and an art. By first hand account, Shelton was a skilled pilot with a fearless streak. He would tilt or dive his small plane to achieve the angle of view he desired.

The photographs in this exhibition demonstrate Shelton's flare for the dramatic. Buffeting Santa Ana winds tear streamers of dust from the "vineyard district" that then surrounded the crossed arms of Ontario Airport. Shelton laconically notes that wind speeds at takeoff were sixty-seven miles per hour and that he climbed through 16,000-feet of turbulence to take the photographs.

Shelton's aerial photographs finally became the memorable heart of his classic book, *Geology Illustrated*. The 1966 publication was named by *American Scientist* magazine one of the one hundred most influential science books of the last century.

Ron Jude [pages 233–236]

Ron Jude's *Lago* project revisits his early childhood on the edges of the California desert. The project is autobiographical, but the photographs are glimpses, speculative retrievals. Jude's subject is not fact-finding, but the thin fabric of recollection itself, "the gap that exists between the smooth edges of memory and the staccato nature of actual experience." The images are elusive and elliptical, "more psychological than political." They offer found objects, restrained metaphors, and three-hundred-square-miles of uncertainty.

Jude spoke with writer Brad Feuerhelm in 2015: "I made my first trips out there with the simple aim of looking at a landscape that I hadn't seen since 1969. I wanted to see if anything seemed familiar, or if the place stirred up any latent memories. What I found was that my moments of recall had far less to do with narrative than any other place I've spent time in. The desert holds my earliest memories, and they're more like flashes than stories. . . . I also encountered death, physical trauma and solitude for the first time while living in the desert. It was a perfect formula for the existential perspective that's been with me for as long as I can remember. I see the desert landscape as the physical embodiment of this perspective. At this point in my life, I see the desert as an indescribably beautiful place, but as a four year-old it was fraught with daily struggles, both physical and psychological."

Kim Stringfellow [pages 237–238]

Desert is the home habitat and operating territory for artist Kim Stringfellow. Her photographic and multimedia projects have ranged widely, from the eastern Mojave south to the Salton Sea and north to the Owens Valley. Mojave Narrows, the subject of her two photographs, is on the fringe of her normal zone of focus, closer to the inland basin than the deep desert, but it is a place laden with history and metaphor.

The Mojave River rises from the desert side of the San Bernardino Mountains and flows 110 miles northeast into the sinks and wastes of the eastern Mojave. Except that flow is a misnomer. It is underground nearly its entire course. In 1826, Jedediah Smith followed the Mojave Indian Trail west, becoming the first American to reach California overland. He called it the "Inconstant River." The Spanish termed it *Río de las Ánimas*, River of Souls. The bedrock gorge of Mojave Narrows at the edge of Victorville is a rare exception. An impermeable granitic plug forces the water to the surface.

Stringfellow's work tends toward the speculative, the concealed, the immersive. These photographs exhibit the flat affect and clear-eyed description of *New Topographics*, but they depict an oasis, marred and modified by man, but an oasis nonetheless. A river appears from nowhere, flows for a mile, then sinks again below the sand.

Alia Malley [pages 239–240]

"I consider these photos revisionist landscapes," comments artist Alia Malley. "They exist in the space between traditional, historical landscape painting and vehemently realist photographs—they are documents of our time, showing us what this place looked like on a certain day at a certain time."

Malley's *Southland* photographs are pastoral and painterly. The colors are muted, the lighting soft, the locales unremarkable. Her calm, accepting images feel like they exist outside of time. Photographs, of course, change the way we see. Extreme cases spring quickly to mind. Outlandishly remote places—Mars!—brought close, meteoric velocities frozen, the impossibly vast or microscopic made visible. But this function is often more subtle and Malley's photographs offer an example.

On first view, the places she shows us seem nondescript, everyday, fallow. Look long enough, however, and we realize their central characteristic: familiarity. These are places which are everywhere and could be anywhere.

This is the sprawling landscape we pass through endlessly on our way to small islands of 'actual' places. Malley calls it the "landscape of currently disused spaces," "in-between sites." The artist has recalibrated our sight. She has pointed us toward ubiquitous, unnoticed, interurban landscapes, standard to much of the world, familiar, banal. Seeing is not as simple as looking. Mysteries are layered into the everyday, waiting to be perceived.

Hannah Karsen [pages 241–242]

Hannah Karsen seems to specialize in poetry made from the evidence. Her photographic pathways are largely poetic pursuits—exploratory, suggestive, attuned to what she calls "metaphysical subtleties."

She describes her central interest as the "ephemera of occurrences." The photographs in this exhibition are certainly examples. A tangled pattern of golden stems offers evidence of passage, a subtly delineated path. A shallow eroded granite surface is painted, repainted, overpainted. But the pathway leads nowhere in particular, and the painted surface yields no message.

These images arise from fleeting encounters with transitory conditions. They carry no narrative arc, no beginning, no end. Careful attention gives us reflective reports. But our view is limited. The focus is tight and the traces faint. Karsen is unafraid of cyphers, openness, gaps in understanding. Her goal, she says, is to explore sentimentality, the "limitations of emotion or feeling," and the task of "trying to connect visually to one's surroundings and its subtleties." Karsen's 2016 master of fine arts thesis statement has an epigraph from writer Rainer Maria Rilke: "And I seem to myself like a photographic plate which is exposed too long, in that I still lie open to what is here, this powerful influence."

M. Robert Markovich [pages 243–245]

It's called the *Near* series—"close to a place, but never quite there." This is reinforced by Markovich's titles: *Near Mount Rubidoux, Near Oak Glen, Near Crestline.*

We can add another: near natural. The images depict nature as close to untrammeled, but not quite. Human intrusions are woven throughout. A path, a fence line, a fallen wire, a double white ellipse of sewer manholes. We seek the signs of man's stamp. Did you find the sun-bleached beer can in the spring grass?

Changing camera technologies are another "near." These images have made the leap from film to digital. Markovich worked on his expansive *Near* series through most of the 1980s. He used a tripod-mounted field camera to shoot four- by five-inch color negative film. He managed a commercial color lab at the time, developing his film and making personal prints in off hours. Roseate flares, clamp scuffs, and chemical stains reveal the film origins. (And the black film holder edge—the shadow of the camera.)

But these are digital prints. "I am now in the process of scanning the original color film and re-printing the body of work as archival digital prints," he explains. And so, these are 'nearly' film photographs.

J. Bennett Fitts [pages 247–248]

Large cars and cheap gas. Brenda Lee crooning "I'm Sorry" on every small-town radio station. Nineteen-sixties motels and the summer vacation road trip. Southern California photographer J. Bennett Fitts traveled 20,000 miles across America making luscious large-format photographs of abandoned swimming pools. Inland Southern California offered him a rich array.

Fitts's photographs have the feel of a fading memory. Was this how we lived? How did we lose it? The sign by the sod-covered pool still reads "NO LIFEGUARD ON DUTY." Is this a simple caution? Or is it a warning about life in America?

The project sets off from a three-way intersection: Ed Ruscha's pool pictures; Bernd and Hilla Becher's topological inventories of obsolete architectures; and Richard Misrach's sumptuous color captures of metaphoric landscapes. But Fitts takes his own road. He dispenses with the quasi-science of topologies, the

deadpan cool of *New Topographics*. These photographs are unapologetic elegies. They are softly tinged. They encapsulate loss. Fitts photographs at the magic hour—making use of the witching tones and the rich hues of late light. Shadows are banished. In these photographs, the sun is always on the verge of going down. In the end, what Fitts mourns is not just a dip in a cool pool. It is America.

Tony Maher [pages 249 252]

Sometimes beauty is not pretty. Couches, battered love seats, random furniture despoil an already neglected landscape in Tony Maher's *Disposable* photographs, "Unnatural additions to the land," he calls them. The abuse is an affront to a specific place, and highlights general environmental degradation. But it can also stand in for disposable neighborhoods, regions, and people.

The abject subjects, however, are in tension with the artist's sumptuous treatments. Maher chooses his hour carefully and uses elaborate studio equipment to augment natural light. An overturned couch lies on a littered roadside, but is pictured under radiant late light so smoothly enveloping that it evokes a chiaroscuro dreamland. The compositions reference landscape traditions but tilt into what Maher calls "incongruent and offset perspectives."

Each site of discard triggers Maher's transformative attention. The discards are catalysts of focus. A jettisoned object becomes the nucleus around which Maher's vision crystallizes. With the photographer's attention comes deep focus and these sites take on a holy air, enshrined in multiple panels. The couch, the abandoned loveseat, fades away. Remarkably, the place, the surrounding landscape becomes foreground.

This is photography as a tool for stripping the world of spiritual grime. The discards are offerings and Maher's photographs are sanctified scenes in a transitory world. The attention exemplified by these images offers purification, transformation, and in the end, a measure of redemption.

Corina Gamma [pages 253-254]

Corina Gamma's photographs depict the newly built "Colonies Crossroads" in Upland. It's a classic California master-planned community: 434 acres, 1,100 single family homes, 305 apartment units, $500 million worth of commercial and residential development.

At first glance the photographs seem straightforward—neutral views in the tradition of *New Topographics* and the New Color photography. Cubes of sandbags beneath a wall of painfully fake rock echo the cubes of houses beneath a blank sky. But a history lies beneath the surface. Gamma made these images just prior to what is known as the Colonies corruption case, an alleged a $102 million political fix that led to a decade-long set of multiple felony trials. The case dragged down San Bernardino County supervisors, members of their staff, and the developers. The criminal trials largely hinged on public expenditures for the massive flood control structures and retention basins required for the foothill-area project. The impounded water is visible at the lower margin of Gamma's photograph.

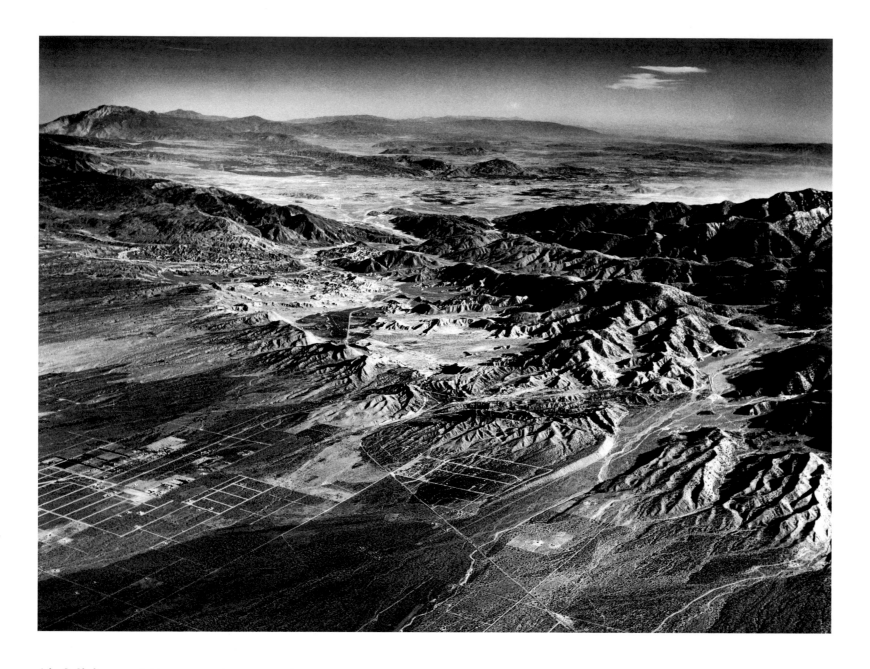

John S. Shelton, *Untitled (Cajon Pass, February 19, 1961)*, 1961, © University of Washington Libraries, Special Collections, John Shelton Collection, Shelton 4188

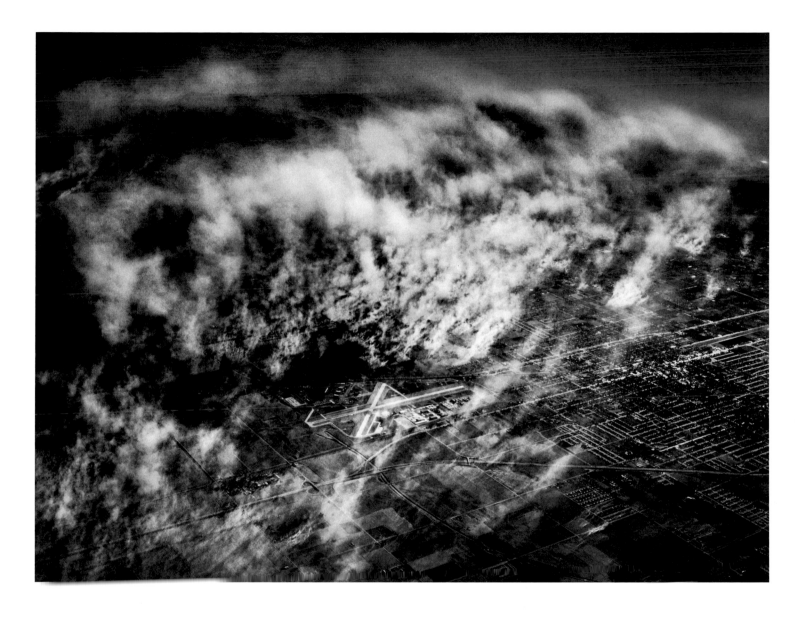

John S. Shelton, *Untitled (Dust storm, Ontario, November 21, 1957)*, 1957, © University of Washington Libraries, Special Collections, John Shelton Collection, Shelton 738

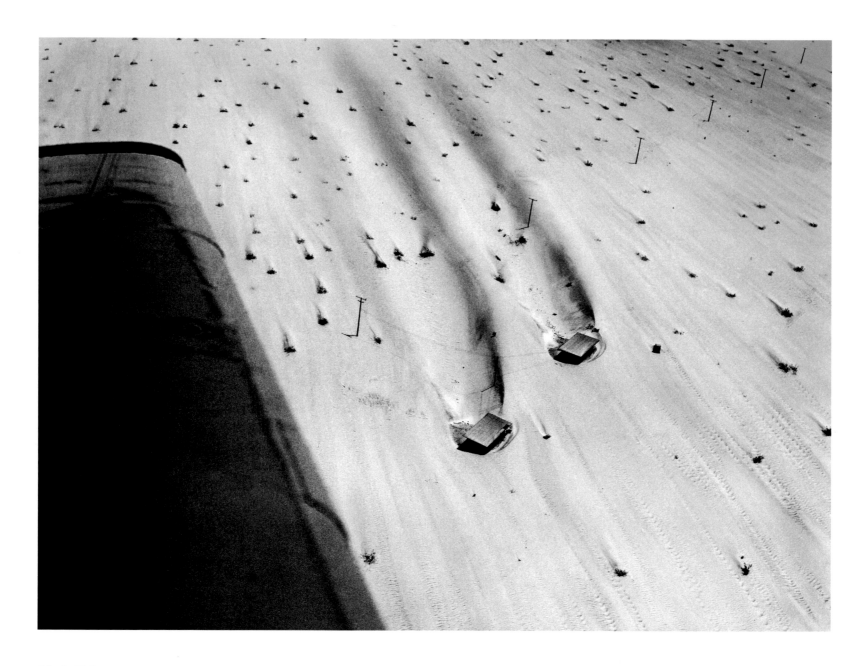

John S. Shelton, *Untitled (Blow Sand, Coachella Valley, June 4, 1963)*, 1963, © University of Washington Libraries, Special Collections, John Shelton Collection, Shelton 4186

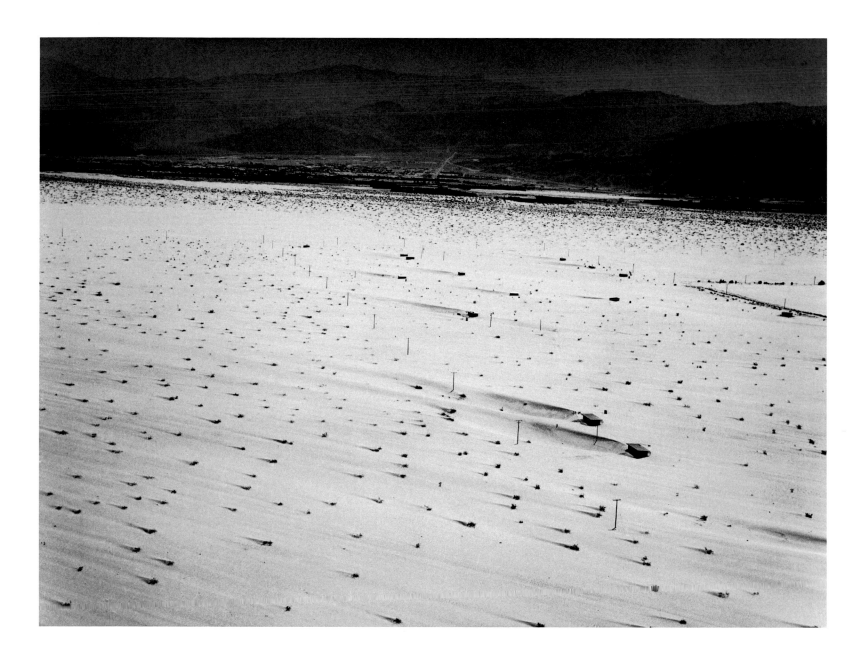

John S. Shelton, *Untitled (Looking South Toward Palm Desert, June 4, 1963)*, 1963, © University of Washington Libraries, Special Collections, John Shelton Collection, Shelton 4185

Ron Jude, *Fence with Deep Shade*, 2013

Ron Jude, *Target Practice #2 (Box)*, 2014

Ron Jude, *Citrus #1 (w/ tire)*, 2013

Ron Jude, *Particle Board Fence*, 2014

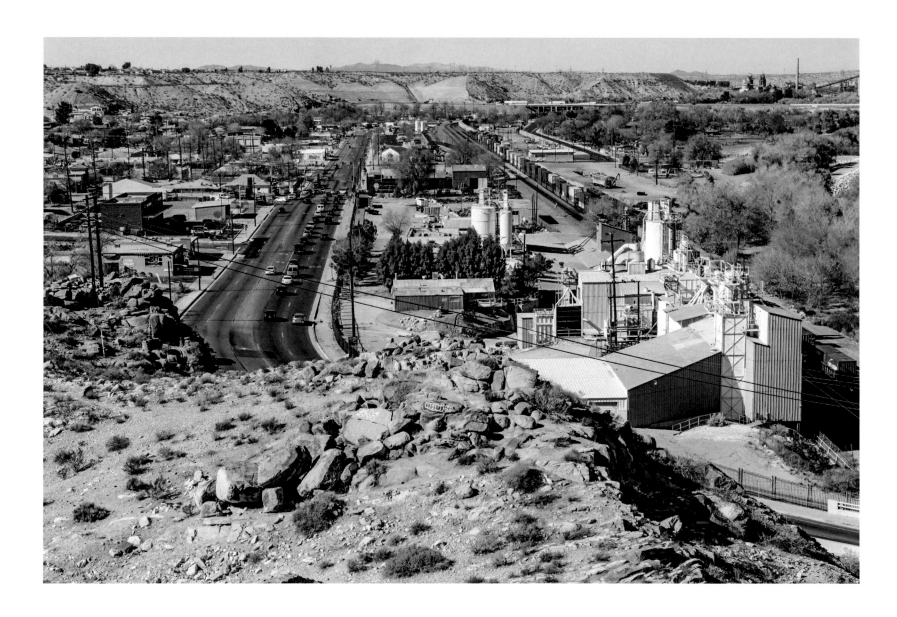

Kim Stringfellow, *Victorville, CA*, from the *Mojave Series*, 2018

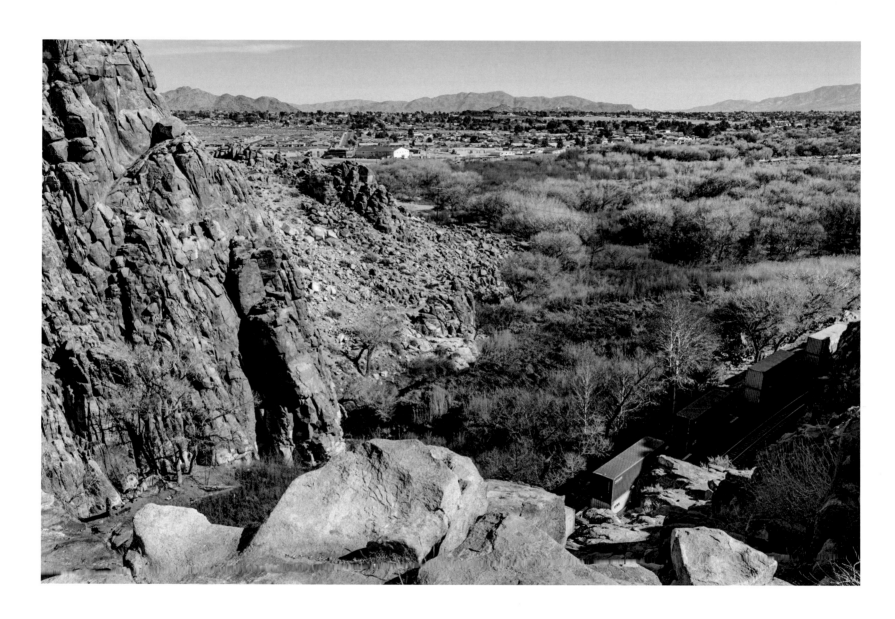

Kim Stringfellow, *Mojave Narrows, Victorville, CA*, from the *Mojave Series*, 2018

Alia Malley, *Riverside 05*, from the series *Southland*, 2009

Alia Malley, *Riverside 03,* from the series *Southland,* 2009

Hannah Karsen, *double property,* 2017

Hannah Karsen, *image to image*, 2017

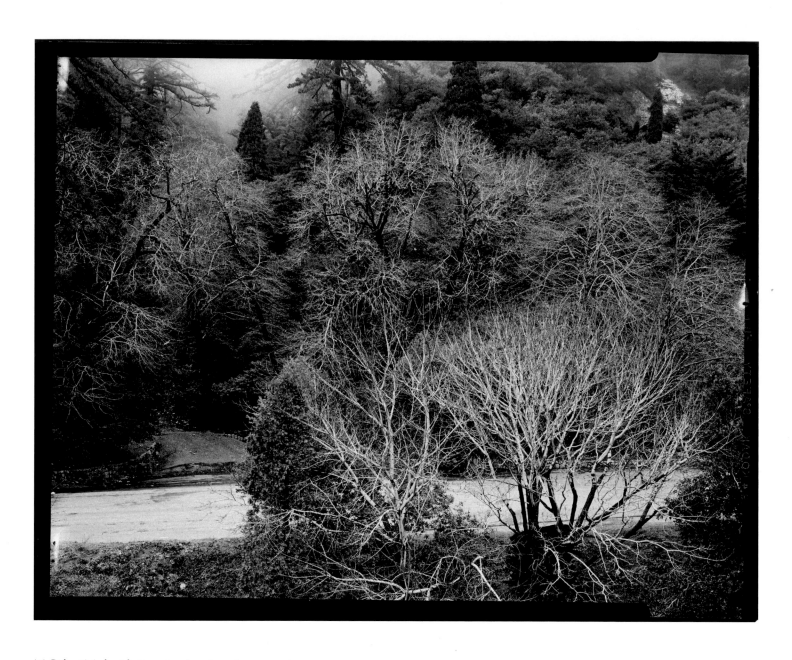

M. Robert Markovich, *Near Crestline*, from the *Near* series, 1981

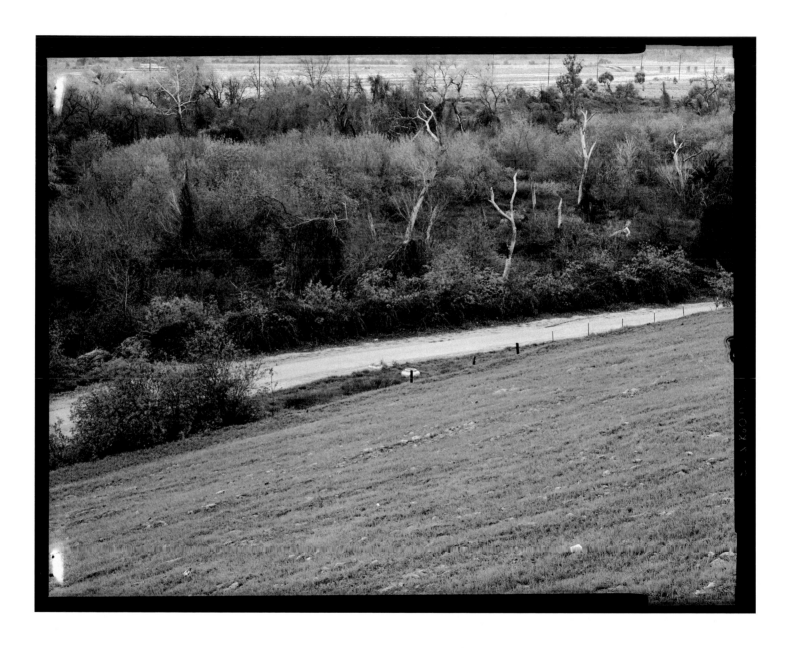

M. Robert Markovich, *Near Mount Rubidoux*, from the *Near* series, 1987

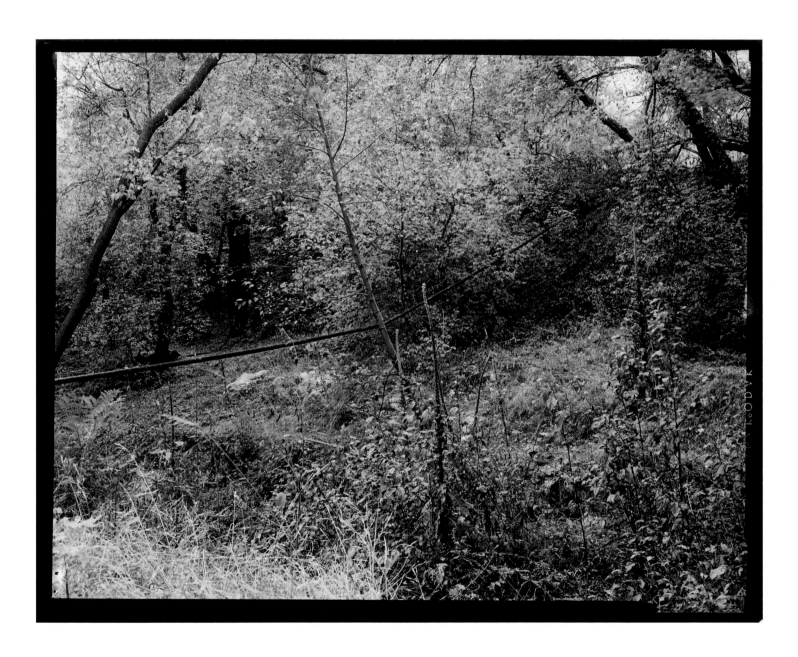

M. Robert Markovich, *Near Oak Glen*, from the *Near* series, 1986

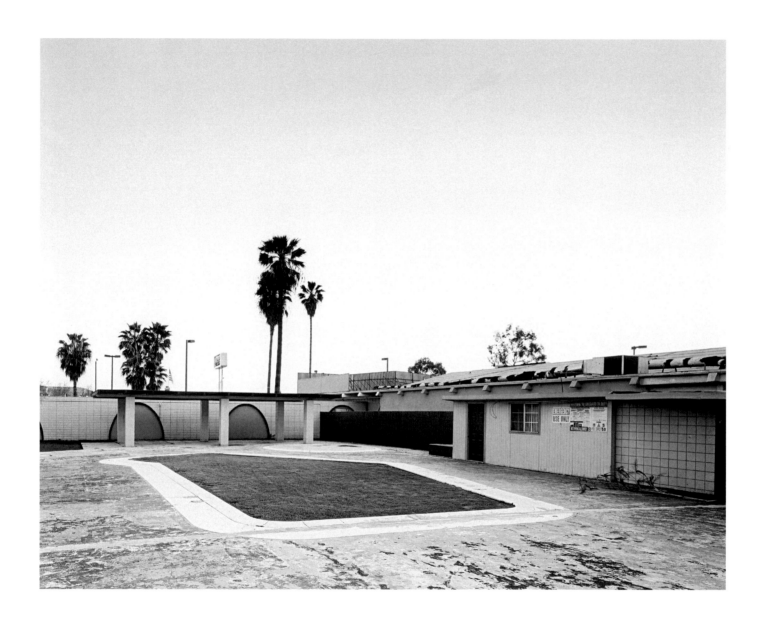

J. Bennett Fitts, *Inland Empire*, from the series *No Lifeguard on Duty*, 2005

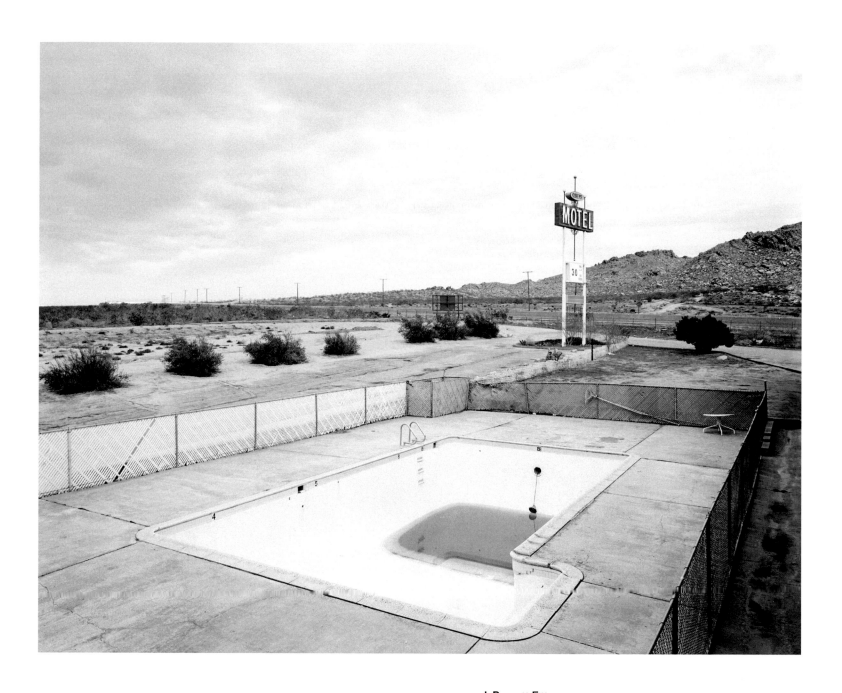

J. Bennett Fitts, *Victorville*, from the series *No Lifeguard on Duty*, 2005

Tony Maher, *Floral Couch, 8th and Hermosa,* from the series *Disposable,* 2008

Tony Maher, *Couch, Roswell Avenue, Chino,* from the series *Disposable,* 2007

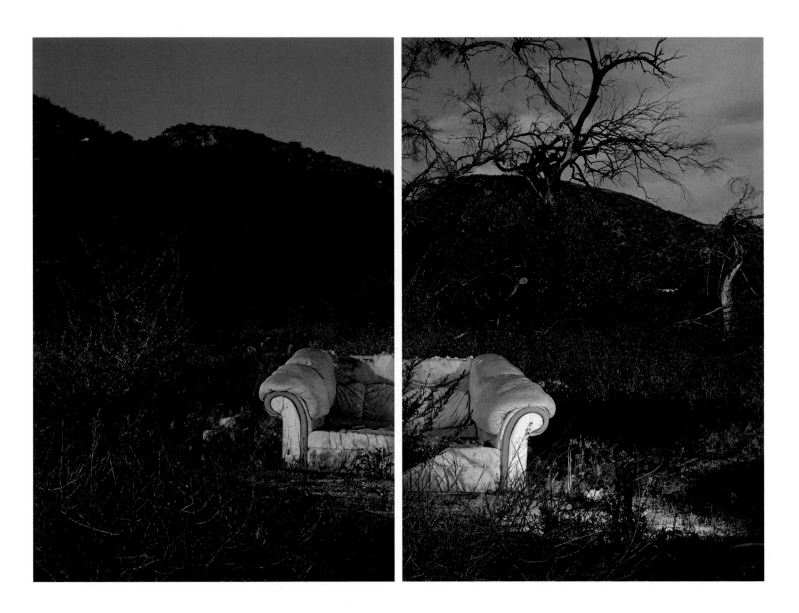

Tony Maher, *White Couch, Rosena Ranch,* from the series *Disposable,* 2007

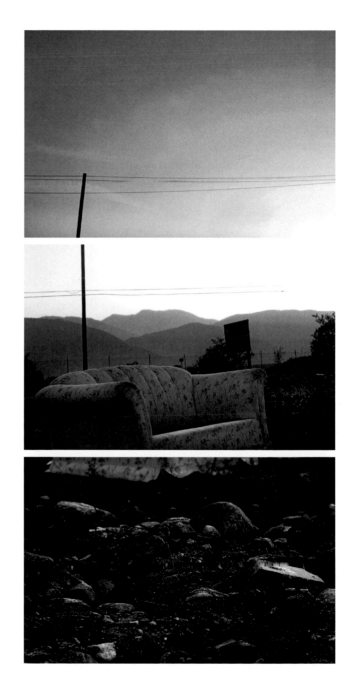

Tony Maher, *Love Seat, Cajon*, from the series *Disposable*, 2007

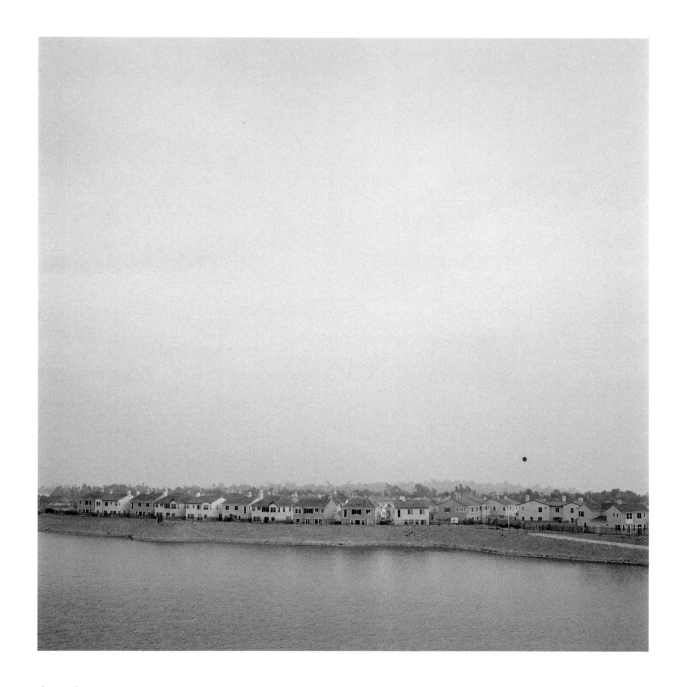

Corina Gamma, *California Elegance (houses)*, 2006

Corina Gamma, *California Elegance (sandbags)*, 2006

WORKS IN THE EXHIBITION

All copyrights are retained by the artists and all works are courtesy of the artist unless noted below. This index is alphabetical by artist with individual works by each artist listed in catalogue page order.

Kim Abeles

The Map Is the Legend (Equidistant Inland Empire), 2018, Mixed media, installation, [page 156]

Ansel Adams

Palm Leaves Near Palm Desert, 1966 (printed 2018), Chromogenic print, 20 x 20 inches, Collection of UCR ARTS: California Museum of Photography, Fiat Lux: The University of California, © Regents of the University of California, [page 201]

Campus Scenes, UCR, 1966 (printed 2018), Chromogenic print, 20 x 20 inches, Collection of UCR ARTS: California Museum of Photography, Fiat Lux: The University of California, © Regents of the University of California, [page 202]

Robert Adams

Looking Past Citrus Groves into the San Bernardino Valley; Northeast of Riverside, California, 1983, Gelatin silver print, 11 x 14 inches, Collection of Yale University Art Gallery, © Robert Adams, Courtesy Fraenkel Gallery, San Francisco, [page 019]

New development on former citrus-growing estate, Highland, California, 1983 (printed 1998), Gelatin silver print, 11 x 14 inches, Collection of Yale University Art Gallery, © Robert Adams, Courtesy Fraenkel Gallery, San Francisco, [page 020]

Santa Ana Wash, San Bernardino County, California, 1983 (printed 1991), Gelatin silver print, 10 7/8 x 14 inches, Collection of Yale University Art Gallery, © Robert Adams, Courtesy Fraenkel Gallery, San Francisco , [page 021]

Development Road, San Timoteo Canyon, Redlands, California, 1978, Gelatin silver print, 11 x 14 inches, Collection of Yale University Art Gallery, © Robert Adams, Courtesy Fraenkel Gallery, San Francisco, [page 022]

Yolanda Andrade

I Feel Lonely Here, 1991, Gelatin silver print, 14 x 11 inches, Collection of UCR ARTS: California Museum of Photography, [page 089]

Casablanca, 1991, Gelatin silver print, 14 x 11 inches, Collection of UCR ARTS: California Museum of Photography, [page 090]

Lewis Baltz

Claremont, 1973, Gelatin silver print, 6 x 8 7/8 inches, Collection of Smithsonian American Art Museum, © J. Paul Getty Trust. Getty Research Institute, Los Angeles, [page 023]

Noah Berger

Embers From the Blue Cut Fire, 2016, Chromogenic print, 16 x 24 inches, [page 166]

Laurie Brown

Recent Terrains #8, 1991, Gelatin silver print, 34 x 49 inches, [pages 053–054]

Recent Terrains #7, 1991, Gelatin silver print, 34 x 49 inches, Collection of Los Angeles County Museum of Art, [pages 055–056]

Rachel Bujalski

John Hockaday on his Porch, Cajon Pass, CA, 2018, Archival pigment print, 30 x 40 inches, [page 129]

John Hockaday in his Living Room, Cajon Pass, CA, 2018, Archival pigment print, 30 x 40 inches, [page 130]

Bystedt & Egan (Amy Bystedt, Sally Egan)

Fotomat 01, 2015, Archival pigment print, 20 x 20 inches, [page 143]

Fotomat 03, 2015, Archival pigment print, 20 x 24 inches, [page 144]

Fotomat 07, 2015, Archival pigment print, 20 x 20 inches, [page 145]

Fotomat 12, 2015, Archival pigment print, 20 x 24 inches, [page 146]

Fotomat 02, 2015, Archival pigment print, 20 x 24 inches, [page 147]

Fotomat 09, 2015, Archival pigment print, 20 x 24 inches, [page 148]

Judy Chicago

Snow Atmosphere, 1970 (printed 2011), Archival pigment print, 44 x 30 inches, Collection of Pomona College Museum of Art, © Judy Chicago / Artists Rights Society (ARS), New York, [page 137]

Snow Atmosphere, 1970 (printed 2011), Archival pigment print, 30 x 44 inches, Collection of Pomona College Museum of Art, © Judy Chicago / Artists Rights Society (ARS), New York, [page 138]

Will Connell

Kaiser Steel Furnace, 1958 (printed 2018), Chromogenic print, 26 x 20 inches, Collection of UCR ARTS: California Museum of Photography, © Estate of Will Connell, [page 081]

Kaiser Steel Mill, 1958 (printed 2018), Chromogenic print, 20 x 26 inches, Collection of UCR ARTS: California Museum of Photography, © Estate of Will Connell, [page 082]

Joe Deal

Colton, California, from the *Fault Zone Portfolio*, 1978, Gelatin silver print, 11 1/4 x 11 1/4 inches, Collection of UCR ARTS: California Museum of Photography, © The Estate of Joe Deal, Courtesy Robert Mann Gallery, New York, [page 161]

San Bernardino, California (I), from the *Fault Zone Portfolio*, 1978, Gelatin silver print, 11 1/4 x 11 1/4 inches, Collection of UCR ARTS: California Museum of Photography, © The Estate of Joe Deal, Courtesy Robert Mann Gallery, New York, [page 162]

Soboba Hot Springs, California (II), from the *Fault Zone Portfolio*, 1979, Gelatin silver print, 11 1/4 x 11 1/4 inches, Collection of UCR ARTS: California Museum of Photography, © The Estate of Joe Deal, Courtesy Robert Mann Gallery, New York, [page 163]

Fontana, California, from the *Fault Zone Portfolio*, 1978, Gelatin silver print, 11 1/4 x 11 1/4 inches, Collection of UCR ARTS: California Museum of Photography, © The Estate of Joe Deal, Courtesy Robert Mann Gallery, New York, [page 164]

Lewis deSoto

Del Taco, Riverside, California, 1978, Archival pigment print, 13 x 20 inches, [page 040]

Audi dealership, Riverside, California, 1979, Archival pigment print, 13 x 20 inches, [page 041]

Green pool, San Bernardino, California, 1979, Archival pigment print, 13 x 20 inches, [page 042]

E Street car lot, San Bernardino, California, 1979, Archival pigment print, 13 x 20 inches, [page 043]

Car lot, Banning, California, 1979, Archival pigment print, 13 x 20 inches, [page 044]

Mount Vernon, Colton, California, 1979, Archival pigment print, 13 x 20 inches, [page 045]

Colton, intersection of North Mount Vernon Avenue, North La Cadena Drive, and East Grant Avenue, July 2012, 2012, Archival pigment print, 13 x 20 inches, [page 046]

Richard Misrach

Desert Fire #1 (Burning Palms), 1983, Dye destruction print, 27 7/8 x 30 1/4 inches, Collection of Orange County Museum of Art: Museum purchase with funds provided through prior gift of Swedlow, Inc., © Richard Misrach, Courtesy Fraenkel Gallery, San Francisco, [page 165]

Chelsea Mosher

The Orange Blossom, 2015, Gelatin silver print, 24 x 30 inches, [page 061]

Evening (Ranch), 2017, Gelatin silver print, 24 x 30 inches, [page 062]

Untitled (Roadside), 2017, Gelatin silver print, 24 x 30 inches, [page 063]

Winter's Lane, 2015, Gelatin silver print, 24 x 30 inches, [page 064]

Kenda North

Untitled, from the series *Kress Building*, 1987, Dye destruction print, 20 x 24 inches, Collection of UCR ARTS: California Museum of Photography, [page 153]

Untitled, from the series *Kress Building*, 1987, Dye destruction print, 20 x 24 inches, Collection of UCR ARTS: California Museum of Photography, [page 154]

Untitled, from the series *Kress Building*, 1987, Dye destruction print, 24 x 20 inches, Collection of UCR ARTS: California Museum of Photography, [page 155]

Naida Osline

Sacred Datura, 2010, Archival pigment print, 54 x 38 inches, [page 131]

Stuart Palley

The Etiwanda Fire, 2014, Archival pigment print, 40 x 60 inches, [page 167]

Lake Fire Meadow, 2015, Archival pigment print, 40 x 60 inches, [page 168]

Leopoldo Peña

Chimney, Moreno Valley, from the series *Desert Errant*, 2015, Gelatin silver print, 14 x 14 inches, [page 207]

Pipe, near Victorville, from the series *Desert Errant*, 2013, Gelatin silver print, 14 x 14 inches, [page 208]

Jacuzzi, Jurupa Valley, from the series *Desert Errant*, 2014, Gelatin silver print, 14 x 14 inches, [page 209]

Box, Moreno Valley, from the series *Desert Errant*, 2014, Gelatin silver print, 14 x 14 inches, [page 210]

Ryan Perez

I.E. Barbarians (Catawba Ave.), 2015, Archival inkjet print, 50 x 40 inches, Courtesy of the artist and BWS, Mexico City, Mexico, [page 116]

I.E. Barbarians (Lytle Creek Rd.), 2015, Archival inkjet print, 50 x 40 inches, Courtesy of the artist and BWS, Mexico City, Mexico, [page 117]

I.E. Barbarians (Maloof Ave.), 2015, Archival inkjet print, 50 x 40 inches, Courtesy of the artist and BWS, Mexico City, Mexico, [page 118]

Herb Quick

San Bernardino, CA, 1969, Gelatin silver print, 14 x 11 inches, Collection of UCR ARTS: California Museum of Photography, © Regents of the University of California, [page 057]

New Sewer, Riverside, CA, 1987, Gelatin silver print, 14 x 11 inches, Collection of UCR ARTS: California Museum of Photography, Regents of the University of California, [page 058]

Trafalgar and Alessandro, Riverside, CA, 1987, Gelatin silver print, 11 x 14 inches, Collection of UCR ARTS: California Museum of Photography, © Regents of the University of California, [page 059]

Riverside (Grading), 1987, Gelatin silver print, 11 x 14 inches, Collection of UCR ARTS: California Museum of Photography, © Regents of the University of California, [page 060]

Protest in front of Kress, 1948, Gelatin silver print, 11 x 14 inches, Collection of UCR ARTS: California Museum of Photography, © Regents of the University of California, [page 084]

Mark Ruwedel

Dillon Road Orchard #18, from the series *Paintball Sites*, 2012, Archival pigment print, 11 x 14 inches, [page 125]

Myoma #2, from the series *Paintball Sites*, 2015, Archival pigment print, 11 x 14 inches, [page 125]

Dillon Road Orchard #13, from the series *Paintball Sites*, 2017, Archival pigment print, 11 x 14 inches, [page 125]

Off Dillon Road #11, from the series *Paintball Sites*, 2012, Archival pigment print, 11 x 14 inches, [page 125]

Dillon Road Orchard #24, from the series *Paintball Sites*, 2017, Archival pigment print, 11 x 14 inches, [page 125]

Off Dillon Road #13, from the series *Paintball Sites*, 2013, Archival pigment print, 11 x 14 inches, [page 125]

Allan Sekula

Kaiser steel mill being dismantled after sale to Shougang Steel, People's Republic of China. Fontana, California. May and December 1993, from the series *Fish Story*, 1989–1995, Cibachrome prints, Diptych comprised of two 40 x 30-inch prints arranged vertically, Courtesy of the Allan Sekula Studio, © Allan Sekula Studio, [page 083]

Julie Shafer

Cajon Pass n.3, from the series *The Parting of the Ways*, 2018, Archival pigment print, 24 x 36 inches, [page 119]

Cajon Pass n.2, from the series *The Parting of the Ways*, 2018, Archival pigment print, 24 x 36 inches, [page 120]

Cajon Pass n.1, from the series *The Parting of the Ways*, 2018, Archival pigment print, 24 x 36 inches, [page 121]

Cajon Pass n.5, from the series *The Parting of the Ways*, 2018, Archival pigment print, 36 x 24 inches, [page 122]

Cajon Pass n.4, from the series *The Parting of the Ways*, 2018, Archival pigment print, 24 x 36 inches, [page 123]

John S. Shelton

Untitled (Cajon Pass, February 19, 1961), 1961 (printed 2018), Chromogenic print, 20 x 24 inches, Collection of University of Washington Libraries Special Collections, © University of Washington Libraries, Special Collections, John Shelton Collection, Shelton 4188, [page 229]

Untitled (Dust storm, Ontario, November 21, 1957), 1957 (printed 2018), Chromogenic print, 20 x 24 inches, Collection of University of Washington Libraries Special Collections, © University of Washington Libraries, Special Collections, John Shelton Collection, Shelton 738, [page 230]

Untitled (Blow Sand, Coachella Valley, June 4, 1963), 1963 (printed 2018), 20 x 24 inches, Chromogenic print, Collection of University of Washington Libraries Special Collections, © University of Washington Libraries, Special Collections, John Shelton Collection, Shelton 4816, [page 231]

Untitled (Looking South Toward Palm Desert, June 4, 1963), 1963 (printed 2018), 20 x 24 inches, Chromogenic print, Collection of University of Washington Libraries Special Collections, © University of Washington Libraries, Special Collections, John Shelton Collection, Shelton 4185, [page 232]

Julius Shulman

Rubidoux Drive-In, 1951, Gelatin silver print, 8 x 10 inches, Collection of Ruhnau Clarke Architects, © J. Paul Getty Trust. Getty Research Institute, Los Angeles, [page 077]

Riverside Press-Enterprise, 1956, Gelatin silver print, 10 x 8 inches, Collection of Ruhnau Clarke Architects, © J. Paul Getty Trust. Getty Research Institute, Los Angeles, [page 099]

Sierra Junior High School, Riverside, 1956, Gelatin silver print, 8 x 10 inches, Collection of Ruhnau Clarke Architects, © J. Paul Getty Trust. Getty Research Institute, Los Angeles, [page 100]

Joel Sternfeld

After a Flash Flood, Rancho Mirage, California, 1979, Chromogenic print, 20 x 24 inches, Collection of Carnegie Museum, [page 165]

Kim Stringfellow

Victorville, CA from the *Mojave Series*, 2018, Archival pigment print, 24 x 36 inches [page 237]

Mojave Narrows, Victorville, CA from the *Mojave Series*, 2018, Chromogenic print, 24 x 36 inches, [page 238]

Hiroshi Sugimoto

Rubidoux Drive-In, Rubidoux, 1993, Silver gelatin print, 19 1/4 x 23 1/4 inches, Courtesy Stephen Bulger Gallery, Toronto, © Hiroshi Sugimoto, Courtesy Fraenkel Gallery, San Francisco, [page 078]

Larry Sultan

Empty Pool, 1991, Chromogenic print, 40 x 48 inches, Courtesy of the Estate of Larry Sultan and Casemore Kirkeby, San Francisco, [page 107]

Fixing the Vacuum, 1991, Chromogenic print, 40 x 50 inches, Courtesy of the Estate of Larry Sultan and Casemore Kirkeby, San Francisco, [page 108]

Andrew K. Thompson

San Bernardino Smoke, 2014, Heat transfer print on canvas, thread, needles, 10 x 36 inches, Courtesy of the artist and Klotz Gallery, New York, [page 169]

San Bernardino Weed, 2015, Pigment print on fabric, thread, 9 1/2 x 7 1/2 inches, Courtesy of the artist and Klotz Gallery, New York, [page 170]

Untitled (Orange landscape with blue powerlines), 2016, Chromogenic print, thread, chemical stains, processing residue, hand cut edges, 8 x 10 inches, [page 171]

Untitled (Yellow and green landscape), 2016, Chromogenic print, thread, chemical stains, processing residue, hand cut edges, 8 x 10 inches, [page 172]

Brett Van Ort

"Beirut," Corona, California, USA, 2013, Chromogenic print, 16 x 20 inches, [page 126]

"Baghdad," Corona, California, USA, 2013, Chromogenic print, 16 x 20 inches, [page 127]

"Bosnia," Corona, California, USA, 2013, Chromogenic print, 16 x 20 inches, [page 128]

Aashanique Wilson

Untitled, 2018, Chromogenic print, 20 x 30 inches, [page 085]

Untitled, 2018, Chromogenic print, 20 x 30 inches, [page 086]

Untitled, 2018, Chromogenic print, 20 x 30 inches, [page 087]

Untitled, 2018, Chromogenic print, 20 x 30 inches, [page 088]

BIOGRAPHIES

Artists

Kim Abeles

Kim Abeles is an artist whose community-based projects explore biography, geography and environment. She has created projects with the California Science Center, air pollution control agencies, health clinics and mental health departments, and natural history museums in California, Colorado, and Florida.

Abeles received a 2013 Guggenheim Fellowship, and is a recipient of fellowships from J. Paul Getty Trust Fund for the Visual Arts, California Community Foundation, and Pollock-Krasner Foundation. She is currently working on sculptural suitcases for Camp Ground: Arts, Corrections and Fire Management in the Santa Monica Mountains that embeds artists in the Los Angeles County Fire Department to work in collaboration with the paid and inmate workforces.

Her work is in public collections including the Los Angeles Museum of Contemporary Art, Los Angeles County Museum of Art, Berkeley Art Museum, California African American Museum, and National Geospatial Intelligence Agency. Abeles' journals, books, and process documents are archived at the Center for Art + Environment, Nevada Museum of Art.

Ansel Adams

Ansel Adams' San Francisco childhood was marked by the great fire and earthquake of 1906 when he was four years old, which left him with a broken nose, as well as the reversal of his family's fortunes in the financial panic of 1907. He struggled in school until at age twelve, he left to be home-schooled and blossomed as both a classical pianist and a photographer. His work at Yosemite and in the Sierra began while he was a custodian in the Sierra Club's lodge in the 1920s and his first exhibition was held at club headquarters in San Francisco.

Adams and friends Edward Weston and Imogene Cunningham founded Group f/64 in 1932. Their sharply focused images and use of the entire tonal range from black to white gained national attention and the de Young Museum gave the group its first exhibition followed by a one-man show for Adams later that same year. His first New York show followed in 1933 at the Delphic Gallery and in 1936, Alfred Stieglitz gave Adams an exhibition at An American Place. Known for his technical expertise, he was commissioned in 1935 to write *Making a Photograph*, illustrated primarily with his own photographs.

In 1940, Adams helped found the first photography department at The Museum of Modern Art in New York, and in 1946, the California School of Fine Art, now known as the San Francisco Art Institute. In 1948, he published *The Negative*, a synthesis of his technical and aesthetic views, including his "zone system" principles. From 1934 to 1971 Adams served as a director of the Sierra Club and his 1960 *This Is The American Earth* (with Nancy Newhall) is credited with reawakening the modern conservation movement. He received the Presidential Medal of Freedom in 1980. He died in 1984.

Robert Adams

Born in New Jersey in 1937, Robert Adams had health challenges as a child, including asthma, chronic bronchial problems, and polio in his back, left arm, and hand, contracted at age twelve and from which he was able to recover. He discovered the West when his family moved to Colorado in 1952 and he relished the outdoor life of hiking, camping, and mountain climbing. He left Colorado for Inland Southern California, attending the University of Redlands and eventually receiving a doctorate in English in 1965 from the University of Southern California in Los Angeles. In 1963, he returned to Colorado to teach English at Colorado College and began to take photographs. By 1966, he began to teach part-time in order to have more time for photography. In 1969, he met John Szarkowski, curator of photography at The Museum of Modern Art in New York, which later acquired four of his photographs.

In 1975, Adams was included in the seminal *New Topographics: Photographs of a Man-altered Landscape* at George Eastman House and his work became identified with the movement. He began to exhibit and published widely. In 2010, the Yale University Art Gallery mounted *The Place We Live, A Retrospective Selection of Photographs (1964–2009)*, which traveled to eight museums in Canada, Europe, and the US. His work is held in the collections of The Museum of Modern Art, New York; The Metropolitan Museum of Art; the Whitney Museum of American Art; and the National Gallery of Art, among many others. He is the author of fifty books and the recipient of many awards including a MacArthur Fellowship and the Deutsche Börse Photography Prize. He lives in Oregon.

Yolanda Andrade

Yolanda Andrade was born in Villahermosa, Tabasco, and studied at the Visual Studies Workshop in Rochester, New York. In 1994, she received a Guggenheim Fellowship to pursue a project focused on Mexico City. She has been a fellow of the Sistema Nacional de Creadores de Arte, Mexico City, since 1994 and in 2000 received a grant from the organization to publish Mexican Passion. In 1991, she was artist in residence at the California Museum of Photography and in 1994, at the

Sheldon Art Galleries, St. Louis, Missouri; El Museo Latino, Omaha, Nebraska; and at the Visual Studies Workshop, Rochester, New York.

She has published several books: *Los Velos Transparentes, las Transparencias Veladas* (1988), *Mexican Passion/Pasión Mexicana* (2002), *Melodrama barroco* (2007), *Fragmentos, Visiones paralelas, El color del cristal* (2008), *Las Vegas, Artificio y Neón* (2013), and *Dentro y fuera. Yolanda Andrade, Vigía de la sorpresa* (2018). She has also independently published *ese extraño mundo de las imágenes* (2009), *Diario de Varanasi y Calcuta* (2011), *Una Mexicana en Paris* (2012), and *Enigma* (2017).

Andrade has exhibited in numerous one-woman and group shows in Mexico, the United States, Asia, and Europe. Her photographs are in the collections of Visual Studies Workshop; Museo de Arte Moderno and Centro de la Imagen, Mexico City; California Museum of Photography; Museum of Fine Arts, Houston; Southeast Museum of Photography, Florida; Southwestern and Mexican Photography, San Marcos, Texas; Chicago's Museum of Contemporary Photography; the J. Paul Getty Museum; El Museo del Barrio, New York; Guangdong Museum of Art, China; Kiyosato Museum of Photographic Arts, Japan; and the Hammer Museum, Los Angeles.

Lewis Baltz

Lewis Baltz was one of the signal photographers of the *New Topographics* movement and was included in the 1975 exhibition of that name. His work focused on the effects of twentieth century culture and suburban development on the landscape, presenting a view of the built environment that challenged nineteenth century traditions of landscape photography in the West. Born in Newport Beach, California, he received a master of fine arts from Claremont Graduate School in 1971. He received National Endowment for the Arts grants in 1973 and 1977 and a Guggenheim Fellowship in 1977.

He taught at California Institute of the Arts; University of California, Riverside; University of California, Santa Cruz; Yale; École nationale superieure des Beaux-Arts, Paris; and the Academy of Fine Arts in Helsinki. In 1978, he was included in the exhibition *Mirrors and Windows: American Photography Since 1960* at The Museum of Modern Art, New York.

Baltz often selected a particular theme and produced works in series, usually published in book form. Three of the best known are *The new Industrial Parks near Irvine, California* (1974), *Nevada* (1978), and *Park City* (1981). He died in 2014.

Noah Berger

Noah Berger is a freelance photographer who has spent eighteen years covering California for editorial, corporate,

and government clients. He started his editorial career at the University of California, Berkeley's *The Daily Californian* and the *Oakland Tribune*. As he describes it, "It was through the student paper that I had my first ever assignment. I was eighteen years old and I completed five or six shoots which earned me more than $150. This was what got me hooked working for newspapers." Currently his work appears regularly for the Associated Press, the *San Francisco Chronicle*, *Bloomberg News*, and *The New York Times*.

Wildfires are a specialty as are politics, natural disasters, and public protests. His work focuses on "staying open to new ways of shooting and thinking. . . . I have been a photographer for a long time, so when I take photographs, I imagine an audience residing in another city. I generally look for single images that convey the story as stand-alone photos."

Laurie Brown

Artist/photographer Laurie Brown was born in Austin, Texas, and grew up in Los Angeles, California. She received a bachelor of arts from Scripps College, Claremont, and a master of fine arts from California State University, Fullerton.

Brown's photographs have been exhibited widely and are in the permanent collections of the Art Institute of Chicago, San Francisco Museum of Modern Art, Los Angeles County Museum of Art, Philadelphia Museum of Art, Museum of Contemporary Art San Diego, California Museum of Photography, Santa Barbara Museum of Art, and Minneapolis Institute of Arts, among many others.

In 1978, Brown was awarded a National Endowment for the Arts Fellowship and, in 2002, was chosen Outstanding Artist of the Year by ARTS Orange County. The Johns Hopkins University Press published Laurie Brown's first book, *Recent Terrains*, in 2000. Many of these photographs were exhibited in one-person shows at the Laguna Art Museum and Craig Krull Gallery, Santa Monica, California. More recently, Brown's solo exhibition at the Nevada Museum of Art in Reno, Nevada, featured photographs from her latest book, *Las Vegas Periphery, Views from the Edge*, which was released by George F. Thompson Publishing in 2013.

Laurie Brown's landscape images explore the changing terrain on the edges of our expanding urban areas in Southern California and in the Mojave Desert. Photographing at the shifting intersection of culture and nature, her panoramic views of the land create a strong sense of place and time along our ever-changing frontiers. Brown currently lives in Newport Beach, California.

Rachel Bujalski

Rachel Bujalski is a documentary photographer based in Los Angeles and San Francisco, California. Her work documents Americans living in alternative situations and revolves around our current housing crisis. Since 2012 she has committed herself to exploring long-term projects documenting people breaking out of traditional housing norms. By highlighting human needs and values in her work, Rachel addresses possible holes in our system by revealing overlooked pockets in our communities. Her work has been published in *National Geographic Magazine*, Vice, *WIRED*, and many others. In 2015, her *Connected Off-the-Grid* project joined The Story INSTITUTE, an international visual storytelling distribution platform.

Bystedt & Egan

Bystedt & Egan is comprised of fine-art photographers Amy Bystedt and Sally Egan. Their collaborations go back ten years, but working together is nothing new for these two California-based artists.

For over twenty years, the artists have served as sounding board, competitor, and often subject for one another's personal work. Stepping in front of the camera started out as mere convenience, but ended up playing a significant role in their collaborative work.

In their narrative-driven, scripted scenes, Bystedt & Egan play the role of subject in their images. Having photographed each other for so many years, it makes sense to step in front of the lens for their collaborations. Transforming themselves into different characters, they stage a questionable reality. In this social media driven culture bombarded with imagery, they reach into the past and deconstruct the familiar.

Judy Chicago

Judy Chicago is an artist, author, feminist, educator, and intellectual whose career now spans five decades. Her influence both within and beyond the art community is attested to by her inclusion in hundreds of publications throughout the world. Her art has been frequently exhibited in the United States as well as in Canada, Europe, Asia, Australia, and New Zealand. In addition, a number of the books she has authored have been published in foreign editions, bringing her art and philosophy to readers worldwide.

In the early seventies after a decade of professional art practice, Chicago pioneered feminist art and art education through a unique program for women at California State University, Fresno, a pedagogical approach that she has continued to develop over the years.

In 1974, Chicago turned her attention to the subject of women's history to create her most well known work, *The Dinner Party*, which was executed between 1974 and 1979 with the participation of hundreds of volunteers. This monumental multimedia project, a symbolic history of women in Western Civilization, has been seen by more than one million viewers during its sixteen exhibitions, held at venues spanning six countries. Other collaborative projects include *Birth Project* (1980–1985) and *Resolutions: A Stitch in Time* (1994–2000).

In 2011 and 2012, Chicago's important contributions to Southern California art were highlighted in *Pacific Standard Time*, a Getty-funded initiative documenting and celebrating the region's rich history. She was featured in eight museum exhibitions and kicked off the Getty PST Performance Festival with the restaging of two events, *Sublime Environment* (a dry ice installation) and *A Butterfly for Pomona*, the first fireworks piece Chicago had done since 1974.

Will Connell

Will Connell was born in 1898 in McPherson, Kansas, a farm community, where Connell's grandmother gave him a Brownie camera in 1910 and he began shooting photographs.

He moved to Los Angeles with his mother in 1914 and by 1917 was a skilled amateur associating with members of the Los Angeles Camera Club. By 1925, he was working as a commercial photographer and publishing in *Collier's* and *The Saturday Evening Post*. In 1931 he founded the Photography Department at The Art Center School in Los Angeles, teaching there for thirty years until his death in 1961. He also worked with the Camera Pictorialists of Los Angeles from the 1920s on, participating in salons and helping to select the artists for the group's first major publication in 1930, which included photographs by Laura Gilpin, Willard Van Dyke, Imogene Cunningham, Ira Martin, Brett Weston, and Thurman Rotan.

Images from Connell's 1937 series on the movie industry, *In Pictures*, were exhibited at the American Pavilion at the International Paris Exposition and became a book. His other books were *The Missions of California* and *About Photography*.

Joe Deal

As one of the 1975 *New Topographics* photographers, Joe Deal focused on a detached exploration of the landscape that included human development and its consequences. A graduate of the Kansas City Art Institute, Deal completed a master of fine arts at the University of New Mexico in 1974 and had exhibited at the Yale University Art Gallery; California State University, Humboldt; University of New Mexico; The Photographer's Gallery, London; Arizona State University's Northlight Gallery; and Boston's Museum of Fine Arts by the time of the 1975 exhibition.

He continued his *New Topographics* work when he moved to California and began teaching at the University of California, Riverside, the next year. That project, the *Fault Zone Portfolio*, continued to document the fraught relationship between human development and the landscape.

He went on to be dean of the College of Art at Washington University, Saint Louis, and provost of the Rhode Island School of Design. Near the end of his life, Deal returned to working on the Great Plains, producing *West and West: Reimagining the Great Plains* (2009). Deal writes of the project in his concluding essay: "If the square, as employed in the surveys of public lands, could function like a telescope, framing smaller and smaller sections of the plains down to a transect, it can also be used as a window, equilaterally divided by the horizon, that begins with a finite section of the earth and sky and restores them in the imagination to the vastness that now exists as an idea: the landscape that is contained within the perfect symmetry of the square implies infinity." His work is held in The Museum of Modern Art, New York; San Francisco Museum of Modern Art; Museum of Fine Arts, Boston; the J. Paul Getty Trust; and the International Museum of Photography at George Eastman House, Rochester.

Lewis deSoto

Lewis deSoto is of Cahuilla origin from the Southern California region known as the Inland Empire. He studied art, philosophy, and religion at the University of California, Riverside, and received his bachelor of arts in studio art in 1978. He received his master of fine arts from Claremont Graduate School in 1981.

He has taught at Otis Art Institute of Parsons School of Design, Los Angeles; Cornish College of the Arts, Seattle; California College of Arts and Crafts, Oakland/San Francisco; and the San Francisco Art Institute. He is currently a professor of art at San Francisco State University.

His works of photography, sculpture, installation, and other media are in the collections of The Museum of Modern Art, New York; Museum of Contemporary Art, Los Angeles; the Los Angeles County Museum of Art; The Museum of Contemporary Art San Diego; the Columbus Museum of Art, and numerous public and private collections.

His book of essays and photography, *EMPIRE*, was published by Heyday Books; the Inlandia Institute; and the Robert and Frances Fullerton Museum of Art, CSU San Bernardino; in late 2015.

He has studios in Southern and Northern California.

John Divola

John Divola was born in Los Angeles and received a master of arts from California State University, Northridge, and a master of fine arts from the University of California, Los Angeles. Since 1975 he has taught photography and art at numerous institutions including California Institute of the Arts (1978–1988), and, since 1988, he has been a professor of art at the University of California, Riverside.

Since 1975, Divola's work has been featured in more than eighty solo exhibitions in the United States, Japan, Europe, Mexico, and Australia. Since 1973, his work has been included in more than two hundred group exhibitions in the United States, Europe, and Japan.

Among Divola's awards are Individual Artist Fellowships from the National Endowment for the Arts in 1973, 1976, 1979, and 1990; a John Simon Guggenheim Memorial Foundation Fellowship in 1986; a Flintridge Foundation Fellowship in 1998; a City of Los Angeles Artist Grant in 1999; and a California Arts Council Individual Artist Fellowship in 1998.

Books by John Divola are *Continuity* (art work and preface by John Divola, Ram Publications/Smart Art Press, Los Angeles, California, 1997), *Isolated Houses* (with essay by Jan Tumlir, Nazraeli Press, 2000), *Dogs Chasing My Car In The Desert* (preface by John Divola, Nazraeli Press, 2004), the Aperture book *Three Acts* (essay by David Campany, interview by Jan Tumlir, May, 2006), *The Green of This Notebook* (Nazraeli Press, 2009), *As Far As I Could Get* (Prestel, 2013), and *Vandalism* (MACK, 2018).

John Divola works primarily with photography and digital imaging. While he has approached a broad range of subjects he is currently moving through the landscape looking for the oscillating edge between the abstract and the specific.

Christina Fernandez

Christina Fernandez is a Los Angeles-based photographer/artist. Fernandez's work explores a personal connection to Los Angeles—the city and its environs are featured as an important backdrop for works that address labor, gender, migration, and her Mexican-American identity. Working in a documentary format, her urban and landscape photography convey social and political commentaries regarding her immediate environment.

Text and staged photographs depicting mythical and historical figures are part of her early oeuvre including *Maria's Great Expedition* (1995–1996), the *Ruin* series (1999), and *Manuela S-t-i-t-c-h-e-d* (1996–2000). These works feature stories about women, specifically Chicana herstories.

In *Manuela S-t-i-t-c-h-e-d* and the *Lavanderia* (2002) series, Fernandez examines the work and domestic life of the Latinx residents of eastern Los Angeles—exteriors of anonymous sweatshops and interiors of local laundromats speak about the interplay of private and public spaces.

Fernandez's series *Sereno* (2006–2010), depicts exterior spaces from her eastside neighborhood of El Sereno. The series exposes the tension between dense residential areas and "natural" spaces in urban landscapes.

The View from here (2016) series is about portent or prospect. Landscapes are pictured out of focus, through architectural frameworks built by artists or historical figures (such as Noah Purifoy and Cabot Yerxa). Window frames represent a threshold between shelter and the elements, life and death, present and future, presence and vision, and are a stand-in for the historic body.

The *Reflect/project(tions)* (2017) series evokes the idea of transition through portraits of her former students. The series conveys the idea of being on a threshold, the evolution of creative people moving from one thing to another, with fluidity and depth.

Judy Fiskin

Judy Fiskin is a photographer and video maker who lives and works in Los Angeles. Her videos and films have been screened at international venues, including The Museum of Modern Art in New York, the International Documentary Film Festival Amsterdam, and the National Gallery in Washington, DC. Her photographs have been shown at museums and galleries around the world, including such venues as the Museum of Contemporary Art, Los Angeles; the Centre Pompidou, Paris; and the International Center of Photography, New York. She is represented in Los Angeles by Richard Telles Fine Art. She has been teaching at the California Institute of the Arts since 1977.

J. Bennett Fitts

Born in Kansas City, Missouri, J. Bennett Fitts holds a master of fine arts degree and has been exhibiting widely since 2004. His solo exhibitions include *Golf* (2004), *No Lifeguard on Duty* (2006), *Industrial Landscap[ing]* (2009), and *8 Dead Palm Trees* (2012) at the Kopeikin Gallery. *No Lifeguard on Duty* was also exhibited at galleries in Boston, New York, Portland, and Dallas. His work has been included in group exhibitions both nationally and internationally. He is winner of awards from the American Photography Annual, the International Photography Awards, the International Color Awards, NY Photo Awards, and Photo District News. He has been featured in *Photo District News* and *Art in America*.

Robbert Flick

Robbert Flick is a Southern California artist who uses photography as his primary medium. He has been exhibiting his photographs for over 50 years and his work has been shown and collected by numerous private and public venues both nationally and internationally. He is the recipient of multiple fellowships and in 2001 was the recipient of a Guggenheim Fellowship in Creative Arts. The retrospective *Robbert Flick: Trajectories* was shown at the Los Angeles County Museum of Art in 2004, accompanied by a comprehensive exhibition catalogue co-published by LACMA and Steidl. In 2016, Nazraeli Press published *Robbert Flick / LA Diary*. He is represented by ROSE Gallery in Santa Monica and Robert Mann Gallery in New York.

Corina Gamma

Corina Gamma devotes her life to photography and documentary filmmaking. Her photographs and films often explore the relationship between people and their altering environment. Each of her series spans several years documenting the same landscape.

Gamma earned a bachelor's degree at the University of California, Riverside, and a master of fine arts from Claremont Graduate University. Her photographs and experimental installations have been exhibited at the Riverside Art Museum, Museum of Photographic Arts in San Diego, Woodbury University, Goethe-Institut, and galleries overseas. Her work has been featured in *photograph*. Her recently completed documentary *SILA and the Gatekeepers of the Arctic* gained several nominations and awards.

Anthony Hernandez

Anthony Hernandez was born in 1947 in Los Angeles, California. He is a self-taught artist who has been exhibiting his work since 1970. His books include *Landscapes for the Homeless* (Sprengel Museum, Hanover, 1995), *Sons of Adam: Landscapes for the Homeless II* (Centre National de la Photographie, Paris, and Musée de l'Elysée, Lausanne, 1997), *Pictures for Rome* (Smart Art Press, 2000), *Waiting for Los Angeles* (Nazraeli Press, 2002), *Everything* (Nazraeli Press, 2005), *Waiting, Sitting, Fishing, and Some Automobiles* (Loosestrife Editions, 2007), *Rodeo Drive* (MACK, 2016), and *Forever* (MACK, 2017). In 2016, a retrospective of his work was organized by the San Francisco Museum of Modern Art and traveled to the Milwaukee Art Museum and Fundación MAPFRE, Madrid, accompanied by the catalogue *Anthony Hernandez*. His work is included in museum collections in the United States and Europe.

Ellen Jantzen

Ellen Jantzen was born and raised in St. Louis, Missouri, moved to California where she resided for twenty years, and after a brief return to the Midwest to help aging parents, moved to Santa Fe, New Mexico, where she lives today.

Jantzen describes her work, "I don't consider myself a 'photographer' but an image-maker, as I create work that bridges the world of photography, prints and collage. As digital cameras began producing excellent resolution, I found my perfect medium. It was a true confluence of technical advancements and creative desire that culminated in my current explorations in photo-inspired art using both a camera to capture imagery and a computer to alter, combine and manipulate the pieces."

Jantzen's work is shown and published internationally. Awards and recognitions include: Special Photographer of The Year, 2017 International Photography Awards; first place, 2017 International Photography Awards (Digitally Enhanced Category); first place, 2016 Moscow International Foto Awards (Fine Art, Special Effects Category); and the Julia Margaret Cameron Award which included participation in the Berlin Foto Biennale 2016.

She was also awarded first prize in the prestigious PX3, Prix de la Photographie, Paris (Fine Art Category) for her series *Transplanting Reality; Transcending Nature*.

She is represented by, among others, the Susan Spiritus Gallery in Newport Beach, California; the Bruno David Gallery in St. Louis, Missouri; and Edition One Gallery, Santa Fe, New Mexico.

Ron Jude

Ron Jude, born in Los Angeles in 1965, lives and works in Eugene, Oregon, where he is a professor of art at the University of Oregon. His photographs, which often explore the nexus between place, memory, and narrative, have been exhibited widely since 1992 at venues such as the Getty Center, Los Angeles; The Photographers' Gallery, London; Daugeu Culture and Arts Center, Daugeu, South Korea; Proekt Fabrika, Moscow; and Museum of Contemporary Photography, Chicago. Jude is the co-founder of A-Jump Books and the author of ten books, including *Alpine Star* (A-Jump Books, 2006), *Other Nature* (The Ice Plant, 2008), *emmett* (The Ice Plant, 2010), *Lick Creek Line* (MACK, 2012), and *Lago* (MACK, 2015). He is represented by Gallery Luisotti in Santa Monica.

Hannah Karsen

Hannah Karsen, born in Chicago, is an artist based in Los Angeles. Recent exhibitions of her work include Gallery Luisotti, Santa Monica; Roger's Office, Los Angeles; Elevator Mondays, Los Angeles; Los Angeles Contemporary Exhibitions; Riverside Art Museum, Riverside; and the UCLA New Wight Gallery, Los Angeles; among others. Karsen holds a master of fine arts degree from the University of California, Riverside, and bachelor's degree in fine art and history from Chapman University.

Sant Khalsa

Sant Khalsa is an artist, educator, and curator whose photographic work examines the nature of place and the environmental and societal issues in the landscape of the American West. Her work has been widely shown internationally in over 150 exhibitions and is represented in permanent museum collections including the Los Angeles County Museum of Art, Center for Creative Photography in Tucson, Nevada Museum of Art, and California Museum of Photography. Khalsa is professor of art emerita at California State University, San Bernardino, where she served on the art faculty beginning in 1988 and as Art Department Chair from 2003–2012.

Meg Madison

Meg Madison is an artist who uses photography to conceptually examine contemporary life. She was born and raised in New York City, studied film at San Francisco State University, and came to art late with her first solo exhibit at the Kristi Engle Gallery in 2005. Madison has embraced art making with community projects, collaborations, and exhibitions in galleries, non-profit spaces, and museums in Los Angeles and beyond.

Madison's early work explored memory, ritual, and the ecological transition from being wanted to being discarded. This was followed by projects on land use and measuring, mapping, and the human connection to the land. *Jemez Homestead: Stolen Land* is a long-term project using the sun to create cyanotype prints that map a five-acre parcel in the high desert. Coated paper is snuggled into shrubs and braced against desert plants then, exposed to the desert sun. The resulting print has touched the land—the land leaves marks, holes, and scratches on the paper—but no plant is damaged in the process.

Planted, as with the series *thirst*, is a performance at the water with another person, In collaboration, Madison and her co-performer make a photogram marking the body's connection to the land. The elements of the sun, the wind, the iron ore chemicals on the paper, the physical presence (on the paper) on the land, and finally the nearby water to develop the image—all collide in the creation of the cyanotype print of the body-land connection.

Tony Maher

Tony Maher is a Southern California-based artist, educator, and avid obstacle course racer. His work generally revolves around the presence of history both in and attached to the photographic image. The basis of the art ranges from large-scale images of narrative dioramas to altered landscapes, as well as to documenting the grueling sport of obstacle-course racing. He is an adjunct lecturer at California State University, San Bernardino; Antelope Valley College; and Fullerton College.

Maher received his master of fine arts from California State University, Los Angeles, and has exhibited in *Dotphotozine*, at NY Delight in Pomona, and LIFEWORK Gallery in Palm Springs. His series *HiStory* (2010) showed at the Robert and Frances Fullerton Museum of Art. Tony Maher is the author of *Mermaids* (2013), *Alcatraz* (2009), *Disposable* (2009), and *San Berdu* (2009).

Alia Malley

Alia Malley received her bachelor of arts in critical film studies from University of Southern California School of Cinematic Arts and her master of fine arts in visual arts from University of California, Riverside. Working primarily with photography and video, she explores representation and content, specifically in the context of landscape and cinema, the history of photography, human geography, and narrative of place.

She was the recipient of the 2010 Merck-Prize and was selected for the Farm Foundation's Arctic Circle residency in Svalbard, 2013. She was also selected for the 2015 Field_Notes HYBRID-MATTERs residency at the Kilpisjärvi Biological Station in Lapland, Finland. In 2016, Malley received a grant from the National Endowment for the Arts to produce her large-scale outdoor video projection, *Projection for Two Stations: Christmas Eve in Panorama City*. In 2017–18 she collaborated with designer Paul Smith to produce a special edition of her project *Captains of the Dead Sea* which was presented in a traveling exhibition and included installations in Los Angeles, Amsterdam, and Paris. Her work is included in the permanent collections of the Los Angeles County Museum of Art, UCLA Library Special Collections, and the Beth Rudin DeWoody Collection.

She lives and works in Los Angeles.

Ken Marchionno

Ken Marchionno's photography, interactive works, installations, and videos have been featured in exhibitions and festivals throughout North America, South America, Europe, and Asia. His work is presented in Dr. Betty Ann Brown's *Art & Mass*

Media and Robert Hirsch's *Exploring Color Photography*. He has been a stringer for the Associated Press and his photography has been featured in magazines in the US and Korea, including the contemporary art quarterly *X-TRA*. He has written criticism for *Art Papers* and *Sajin Yaesul*, and his creative writing has been included in the literary journals *Errant Bodies* and *Framework*.

Marchionno's ongoing project, *300 Miles, the Oomaka Tokatakiya*, is a community-engaged project, working with Reservation youth, and using social media as a platform. Started in 2004, it has been exhibited in the US, Asia, and Europe, including the Smithsonian Institute, the US Embassy in Prague, and forthcoming at the Museum of Art and History in Lancaster, California.

In 2015, Marchionno was artist in residence at the Art Mill in the Czech Republic where he started a series of landscape pieces, stitching multiple images together to form a panorama with extremely shallow depth of field. The pieces are as long as twenty-five feet at full resolution and often have an ethereal, dreamlike presence. He has continued this practice in the *Crestline Panorama* series.

Marchionno's work has received funding from the arts and humanities, and most recently the California Community Foundation, the Society for Photographic Education, and the Sidney Stern Memorial Trust.

M. Robert Markovich

M. Robert Markovich was born in Munich, Germany. He graduated with a bachelor of fine arts from the University of California, Riverside, and a master of fine arts from California State University, San Bernardino. His work has been exhibited, published, and collected throughout the Southern California area including Palm Springs, San Bernardino, Riverside, Laguna Beach, San Diego, Santa Barbara, and Los Angeles; nationally in New York, San Francisco, Oakland, Chicago, Minneapolis, Seattle, and Washington, DC; and internationally in Japan, Germany, Italy, and Great Britain. The work frames issues of perception, representation, apparatus, and memory. He lives and works in Southern California.

Douglas McCulloh

Douglas McCulloh is a photographer, writer, and curator based in Southern California. His work has been shown internationally in more than 250 exhibitions including Victoria and Albert Museum, London; Central Academy of Fine Arts, Beijing; Musée de l'Elysée, Lausanne; Musée Nicéphore Niépce, France; La Triennale di Milano, Italy; Centro de la Imagen, Mexico City; Instituto de Cultura, Barcelona; Art

Center College of Design, Los Angeles; Southeast Museum of Photography, Florida; Contemporary Arts Center, New Orleans; Smithsonian Institution, Washington, DC, and The Cooper Union School of Art, New York. McCulloh's fifth book is *The Great Picture: Making the World's Largest Photograph*, part of the Legacy Project Collaborative and published by Hudson Hills Press, New York.

McCulloh is a five-time recipient of support from California Humanities and serves as senior curator for UCR ARTS: California Museum of Photography. The most noted of his curatorial projects is *Sight Unseen: International Photography by Blind Artists*, the first major survey of photography by blind artists, which has traveled to fifteen museums in five countries. Exhibitions curated by McCulloh have shown in a range of venues: Kennedy Center for the Arts, Washington, DC; Canadian Museum for Human Rights, Winnipeg; Centro de la Imagen, Mexico City; Flacon Art and Design Center, Moscow; Center for Visual Art, Denver, Colorado; Centro Fotográfico Álvarez Bravo, Oaxaca; Sejong Center, Seoul, South Korea; Central Academy of Fine Arts, Beijing, China; and Petersen Automotive Museum, Los Angeles.

Thomas McGovern

Thomas McGovern is a photographer, writer, and educator. He is the author of *Bearing Witness (to AIDS)*, *HARD BOYS + BAD GIRLS*, *Amazing Grace*, and co-author with poet Juan Delgado of *Vital Signs* (Heyday Books, Inlandia Institute), which received an American Book Award in 2014. His photographs are in the permanent collections of the International Center of Photography; Los Angeles County Museum of Art; Brooklyn Museum; Baltimore Museum of Art; Museum of Fine Arts, Houston; Schomburg Center for Research in Black Culture; and Riverside Art Museum, among others. His exhibition reviews and features have appeared in *Afterimage*, *Artweek*, *Art Papers*, and *Art Issues* and he is the founder and editor-in-chief of *Dotphotozine*. He is a professor of art at California State University, San Bernardino.

Mark McKnight

Mark McKnight (born Los Angeles, California in 1984) is an artist based in Los Angeles whose work has been exhibited and published throughout the United States and in Europe.

Most recently, he has had solo exhibitions at QUEENS, Los Angeles, and James Harris Gallery, Seattle. In 2017, he was an artist in residence at Storm King Art Center, New York, and published *NOUNS*, a book of photographs that was released at the L.A. Art Book Fair.

Previously, his work has been exhibited at Gallery Luisotti, Los Angeles; Park View, Los Angeles; BBQLA, Los Angeles; Human Resources, Los Angeles; Arturo Bandini, Los Angeles; M+B, Los Angeles; The Pit, Glendale; Charlie James Gallery, Los Angeles; Riverside Art Museum; Roberts & Tilton, Los Angeles; San Francisco Arts Commission, San Francisco; and as part of the 2008 New York Photo Festival, among others.

Solo exhibitions include the Riverside Art Museum in 2015 and Strongroom, Los Angeles, also in 2015. In 2009 he traveled to Finland on a Fulbright Scholarship. He earned his bachelor of fine arts at the San Francisco Art Institute in 2007 and his master of fine arts at the University of California, Riverside, in 2015.

Kurt Miller

Kurt Miller is an award-winning photojournalist who has spent most of his life chronicling his beloved hometown of Riverside, California, through images. In the course of his thirty-six-year career at *The Press-Enterprise*, Miller dedicated himself to capturing some of the most dramatic news events in Inland Southern California.

His Pulitzer Prize-nominated work includes the 2015 terrorist attack in San Bernardino and the deadly 2006 Esperanza Fire. Miller's photo of silhouetted troops boarding a plane at March Air Force Base for the first Gulf War in 1990 was named *The Press-Enterprise* Photo of the Century after it was picked up by *Life* magazine and numerous outlets across the country; the iconic image remains on permanent display at the Time Life Building in New York.

Since leaving the newspaper in 2016, he has pursued a major series project documenting the demolition of the newspaper offices where he formerly worked, in addition to commercial photography.

Richard Misrach

Richard Misrach's work is focused on the earth and topography, balancing beauty with evidence of the negative effects of human development on the environment. Early in his career he began to photograph the American Southwest, producing large-scale color images. The epic series *Desert Cantos*, an eighteen-part series of related groups of images, juxtaposes nature and culture. The project was exhibited in a mid-career retrospective organized by the Museum of Fine Arts, Houston, and also shown at the Center for Creative Photography, Tucson. Other major exhibitions include *Cancer Alley* at the High Museum of Art in Atlanta, *Richard Misrach: Berkeley Work* at the Berkeley Art Museum, and *Richard Misrach: On the Beach*.

Richard Misrach continued

Other series include *Battleground Point*, *Golden Gate*, *Negative*, and *Petrochemical America*.

Misrach is the author of twelve award-winning photography monographs: *Telegraph 3 A.M.: The Street People of Telegraph Avenue* (1974), *Desert Cantos* (1987), *Bravo 20: The Bombing of the American West* (1990), *Violent Legacies: Three Cantos* (1992), *Crimes and Splendors: Three Desert Cantos for Richard Misrach* (1996), *The Sky Book* (2000), *Richard Misrach: Golden Gate* (2001), *Pictures of Paintings* (2002), *Chronologies* (2005), *On the Beach* (2007), *Destroy this Memory* (2007), and *Petrochemical America* (2012).

Misrach has received four fellowships from the National Endowment of the Arts, a Guggenheim Fellowship, the Infinity Award (Publication) from the International Center of Photography, and the Distinguished Career in Photography Award from the Los Angeles Center for Photographic Studies. His work can be found in the collections of more than fifty museums worldwide. He lives and works in Berkeley.

Chelsea Mosher

Chelsea Mosher received her master of fine arts from California State University, Long Beach. She has exhibited widely in the US. Recent exhibitions include *Artforum Critics' Pick*, *In The Cut* at Gallery Luisotti, *Desert Waters* at the Marks Art Center in Palm Desert, and *Southland* at Pehrspace in Los Angeles.

Mosher's work is represented in the collection of the Los Angeles County Museum of Art and included in the museum's publication, *27 L.A. Photographers*. Her book *Shallow Seas* has recently been published by ultraterrestrial.xyz, a press specializing in small edition, handmade photography books, and launched at the 2018 Printed Matter New York Art Book Fair.

Mosher currently teaches photography as a lecturer at the University of California, Los Angeles, and California State University, Long Beach, and lives in Long Beach, California.

Kenda North

Kenda North resides in Dallas and is professor of photography at the University of Texas at Arlington. She received her master of fine arts from the State University of New York at Buffalo program at the Visual Studies Workshop, Rochester, New York, in January 1976. She has taught at the School of the Art Institute of Chicago; the University of California, Riverside; and has been at the University of Texas since 1989. She received the Honored Educator Award from the Society for Photographic Education South Central Region in 2009.

Her work is represented by Craighead Green Gallery in Dallas. She has had over fifty one-person exhibitions (national and international) and participated in hundreds of juried group exhibitions since 1977. Her work is in the collections of over fifty museums and galleries including the Smithsonian, the Federal Reserve, Los Angeles County Museum of Art, San Francisco Museum of Modern Art, and the Santa Barbara Museum of Art.

Naida Osline

Naida Osline is a Southern California-based artist who combines, layers, and manipulates images sourced from both analog and digital processes, blending conceptual and documentary photographic practices with an abiding interest in the transformative, mythical, and ethereal nature of existence. Osline works and exhibits primarily in the Americas, delving into a number of themes that explore the human body, identity, gender, power, aging, and the natural world in tension with the human-built environment.

Osline has had numerous solo exhibitions and has been included in many group shows throughout Southern California and in the Americas. Most recently, she had a solo exhibition at the Riverside Art Museum. Her work has been reviewed in numerous publications including the *Los Angeles Times*, *Artillery Magazine*, *Huffington Post*, *The Orange County Register*, *Artweek*, and *Artscene*. Osline has participated in several artist residencies in US national parks and urban residencies including the Grand Central Art Center. She has worked south of the border through extended stays in Mexico and Colombia. In 2018, Osline released a twelve-part film series, *Gringotopia*, which explores the expat community from the US and Canada in the Lake Chapala region of Mexico.

Stuart Palley

Stuart Palley is based in Southern California and specializes in environmental, art, editorial, and commercial/corporate subjects.

His recent work on wildfires, *Terra Flamma: Wildfires at Night*, focuses on documenting wildfire, the most acute effect of California's ongoing drought, through long exposures made at night. Over the past five years Palley has photographed almost one hundred wildfires in the state and has formal wildland fire training. The project has been featured in dozens of media outlets across the globe and was recognized as a finalist in the Environmental Vision category of the prestigious Pictures of the Year International photography competition in 2016. The project also received awards in 2015 and 2018.

Terra Flamma is a visual commentary on the collision of man and nature, on fire and climate change. Each image seeks to place fire in its geographic context whether it is a blaze on the edge of urban Los Angeles or far up into the Sierra Nevada Mountains.

Most recently his work from the project was published as part of an article on electronic surveillance entitled "We Are Watching You" in the February 2018 issue of *National Geographic Magazine*.

Born and raised in Southern California, Palley has photographed for *National Geographic Magazine*, *The New York Times*, *The Wall Street Journal*, the *Los Angeles Times*, *The Washington Post*, and many other publications. His work has appeared in *TIME Magazine*, *WIRED*, *New York Magazine*, and *The Washington Post*.

He completed undergraduate degrees at Southern Methodist University studying finance and history and minoring in photography and human rights. He holds a master's degree in photojournalism from the University of Missouri. When not photographing wildfires, he can be found on road trips throughout the Southwest photographing the Milky Way.

Leopoldo Peña

Leopoldo Peña was born in Michoacán, Mexico and is a longtime resident of Los Angeles. Currently, he is a PhD candidate in the Department of Spanish and Portuguese at University of California, Irvine. He is doing research on early twentieth century photography in Mexico. He works as a freelance photographer/language educator and on personal photo projects.

His photographic work centers on two underlying themes: immigration and environment. He develops long-term documentary projects on cultural performance and daily life in immigrant communities. He takes the environment as a human-intervened space. He is working on a series of photographs on the desert similarities connecting California, Baja California Norte, and Baja California Sur.

His work has been published in *La Jornada*, *StreetNotes*, *La Opinión*, *Al Borde*, *Derive*, *Grey Magazine*, *Retina Magazine*, *NACLA: Report on the Americas*, *Black & White Magazine*, and *El Tequio*.

Ryan Perez

Ryan Perez is a Filipino-Mexican-American Southern California artist who primarily works with photography as a means to present ideas regarding identity and societal existence.

While Perez's work spans across image-making, the sculptural, and the moving image, for him the conversation tends to start with understanding his perception of the world through the structure of photographic discourse.

IIis work has been exhibited at Yautepec Gallery, Mexico City; C24 gallery, New York; Control Room, Los Angeles; Vacancy Projects, Los Angeles; the Los Angeles County Museum of Art; and the Sweeney Art Gallery, University of California, Riverside. He recently contributed work to the collective show *Vision Valley* presented by the Glendale Brand Library and curated by The Pit, Glendale. He shares a close friendship and partnership with BWS, Mexico City, and spends a lot of time chilling with his art crew, The Boys of Summer. He currently lives in Rancho Cucamonga, California, his studio is in Riverside, and he teaches at Art Center College of Design, Pasadena.

Herb Quick

Herbert Quick was born in Manistique, Michigan, in 1925. In the early 1930s, at the age of six, he developed an affinity for photography, which he demonstrated through his depictions of the Seils-Sterling Circus. In the late 1940s, Quick began to pursue a career in photography. He received his formal training at the Art Center School in Los Angeles. He met and was given guidance by Edward Weston, who was then suffering physical decline from Parkinson's disease, and was befriended by Dorothea Lange and, for a time, worked as her printer. He later took courses from Fred Archer and Ansel Adams at Art Center School. Quick credited Max Yavno, his life-long friend, with helping him further develop his style. Quick's main subjects were architecture, portraits, and landscapes.

In 1964, he became a staff photographer and lecturer at the University of California, Riverside, introducing large-format photography into the curriculum and going on to become manager of photographic services.

Quick's solo and group exhibitions included Camera Work Gallery, Palos Verdes Art Center, San Francisco Museum of Modern Art, International Museum of Photography at George Eastman House, Norton Simon Museum, National Museum of Canada, and the Museum of Modern Art in Mexico City, among others. Quick died in 2006.

Mark Ruwedel

Born in Pennsylvania in 1954, Mark Ruwedel lives in Long Beach, California. He received his master of fine arts from Concordia University in Montreal in 1983 and taught there from 1984 to 2001. He is currently professor emeritus at California State University, Long Beach. He received major grants from the Canada Council for the Arts in 1999 and 2001.

In 2014, he was awarded both a Guggenheim Fellowship and the Scotiabank Photography Award.

Ruwedel is represented in museums throughout the world, including the Getty Center; Los Angeles County Museum of Art; Metropolitan Museum, New York; Yale Art Gallery; National Gallery of Art, Washington, DC; National Gallery of Australia; and San Francisco Museum of Modern Art. He was included in the National Gallery of Canada's Biennial in 2012. Most recently, Ruwedel's work was on exhibit at Tate Modern, London, through December 2018.

Publications include *Westward the Course of Empire* (2008) and *1212 Palms* (2010), both from Yale Art Gallery; *Pictures of Hell* (RAM Pubs, 2014); *Mark Ruwedel Scotiabank Photography Award*, (Steidl, 2015); *Message from the Exterior* (MACK, 2017); and *Dog Houses*, (August Editions, 2017).

Ruwedel is represented by Gallery Luisotti, Santa Monica; Yossi Milo Gallery, New York; Olga Korper Gallery, Toronto; and Art45, Montreal.

Allan Sekula

Allan Sekula was a renowned American photographer, theorist, historian, and writer. His extraordinary body of experimental work has mainly been concerned with chronicling the social, economic, and political dynamics of life on the oceans and exploring the consequences of globalization, as well as the function of documentary photography in the media, art, and society. Known for his formally rigorous perspective toward the tradition of social or critical realism, Sekula's work often depicts labor within the workplace. He developed a complex visual language to describe struggle and class conflict, reclaiming photography as a medium that could be descriptive or used to advance socio-political change. He died in 2013 at age sixty-two.

Posthumous solo exhibitions of Sekula's work were organized by NTU CCA, Singapore (2015); TBA21, Vienna (2017); Fundació Antoni Tàpies, Barcelona (2017); and Beirut Art Center (2017). Posthumous group exhibitions featuring his work were organized by Whitney Biennial (2014); Museo Reina Sofía, Madrid (2015); Centre Pompidou, Paris (2015); The Museum of Modern Art, New York (2015); Museum of Contemporary Art San Diego (2016); and Documenta 14 (2017). Posthumous publications either exclusively or largely featuring his visual art and critical writings include *Allan Sekula and the Traffic in Photographs* (Grey Room 55, Special Issue, MIT, 2014); *Facing the Music* (East of Borneo, 2015); *Allan Sekula / Ship of Fools / The Dockers' Museum* (Leuven University Press, 2015). Posthumous symposia organized around Sekula's works

and ongoing influence took place in Zurich (2014), Singapore (2015), Vienna (2017), Antwerp (2017), and Beirut (2017).

Allan Sekula's library was transferred to the Clark Art Institute in 2015; his archive to the Getty Research Institute in 2016.

Julie Shafer

Los Angeles based artist Julie Shafer is chair of the Photography Department and gallery director at Edouard de Merlier Gallery, Cypress College, Cypress, California. Her photography, photographic installations, and creative non-fiction writings examine how man has altered the American lands that historical photographs have mythologized. She was invited by the National Park Service to create a site-specific installation at the Cabrillo National Monument—transforming a lighthouse into a camera obscura in 2016.

Shafer did a TEDx talk about her project *Conquest of the Vertical* in 2013. She received master of fine arts from the University of Southern California. She was invited to be an artist in residence and mentor in the Obracadobra Artist Residency in Oaxaca, Mexico, in 2017. She is the recipient of a 2018 COLA Fellowship.

John S. Shelton

John S. Shelton was a geologist, pilot, and photographer. Raised in La Jolla, Shelton attended Pomona College, went on to earn a doctorate in geology from Yale University, and joined the Geology Department at Pomona College in 1941.

Shelton learned to fly in the early 1940s and started taking aerial photographs of the Earth's surface while piloting his own plane. His aerial photography began as a way to demonstrate geology to his students and to combine his three passions: flying, photography, and geology. From the 1930s through the 1990s, Shelton photographed evidence of continental drift, plate tectonics, and other geological principles all over the globe. His book, *Geology Illustrated*, was chosen as one of the top one hundred science books of the twentieth century by *American Scientist* magazine. His large collection of aerial photographs, taken throughout the world, is still used to teach geology nationwide. The majority were shot with a military aerial reconnaissance camera, the negatives are so large that they show tremendous detail.

In 1993, Shelton received the American Geological Institute's Legendary Geologist Award for "Outstanding Contribution to Public Understanding of Geology." Shelton's contributions to the Earth Science Curriculum Project also led to his receiving the Neil Miner Award from the National Association of Geoscience Teachers in 2002. John S. Shelton died in 2008.

Julius Shulman

Over a seventy-year career Shulman not only documented the work of many of the great architects of the mid-twentieth century, but he elevated the genre of commercial architectural photography to a fine art form. The work of architects such as Neutra, Koenig, and Lautner are known all over the world through the images and perspective of Julius Shulman.

Born in 1910, Shulman and his family moved to California from a small farm in Connecticut at the age of ten. In the mid-thirties, Shulman attended the University of California, Los Angeles, and Berkeley, never formally registering at either school, but auditing classes that appealed to him. In 1936, having just returned to Los Angeles from Berkeley, he accompanied an acquaintance (one of Richard Neutra's draftsman) on a visit to Neutra's Kun Residence, which was under construction. Shulman made six photographs on this trip which Neutra liked and subsequently bought. Soon after Neutra introduced Shulman to other architects and urged him to build his career as a photographer. After making over 260,000 images, Shulman announced his "retirement" in 1989, but the next twenty years were filled with major museum and gallery exhibitions around the world, numerous books by publishers such as Taschen and Nazraeli Press, and a growing list of clients seeking his photographic services. In 2005, the Getty Research Institute acquired Shulman's vast archive, but he continued to work until the age of ninety-eight. Shulman died in 2009.

Joel Sternfeld

Joel Sternfeld is an artist-photographer whose work is concerned with the utopic and dystopic possibilities of the American experience, as well as those of the human experience. Ever since the publication of his landmark study, *American Prospects* (1987), his work has maintained conceptual and political aspects, while also being steeped in history, art history, landscape theory, and seasonality. *On This Site* (1996) examines violence in America while simultaneously raising the question of what is knowable from a single photograph. All his subsequent work has sought to expand the narrative possibilities of still photography primarily through an authored text. His work is as ironic as it is dignified, as poetic as it is documentary. It represents a melding of time and place that serves to elucidate, honor, and warn. His books converse with each other and may be read as a collective whole. Sternfeld is the recipient of two Guggenheim Fellowships and spent a year in Italy on a Rome Prize. He teaches at Sarah Lawrence College, where he holds the Noble Foundation Chair in Art and Cultural History.

Kim Stringfellow

Kim Stringfellow is an artist, educator, writer, and curator based in Joshua Tree, California. Her work bridges cultural geography, public practice, and experimental documentary into creative, socially-engaged transmedia experiences. She is a 2016 Andy Warhol Foundation for the Visual Arts Curatorial Fellow and a 2015 Guggenheim Fellow in photography. She was awarded an honorary doctorate from Claremont Graduate University in 2018. Stringfellow is a professor at San Diego State University's School of Art + Design.

Stringfellow's projects have been commissioned and funded by leading organizations including California Humanities, Creative Work Fund, Graham Foundation for Advanced Studies in the Fine Arts, Los Angeles County Arts Commission, and the Seattle Arts Commission. Exhibitions include those at the International Center for Photography; Los Angeles County Museum of Art; Los Angeles Contemporary Exhibitions; the Autry National Center; Nevada Museum of Art; John Michael Kohler Arts Center; Gagosian, Madison Avenue, New York; University of California, Berkeley's Graduate School of Journalism; and University of California, Riverside's Culver Center of the Arts, among others. Her photographs are included at Yale University's Beinecke Rare Book and Manuscript Library, Western Americana Collection.

Stringfellow is the author of two books, *Greetings from the Salton Sea: Folly and Intervention in the Southern California Landscape, 1905–2005* and *Jackrabbit Homestead: Tracing the Small Tract Act in the Southern California Landscape, 1938–2008*, both published by the Center for American Places.

Hiroshi Sugimoto

Hiroshi Sugimoto was born in Tokyo in 1948. He graduated from Saint Paul's University there before moving to California to attend Art Center College of Design. After graduation he moved to New York. He has received many awards and honors including a Guggenheim Fellowship; Manichi Art Prize; Fifteenth Annual Infinity Award from the International Center of Photography; Officier de l'Ordre des Arts et des Lettres, France; Isamu Noguchi Award, New York; The Royal Photographic Society's Centenary Medal, London; and National Arts Club Medal of Honor in Photography among others.

His books include: *Time Exposed* (1991), *Sea of Buddha* (1997), *Sugimoto: In Praise of Shadows* (1998), *Theaters* (2000), *Noh Such Thing as Time* (2001), *time exposed* (2005), *Utsutsu na zou* (2008), *Sense of Space* (2011), *origins of art* (2012), *ON THE BEACH* (2014), *Hiroshi Sugimoto: Dioramas* (2014), *Hiroshi Sugimoto: Seascapes* (2015), *Hiroshi Sugimoto: The*

Long Never (2015), *Hiroshi Sugimoto: Theaters* (2016), and *Hiroshi Sugimoto: Snow White* (2017) in addition to numerous exhibition catalogues. He exhibits in museums worldwide and his work is held in many collections. Sugimoto also creates site-specific artworks, most notably several for the Benessee Art House Project and Park in Noashima, Japan.

Larry Sultan

Larry Sultan grew up in California's San Fernando Valley, which became a source of inspiration for a number of his projects. His work blends documentary and staged photography to create images of the psychological as well as physical landscape of suburban family life. Sultan's pioneering book and exhibition *Pictures From Home* (1992) was a decade long project that features his own mother and father as its primary subjects, exploring photography's role in creating familial mythologies. Using this same suburban setting, his book *The Valley* (2004) examined the adult film industry and the area's middle-class tract homes that serve as pornographic film sets. *Katherine Avenue* (2010), the exhibition and book, explored Sultan's three main series, *Pictures From Home*, *The Valley*, and *Homeland* along side each other to further examine how Sultan's images negotiate between reality and fantasy, domesticity and desire, as the mundane qualities of the domestic surroundings become loaded cultural symbols. In 2012, the monograph *Larry Sultan and Mike Mandel* was published to examine in depth the thirty-plus-year collaboration between these artists as they tackled numerous conceptual projects together that include *Billboards, How to Read Music In One Evening*, *Newsroom*, and the seminal photography book *Evidence*, a collection of found institutional photographs, first published in 1977.

Sultan's work has been exhibited and published widely and is included in the collections of the Los Angeles County Museum of Art; the Art Institute of Chicago; The Museum of Modern Art, New York; the Whitney Museum of American Art; the Solomon R. Guggenheim Museum; and the San Francisco Museum of Modern Art, where he was also recognized with the Bay Area Treasure Award in 2005. Sultan served as a Distinguished Professor of Photography at California College of the Arts in San Francisco. Born in Brooklyn, New York, in 1946, Larry Sultan passed away at his home in Greenbrae, California in 2009.

Andrew K. Thompson

Andrew K. Thompson lives and works in Riverside, California. He holds a master of fine arts from California State University, San Bernardino, and a bachelor of fine arts in photography from the Academy of Art, San Francisco. His has exhibited throughout the United States including at the AIPAD Photo

Show, Alan Klotz Gallery in New York, Gallery 1/1 in Seattle, and solo shows at the SRO Photo Gallery at Texas Tech University and CACtTUS, Long Beach. Musings on his work have appeared on *Saturday Night Live*, the *Village Voice, L.A. Weekly*, and *KVCaRts*. He has published images in *Elle, Urban Italia, Rhythm Magazine, Time Out New York*, the *Village Voice*, and *Artvoices*. He has written for *Artvoices Magazine* and *Dotphotozine*. Curatorial projects include *The Mysterious Burial Mask: Information and Evidence* at the Robert and Frances Fullerton Museum of Art. He has been a professional wrestler and creator of Punk Rock Pillow Fight.

Brett Van Ort

Brett Van Ort was born in Washington, DC, and raised and schooled in Texas. He moved to Los Angeles where he worked as a camera assistant and camera operator for various films, television shows, commercials, and documentaries, most notably Errol Morris' Oscar-winning *The Fog of War*. He moved to London in 2008 and received his master's degree in photojournalism and documentary photography at the London College of Communication, University of the Arts London, shortly thereafter.

Van Ort has always been interested in land, the outdoors, and how we as humans use and commune with our environment. Many of his personal projects focus on the landscape, interaction with our environment, and what is concealed by nature.

His first monograph *Minescape*, showing the hidden danger of landmines in Bosnia, was released as a printed book by Daylight Books. TED books and Daylight Digital converted *Minescape* into a digital, ebook version, days after the printed version's release.

He moved back to Los Angeles in 2012 to continue projects about landscape in the United States. His most recent work *C.E.R.C.L.A.* looks at some of the 1,383 Environmental Protection Agency Superfund sites around the country.

Aashanique Wilson

Aashanique Wilson's artistic goal is to represent her community—Riverside's Eastside, and its satellite neighborhood, Rubidoux. Both are traditionally black and Latinx. Both have also spent a century hidden in plain sight, underrepresented in opportunity, politics, and art.

Wilson makes photographs, videos, and music. She dances, writes poetry, and performs spoken word. Much of her artistic production is posted online under a host of names, most commonly Shrxxm. Wilson was born in Riverside in 1996 and is currently a student in music technologies at Riverside City College.

Wilson has undertaken a five-year-long photography project centered on the stucco bungalow and Rubidoux neighborhood of her great-grandmother Juanita Powell. Powell was a civil rights pioneer; in 1936, Powell's daughter Marcille was the first African-American child to attend West Riverside Elementary. Wilson has made many hundreds of photographs for the project, black-and-white and color, film and digital. Some have been under the guidance of RCC photography instructor Nancy Gall, but most on her own initiative. The artist believes greatness is everywhere and holds that ambition rises from struggle. She cultivates a "will of fire"—a fierce love and belief in one's village. Wilson's goal is to give her long overlooked community a clear voice.

Authors

Douglas McCulloh

See above.

Thomas McGovern

See above.

Tyler Stallings

Tyler Stallings' curatorial work focuses on political, social, and popular culture themes. Currently, he is director of Orange Coast College's Frank M. Doyle Arts Pavilion. Prior positions include Artistic Director at UCR ARTSblock's Culver Center of the Arts (2007–2017) and chief curator at Laguna Art Museum (1999–2006).

At UCR ARTSblock he curated or co-curated: *Truthiness: Photography as Sculpture* (2008), *Intelligent Design: Interspecies Art* (2009), *Your Donations Do Our Work: Andrea Bowers and Suzanne Lacy* (2009), *The Great Picture: The World's Largest Photograph & the Legacy Project* (2011), *Margarita Cabrera: Pulso y Martillo* (Pulse and Hammer) (2011), *Lewis deSoto & Erin Neff: Tahquitz* (2012), *Free Enterprise: The Art of Citizen Space Exploration* (2013), *Mundos Alternos: Art and Science Fiction in the Americas* (2017), and *Yunhee Min & Peter Tolkin: Red Carpet in C* (2018).

Other notable exhibitions elsewhere include *CLASS: C presents Ruben Ochoa and Marco Rios: Rigor Motors* (2004); *Whiteness,*

A Wayward Construction (2003); *Surf Culture: The Art History of Surfing* (2002); *Desmothernismo: Ruben Ortiz Torres* (1998); and *Kara Walker: African't* (1997).

At the Doyle, he has organized *Amy Elkins: Photographs of Contemporary Masculinity* (2018), *Elizabeth Turk: ThinkLab .002: Extinct Bird Cages* (2018), and *Stargazers: Intersections of Contemporary Art and Astronomy* (2019). He co-edited the anthology, *Uncontrollable Bodies: Testimonies of Identity and Culture* (Seattle: Bay Press, 1994) and is the author of an essay collection, *Aridtopia: Essays on Art & Culture from Deserts in the Southwest United States* (Blue West Books, 2014).

Susan Straight

Susan Straight has published eight novels, including *Highwire Moon* and *Between Heaven And Here*. Her essays and fiction have appeared in *The New Yorker, The New York Times, Granta, The Guardian*, and elsewhere. She has received The Lannan Prize for Fiction, the Edgar Award, a Guggenheim Fellowship, and the Robert Kirsch Award for Lifetime Achievement from *The Los Angeles Times* Festival of Books. With Douglas McCulloh, she has for years chronicled life in Inland Southern California. She is Distinguished Professor of Creative Writing at University of California, Riverside.

Joanna Szupinska-Myers

Joanna Szupinska-Myers is senior curator at the California Museum of Photography (CMP) at University of California, Riverside. As a curator and writer, she is immersed in contemporary art, photography, and the nature of collections. She has curated solo presentations of work by Marie Bovo, Laurie Brown, Zoe Crosher, Phil Chang, Gordon Matta-Clark, and Penelope Umbrico, among others, and curated and co-curated the group exhibitions *Mundos Alternos: Art and Science Fiction in the Americas* (2017-2018); *Reproduction, Reproduction* (2015-2016); and *Trouble with the Index* (2014) at the CMP, as well as *Skyscraper: Art and Architecture Against Gravity* (2012) and *First 50* (2012) at the Museum of Contemporary Art Chicago. Her texts have been published in English, Polish, German, French, Spanish, Italian, and Mandarin Chinese. Together with Julian Myers, she is one half of grupa o.k., a collaborative endeavor focused on contemporary art, the history and future of exhibition making, and the forms and complexities of collective organization.